The publisher and the University of California Press Foundation gratefully acknowledge the generous support of the Constance and William Withey Endowment Fund in History and Music.

Not Yo' Butterfly

AMERICAN CROSSROADS

Edited by Earl Lewis, George Lipsitz, George Sánchez, Dana Takagi, Laura Briggs, and Nikhil Pal Singh

Not Yo' Butterfly

MY LONG SONG OF RELOCATION, RACE,
LOVE, AND REVOLUTION

Nobuko Miyamoto

Edited by Deborah Wong

UNIVERSITY OF CALIFORNIA PRESS

University of California Press
Oakland, California

Library of Congress Cataloging-in-Publication Data

Names: Miyamoto, Nobuko, 1939- author. | Wong, Deborah Anne, editor.
Title: Not yo' butterfly : my long song of relocation, race, love, and revolution /
 Nobuko Miyamoto; edited by Deborah Wong.
Description: Oakland, California : University of California Press, [2021] |
 Includes bibliographical references and index.
Identifiers: LCCN 2020041533 (print) | LCCN 2020041534 (ebook) |
 ISBN 9780520380646 (cloth) | ISBN 9780520380653 (paperback) |
 ISBN 9780520380660 (ebook)
Subjects: LCSH: Miyamoto, Nobuko, 1939- | Women dancers—United
 States—20th century—Biography. | Women artists—United States—
 20th century—Biography.
Classification: LCC GV1785.M625 A3 2021 (print) | LCC GV1785.M625 (ebook) |
 DDC 792.802/8092—dc23
LC record available at https://lccn.loc.gov/2020041533
LC ebook record available at https://lccn.loc.gov/2020041534

Manufactured in the United States of America

30 29 28 27 26 25 24 23 22 21
10 9 8 7 6 5 4 3 2 1

CONTENTS

LIST OF ILLUSTRATIONS

Intro

i grew up without a song that sang me
i didn't know
i was missing my own song
till i found my sisters and brothers
rising, searching, claiming
their silenced voices
i stood with them
i sang
i learned
we all have
a song within us

now i see my song making
a sacred task
of deep listening
grasping a melody
from the inner ether
weaving meaning
from the madness we're living
and the final act
finding the courage
to sing aloud
to touch even a single a soul
as only a song can do
to sing aloud
to birth a better world
knowing
we all have
a song within us

First Movement

ONE

———

A Travelin' Girl

I WAS BORN WHERE I DIDN'T BELONG. At two I became the enemy, a would-be spy, a threat to US internal security. Soon I was removed with 120,000 others who looked like me to a place the grown-ups called "camp." But it was no summer camp.

My first memory is of riding on my father's shoulders. It was dusty, and there were rows of wooden shacks. We were waiting in a long line with lots of other families, all Japanese. My father's big shoulders made me feel like I was riding an elephant in a parade, looking down on a river of heads covered with hats and scarves, protecting them from a chilly wind. But this parade had no music, no happy shouts, no people waving, no colorful drum majorettes marching. There was only hushed chattering, clutching of children, men in drab uniforms with rifles in hand.

We were moving toward a large building they called a mess hall, where we were going to eat. The food came from cans with a clatter of spoons and forks on metal plates, food that soldiers ate. I was hungry but refused to eat. There was a reason they called it a mess hall. We were at Santa Anita Park racetrack in Arcadia, California, once the playground of the rich and famous. Movie stars like Bing Crosby, Spencer Tracy, and Errol Flynn owned horses that lived and raced there. Now, we slept in the horses' stalls.

On December 7, 1941, Japan attacked Pearl Harbor. It took the US government just three months to transform the ritzy racetrack, a convenient twenty-one miles east of Los Angeles, into a temporary holding camp where 18,000 Japanese, mostly US citizens, could be stored in its 8,500 horse stalls and more than 60 barns. All it needed was more barracks. We were being held there while the government built ten permanent concentration camps scattered in inconvenient, remote places, many on Indian reservations:

Manzanar, Tule Lake, Topaz, Gila River, Poston, Jerome, Heart Mountain, Rohwer, Amache, and Minidoka. More than 120,000 Japanese Americans were removed from our homes in California, Oregon, Washington, and even parts of Arizona, and would be held in these camps until the end of the war with Japan—or maybe forever. We didn't know.

The tsunami that swept us into camp began in smaller waves from the moment my grandfathers stepped onto US shores. Like African slaves, Chinese and Japanese labor was an unwelcome necessity to develop this country, a need us / hate us relationship. Their labor and lives were seen as cheap, or in the case of the enslaved, free.

My mom's father, Tamejiro Oga, was a second son of a farming family in Tachiarai, Fukuoka prefecture, Japan. Only the oldest son would inherit land, so in 1905 he pursued his dream of a rice farm in California, taking on backbreaking work to clear the virgin land. My dad's father, Miyamoto, from Kumamoto, was among those recruited to work on the railroad, replacing Chinese laborers who were organizing against unfair treatment.

In 1913, a year before my mom was born, the Alien Land Law stopped her father from owning the farmland he cleared in Chico, California, because he wasn't a citizen. Every European, on the other hand, had an immediate right to naturalized citizenship. Those words on the Statue of Liberty were not meant for us. I wonder what America would look like if anyone who came to this land had been welcomed—by the Indians, of course. In 1924 the Japanese Exclusion Act slammed the door on Japanese immigration, and the media and the movie business stayed busy stirring up racist fantasies of Japanese invading the United States. Now their fantasies seemed real.

On December 8, the day after Japan attacked Pearl Harbor, my friend Reiko, who was ten, went to school and heard speakers blare President Roosevelt's speech declaring war on Japan. At recess kids taunted her and asked if she had webbed feet. "All of a sudden I was the enemy." The next day White men came to her house and took away her father, a Buddhist priest. They later sent him to Japan. She never got to say goodbye, and she never saw him again. Many Japanese community leaders were swept up and imprisoned on that day. The government already knew who they were and where they lived. My family's fate would take a little more time.

Each day my mother, Mitsue, and her older sister, Hatsue, sipped coffee and murmured their worries over the kitchen table. They were used to shar-

ing hardships. They were nisei (second generation), born in Oakland, but life was still hard in America. They'd been sent at a young age to Japan to be raised by their grandparents, a common practice. After ten years of living in comfort there, their mother, Misao, came to collect them and take them home to Los Angeles. Then Misao died. At the ages of twelve and fourteen, the sisters had to take over running the household: caring for a younger sister, cooking for their father's gardening crew, struggling to learn English while going to a strange new school.

Mitsue's and Hatsue's worries enshrouded the whole Japanese community. War hysteria was on the radio, invading our house, our lives. They tried to shield me and my cousin Kay, but we knew something was wrong. Ordinary things like going grocery shopping became embarrassing and fearful events—the hate in people's eyes, newspaper racks blaring "OUSTER THE JAPS," *Life* magazine's story showing how to tell the difference between a Chinese and a *Jap*. My mom wanted to scream her anger: "We're not Japanese Americans anymore, we're all *Japs*!" My mother had become much more American than her older sister. Hatsue married a man from Japan, a marriage that was arranged by a *bishakunin* (go-between), with her approval. For the marriage to be accepted by his family, she had to agree to become a Buddhist (which she put off for twenty years). Hatsue seemed satisfied to be a mother and housewife. Mitsue, on the other hand, always sought something more, some way to express herself. She went from Mitsue to Mitzi (to her girlfriends) and told her father she wanted to be an artist.

"No! No thing for woman!"

Somehow she found a way to go to Chouinard Art Institute. She loved the latest fashions, going on to Trade Tech for fashion design. Like many Japanese women of her generation, she was an expert seamstress. She made all her own clothes and mine, too. That became her art.

Mom also made up her mind to marry for love. Her mother, Misao, had married a picture of a man she'd not yet met. She was a "picture bride," who like many Japanese women in those early days met their husbands for the first time when they stepped off the boat. Asian men who immigrated were not allowed to bring a wife. But while living in Japan, my mom saw one of Misao's sisters marry for love. That was rare in Japanese culture, which traditionally stressed good matches based on economic and family ties. Mitzi was a modern girl and love was what she wanted. When she told her father she wanted to marry Mark Miyamoto, a handsome half-breed, Japanese and Caucasian, Grandpa put his foot down. "No! No good! Who is family?"

It took her five years to stand up to him: "I'm going to marry him whether you like it or not!"

My father, like most nisei men, swallowed his worries in silence. Though his mixed blood made him taller than most Japanese men, he saw himself as no different. He shared their troubles and challenges. Born in Parker, Idaho, to an English Mormon mother and a Japanese immigrant father, my dad was fourteen when his mother, Lucy Harrison, died and Grandpa Harry Miyamoto decided to take his boys to Los Angeles for a better life. My father achieved his first big dream playing baseball at Hollywood High School. He was an ambidextrous pitcher with the LA Nippons, a semipro team in the Japanese American League. They played the likes of Satchel Paige in the Negro League. He was in good company with other men of color when that dream bit the dust.

Dad also had big ears—not only in size, but in what he could hear. He listened to classical music, listened deep. He not only had his favorite composers, but he knew when it was Iturbi rather than Rubinstein playing the piano. And *he* wanted to play the piano too. But fat chance for a nisei to make a living as a musician in those days! Another dream in the dust.

Most issei and nisei were gardeners or in the produce business. So Dad took a job trucking strawberries, onions, and rice for Japanese farmers up and down California. That's when those big ears came in handy. It was easy for him to pick up Japanese so he could communicate with his farmers.

One day Mark came home and said to Mitsue: "Give me the savings."

"What for?" She was the guardian of the money.

"I'm going to buy a truck!"

He was going into business for himself. His independent spirit liked the idea. He also liked having money in his pocket. Business was going good. So in 1940 he went to Chicago to pick up a second truck, a brand-new Mack semi. Now he had two semis! Life was so good, we soon had a nifty new green Packard sedan in our driveway.

Maybe business was *too* good. His nisei buddies at the produce market were talking about greedy White farmers pushing for "Japs" to be removed. They were farming nearly a half million acres in California, a rising force in the economy. White farmers were clucking like vultures to take over their farms and made no secret of it. Mark was looking at the dust again.

On February 19, 1942, President Roosevelt signed Executive Order 9066, giving the War Department the power to designate military areas from

which "any or all persons may be excluded." One of those "military areas" was our neighborhood on Kingsley Drive where Japanese families lived among White neighbors. Another was my auntie's neighborhood in Arlington Heights, where they lived among Black people. Curfews were imposed, and my father stayed closer to home. That made me happy, but he knew the noose was tightening around us.

In early April 1942, signs were posted: INSTRUCTIONS TO ALL PERSONS OF JAPANESE ANCESTRY . . .

It didn't matter that you were a US citizen, or if you were only half Japanese like my dad, or if you were a two-year-old like me. If you had up to 16 percent Japanese blood, you might be a spy, a saboteur. No "innocent until proven guilty," no trial, no jury of your peers. President Roosevelt's Executive Order 9066 considered all Japanese who lived near the Pacific Coast a threat to US internal security, even though at the war's end, only ten people were found guilty of spying, all of them Caucasian.

We had to pack our lives into suitcases and report to the designated assembly place—to be taken where? Look what they did to the Indians! Look what they're doing to the Jews! How long would we be gone? A few years? Forever? Words like "evacuation" and "relocation camps" were misnomers. It was forced removal, like they did to Native people. It was not a relocation camp, it was a concentration camp. That order not only swept away our freedom; it ignored our American identity, it removed our sense of belonging. Our belongingness had always been tenuous, fragile, and now, no matter our superheroic efforts at being accepted as American, we would always wear the face of a foreigner. We weren't just second-class citizens—we weren't seen as citizens at all. We were neither Japanese nor American. We were exiles, refugees in our own country, prisoners of a war we didn't support.

The mass removal of 120,000 people was no easy task. It was almost half the population of all Japanese living in the United States, mostly citizens. Removing us from our homes, clearing us from our neighborhoods, disappearing us from our schools and workplaces, cleansing us from land we cleared and nurtured, leaving behind friends, lovers, businesses, homes, cars, pets, family treasures, dreams—was painful and complicated. Our cooperation was a necessity to evacuate all who lived within fifty miles along the coasts of California, Oregon, and Washington. There were negotiations, individuals who took a stand, but no noisy mass demonstration against our

unjust treatment, no public outcry to defend us. Japan's repressive culture taught us to be obedient. And living in America had taught us that we "didn't have a Chinaman's chance." But mostly we were in shock, in disbelief, that this could happen in America.

Some, like my dad's brothers, tried to make a run for it. Grandpa Miyamoto had already returned to his little family land in Parker, Idaho. He left behind a truck from his East Hollywood nursery. Kay, the youngest, who looked more like their White mother, drove. Harry, the oldest and most Japanese-looking, hid underneath the bed of the truck. They made it across the California border to Nevada, but just as they crossed into Idaho, they got arrested. Sort of like driving while Japanese. Grandpa Harry came and bailed them out. Years later, Harry Jr., who was always broke, found a way to keep three $100 bills tucked deep into his wallet just in case he ever had to make a run for it again.

Dad couldn't take chances. He had me and Mom to think about. Leaving our cozy home on Kingsley Street was chaotic. While Mom decided what to take, what to sell, where to store things, and what to leave behind, Dad was scrambling to keep from losing everything he'd worked for. He had no choice but to leave behind his two semi trucks. He hoped his worker and friend, Joe Ponce, could run the business in his absence.

We were ordered to assemble in Little Tokyo. First Street was a place my mother sometimes took me shopping. In the summer of 1941 we went there for Nisei Week, a festival with Japanese *odori* dancing, exhibits, and a talent show, started by second-generation Japanese Americans to foster pride and bring younger Japanese Americans into Little Tokyo. My mother entered me in the Nisei Week Baby Show, a cuteness contest invented by prideful parents. When the judges came around to look at my mother's little pride, I broke into a crying fit, maybe my first form of protest. Needless to say, I didn't win.

Now my mother, father, and I were in an ocean of confused families, worried and waiting. This time I didn't cry, I didn't protest, I couldn't find a sound within me. There were lots of children younger and older than me, not playing but strangely quiet, clinging to their parents, sitting on suitcases. A big bus arrived, hissing and screeching. As the soldiers loaded us, my father swept me into his arms as my mother scurried for seats. As the bus grunted into movement, the bickering over seats broke into shrieks and cries, not just among children, but grown-ups as well. We were being taken away from the tofu and *manju* sweet shops, from the photography studio where I took my baby photo, from the hardware store where gardeners sharpened their blades,

from the dry-goods store where my mother bought me my first little kimono, from the Buddhist Temple, from the baby show (I promise I won't cry next time), from our house on Kingsley, from our dreams, our happiness, our hopes, our home.

That twenty-one-mile journey took us from the place we thought was America and delivered us to a foreign country. Our belongings were searched when we stepped off the bus, just like criminals. Wading toward our "living quarters" I could feel my parents' dread. The former horse pen still smelled like hay and manure. My mother stuffed our mattresses with hay. My father collected scratchy wool army blankets to keep us warm. Finally, I closed my eyes, gave in to the smell, escaped into a dark sleep.

The next day I woke up scratching. A rash had taken over my two-year-old body. Eczema wept from my skin, crawling on my arms, my neck, my face, the backs of my knees. It itched, and I scratched until I bled. My mother panicked. Somehow she got hold of a salve that smelled like tar to put on my arms and legs. She wrapped me with gauze. During the night I scratched through the bandages, like I was trying to dig myself out of something. I was allergic to the horse dander. I was digging myself out of our desperate situation.

We have been called the "quiet Americans." We are not known to roar over our troubles, cry out our injustices. Maybe it came from the Japanese tradition of *gaman*, and the repressive social system in Japan. *Gaman* means to endure, to swallow your pain and difficulties in silence and push on with life. Despite the unfair, illegal circumstances, we did, for the most part, endure our forced removal. But the quiet didn't last long.

Soon, issei were making sawing and hammering sounds, building tables and furniture. Children were pledging allegiance. Inmate teachers shouted to their classes in the din of a makeshift school in the lobby of the racetrack grandstand.[1] By pushing on in life, conditions improved. Latrines got dividers. Food got better as Japanese farmers made gardens with their smuggled seeds. Soon, younger nisei and sansei (third generation) were making all kinds of sounds that wouldn't be contained by barbed wire—sassy sounds, slang slinging, jitterbugging, remember-I'm-American sounds. Time on their hands and nowhere to go birthed the Japanita Jive band. The Kawasumi Sisters were harmonizing Andrews Sisters hits like "Ac-cent-tchu-ate the Positive." On Saturday nights teens thronged to dances in front of the grandstand. Kids read Superman and Buck Rogers comic books to crack-of-the-bat

baseball sounds (sixty teams). A newspaper called the *Pacemaker* churned out its first biweekly edition (the first of fifty) on April 18.

Santa Anita became a noisy, bustling village of more than eighteen thousand Japanese Americans. We were uprooted like dandelions, stripped of our rights and freedom. Despite being inmates in a giant prison camp, barbed wire could not stifle creative expression.

Like a regular prison, a limited number of visitors were allotted half-hour visits with inmates. People tried turning their despair and fear into something hopeful, livable. To remind themselves they were in America, some decorated their barrack living quarters with US flags that friends mailed them. We were born into a place where we were a minority, and now we were the majority. But we were in a giant ghetto, a prison, a concentration camp with military guards and towers. Some politicians said it was for our protection. But why were the guns pointed in our direction, then?

At the end of August, they began sending us to permanent camps. Auntie Hatsue, Uncle Fred, and cousin Kay were taken to Gila River concentration camp in Arizona. A couple of weeks later, Grandpa Oga and youngest daughter, Mary, were moved to Heart Mountain concentration camp in Wyoming. We didn't know if we'd ever see them again.

In September, army recruiters came to Santa Anita. Lots of the younger men were champing at the bit to prove their loyalty. They were willing to fight against their home country to prove they were good Americans. But not my father. He didn't need to prove anything. "Why should I fight for America if they put us in prison?"

The war caused a shortage of laborers. Recruiters sought volunteers to go to Montana to harvest sugar beets. My father was tired of sitting around that lousy camp. He was thirty, with his family sleeping in a smelly horse stall. He jumped at the chance. He'd pick plenty of sugar beets in Montana if he could take his family with him. So on September 24 we were put on a train with 187 men from Santa Anita. My mom and I were the only women. There was no milk for a child. I have a newspaper clipping with a picture of my family being greeted by nisei women as we passed through Salt Lake City (see photo 4). My mom and dad are smiling. Dad holds me like he's trying to hold on to something normal in our uncertain lives. We were moving again, but we were not free.

TWO

―――――――

Don't Fence Me In

ON THE GLASGOW, MONTANA, FARM it was barracks for the men, but they put my mom, dad, and me in a tiny cabin. We had to go outside for the toilet and my mom had to bathe me in a large wooden barrel in the kitchen, which was also our living and dining room. Bathing was an important ritual for my mother. In Japan, her grandma took her to the neighborhood communal bathhouse, *osento*. Women bathed on one side of a divider and men on the other. You could peek under if you wanted to, but of course no one did—right? One scrubbed and rinsed, then soaked and relaxed with others in the hot water of the big wooden tub heated from a fire beneath.

But Montana turned her bath ritual into hard labor. She had to pump the water by hand from the well outside, haul the buckets of water into the cabin, heat the water on the wood stove, then pour the buckets into the large tub, adjusting the temperature with cold buckets of water. The water from the well was slimy and smelled of sulfur. But there was a silver lining: it was powerful mineral water. After three days of bathing me in that water, my weeping eczema was gone. It was a miracle for Mitsue's baby girl!

My mother was the keeper of our family stories. She began filling me with those stories during our days of wandering, lostness, loneliness, even though I was too young to understand them. She told me how beautiful her mother was, how she held herself, how she dressed, how in Japan, people looked at her when she passed by. She was the first daughter of "a good samurai family." An arrangement was made with another "good family," a farming and landowning family. That's what happened in those days. Misao was seventeen when she was promised and eighteen when, still in Japan, she married a picture of a man she'd never met. She was a "picture bride" and sailed across the Pacific with other picture brides. When she landed in Seattle, she shed her kimono. A corset replaced her

obi. She wore a self-made Western-style dress and a Western-style hat piled with flowers for her wedding to Tamejiro Oga in Seattle's Buddhist Temple (see photo 2). In Oakland and then Chico, California, Misao, first daughter of a samurai family, stepped into her life as a struggling farmer's wife. She had to cook for his workers and take in laundry for extra money. Soon they had two girls. And this was not a proper place to raise them.

Three-year-old Hatsue remembers sitting on the deck of the ship, playing with a new rag doll her mother had made for her. Grandma Misao made all their dresses, even their underwear. Mitsue, two years younger, slept in the arms of a family friend. When the ship moved, Hatsue looked up to see their mother on the shore, moving farther and farther away. Hatsue cried out for her and she didn't stop crying. She shed tears into the Pacific all the way to Fukuoka, Japan. My mother didn't cry. She was too young to know what was happening. She held her loss, her longing, in silence. This silence would later hold her fears, her secrets.

Their grandparents gave them a life of comfort, freedom, and grace in tune with the traditions with which my grandmother, Misao, and her younger sisters grew up. Grandpa Nishimura did well as a businessman in the coal industry. He was a loving *ji-chan* (grandfather) who did everything to make them happy. One day he brought them a kitten in the sleeve of his kimono. Mom told me that cat waited every day for *ji-chan* to come home. But it was Hatsu, my *baachan* (great-grandmother), daughter of a samurai clan, who ruled the household and raised the girls. She became their anchor, their teacher. When they were old enough, she would take them to a Christian church, saying, "You are going to live in America. You should be Christian." Then Hatsu crossed the road and went to her Buddhist temple. She taught them what it meant to be Japanese, but she also taught them to adapt, to be able to absorb and fit in. She was preparing them for life in America.

Ten years later Misao came for the girls with a new baby sister, Mary, and nine-year-old brother, Ta. Ta was sick with cancer and she was seeking a cure in Japan. But they had to return to the United States before the 1924 Japanese Exclusion Act closed the door to immigration. Misao tore Mitsue and Hatsue away from their grandparents, their life of comfort and culture. The girls returned to Los Angeles, a father they didn't know, and a neighborhood of strangers, and went to school without knowing English. A few months later, Ta died. Soon after, Misao also died. My mother said she died of "a broken heart." Years later, Auntie Hatsue told me she committed suicide. She drank

a bottle of Lysol. It happened on a Sunday. Mitsue and Hatsue went to school on Monday. No one in the school knew what happened. Life for Mitsue and Hatsue just pushed on.

My mother had been torn from her secure and comfortable life. Now she was torn from her mother. She told me how she would go to the ocean to try to see Japan, try to see her grandparents, try to see those happy days. And now she was in Montana, trying to see how she could get beyond the invisible barbed wire that imprisoned us. Being a prisoner not only stifled her dreams, it was an affront to her dignity. The only place she could express her anger was to me. She'd say, "They didn't put Germans in camp, so why us?!"

On that farm there was one little boy I played with. I remember him because he wanted me to eat his raw potato with him. "Poo! That's nasty!" He didn't speak English; he was speaking German. As it turned out, there *were* a few Germans in that work camp.

Mitsue knew that if you had a sponsor and a place to live and work inland, you could get permission to be released from camp. After the harvesting season, a forty-below winter, and too many pails of well water, she worked herself up to approach the foreman of the farm. She told him that her father-in-law had a place we could go to in Idaho.

"Where in Idaho?"

"Parker," she responded.

"Parker—I'm from Parker! What's his name?"

"Miyamoto."

The foreman jumped. "Harry Miyamoto?"

"Yes!"

"Why, I'll be doggone, I was at his wedding! Boy, that wedding was the talk of the town. Our Lucy Harrison marrying a man from Japan."

The memory of Harry's and Lucy's wedding was our ticket out of Glasgow. We were now headed to the little town where my dad was born, Parker, Idaho, where the population today is still three hundred.

Yikes! Chickens are running wild around my grandpa's yard. The rooster is clucking and strutting like it's the boss and I'm an invader. I can't go outside without my mother to defend me. I'm three and bigger than they are, but I don't like these chickens!

The house seemed so big to me, but everything seemed big compared to the little cabin we left in Montana. It was only 560 miles away, but we were

in a different world. This was the house where my father was born and grew up. Mom said he walked five miles to school each day. There was a pigpen, where my mother lost her wedding ring, and open space all around us with lots and lots of cherry trees. The best part about it was *no barbed wire*, though I wouldn't have minded if they wrapped some wire around those chickens.

There were no children to play with in Parker, so grandpa became my playmate. Unlike most issei, he spoke English, being with Lucy and all. And he was fun. Grandpa had agile hands. I loved to watch him roll his cigarettes the old-fashioned way. His tobacco was in a cotton pouch tied with a string. He tapped just the right amount onto rolling paper, pulling the pouch string shut with his teeth. With one hand, he could roll the paper, lick it shut—and like magic, a perfect little cigarette! He had a special way of peeling an apple, too. Using his pocketknife, he would carve its green skin into one perfect spiral. More magic. Maybe that's how he caught Lucy's attention, with his magic hands.

I never met my Grandma Lucy. She was always a mystery to me. Mom told me she died at the age of thirty-eight from a goiter, a disease of the throat caused by iodine deficiency. My father was fourteen at the time. He never spoke a word about her. As a child I saw only one picture of her, taken in 1897 in Ogden, Utah. She was seven, sitting below her bearded father, younger brother George, and her mother. Lucy's face was framed by her auburn hair and fluffy white collar of her dress. Her big eyes gazed straight at me. I wondered, who was Lucy, the grown-up?

In 1900, when Tokumatsu Miyamoto was recruited in Kumamoto, Japan, to work for the railroad, he was nineteen. It was most likely a boss man who couldn't say "Tokumatsu" who renamed him Harry. Chinese and Japanese railroad workers were commonplace in Idaho (33 percent) in those days, but segregation was the rule. In 1864, Idaho had an anti-miscegenation law that prohibited interracial marriage and sex. Asian women who weren't already spouses were prohibited from immigrating. This law kept them from inter-marrying and multiplying. In 1921, a special amendment was created to include Mongolians (Chinese). The Mormons also had rules that prevented people of color from becoming part of the church, let alone marrying into it. Harry also came from a place with a monoculture and hierarchically strict rules and customs. He was six thousand miles from Kumamoto and every-thing was set up to keep these two people apart. So how did Harry get

together with Lucy? What did it take for him to ask her to marry him? And what was it in her that said "yes"?

Many years later a Mr. Parkinson, a ninety-two-year-old Mormon, came to my door and introduced himself as my distant second cousin. He was writing a book about his family and wanted to know about his relatives, the Miyamotos. He told me Lucy came from a long line of travelin' women. Her great-grandmother Charlotte Rose was born in Chatham, Kent, England, in the time and the town of Charles Dickens and Florence Nightingale. He said she was a "colorful woman" who had four husbands (not at the same time) and eight children. With her last husband she went to colonize Australia, then lived in Valparaiso, Chile. She reached America via New Orleans, then sailed up the Mississippi to St. Louis, where she died in the cholera epidemic of 1849. Her daughter Lucy Berry (Lucy's grandmother) crossed the plains with her father and his new Mormon wife, following the Mormon Trail to Utah and then Idaho. They braved hardships and "skirmishes" with Indians (oh no!) and established some of the first settlements of Idaho.

So Grandma Lucy came from a long line of border-crossing women. It wasn't so farfetched that she had the guts to take a bit of a left turn and say "yes."

Much later, my cousin Kathy Miyamoto gave me a picture of a grown-up Lucy and her three boys, Harry, Mark, and Kay, surrounded by a group of Japanese women and their children (see photo 3). She told me Lucy was a jolly woman who would shoot quail from her front porch. She was taller than Harry, but that didn't make no mind. Lucy loved Harry and nothing was going to interfere with that.

I found an article published in 1918 in the *Rigby Star News* describing an accident in St. Anthony when "the car containing Mr. Miyamoto, wife and four children was thrown into a ditch" by a hit-and-run driver. The article goes on to say that "one of the five-year-old boy twins suffered a fractured skull" and that all the occupants were badly bruised and shaken up. A helpful driver stopped to take them to a hospital, but the twin's head was badly crushed, and he died. "A mysterious feature" was that the car had been burned by the time they returned to collect it the next day. The boy who died was my Uncle Kay's twin brother, Ivan, a death no one ever talked about.

But that picture with Lucy and her three boys, surrounded by Japanese ladies and their children, told me Lucy was a brave soul who managed to cross

the barriers of culture, language, and custom to become part of the small, tight-knit Japanese community in Ogden. However they came together, I believe Lucy's and Harry's love was a brave new song. Their union went against all prevailing arrangements of race, religion, and law. It was a love that bridged the geocultural history of three continents.

For some reason Grandpa Harry held on to his Idaho land, even when he and Lucy lived in Ogden. After she died and they moved to Los Angeles, Grandpa still held on to it. When the war started, Grandpa headed back to Idaho. He had somewhere to go. Now this house in Parker saved us and Dad's two brothers from being kept in camp for the whole war. Being there did not make my father happy. He was restless and worried. What was happening with his trucking business? How would he make money to support us here?

For me, being on the land that belonged to Harry and Lucy made me feel I belonged someplace. We were uprooted, hated, and homeless, but this little patch of earth in the middle of nowhere connected us to something that was ours. Maybe that's why I loved and clung to my grandpa. He connected me to the land. He would take me into the cherry orchard and let me climb a ladder with him, up, up to the red cherries that dangled from its branches. We would guide me toward the darkest, purplest, fattest one, which I plucked and ate. The next one I'd pluck and put in the bucket. One in my mouth, one in the bucket. This went on until my hands and mouth were purple.

But my favorite thing about the cherry trees is that they attracted the dragonflies. They seemed to know when I was there. They would swoop down to visit me, buzzing and dancing with their silky iridescent wings. The dragonflies were like fairies with shiny costumes of blue, green, purple. I couldn't decide which color was prettiest. They danced around me in every direction, to the right, left, up, down, appearing, disappearing like magic. So fast, so free, without limits. I wished I could be like my friends, the dragonflies.

Just when I was feeling comfortable, at home, Dad got the news. His brother Kay had gotten him a job driving a truck for his old boss in Ogden, Utah. We were moving again, away from Grandpa, away from the chickens, away from my friends, the beautiful dragonflies.

A Tisket, a Tasket, a Brown and Yellow Basket

SOMEHOW MY DAD'S SHINY GREEN Packard was back in our lives. Maybe a friend brought it, or maybe it was the magic dragonflies. Anyway, we were traveling again. It was only 222 miles, a day's ride through the mountains, to Ogden. My mother made me comfortable in the back, on a pile of bedding. Out of the rear window I waved, "Bye bye Grandpa—bye bye cherry trees—bye bye chickens." I could live without the chickens, but it was hard to leave Grandpa.

It's late in the day. The sky is gray and filled with rain. We're now in Utah, near Promontory Summit, where the Central Pacific and the Union Pacific raced to complete the first transcontinental railroad in 1869, a major moment in the American story.

Now we're driving through the Mormon towns of Logan, Brigham, and finally Ogden. The towns in this chain are deliberately forty miles apart, a day's ride by wagon from Salt Lake City, center of the Mormon universe. As we enter Ogden, we're driving on Washington Boulevard on our way to a house that Dad's boss has rented for us at 180 17th Street. As we turn the corner on 17th Street, my father says things look familiar. When we pull up to the house, he realizes, "This is the same house my family lived in!" We would be living in the very house where he lived with his mom, my grandmother Lucy, the jolly woman who made friends with the Japanese neighbors. This is the house of Lucy, who on her last day kissed her boys and sent them off to school, locked the door, and passed into the next world. This is the house of Lucy, whom my father never told me about.

It was a dingy brick house with two bedrooms, dark wood floors, and a dank basement. But it wasn't a barracks, it wasn't camp. My mother was filled

with a new energy, dreaming how she could transform this little house, which held part of our story, into our home. She'd been discouraged from being an artist, but that didn't stop her from making art. Mitsue was a visual person with a sense of style. She loved beauty and was a perfectionist. All she needed was some paint and a sewing machine. Soon we had curtains and color around us. Spring came, and the government encouraged people to plant "victory gardens" to help families with food shortages. My mother had a green thumb, too. Outside the back porch, she planted rows of carrots, corn, green beans, sugar snaps. But my favorite was the strawberries. Every morning I'd run out to see the red strawberries. I was happy if there was even one. We never seemed to have enough for a whole bowl. To have fruits in the winter, Mom canned. I'd help her cut and peel. Our friends the Hayashidas were on a farm in Brigham and gave us fruit to make jam. Now the dark cellar was filled with color: rows of glass jars full of pink peaches, red and purple jams, green string beans. One day I went down into the cellar and found something in a trap we'd set. It was cute, with a long, skinny tail. I went up the stairs holding the tail. "Mommy, look what I found!" She shrieked and grabbed the dead rat from me. She washed my hands so hard I almost had no skin left. I guess she was afraid I'd get something worse than eczema.

Mom could fix anything. One day I brought home a little cat I'd found. Its dark fur had dried blood on it. A dog had taken a bite out of her stomach. My mother was on a ladder cleaning a light when I came in holding the cat. "Look Mommy, this poor kitty is hurt." She clattered off the ladder and cleaned Kitty's wound and bandaged it carefully. Slowly, little Kitty healed. Now I had a pet for company and Mom had a cat to keep the rats at bay. But besides my mom and Kitty, I had no friends. Sometimes I'd go out back, beyond the cornstalks to the railroad track. The trains passed and I'd wave at the engineer in the last car. He'd wave back. He became my friend. One day mother went out beyond the tracks and came back carrying something in her hands and yelling, "*Gobo, gobo!*" I thought she'd found gold, but it was a root, a food she missed from her time in Japan. The English name is burdock, and it's very healthy for you, but I thought it tasted like dirt.

Living in exile in the sleepy, gray town with long winters was a lonely time for Mom and me. Dad was gone trucking for three or four days at a time, and when he was home, he was sleeping. Sometimes I'd sit and watch him sleep, just to be with him. Mom did her best to keep us occupied in a place where there was little to do. Even though we weren't surrounded by barbed wire, she moved with caution. The war and people's attitudes were never far from her

mind. Once in a while she drove the Packard to go shopping to get *shoyu* (soy sauce) and tofu in the small Japanese neighborhood in Salt Lake City. Around the turn of century, after the Chinese Exclusion Act, Japanese laborers like my grandpa were imported as cheap labor on railroad gangs. It was almost like a chain gang. They worked for as little as fifty cents a day, slept in crowded bunkhouses, and asked for Japanese foods like rice, fish, vegetables, and tea. Later they formed Japanese associations to protect themselves.

Our visits with Harry and Rosie Hayashida, our "relocated" friends who worked a small farm in Brigham, Utah, were rare and precious (see photo 6). They had a son, Ronnie, about my age, who was my best friend. Notice how we all had American names—that "trying to be American" thing. My name was JoAnne, but JoJo was what most people called me. JoJo also had a very American hairdo. A popular child movie star at that time was Shirley Temple. She had reddish brown hair with curly ringlets. One day Mother took me to a beauty parlor, and they changed my naturally straight black hair using a smelly solution and a scary space-age helmet with curlers that fried my hair into ringlets. I still didn't look like Shirley Temple, but I gained an allergy to beauty shops.

Dad's brothers Harry and Kay left Parker and came to Salt Lake City. Harry now had a wife, Wanda. That was the first time I noticed: oh, she's got brown hair and pink skin. Harry's Japanese, like us. We're different. This awareness of differentness grew when I turned four and started kindergarten. It was in the same school my father attended when he was a boy, but I didn't feel I belonged there. I had never been around so many children, all of them White. Being quiet and shy amid their noisy chatter made me feel even more different and uncomfortable.

Uncle Harry's wife, Wanda, was not only White, she was Mormon, like Grandma Lucy. She had a different way of eating than us: no coffee, no Coca-Cola, no green tea. They have caffeine. And, of course, no alcohol or smoking! Mormons believed in clean living. But sugar was okay, and Wanda could bake. Every Christmas she would bake us yummy homemade bread, cookies, and fruitcake as presents. I hated the fruitcake but I loved the cookies and bread. This tradition went on even after we returned to Los Angeles.

There's nothing like homemade bread with butter. That was a delicacy for us. The war caused a shortage of a lot of things. Butter, eggs, and milk were all rationed. Each family had a little book of ration stamps that had planes, warships, and guns on it. At the store you would use the stamps, plus your money, to buy a limited amount of goods like butter. This shortage inspired

the invention of a cheap stand-in for butter: margarine. It came in two parts: a clump of whitish lard and a little packet of orangey powder. At home you combined the two and voila! You had something that looks almost like butter but tastes like margarine—yuck! To this day I can't stand margarine.

Our life took a drastic turn when Dad came home and told Mom that he'd invited a nisei guy he worked with and his wife to live with us. George and Haru Hayashi were total strangers. They'd just got out of camp at Rohwer, Arkansas, and George had gotten a job driving for Fuller-Topanze Trucking, where my father worked. His wife was pregnant and they had no place to live yet. Without a second thought and without asking my mom, my father told him they could come live in our house. Mom was miffed at first, but it turned out to be the best thing for all of us. Now she had a live-in friend in Haru, who was lively, fun, and *very* pregnant. A few weeks later, little Kenny was born and I became a big sister! We grew up thinking we were real family, and we were. That was one of the good things that came out of camp. Hard times taught us how to open our hearts and help each other.

Our biggest connection to the outside world was radio, where we heard the news about the war, and music. Mom hated them calling her people and us "Japs." What I wanted to hear was the music. My favorite song at the time was "A Tisket, a Tasket, a Brown and Yellow Basket." Ella Fitzgerald made a jazzy version of the game children played. I loved that song and sang it around the house. I also liked Frank Sinatra, but I couldn't sing along with him.

My father's passion was classical music. I don't know where he got exposed to it. Was it Lucy, or did he tune in on his truck radio on those long, lonely drives? However he found this music, it became a big source of entertainment in our house. He had a small portable record player and a collection of classics he listened to on his days off. Eyes closed, relaxed and leaning back in his chair, he listened deeply, sometimes waving his hand following the sounds. He could tell who was playing piano, Rachmaninoff or Rubenstein, in his favorite concertos. He could even tell who was conducting, just by the feeling of the music.

One day Daddy came home and told us he was taking us to a concert. A concert? The famous English conductor Sir Thomas Beecham was coming to conduct the Utah Symphony at Kingsbury Hall. He'd already bought the tickets. It was a special occasion. My mother sewed new dresses for me and for herself. My father bought a suit. That Saturday afternoon he washed the

green Packard. It was shiny and so were we. My father's handsome face cracked a rare full smile as he opened the car door for my mom. She slipped onto the leather seat, looking elegant with her perfectly shaped red lips and dress that looked designer-made. In the back seat I felt special, too, shaking with excitement in my new dress and patent-leather shoes. For that moment, we forgot we were exiles, would-be spies, war refugees in our own country. For that moment, we looked like a normal, happy American family, on our way to a special occasion: my very first concert.

The hall was like a palace, packed with people bustling to their seats. With Mom and Dad holding each of my hands, we climbed the grand staircase to the balcony. We sat in a sea of two thousand people below and around us—all White people, dressed in their best. The lights dimmed and as the huge wine-colored curtain slowly rose, the audience hushed. There were rows of musicians with instruments I'd never seen before. They were making a chaos of sounds as they finished tuning. I could feel something was about to happen as they became silent. Then a white-haired man with a mustache appeared in a black penguin-like suit, walking to the center of the stage. Sir Beecham made a dignified bow to us. He then stepped onto a platform facing the musicians, holding in his hand what looked like a magic wand. The musicians leaned forward, instruments poised, giving him their total attention. In that moment of silence, it felt like all two thousand people in the hall, including me, stopped breathing.

The conductor carefully pierced the magic wand into that silent space and began a journey into another world. First the delicate sigh of violins. Then deeper bass sounds, each wave of his magic wand inviting more sounds—cellos, flutes, horns—making a melody that seemed to be calling me. Everywhere it went, I followed. Sir Beecham swayed his body, swung his wand, left, right, up, down, encouraging, guiding. They were playing Otto Nicolai's *The Merry Wives of Windsor*. The playful melody and quickening tempos made me feel joyful. Then grand and powerful sounds, larger than anything in life I'd known. Yet I understood. It was speaking a language I needed no words for. It was a knowing I felt in my heart. Soon the dizzying dance of sounds took over my whole body. Through every piece they played, through Elgar, Haydn, Handel, my five-year-old body was awake, alive. I followed. Then finally, Tchaikovsky's *Romeo and Juliet*. Nothing else existed—no war, no wandering, no loneliness. I was in the world of music. I had never heard anything so beautiful, so painful, so powerful. I was sitting in my seat in the balcony, but that music made my soul dance.

I came away a different child. Something that night touched me in ways I had no words for. It took me inside a world where I didn't need words, where I didn't feel lost. It connected me with something greater than myself. It also sparked in me a deep longing, drawing my body like a moth to the light. Somehow, I had to be part of this great, flowing, majestic, magical world of music.

I went home and found that grand music inside our little Ogden house. Every day I began playing my father's favorite records and I danced to Rachmaninoff, Beethoven, Tchaikovsky. I didn't care who was or wasn't watching. I was *in* the music. My mother watched me and took the cue. She found a local dance school, the Reid School of Dance. As a five-year-old I could only take tap dancing, but I didn't care. I was moving, making rhythms and sounds. For my first recital, my first time on a stage, my mom made me a shiny silver costume with a big poof on my right shoulder (see photo 5). Now I felt as beautiful and free as my dragonflies.

When I danced with the music I didn't feel like a lost, alone, rootless wanderer. Dancing gave me a sense of place, a way to be in the world. It was a way to express my feelings. Dance was my first language, my first voice.

On August 6, 1945, my mother sat before the radio. An announcer reported: the atomic bomb, the first ever, had been dropped on Hiroshima! The whole damn city blown away, a hundred thousand Japs dead! Just one bomb, America's first A-bomb!

My mother stares into the radio. She knows Hiroshima is one hundred miles north of her grandparents' home in Fukuoka, the place of her happy childhood. What is this A-bomb? They dropped it in the morning on people going to work, children going to school, killing Japanese people, not soldiers. The radio blares jubilation. Japs forced to surrender! The war is over!

Three days later my mother still listens. A second atomic bomb was dropped over Nagasaki. My mother sees through the radio. She sees a second sun over Nagasaki, sixty-five miles south of her family home in Fukuoka. She sees her cousin, Shiro, along with seventy thousand Japanese people—children—human beings—turned to ash in seconds.

They said the atomic bomb saved lives. Whose lives? The war is over. GIs are coming home. *We're* going home. Where is home? What is home?

FOUR

———

From a Broken Past into the Future

WE WERE LOADING UP THE GREEN PACKARD AGAIN. The Hayashi family had already returned to California, but Dad was cautious. He had a job in Ogden. What did he have to go back to? The two semis and the business he'd entrusted to his driver friend, Joe Ponce, were lost. He never blamed Joe out loud, but the bitterness and worries of these years of wandering ground inside him. He had ulcers.

As for most Japanese, our coming back from "camp" was just as hard as leaving. Would we be safe? What would we come back to? Some were lucky, like the Hayashidas and Auntie Hatsue and her husband. They'd left their houses under the watch of neighbors in the Black community, and now still had their homes to come back to. Others stayed in local Japanese churches and temples until they could find places to live. Japanese temples and churches offered safe spaces, temporary hostels, where families slept, cooked, and figured out their future. People would go shopping in groups for fear of being attacked on the street. Little by little, they restarted their lives from zero.

Our family took a short road trip to visit friends and family in Los Angeles and test the waters. Dad thought it seemed okay, it was time to go back. Mom was again packing our suitcases, deciding what to take, what to leave behind. Piling layers in her Japanese way in the back of the Packard, she made me a comfortable place to see out the back window, to see what I was leaving behind. As our heavily laden car pulled away from the 17th Street brick house that my mom had made into a home, the house where Lucy and Harry and family once lived, one family member was left behind. In the middle of the street, my Kitty. We couldn't take her with us. She sat there and watched the car slowly drive off. Then, like she understood our situation, she lifted

her right paw and slowly waved to me—yes, she really did, she waved goodbye to me.

The Hayashidas invited us to stay at their house on Second Avenue, just south of Jefferson. It was a bungalow with three small bedrooms, but we all made do. Harry Hayashida got back his old job as a gardener at Chapman Park. In our circle Harry was always the photographer, the documentarian. He developed his own film in his garage darkroom. We didn't realize he was an artist. He never pursued it as a career, like Toyo Miyatake, but he was part of a Japanese photography club in LA, pursuing a more artistic approach to the medium.

For Japanese men, getting a job was difficult. Who would give a job to the enemy? Every Japanese man I knew in those days was a gardener. But my father had other ideas. Mom and I would stay in LA while he explored a business venture with his friend, my Uncle Tooru, in Mexico, harvesting fish livers to be used as iron vitamin supplements (hmmm). Unfortunately, a drug company came up with a chemical version, Carter's Little Liver Pill, turning their big gamble, involving three lonely months living on beaches on the Gulf of Mexico, into a bust. Uncle Tooru ended up starting a farm in Mexico, shipping the produce to LA markets. Dad didn't like being separated from us. He returned, swallowed his pride and entrepreneurial spirit, and went to work for Grandpa Oga as a gardener.

After a while we moved to my mom's sister's modest wooden bungalow at 2706 South Hobart, a neatly grassed, Black neighborhood near Adams and Western. This area, now called Jefferson Park, was one of the areas in LA where the usually restrictive housing covenants allowed Blacks, Japanese, and other people of color to buy houses. We had graduated from the segregation of "camp" to another form of segregation. To get to Twenty-Fourth Street Elementary School, we walked up a hill and across Adams, where the houses were much bigger and grander than our little bungalows. I'd never seen houses so big. Sometimes we imagined they were haunted. This area was called Sugar Hill. Well-to-do Blacks were now able to buy the houses of rich Whites who began fleeing the encroaching Black population. This was called "White flight." I was becoming aware of our special relationship with Black people. Though they were our neighbors, there was an unspoken (and sometimes not-unspoken) rule about *kuro-chan* (Black people). My Auntie would talk politely to her Black neighbor over her fence, but my mom would tell me, "Don't play with the *kuro-chan* kids!"

Twenty-Fourth Street School is where music came back into my life. I was in the third grade. Our teacher, Mrs. Jackson, was a Black woman and a trained musician who thought music should be part of every child's education. She believed children could be taught to read music just like reading books. They could learn to sing, not just simple stuff but four-part contrapuntal melodies, like Bach and Handel chorales. And we did. It was big fun, singing this grand music, learning to harmonize.

Auntie Hatsue's and Uncle Fred's house had a piano. It was the old Kimball that Grandpa Oga bought for the girls after their mother died. My mother could play one song on it: "Tell me a story of long, long ago . . ." She would play the song and tell me stories of our family. On that old piano, my older cousin, Kay, and I got piano lessons, but this was not one of those peak experiences like with Mrs. Jackson. I remember Mr. Sessums putting a sheet of music before me and asking what key it was in. I would guess because he never told me how to find the key. When I guessed wrong, he would hit my knuckles with a pencil as a punishment. Sometimes he'd play a piece of music for me that he wanted me to learn. I could usually figure out how to play it by ear faster than with my eyes. Sorry, Mr. Sessums. That's a bad habit I wish he'd caught me at. Maybe I'd be a better reader today.

My father would also sit at the piano with me. With his big hands he'd pick out the melodies of his favorite symphonies. He also took me to films with musical themes, like *Song without End*, *Bambi*, and of course *Fantasia*. Being the only child for seven years gave me special bonding time with my father. He also took me to baseball games at Wrigley Field.

My Uncle Fred also liked music—Japanese music. He was born in Japan. His real name was Yachihiro Nishimura. Auntie Hatsue's and Uncle Fred's life was much more Japanese than ours. For one thing, they ate more *nihon shoku* (Japanese food) than we did. Uncle Fred was a handsome man who always seemed to have a smile on his face. At dinner he would gently grunt orders "Hatsue, more *ocha* [tea]!" Without resistance, she'd serve him. Their house was filled with Western furniture mixed with Japanese artifacts. The aroma of incense lingered from their *butsudan*, a small wooden altar that sat on a small table in a corner of their dining room, a miniature version of the altar in a Buddhist temple. The doors of the carved wooden box opened into a small world of beauty representing the pure land. Inside was a golden miniature of the Buddha and scrolls with *kanji* writing. Periodically, during a quiet time of day or evening, Auntie or Uncle would light incense and use a small *bachi* (wooden mallet) to gently strike a metal bowl sitting on a tiny

brocade pillow. It sang a sweet and pure tone that penetrated the whole house. Later I learned it was a sound to bring one to the present moment. With prayer beads wrapped around their hands, they bowed and chanted *namo amida butsu*. I didn't know what it meant. To me it was a place of mystery and sacredness far from my world.

Uncle Fred, like all Japanese men I knew, made his living as a gardener, but on Wednesday evenings he came home early. After a bath, he would put on a kimono-like jacket. At half past seven, a few other Japanese gardeners would arrive, leave their shoes on the porch, and sit on the living room floor, hands on knees. Uncle Fred taught a Japanese style of singing called *utai*. In his right hand, he held a closed Japanese fan, which he slapped on his thigh to set the rhythm of the singing. Back straight, kneeling, he wasn't a gardener anymore; he carried himself like a samurai. The singing was more like chanting, with growls and groans that sounded weird to me and cousin Kay. We'd make a beeline for the bedroom and hide under our twin beds, laughing and covering our ears to drown out the sound. We loved ballet and Bach, but *utai* was not music to us.

Many years later, I saw my Uncle Fred perform at the Koyasan Buddhist Temple in Little Tokyo. He'd been invited as a guest, with a Noh theater group from Japan. This time he was on his feet, wearing a dark kimono and *hakama* (wide trousers), gliding in his *tabi* (fabric shoes), ever so slowly, fan in hand, subtly turning and sometimes punctuating with a stomp at just the right moment. He was dignified and beautiful, totally in his body, in his element, chanting his song. My Uncle Fred, who cut lawns, trimmed hedges, and planted flowers for well-off White ladies, was keeping the ancient Japanese storytelling art of Noh theater alive in America.

I was seven when Mom finally delivered me my baby brother, Robert Ken. Yes, Ken is a Japanese name that sounds suspiciously like English. We affectionately called him Robert-kins. The fact is, he looked much more White than me. My hair was raven black with eyes to match. His hair was almost blond and his eyes were hazel. My naturally tan skin easily drew in the sun, so I was a bit darker than most Japanese kids. I didn't know why I was so much darker than him. In summers we often spent Sundays at the beach and my mother would chase me to cover me, calling me "Ol' Black Jo" or "Little Black Sambo." Japanese culture had a definite class system. Being dark meant you worked in the fields. Though my Americanized mom was Mitzi, there

was also a Mitsue in her that came from a "good Japanese family," and she didn't want her little girl to look like a farmer or a Mexican.

With my new brother, we were too many to stay in Auntie and Uncle's house. This time we moved east to Boyle Heights, just across the bridge from Little Tokyo.[1] The Tsukida family had a small triplex squeezed into one lot. We lived in one of the front two units, and they lived in the back house. It had one bedroom, which my little brother and I shared. My parents slept in a Murphy bed that was stored vertically in the dining room closet during the day and fell into horizontal position at night. It was a very efficient use of space in a Japanese way. The Tsukidas had two daughters: June, who was my age, and Mayumi, a bit younger. Now I had some girlfriends to play with!

Being shy, adjusting to another new school was difficult. We had moved six times since I was born. This was my fourth school, and I was only in the third grade. But my mother, who had had no mother of her own, had an amazing instinct for inspiration. She learned that our landlord's daughter June was going to dance lessons in a neighborhood school (see photo 5). I was dancing again!

The West Coast School of Music and Dance on Whittier Boulevard was a colorful place, alive with sounds of kids, tap shoes, and music. The young dancers were a mixture of Mexican and Japanese, mostly girls. The class I was taking was also a mixture. We had a bit of acrobatics, some tap, and ballet, all in one hour and a half. I looked up to June, who knew the ropes and was the best dancer in our class. She could extend her legs higher than anyone else. Her beautiful feet could point to the sky. Would I ever be able to do that? I was going to try.

Mrs. Gelman's dance school in the heart of Boyle Heights was a starting point for three girls' careers in dance that I know of. June Tsukida, who became June Watanabe, later had a modern dance company and taught at Mills College. Stella Nakadate Matsuda went on to teach dance at Moorpark College and was director of the Alleluia Dance Theater. I was the third. The school became the center of my life. I don't know if it was my competitive spirit or what, but something began pushing me. I always wanted to have friends, but now, if kids came knocking on my door to play jacks (and I was the queen of jacks), I'd say, "No, first I have to practice." Nobody *told* me to practice; it was something I *wanted* to do. There was a full-size mirror on one of our closet doors and I would practice, practice, practice—one pirouette, two pirouettes . . . I couldn't do three yet.

Ballet was a rarefied world where a woman was the centerpiece. It was also a lily-white European tradition with queens and swans all fair-skinned. But there were a few exceptions, and my mom encouraged me to be one of them. She showed me books with pictures of some of the great ballerinas. Among them were a handful of slightly tanned ballerinas: Maria Tallchief, a Native American; Alicia Alonso, a Cuban; Ruth Ann Koesen, a Korean; and my favorite, Sono Osato, who was half Irish and half Japanese, almost like me!

I could see the beautiful forms of their bodies, the lines, the extensions, their exquisite pointed feet, like June's. After only three months at West Coast, Mrs. Gelman put me en pointe, like the ballerinas in the book. That is a bit early for a seven- or eight-year-old, but luckily my ankles and feet were strong. Now I had my first pair of beautiful Capezio pink satin pointe shoes. The long pink ribbons crossed in front and wrapped around my ankles, just like Sono Osato's. I learned how to stuff a little lambswool inside to protect my toes. It was a bit painful, but I got used to it. I kept practicing and practicing: bourrées, pique turns, pirouettes. By the time I was eight, I knew what I wanted to be—a ballerina. As a ballerina I could be a bird, a swan, a princess. My mother, who buried her dreams to be an artist, knew that being a ballerina was the one place woman could be queen.

My endurance to physical pain didn't protect me from another kind. World War II was only a couple of years behind us. Hatred doesn't die easily, and in those days there were no cultural diversity programs telling people it's politically incorrect to be a racist.

One day a White boy rode by me on his bike and yelled, "You dirty Jap!" His words were mud thrown at my face. I was shocked. I knew it was a nasty word to call the enemy. But why did he call *me* a Jap? I wasn't his enemy. I didn't know what to do. I just ran home to Mom, confused and crying. She told me, "No use to shout back. Don't stoop to his level. Just ignore him." I got the message that what he did was a lowly act. But I wish to this day that I had screamed some mud right back at him.

My worst hurt came from one of my own, a Japanese girl. One day I went to the house behind us and knocked on June's door. I was standing on her porch where her father had built her a ballet barre. How lucky she was to have her own barre! Knock, knock. Her sister answered.

"Can June come out and play?"

Her little sister replied sharply, "*We* don't want to play with someone like *you*!" and slammed the door in my face.

I stood frozen. Her words pierced me, the force of the door pushed me from their world. I was new to this neighborhood, but in my eight-year-old mind, this was a friendly world I wanted to be part of. What did "we" mean? Just her and her sister, June? The other girls in the neighborhood? "*We* don't want to play with someone like *you*." I thought I was like them, like June, my friend who also loves to dance. Why doesn't *she* want to play with me? Why am I not like them? My hair is black, like them. My eyes are dark, like them. I'm Japanese—well—almost all. Maybe I'm not like them? Maybe she sees that I am different. I wanted to scream through that "YOU DO NOT BELONG" door. I wanted to pound it down to demand, "Why am I not like you?!" My mouth was open, but I knew no words to fight back or protect me from her hurtful message.

All I had were tears. I ran the few steps to my house, to my mother's arms. Maybe she could explain why I'm not like them? If I don't belong here, where do I belong? My tears wouldn't stop. She couldn't console me. It didn't matter why Mayumi said those cruel words. Maybe she was having a bad day, or just throwing words like seven-year-olds do. My only thought was they didn't want to play with me because I wasn't all Japanese. I wasn't one of them.

My mom was used to prejudice, even from her own family. Her father had forbidden her to marry my father because he was half White. Now she watched me suffer because I'm not all Japanese. She gave me this pearl of wisdom: "She who walks alone, walks faster." I could walk alone, I could dance alone—and dance better, faster, and farther. "She who walks alone, walks faster" became my shield, my mantra. It helped focus my loneliness, my fear, my anger. It energized my ambition. I was going to dance better than everyone else. Dance became my anchor, my place, my home.

Boyle Heights was a place of immigrants, a bridge into the future. It was a crazy quilt of poor folks who'd all survived racism, relocation, and hardship—all hustling to make a better life. On Brooklyn Avenue there was the Jewish Detroit Bakery, where friendly ladies in white uniforms frequently gave me a free cookie. At Phillips Music Company, a hangout for young musicians, my dad bought his classical records. Mexican food satisfied my parents' love for spicy food. They'd have chili-eating contests at different restaurants

to see who could eat the hottest. Even my brother, who was about three, was getting a taste for it.

Yes, there were gangs, like the Black Wands, which brought Buddhaheads and Mexicans together. Buddhaheads, a slang word first used to describe the much-decorated Japanese American 442nd Infantry Regiment in World War II, was adopted on the streets. Buddhaheads in Boyle Heights took on the flavor of their brother cholo Mexicans, while Buddhaheads on the Westside acted more like Blacks.

But my world was dancing at the West Coast School. It became my mom's world, too. Before a recital we'd cross the bridge to the Garment District to buy taffeta and tulle for new costumes she designed for me and other young dancers. My mother wasn't the only seamstress. Most women in those days didn't have a job outside the home. If you were poor and wanted your kids to look good, you needed to sew. Being part of a dance school performance, the flurry of rehearsals and costume making was a big community effort. After being ostracized by the war, Boyle Heights gave us just what we needed: a community where we could belong.

Just when I was getting comfortable, we "relocated" again. My Grandpa Oga had bought an apartment building in the Pico-Union area, in mid–Los Angeles. Today, Pico-Union is known for intense gang activities, Salvadoran and Guatemalan immigrants fleeing civil wars, and the crisscross of the 10 and 110 freeways. But Pico-Union in 1950 was a calmer, poor immigrant community of mainly Whites and Jews. Our apartment was a slightly bigger one-bedroom, with my parents still sleeping in a bed falling out of a closet. My mom's youngest sister, Mary, and her husband, Jack Murata, plus three kids moved into one of the upstairs apartments, so we were around family again. Uncle Jack was a veteran of the 442, the most decorated infantry unit of the war. He wore a black patch over his left eye, which he had lost during combat. Auntie Mary was quite beautiful and had had a lot of ambition before the war. She was very artistic and loved to dance. But after the war, she slept a lot, which my mom called laziness. Now we know it may have been depression caused by a bipolar condition. My younger cousins had unusual names like Bunny, Punkins, and Dinx, a custom in Hawaii, where Uncle Jack was born.

My dad still had his 1940 green Packard. Cars were made to last in those days. And he was still a gardener. But something new had moved into our

lives: television! The 1950s was the golden age of television. Every family had to have one. My dad believed in buying the best. Our television was a combo with a record player, in a mahogany console. It had these funny aerial metal rabbit ears on top. You had to move them around in different directions, depending on the channel and where you lived, to get a good picture. We had fun gathering around our black-and-white twelve-inch television to watch our favorite shows.

The first person I saw on television who looked like us was Hilo Hattie from Hawaii. She was the opposite of the bikini-clad, grass-skirted "Lovely Hula Hands" version of Hawaiian women used to lure tourists to the vacation paradise. Hilo Hattie was a robust, full-blooded, barefooted Hawaiian who wore her signature flowered muumuu, straw hat, and leis. She "talked story" in pidgin English, played the ukulele, sang, and swayed her big hips with a good sense of comic timing. Her character and her name came from her novelty song that miraculously became a big radio hit: "When Hilo Hattie Does the Hilo Hop." My cousins and I loved us some Hilo Hattie! She was fun. She was our big auntie. White kids grew up with plenty of heroes and heroines to look up to. We were pretty much invisible, so Hilo Hattie was a big deal. She was *ours*.

During the Pico-Union years, my dance training continued at a higher level. Mother enrolled me in the Los Angeles Conservatory of Music and Arts. It was located a mile east of us on Figueroa near Ninth Street, so I could bus there by myself. One could do that as a ten-year-old in those days. Later, the conservatory, in a deal led by Walt Disney, joined with Chouinard Art Institute to become the California Arts Academy (CalArts). Walking through the large hallways to dance class, I loved the cacophony of sounds— French horns, violins, clarinets, bass, and more, musicians taking lessons, practicing, rehearsing, preparing for that moment when they would play together, just like my first concert in Salt Lake City.

My ballet teacher was Patricia O'Kane, a beautiful woman who seemed too delicate to shape our unruly preteen bodies into disciplined ballet dancers. My Boyle Heights dancer friend June Tsukida joined the school and continued to compete with and push me. Miss O'Kane, who was trained in both the Russian and Cecchetti styles of ballet, was tough on me and June. And she emphasized musicality. Now I was listening and dancing more deeply with the music, taking on its qualities and emotions. I was also

learning to make myself into characters. Where else could a Japanese kid play a French cancan girl, or a white swan?

While June and I were getting schooling in the Western classical arts, something was happening in our Japanese community: the Nisei Week Festival. Nisei Week originally started in 1934, during the Great Depression. The leadership of second generation (nisei) and first generation (issei) wanted to attract more people to LA's Little Tokyo and promote and revitalize economic activity there. The August event celebrated the best of Japanese culture: *ondo* dancing in the streets, martial arts, ikebana (flower arrangement), tea ceremonies, calligraphy, art shows, a talent show, and a baby show (the one where I'd cried and lost years back). We even had a beauty contest, our answer to Miss America: the Nisei Week Queen. (When I was seventeen I was a mere princess, a runner-up.)

Of course, the war and our incarceration closed down Nisei Week. After six years of silence, with our community still scrambling to get back on its feet, Nisei Week resumed in 1949. In 1950, June and I danced in our first Nisei Week talent show. Now, the festival had taken on a deeper purpose: to reclaim our pride, our dignity, our culture. Besides trying to rebuild our economic lives, we needed to heal the psychological and emotional wounds of incarceration. It was perhaps a form of resistance, as Japanese American people were beginning to step back into a still-hostile world.

When issei and nisei got out of camp, the Nisei Week Talent Show gave them a place to show their stuff. You can imprison people, but you can't imprison creativity, and there was plenty of it trapped within those barbed wires. On Friday, Saturday, and Sunday, Nisei Week variety shows attracted standing-room-only crowds at Koyasan Buddhist Temple on East First Street. It was built in 1940 and had a large gymnasium hall with a good-size stage on one side. Many Buddhist temples, mostly built in the prewar years, had similar setups. Temples were not only for religion; they were community and cultural centers.

The shows were two-and-a-half-hour marathons featuring a mishmash of contemporary and traditional Japanese genres. There were big bands led by Tak Shindo and Paul Togawa, the Kawasumi Sisters harmonizing on "How High the Moon," a fusion group playing and singing "Shamisen Boogie Woogie." The Hawaiian Surf Riders did a medley with hula dancers, accordion player Gene Kimura played "Deep in the Heart of Texas," and Betty Yamada performed "Kanashiki Kuchibue." I told you it was a mishmash. My dancer friends June Tsukida and Stella Nakadate and I performed an excerpt

from *Swan Lake* supported by a corps de ballet. Backstage was a chaotic cultural traffic jam. I already mentioned my Uncle Fred, chanting and gliding on stage with his fan in a slow Noh theater piece. That was the first time I saw Reiko Sato dance. Costumed in a slinky slit-up-the-thigh skirt and a French beret, cigarette dangling from her mouth, she did a sensational sexy dance duet to "Slaughter on Tenth Avenue." Reiko blew my mind.

I was ten in my debut performance in 1950, in a solo ballet piece titled "Love Notes." The next year, Miss O'Kane choreographed a piece in which June and I danced "Raggedy Ann and Raggedy Andy" (see photo 7). My mother made us costumes that made us look just like the rag dolls: white gloves, white makeup, red-circle cheeks. It got me my first review in the local *Rafu Shimpo* paper: "Joanne [*sic*] Miyamoto, in a Raggedy Ann ballet number with June Tsukida, is this reviewer's 'apple-of-the-eye.' Her expressive face would endear the most critical." Haha—aw, shucks.

Another postwar cultural phenomenon were the *kenjinkai* picnics—gatherings of families who came from the same areas in Japan. Ours was the Fukuoka-Ken. At these *ken* picnics, usually held at Elysian Park, issei were in charge. They could speak Japanese freely. Food was brought in beautiful lacquered stacked bento boxes, black on the outside and red on the inside, and wrapped inside a colorful *furoshiki*, a square scarf tied in two crisscrossed knots on top. One level would hold teriyaki chicken, the next *onigiri* (rice balls) wrapped in seaweed, the third level potato salad—yes, potato salad—and next was Jell-O! Potato salad and Jell-O were part of our Japanese American cuisine. And don't forget *tsukemono* and *umeboshi*—the smelly and salty pickles yummy with rice. We ate on paper plates with disposable chopsticks called *waribashi* (more about this later), sitting on straw tatami mats.

Kids did three-legged races and other games, but the issei were the best entertainment. On a platform stage with a sound system and a colorful painted Japanese-type background, a line of normally quiet, reserved gardeners appeared—dressed like women, chests stuffed with oranges and skirts lifted to reveal garters on their hairy legs—doing the cancan! With a little help from sake wine, they were totally unabashed. Of course, in Kabuki theater, men traditionally played women's parts, but these were our gardener grandpas acting funny and weird! They did skits and stand-up comedy, all in Japanese, acting like crazy fools and loving it. I loved it, too. There were also real women dancers in their beautiful kimonos, wigs, and painted-white

faces, doing traditional *minyo* dances. Even my Grandpa Oga got up there and sang, backed up by my shamisen-playing step-grandma. These Sunday summertime *kenjinkai* picnics gave us a rare glimpse of who our grandparents really were.

I was performing quite regularly now, with Miss O'Kane's recitals and shows in places like the Assistance League Playhouse and the Wilshire Ebell Theatre. She was prolific in choreographing pieces that were story-based ballets. Now we were adding acting to our dancing skills. This was when my mother got her next great idea: a television show called *Hollywood Road to Fame*. On local TV station KTSL, hosted by Nils Granlund, it was a primitive forerunner of shows like *So You Think You Can Dance*: you perform and your friends and fans send in postcards to vote for you. The studio was on Vine Street in Hollywood. This was the first time I'd ever *been* in, let alone performed in, a television studio. I did my best, but dancing in a studio without a real audience was weird. I didn't win. I guess I didn't have enough friends or fans—and no Facebook!

Just when I was beginning to figure out how to navigate the hallways and get to my classes on time at Berendo Junior High, Mom and Dad bought their first house at 1635 Fourth Avenue, near Arlington and Venice. We were relocating again, this time by choice, to our own home. Grandpa Miyamoto moved in with us.

FIVE

───────

Twice as Good

IN BALLET YOU CAN'T LIE, you can't fake. You can't balance unless you're centered. You can't do multiple turns unless you're plumb. There's a technique to building and holding high extensions. It takes energy, physical strength, will power, mental concentration, determination, discipline, visual perception. It takes strength to appear soft and gentle. It takes rigor.

Ballet also demands a certain body type, a standard, which in the United States was set by George Balanchine. His dancers were thin, with long legs, short torsos, incredible extension, high arches, and turned-out hips and legs. When my mother saw me as a child walking one day with my pigeon-toed gait, she thought, What she needs is ballet! I was naturally turned in—not only my legs, but my personality. I was shy. I was Japanese. That drop of Anglo English blood didn't give me long legs like Balanchine dancers. And my arches—well, my right foot was pretty good, but my left needed work.

I found joy and friendship dancing in Boyle Heights. I built technique and the beauty of expression with Miss O'Kane. But the American School of Dance taught me rigor. Now, there's all kinds of rigor. Athletes need physical rigor to win. Students need mental rigor to learn. Yogis need spiritual rigor to reach Nirvana. I think a good dancer needs all three to be able to express emotions, physicalize ideas, and tell stories with their entire being.

Mr. Eugene Loring was the director of the American School of Dance. He was a renowned choreographer who created the ballet *Billy the Kid* for the American Ballet Theatre. With its music by Aaron Copland, bold subject, and modern movements, it pushed the boundaries of ballet. In Hollywood Mr. Loring worked with movie stars like Audrey Hepburn in *Funny Face* and Cyd Charisse in *Silk Stockings*. But Loring, at heart, was an intellectual academic who put his philosophy into action at the school. (He went on to

establish the first bona fide university dance department at the University of California, Irvine.) At that time, most dance schools centered around a particular teacher or dance style, such as the Carmelita Maracci ballet school, or Lester Horton Modern Dance. The American School of Dance put ballet, modern dance, jazz, character/ethnic dance, tap, and more into one place with a cadre of fine teachers from each field. There were different levels—for instance Ballet I, II, III, and IV—each with a defined curriculum. Mr. Loring's philosophy and training principles were based on his belief that good dancers must be proficient in all forms.

I had been studying ballet at American School of Dance for about a year. I don't know how my mom found this school. She took that saying "I want my child to have opportunities I never had" to a new level, especially considering she had no mother to serve as an example. We were definitely moving up and out in the world. The school was located at 7021 Hollywood Boulevard, and from it you could look east and see Grauman's Chinese Theater, the Egyptian, and the Pantages, all the way to Hollywood and Vine—a path of neon and starlit dreams, lighting up a walk of fame, with hand- and footprints and famous names embedded in concrete, a sure sign you will be remembered from here to eternity. This was the street I was dancing and dreaming on.

The school was housed in the basement floor of a once-grand four-story apartment-hotel that was still home to a few elder Hollywood characters who'd occasionally wander down the front marble stairs with their canes. Walking up the driveway, Chopin's classic warm-up music, played by Mrs. Levman the pianist, led you to the entrance. Through the big windows you could see Studio A, the larger of the two classrooms, filled with Ballet II students—girls in black leotards, black or pink tights, white socks, and pink ballet shoes. Eleanor Marra would be shouting, "1–2–3, 2–2–3, step arabesque, hold 2–3, good!"

Miss Marra was one of my favorite teachers. She didn't just teach technique; she poured her soul into us to make us feel what we were dancing. She was French, I think. When I looked beyond her thin pale skin, dark-painted blue eyes, and turban-covered blonde hair, I tried to imagine the beautiful young ballerina that inspired Léonide Massine to choreograph *Blue Danube* for her when she was only sixteen, almost my age. She then became a soloist with Ballet Russe de Monte Carlo and Ballet Theater, working with the likes of Balanchine and Agnes de Mille. We thought she was ancient, but she was probably forty-five, teaching us teens who took her for granted. After class,

I'd see her waiting at the bus stop, still in her turban, puffing on a cigarette, on her way to the apartment where she lived with her teenage son from her old dance partner, Marc Platt. I always felt that the last act of this ballerina's life was such a humbling distance from her exalted beginnings. Is that the life of a dancer? Years of rigorous training, a few magical moments on stage, and a bus ride home?

When the American Ballet Theatre came to town, they sometimes used Studio A for early-morning class and rehearsal. Through the glass doors we'd watch the dancers do their rigorous warm-ups and stretches in old, worn toe shoes and holey leg warmers they'd knitted themselves. Their impoverished look was worn like a badge of honor that seemed stylish to us. They weren't dancing for the money. It was a kind of devotion to art and physical perfection beyond this world.

I was fourteen when Mr. Loring called me into his office to tell me the good and the bad news. From behind his desk, in his soft-spoken voice, he announced he was giving me a scholarship. My parents would continue paying $18.50 a month for my two weekly classes, but I would now be able to take twelve classes a week. Wow! A scholarship at a professional school! I *am* going to have a career as a dancer! He continued: to earn this I would, like the other few scholarship students, help around the studio by cleaning the mirrors and sweeping the floors. No problem! Thank you so much, Mr. Loring. Then the bad news. Leaning toward me, he clasped his hands and said, "JoAnne, in order for you to make a living as a dancer, you'll have to be twice as good as everyone else."

My breath stopped. What? Twice as good? What does he mean, twice as good? Mr. Loring didn't need to say it was because I was Japanese. I knew it. I knew I was pushing into a world not made for me. I knew blondes had more fun, more opportunity, more success. I knew this scholarship gave me a better chance than most like me. I knew I was a long shot and Mr. Loring was betting on me. But "twice as good" hurt me just the same because I knew it was true.

From that moment on, at every class with Loring, he put me in the front row where he could watch me, correct me, push me. Becoming twice as good was not only my challenge; it was his as well. This was the mid-1950s. There was no talk of equal opportunity for minorities, but I was his personal equal-opportunity project. At that time, I was the only person of color on scholarship, a "minority" of one in an elite cadre of dancers, among them Donna and Paula Anderson, Jim Bates, Paul Gleason. We were all striving and sweating for excellence, competing and learning together, each with different qualities

and challenges. The color of my skin and shape of my eyes seemed minor as we trained and became family. But they were always there, unspoken.

Howard Jeffrey was a fair-skinned African American who was a bit older and part of the previous group of scholarship students. Howard was a fabulous dancer and technician who later became Jerome Robbins's assistant for the movie *West Side Story*. A bit later Maria Jimenez, a Mexican American, and José De Vega, Pilipino and Guatemalan, also dancers of color, joined the school.

With Mr. Loring's curriculum, my dance vocabulary was expanding. Not only was I getting a daily dose of ballet, with an array of teachers. Along with Miss Marra there was Aaron Girard, Matt Mattox (who scared us with his stick), and Sally Whelan, each with different strengths and emphases. I quickly took to Gloria Newman's Martha Graham technique. Tap was fun. I thought I was pretty good—until I heard myself tap alone. Yikes! My respect grew for the finesse it takes to get good sound and rhythm. I bow to Fred Astaire and Sammy Davis Jr.! We had ten-week series of different "character dances," or ethnic forms, like flamenco, bharata natyam, and even Japanese dance from Madame Azuma. Japanese was not my favorite; it felt too contained and subtle. My body had danced far away from the Japanese style of moving. My muscles and movement memories were being programmed in other ways. On the other hand, there was jazz, my biggest challenge. Please don't put me in the front row! I wanted to crawl into a hole at the hip motions and swagger. It made me feel Japanese. It took me a while to loosen my body and my mind.

But we weren't just dancing. We had music theory, art, and Mr. Loring's methodology of dance notation, kinesiography. That was tedious and hard. Thank goodness there's video today. Dance is impossible to notate as specifically as music. What magic to read a music score and sing or play what Bach heard in his head! Of course there is musical interpretation, but a piano is a piano, a violin a violin, with its specific sounds and abilities. The human body is a much more complicated instrument, with many more parts and ranges of motion, including cultural styles. You just can't notate the infinite possibilities of movement.

In the summertime, classes increased to eighteen a week, with workshop series by special guest teachers like Merce Cunningham, a powerful mover and a big man. I loved watching the back of his neck. He moved with an animalistic quality. He introduced us to his original notions of composition using chance—literally tossing a coin to decide what kind of movement would follow what. Choreography class was also a challenge for me. I was shy

about expressing my own ideas, my own creativity. I didn't really have my own ideas then. My goal was to be Mr. Loring's vision of a well-rounded dancer, a perfect tool for any choreographer. I wanted someone else's genius and creativity to tell me what to do.

This world of dance training was demanding and exhausting. I had just graduated from Mount Vernon Junior High School with so-so grades. I couldn't get straight A's like the Japanese kids did. I wasn't that smart. I thought Phyllis Ichinose and Mae Wakamatsu were so much smarter than me. Anyway, I didn't care. Dance was my life, my whole world. But going to Los Angeles High School and taking twelve dance classes a week with homework on both sides was stressful. My old friend eczema came to visit, breaking out on my neck and arms. Off and on for years I never wore short sleeves, and I had ointment and bandages wrapped around my arms to keep me from scratching at night. One year I had X-ray treatments every week. I must have been radioactive. When they stopped, the rash went away.

Mr. Loring considered going to auditions a part of our training. I was getting a taste of his "twice as good" message. After an audition for one of the chorus dancers for Dean Martin's television variety show, the assistant came up to me and said, "You're a very good dancer, but I'm sorry, you'll stick out." This became routine, except most rejections didn't come with apologies. After a while I was dreading auditions. An exception was Jerome Robbins's audition for the Broadway musical *Peter Pan*. He picked me out and wanted me for the part of the Indian girl, Tiger Lily (typecasting, but I could pass for an Indian). Wow! Broadway! A meeting was arranged at American School with Robbins and my dad. I think my father knew he had to take care of this one. Robbins assured him I would have a tutor and chaperone. They would take care of me. But unlike my mother, my father was unimpressed with all this show-business stuff. Though he loved music and the arts, he wanted to protect me more. It didn't take a heartbeat for him to say no. Though Mom and Dad argued periodically that she was putting too much pressure on me, Mom didn't press on this one. She wasn't ready for me to leave the nest at fourteen, either. So goodbye Tiger Lily, fly away Peter Pan. I was disappointed, but I don't think I was ready yet to leave the nest either.

Soon Mr. Loring invited me to be part of his company, Dance Players (see photo 8). "Dance Is a Language" was a lecture-demonstration with twelve dancers (Donna and Paula Anderson, Pat Aylward, Jim Bates, Paul Gleason, Marianna McGuire, Carol McGahan, Carol Warner, Don Canna, Howard Moss, Bob Turk, and JoAnne Miyamoto) performing ballet, modern, jazz, tap,

and more, with Mr. Loring lecturing about his theories of the various forms. This was the first time I'd worked for Loring as a choreographer. I remember his nervous habit of chewing on his cigarette, smoke rising, while trying to choreograph the next moves. Good choreographers have a way of utilizing the special qualities of a dancer to benefit their work. Loring did that with all of us. The music was an intricate piece by Benjamin Britten, with changing time signatures: 123, 123, 12345, 1234567, 1234. It was both crazy-hard and fun. The musicality, math, drama, and dynamics were driving us further than we could imagine our exhausted bodies going. It was a high, and I loved it.

Mr. Loring also gave me my first taste of colorblind casting. He was taking Dance Players on tour to Madison, Wisconsin, to do "Dance Is a Language." We were also going to be part of a musical production. Loras College was a Catholic School and *Finian's Rainbow* was an Irish-tinged musical that was a hit on Broadway in 1947. Loras supplied the actor-singers and we were the dancers. Among the main characters in the show is a mute who communicates through dance, "Susan the Silent." Mr. Loring cast one of our red-headed, fair-skinned dancers, Paula, to be Susan. But a couple of days before opening he decided that black-haired, brown-skinned me would take the part instead. I was stunned. For one, how could I learn all this new choreography in two days, and then, how would the audience receive me as an Irish mute? Loring maybe thought I had the right quality for the role even though I had the wrong look, so he just did it. It was just a college performance, but it made me think that maybe I didn't have to be bound by my skin. Maybe there was a chance to work across the color line. Maybe I don't have to be blonde to have more fun.

At Loras, I also got my first taste of romance. A secret admirer reached me with a poem. He was in the band and older, maybe twenty, Irish, and looked like James Dean. One kiss and many letters. The only thing besides music and dance that turned me on.

On the trip home, our caravan made a pit stop in Las Vegas, where we encountered another kind of cultural phenomenon. As we piled out the station wagon to use the john at the Desert Inn, he was standing there, with his sideburns and a slicked-up pompadour, leaning over a railing with a pen in his hand. He didn't have on his blue suede shoes, but we knew who he was. "Hey," he said real friendly-like, "are you guys in show business?" I guess our wide strides and stretches made us look gypsy-ish. He tapped his autograph-ready pen on his palm, and Jim said "yup" with a chuckle. A couple of girls stopped to chat, but I had to pee. Elvis Presley was at the beginning of his miraculous trajectory, but at that moment he seemed so green, so fresh off the

farm. He had a song to sing but also a fever for fame. We had a fever too, as dancers, but I knew it would never bring us his kind of fame or a house in Graceland.

We performed "Dance Is a Language" at many colleges and schools around Los Angeles, to rave reviews, but my most memorable experience was at Immaculate Heart College. It was known for its progressive education and a vibrant community of sisters who were at the simmering point of turning the Catholic Church on its head. Mr. Loring had been invited by Sister Corita Kent for their "Great Men" series of conversations with the likes of Buckminster Fuller, John Cage, Saul Bass, and Alfred Hitchcock. (What, no great women?) We learned how this artist-nun and her students were democratizing art with posters. Silkscreen posters are cheaper than paintings because they can be mass produced. They populated homes with joyful, spirited social messages and raised funds for the art department. But Sister Corita's art was more than wild splashes of color and distinctive use of text. The notorious pacifist and activist priest Father Daniel Berrigan called her "the very witch of invention . . . she was dangerous, that one."[1] Dangerous in that she was using art for social change!

Mr. Loring arranged for us to have a workshop with Corita. She was a nun, but lively and fun. I don't remember what I made, but I remember what she said: *Question everything.* Another rule in her classroom was: *Break all the rules.* I could see how this could be dangerous. A few years later I was seeing Sister Corita's "dangerous art" everywhere. Hers was an iconic voice of the 1960s. One of her anti-war pieces featured an image of Father Daniel Berrigan and his brother Phil burning draft cards, protesting the Vietnam War. Along with her Immaculate Heart sisters, her quest for spiritual truth, total creativity, and "breaking the rules" led them to break out of their habits and eventually break, or be pushed out from, the male-dominated church. I thank Mr. Loring for deepening our artistic curiosity and connecting us with these radical, creative artist-thinker-teachers. Maybe it planted a seed in me that bloomed later.

SIX

Shall We Dance!

IN 1955 I CELEBRATED MY FIFTEENTH BIRTHDAY on my first real job, dancing in the film *The King and I*. The Rodgers and Hammerstein musical originated on Broadway in 1951, but now 20th Century Fox was putting it on the silver screen starring Yul Brynner, a sexy, bald-headed, bare-chested, brown hunk of a king; a harem of luscious "Oriental" wives (a White male fantasy for sure); a tribe of adorable children; and last but not least, a full-breasted, fiery-haired, British schoolmistress, Miss Anna, played by Deborah Kerr.

No matter that Brynner wasn't a real Asian or Thai. His Russian blood made him look close enough. No matter the moral conscience of the story was a British woman showing this Asian king the values of democracy. This was the first time US audiences were exposed to a powerful, seductive Asian male character on the big screen (Bruce Lee wouldn't hit until the 1970s). Brynner originated the role on Broadway, performing it more than four thousand times, embodying the king with passion, humor, inquisitiveness, charm, and a keen physicality. With Miss Anna as foil and ally, he wants a Western education for his children and wives, while grappling with colonial infringement on his country and his own contradictions with slavery. This king was a complex human being who was hard not to love—on screen and in person. We were happy when our friendly brown king visited us in our schoolhouse on the set. And it felt good being part of the tribe of brown kids and women who were the center of the story.

I was a dancer in Jerome Robbins's beautiful pseudo-Thai-style ballet "Small House of Uncle Thomas," based on Harriet Beecher Stowe's antislavery novel *Uncle Tom's Cabin*. This time my dad said "yes" to Robbins and I got my chance to work for this dance genius. The downside was that my mom

was required to be with me on the set every day from six in the morning to six at night, creating a hardship for our family. This was a law to protect child stars from being exploited, pushing them, even drugging them to work long hours, while at the same time they were adored, indulged, and pampered (a lot of bucks were made off Judy Garland's and Mickey Rooney's talent). Four of us in the ballet were minors (the others were June Tsukida, Pat Uyehara, and Alice Uchida), but we weren't indulged or pampered. We were expected to squeeze in four hours of schooling with a tutor on top of rigorous rehearsals keeping up with the adult dancers. As far as the studio was concerned, we were costing them extra money.

The lead character, Eliza the runaway slave, was played by Yuriko. She was a nisei born in San Jose. During the war, she taught ballet classes to young internees in Gila River concentration camp. Too feisty and ambitious to be held back by barbed wire, she found her way out of camp to New York, where she sewed in a sweatshop and studied modern dance with Martha Graham. She went on to become a revered soloist and teacher with the Graham company. She was a dance star and needed only one name: Yuriko.

Like most of the ballet's lead characters, Yuriko had danced her part on Broadway. The curve of her hands, the flex of her feet, her expressions, were part of her muscle memory. But we lowly serfs were in boot camp doing catch-up. We had eight weeks to learn a ten-minute ballet, a meager amount of time for Michiko, a Thai dance expert who trained us in Thai traditional dance form. We spent so much time on our knees, they creaked, everything ached. When we finally got the form and the choreography, then there were the costumes. No expense was spared, with famed designer Irene Sharaff in charge. She was a bit scary and mysterious, always in a black dress, black hose, black high heels, black Nefertiti hat, and black Egyptian eyes. But her costumes surrounded her with color—lavish orange and purple imported Thai silks. It was beautiful, but I hated the heavy eighteen-inch spiraling jeweled headpiece. The first time I put that skyscraper on my head it was impossible to move, let alone dance freely. For months it left a circular dent embedded in my skull.

Every day, perfectionist Robbins continued to polish his already-proven masterpiece ballet for the screen—the choreography, the staging, the costumes, the shooting setups, the lighting, and the *set*. The first day of our two-and-a-half-week shoot, Robbins walked us onto the soundstage, into his fantastic vision of a stage—with a brilliant, satin-smooth black lacquered floor. As we glided with our bare feet on this otherworldly set, klieg lights

like a hundred suns surrounded us, making the floor a mirror reflecting our brilliant orange and gold costumes, our white-painted faces, our spiraling headpieces, magnifying the magic. Robbins's use of a huge Kabuki-style stark-white silk material to portray the icy river, contrasted against the black lacquered floor, was amazing. We moved in slow motion, exploring the mystical space around us, feeling a warmth that seemed to be rising through our bare feet. The warmth intensified. Then we realized the lights were turning the black lacquered floor into a bed of hot coals. Robbins's magic was melting into a hot mess!

"Take ten!" The lights were turned off. Men in suits gathered. Robbins paced. Soon, huge fans were rolled in and placed around the black lacquered floor. The solution: shoot ten minutes, break and turn off the lights, turn on the fans for fifteen minutes. For two and a half weeks—shoot, break, fans, shoot, break, fans. This slowdown was a producer's nightmare. When finished, the ballet of course was magic. The film won five Academy Awards. But it would be a long while before Robbins would be hired to do a movie again.

Today, we might see *The King and I* with different eyes, and consider "Small House of Uncle Thomas," Robbins's bare-feet ballet, cultural appropriation, even though he was trying to artistically deliver an antislavery message with the help of a Thai dance expert. But it was Broadway and Hollywood in the 1950s. As it turns out, the government of Thailand was not pleased with their king's portrayal or Miss Anna changing the course of Thai history. The movie and a later version were banned in Thailand.

I was beginning to think being "twice as good" was working for me. Soon after, I got my second job with another legendary choreographer, Jack Cole, at MGM Pictures, the glamorous dream factory that spun out countless movies that defined American culture, especially musicals—*An American in Paris, Singin' in the Rain, Seven Brides for Seven Brothers, Kismet,* and of course *The Wizard of Oz.* Now I was going to be in one of them: *Les Girls,* starring Gene Kelly!

As my mom and I passed through the MGM gate in Culver City, I felt so small. We walked like tourists through the maze of giant soundstages, seeing occasional actors I didn't recognize and huge sets roll by. I clutched the dance bag hanging from my shoulder, filled with a dancer's paraphernalia: leotards, tights, ballet shoes. I felt like we were immigrants who had finally arrived, which is exactly what we were in this cultural mecca.

Every serious dancer wanted to work for Jack Cole, who was not only a brilliant choreographer, but a dancer's dancer. An innovator in jazz dance, he

was worshipped and feared. His dancers were legendary, too. Those who had the fortune to work, train, and embody his demanding style—Gwen Verdon, Alvin Ailey, Bob Fosse, Donald McKayle—were the best in the business and went on to prominence. Cole and company were *dance warriors*. Lore had it that his dancers were so tough, they could put a cigarette out with their bare feet. My feet were calloused, but was I that tough?

Jack Cole's lineage was linked to early pioneers of modern dance in the 1930s—Charles Weidman, Ruth St. Denis, and Ted Shawn—who were freeing themselves from Western balletic forms and looking to Asia for inspiration. Tokyo-born Michio Ito was a hit in the New York modern dance scene, bringing the aesthetics of Kabuki and Noh into his work. It was he who introduced sculptor Isamu Noguchi to Martha Graham to design her sets. Ito's American career ended in December 1942 when he was arrested for being an enemy alien, put into a camp, and later sent back to Japan.

Cole studied everything from Cecchetti ballet to bharata natyam (a classical Indian dance form) and broke from the concert dance scene to find influences in New York's jazz clubs and dance halls where Black and Brown people threw their bodies into jitterbug and mambo, the closest thing to freedom in those days. He brought the earthbound styles of African, Afro-Cuban, and bharata natyam into his body and developed a style—hip, modern, sensual, soulful—that influences jazz dance today. His innovative choreography dominated Broadway shows, including *Kismet*, *Jamaica*, and *Man of La Mancha*. Cole was in demand in Hollywood as well, where stars like Rita Hayworth and Marilyn Monroe wouldn't work without him. Today, you can see his influences in Madonna's "Material Girl" video, a second-rate takeoff on Monroe's classic "Diamonds Are a Girl's Best Friend." Columbia Pictures gave him a workshop space where his dancers were paid a salary year-round to train, rehearse, and create numbers for their movies. What a concept!

My audition was weirdly un-rigorous. It was on a soundstage inside the huge, thick, padded double doors that kept the real world out while bringing an imaginary world to life. As Mom and I entered the darkness, I breathed in that dank smell that all old soundstages have. A young male assistant whisked me toward an area of the stage with a couple of huge mobile mirrors, lit by some dangling rehearsal lights. There he was, white shirt tied around his taut torso, regular suit pants, and black dance shoes, his arms moving with a trail of cigarette smoke painting the air. He moved with a cougar's energy, dictating the music for the dance to a pianist and a drummer with

vocal sounds and gestures, indicating tempos, dynamic rhythm changes. It was so cool that I forgot my nervousness.

When he finished, Cole looked in my direction and motioned me into the light. I looked around for other dancers, or a place to hide, but it was just me. I was meeting the Wizard of Dance all by myself! I think he took pity on me, seeing I was so young, timid—and Japanese. His face was angular, eyebrows like a V, and one wild eye that made it hard to tell where he was looking. He said with a brisk smile, "You don't have to change, just take off your shoes." Jeez, maybe he didn't want to waste his time on this little mouse! I stood in my bare feet, tight black pants, and white tucked-in shirt. He pulled me beside him in front of the mirror and showed me a series of walks to a drumbeat— knees bent, lowered center, some hip movements and deep knee bends. I followed him for ten minutes and he said, "Okay." That was it. That was it? I didn't even dance, show him what I could do! I went home puzzled, Mom consoling me. A few hours later, I got the call to be there Monday. I got the job!

For the next two months (and the next ten years) I would continue to follow him. Still sixteen, I had my four hours of school, but the rest of the time I was on the set dancing behind him. There were three types of dance styles in the *Les Girls* number. He spent most of the time teaching rigorous Afro-Cuban movements to a group of eight or so dancers, and body-wrenching African-style movements to another group. We four Asian dancers worked about fifteen minutes a day doing simple Balinese movements in deep plie, holding two large fans. His style embraced all these ethnic forms, but he made them his own.

I spent four hours a day dancing with Jack Cole, learning how he moved, watching his back and his torso, sinking my center, strengthening my legs, toughening my feet. He was aggressive and subtle, precise and ever-changing, molding the movements into our bodies through tedious repetition, pushing, cajoling, shouting, showing, and sometimes shoving. You didn't want to get on Jack's bad side. He wasn't just making dance steps for this number; he was teaching a language. I was drinking it into my body. It was just a rehearsal, but I danced like my life depended on it. His sharp sense of humor was endearing, but sometimes he'd pick on one dancer and be brutal. In the end, you forgave him because it felt so good when you got it. If you watch the *Les Girls* number, you would never realize how hard we worked on that piece.[1] Yes, we were the moving background for the stars, making Gene Kelly, Mitzi Gaynor, Taina Elg, and Kay Kendall look fabulous. But we were doing some

badass choreography behind them. Like many great moments in dance, it's not always about what you see on stage or screen.

In that funny MGM world, sometimes Fred Astaire, his debonair self, would saunter in to watch rehearsals (and pick up his then-girlfriend, Barrie Chase, who was one of us dancers). Gene Kelly and Fred Astaire together in the house! They were two rare hoofers who'd danced their (own) way to stardom. For the most part, dancers train hard, sweat more, get paid less, and nobody knows their names. We are the field slaves, grinding our bare feet into the dust of a Hollywood soundstage. But it wasn't about the pay or the glamour; there was satisfaction in doing good work.

I was shy and the only teen on the set. The only person who understood where I was coming from was Reiko Sato. She was that sexy beautiful dancer I saw at the Nisei Week talent show in Little Tokyo when I was a kid. Now I was dancing next to her. Reiko was one of Jack Cole's favorites. He called her Baby-Bu, after the role she originated in *Kismet*, one of the three princesses of Ababu. (For some reason he called me Olive Oyl.) Reiko's body was perfect for Jack's work. Barely five feet tall, she had broad shoulders, full breasts, strong core and legs, and tiny, beautiful, tough feet. She was a sexy samurai who adored Jack and would jump off a cliff for him if he choreographed it.

Reiko was the most unusual, nonconformist, otherworldly creature I'd ever met. She was beautiful but had no vanity and made no effort at fashion—not normal for a woman in the 1950s. She wore wrinkled pants, baggy turtlenecks, zoris, no makeup, and long hair piled atop her head speared by a chopstick. She smoked and read on the set when she wasn't dancing. I grew up miss Goody Two-Shoes, but Reiko was a rebel. I was trying to make it, but Reiko had no ambition or love for show business. I was trying to be accepted, but Reiko didn't care what people thought. She wasn't exactly a beatnik or a hippie. Some people thought her a genie. As Asian dancers, she and I worked many of the same dance jobs over the next ten years. During stage (LA Civic Light Opera) versions of *The King and I* and *Kismet*, we were roomies on the road, staying up all hours of the night discussing life, love, sex, and her favorite subject, Jack Cole.

In San Francisco, a few days before the opening of *Kismet*, rehearsals were getting tense. Jack was tired and mourning Marilyn Monroe, who had just committed suicide. He did some crazy things, like fire his longtime assistants George and Ethyl Martin because *we* weren't wearing our ankle bells during rehearsal. You didn't protest or try to understand his wild temper—you just stayed out of its way. One day he was rehearsing us, the three princesses of

Ababu, in a difficult eight-bar section with lots of knee squats and intricate hand mudras. Over and over again, shouting infinitesimal corrections: "You're thinking of the movement upside down!" or "Olive Oyl! You're doing that movement like you're making love to an asparagus!" After the fiftieth time, I was breaking, turning my back to catch my breath and stop my tears. One more time, two more times, I was at my limit. Then Reiko ran out of the rehearsal room. Where was she going? Jack finally gave up and said, "Break." We groaned and collapsed. What happened to Reiko? Later she told me that she ran outside and threw up. Well, that made me feel I was getting there. Maybe I couldn't put out cigarettes with my bare feet, but I could keep up with Reiko, one of the baddest samurai dancers I knew.

Several years later, in 1965, I got a chance to dance with Jack Cole and Reiko as a trio on *The Hollywood Palace* TV variety show (see photo 9). It was the last time he was known to perform one of his own works. He was juxtaposing two contrasting cultural forms: bharata natyam with Afro-Cuban rhythms. Cool! We rehearsed for weeks with live musicians, jazz pianist-composer Tommy Wolfe ("Spring Can Really Hang You Up the Most"), and a timbales player. He probably spent more than he made—paying us, lavishing us with gorgeous costumes of Indian silks—plus we hung out with him for a daily treat of ice cream after rehearsal. But the best part was moving with him, exploring with him, dancing with him, being part of Jack Cole's process of creation.

At such a young age, I was lucky to work for two dance giants, Jack Cole and Jerome Robbins, who developed dance in the United States in very different ways. In my mind, Robbins was more of a conceptualizer, choreographer, and director who used existing forms. Cole was a dance innovator. They both had deep knowledge and respect for the forms they used and the cultures they came from. And they both expanded both our cellular knowledge and the possibilities of cultural expression with their artistry.

School Daze

REAL LIFE, FOR ME, EXISTED IN THE DANCE WORLD. School was a burden I had to deal with. Being both Japanese and a serious dancer made me a double misfit. My head just wasn't where most kids' heads were at. While they were talking about boys, dating, and what clubs they were in, I was thinking about my career. A little voice inside me wanted to fit in, but my years as a traveling girl gave me no long-term friendships and few common references. It was easier for me to just keep my head into dancing.

Los Angeles High School was ahead of its time as far as being a multiracial campus. But the schoolyard at lunchtime looked something like this: Buddhaheads at the lunch benches, Mexicans near the cafeteria, Jews in the quad, and Blacks near the gym. Everyone had their place and only a few crossed over. I don't know why. In class we were all mixed together, but at lunchtime we self-segregated. Maybe it was a food thing.

Yes, most Japanese have had that embarrassing lunchtime moment when you open your brown bag and see your mom has made your favorite food for lunch today, but you're thinking "oh no!" instead of "oh boy!" Others are unwrapping their bologna or tuna sandwiches, and you're unwrapping the ancient version of a Japanese sandwich, *onigiri*. Understand, in those days, sushi was not on people's weekly menu. Also, there were no "multicultural days" when people dressed in their native costumes and had sharing moments, like they do today. We all were familiar with some ethnic foods like tacos or spaghetti, but this little rice ball wrapped in nori (black seaweed) was weird and foreign. The response was usually, "What's that?!" Plus Mom put my favorite smelly pickle in it too—oh no! This pickled daikon (radish) is a perfect complement for rice, but it smells like a fart! This is the cultural tug-of-war, a kind of litmus test for all people of color and immigrants in this

country. Do I tell Mom, "Please stop making me *onigiri* for lunch," which is a sacrifice for me and confusing for Mom, or do I take a stand for my *onigiri* and tell curious schoolmates, "This is my favorite Japanese lunch. Mmmm, wanna bite?" So maybe that's why kids and people of the same kind hang together. We don't have to explain or apologize for our culture's different-ness. We don't have to school them on things such as why rice tastes better and *is* better for us than Wonder bread and bologna. You just want to be yourself and say, "Mmmm, *onigiri*, so good!"

But I didn't deal with that. My lunchtime was spent in the auditorium doing homework. Socialize, boy talk? No time. Right after school I was on the 85 bus to Hollywood with my one girlfriend, Judy Moorehouse, who also studied at American School of Dance. I got used to being the only yellow dot in this dance world of European Americans. I fit in because we understood the same language: dance. The first dance class of the afternoon, usually bal-let, started at half past four—just enough time to sugar up with a hot fudge sundae at C. C. Browns or some halvah from the Jewish deli across the street. After the first class, we'd have a half-hour break and then go to modern or maybe a character dance class. At nine in the evening I headed home on the 85 bus again, which dropped me off at Venice and Crenshaw. My mother would be sitting in the dark in our family Oldsmobile, waiting to pick me up. Then a late dinner and homework with my head drooping on the table.

During the spring when we rehearsed for Dance Players, we were at the studio until eleven o'clock. Twelve classes a week, plus rehearsal, plus school, was getting to me. My eczema flared. Years later we learned that allergies flare up with stress—like being incarcerated at the Santa Anita Park racetrack. My fatigue level also brought tears that caused stress in my family. Dad accused Mom of pushing me too hard, which led to heated arguments that ended up with me pleading, "No, I want to do it!" Striving for excellence demanded sacrifices from everyone. Something in me longed for something more nor-mal, and so I joined a girls' club at school called Orchesis, meaning "to dance" in Greek. This connected me with other girls, who mostly were dancing for fun. With Orchesis I did a few school talent shows—ethereal pieces playing swans with gauzy tulle costumes and white toe shoes. Nothing to arouse a bunch of high schoolers—until "Steam Heat."

That jazzy showstopper from the musical *The Pajama Game* changed my life. Somehow my shy self got the crazy idea to ask some guys from the football team to dance with me—my first foray into pop and public partici-pation. I also brought my training with Jack Cole into this hip-bumping,

black-pants, bowler-hat number—with a chorus of footballers. "Steam Heat" had humor and it was hot! The day after the performance I was the toast of LA High. My popularity went from zero to a hundred. Everyone wanted to talk to me. I was puzzled and overwhelmed. Shortly after, I got voted homecoming queen. I didn't even know what that was! I'd never been to a football game, or on a date. Every homecoming queen has a king, or at least a date for the homecoming dance. Each day, Mr. Hentchke, the boys' vice principal, whom I worked for in my free period, would ask me, "Got a date for the dance yet?"

"No, Mr. Hentchke." How embarrassing is that? Homecoming queen and miss instant popularity, but no guy on campus thinks of me as a date.

A couple of weeks pass. Finally, a phone call out of the blue. It was a guy I sort of knew from our days at Mount Vernon Junior High, Doug Furuta. He was a big Buddha, smiling-face football player—a real Buddhahead.

"Uh, you got a date for the homecoming dance?"

"No."

"Wanna go with me?"

Wow, finally! Trying to act cool, I said coolly, "Sure, okay." I was so relieved! Later I found out that Mr. Hentchke had done some behind-the-scenes bamboozling, trying to find a Japanese guy to ask me out. Since Doug was on the football team, he was a perfect candidate. So it wasn't out of the blue.

Later I had an unsolicited ask. His tall, handsome, coffee-colored self approached me in the schoolyard, all suave smiles. A sharp dresser, he wore a sports jacket—to school? His chiseled face with cool glasses added to his air of intelligence and sense of style. It was more than an air: he was the head of the debate team. I knew who he was, of course. He was our class president, Ted Jones, son of singer Lena Horne.

"Wanna go out sometime?" Teddy caught me, deer in the headlights.

It was a simple question that every teen faces, but this question, considering who we were, was before its time. In a blink of an eye I thought, oh my god, my parents, my mom, would have a conniption! Sure, I liked him. But what is he asking of me—and himself? This was 1956. The boundaries of race were clear and fences high. Few people in those days rattled that gate. Though I grew up in Black neighborhoods, there were rules. I could hear my mother and Auntie Hatsue in my head. We could play outside, but not with the

kuro-chan (Black kids). It was forbidden and we didn't question it. It was a line we did not cross.

When I entered my teens, we had mother-daughter talks—private moments when she shared her wisdom and observations about life, culture, and art (her real religion), which most of the time were pretty deep. But that talk also laid down the ground rules for a proper young Japanese American woman. Basically, she preferred I date a Japanese. But recounting that her father forbade her marrying my father because he was half White, I could tell she wouldn't be too upset if I was with a White guy. But Black! That was a serious no-no. So here I was, looking at this beautiful brown young man, stuck in embarrassment. Uh ... maybe Teddy was thinking, she's a cool Japanese, just a shade lighter than me, this homecoming queen. People have been testing the waters ever since different tribes encountered each other. Even my grandma Lucy and Harry crossed the no-no line. I'd heard about Japanese war brides who married Black soldiers stationed in Japan, then moved here. But I'd never met one. There was one girl in school who was Black and Chinese: Gina Lim Yu. She was beautiful.

I was suspended in this time-space, mind spinning without a clue what to do. All my dance training didn't give me the guts or the honesty to say: Can we stop a moment to think about what you are asking? We're not just any two teens going on a date. You're Black and I'm Japanese, ten years out of a concentration camp, trying to fit in, be accepted as an American *and* be a good daughter to a family and my people—who might be a bit racist. Yes, you are handsome and smart. Yes, race boundaries are ridiculous. And I'm sorry I'm not as brave as my grandma Lucy. I'm not ready to stand up to society—stand up to my parents—who would *kill me*!

I just looked at handsome Teddy with my jelly mind and said, "I can't." That stupid answer stings me to this day.

"Steam Heat," with my background chorus of dancing guys, had another effect. It opened me up to a circle of athletes, mostly Jewish. I found myself having lunch with them. I was outside, not doing homework, for the first time. They were outgoing and frank. They were also competitively funny and talkative about race and discrimination. They had centuries of experience in these matters. Japanese and Chinese were relatively new immigrants, from monocultures. We were accustomed to class bias in our home countries, but still trying to adjust to the American brand of racism. We weren't making

jokes about it. We were trying to fit in, enduring our pain in silence. Now suddenly, after years feeling like an outsider and a misfit, a group welcomed me in. I felt special. I wasn't just a Miyamoto among a Glassman, Friedman, Citron, and Schacht; I was a shiksa among mensches. My differentness became an object of jokes and laughter. In this circle of new friends, one of them had the nerve to step up and cross the line. Mike Schacht asked me for a date, and this time I said yes.

It wasn't a radical leap like Teddy Jones, but it was a statement in those times. There was only one other interracial couple I can remember from LA High. It was hard not to notice them. Toshiro, born in Japan, had a street-tough physique from judo training. I thought of him as our local version of popular samurai Japanese movie star Toshiro Mifune. Tish, as we called him, ran with the most beautiful, blue-eyed, pale-skinned, blond-haired Nordic girl on campus. They were a spectacle wherever they walked. Tish had the guts to go with this conspicuously White girl, and we admired that.

Mike Schacht and I were not such a high-contrast couple. We were both tan people. He had handsome Mediterranean looks and was a cool dresser, reminiscent of his idol, Cary Grant. I still dressed in clothes my mom made me, always keeping me up to date in her ideas of fashion. We were probably the talk of our ethnically mixed school, too. In the 1950s, the stick-to-your-own-kind mentality was finding some fissures. In a few years, race relations and struggle for social equality would take center stage.

When we graduated from LA High in the summer of 1957, our small experiment in cultural boundary crossing continued. I was feeling like an almost "normal" seventeener, with a boyfriend and still a busy dance schedule. My social life now included dinners at Mike's house with a family nothing like my own. The Schachts' big two-story house on Cloverdale and Wilshire was fancier, funnier, and louder than anything I'd experienced. Cheek pinches, "kana hora" (Yiddish, *kein ayin hara*), hugs, and kisses were part of Mr. Schacht's greeting, whether with Mike's two younger sisters or his two older brothers. He often pinched his wife's behind. Such displays of affection were unheard of in a Japanese household. My father did not greet my brother or me with a kiss. Acknowledging our presence usually involved a grunt, a head motion, and a "hi." My baby sister, who arrived in my seventeenth year, got plenty of kisses until she was nine or ten, and then she was treated like the rest of us. And my mother and father never hugged or kissed in front of us, let alone traded pinches on the ass. That is not to say that there was no love in our house. There was just an invisible way of expressing it.

Besides these outbursts of affection in the Schacht house, dinnertime was marked by outbursts of conversation, layered and contrapuntal like a Bach fugue. Never a pause or a moment of silence. Their conversations were commentary on how you looked, current events, or show business, or a game-like competition of jokes, and jokes upon jokes. One of their uncles was a comedian who visited once in a while, adding to their joke repertoire. They loved movies and movie stars, especially the debonair and charming Cary Grant. Robert Mitchum appealed to their manly side. The girls were slim, long-legged, and pretty, capturing the young Sophia Loren look of the day. And they loved to shop, especially the older sister Julie, who took me to the most fashionable Beverly Hills shops and hairstylists. I was finally learning to choose my own clothes.

The Schachts accepted me quite easily. Mrs. Schacht was sweet, loving, and welcoming, especially with food. Mr. Schacht was a kind tyrant. The family lived under his protection and his fury. He was gentle with me, probably sensing my shyness and social insecurity. They all knew about the Japanese "camps," which were far less concentrated and lethal than the Jewish versions. Still, it gave us some common ground. Being Jewish, with heightened awareness of all degrees of discrimination, they also were very aware of the growing Black struggle for equal rights.

They were Jewish but not religious. They ate bacon, and Saturdays didn't stop them from driving. They did seders for high holidays, but I don't think Mike or his brothers had bar mitzvahs to celebrate their passage into manhood, or ever stepped into a synagogue. But Mr. Schacht was fiercely pro-Israel, seeing it as the only solution for anti-Semitism. In fact, his job as the head of Bonds for Israel in the western United States was specifically to raise funds for the then-fledgling state.

I remember in 1960 going with Mike and his buddies Stan and Tony to an epic movie called *Exodus*. Based on a novel by Leon Uris, the film romanticized the fight to establish an Israeli state. This controversial depiction of the Israeli-Arab conflict starred Paul Newman, another exalted star in the Schacht constellation. The screenplay was written by Dalton Trumbo, who was famous for having stood up to the House Un-American Activities' anti-Communist campaign, for which he paid dearly by being blacklisted in Hollywood. The Schachts revered Trumbo and celebrated the Otto Preminger–directed movie. I could feel Mike's chest puff as we witnessed Hollywood, for the first time, make Jews the heroes, the good guys, the winners. Only fifteen years after the Holocaust, no fearful victims, no striped

uniforms. Like the cowboys against the Indians, it was the Jews against the Arabs, fighting for their homeland. Mr. Schacht often joked about the disorganized and divided Arabs. How could you *not* cheer as brave and bold freedom fighter Paul Newman led his people, who long suffered slavery, persecution, and prejudice, not only in the Bible and in Europe, but even in Los Angeles, where until the 1950s housing covenants kept them, like Blacks and Asians, from buying houses wherever they wanted. This was the big screen, this was Hollywood, this story would reach the whole world. It is said that *Exodus* helped set the stage for America's acceptance of Israel's Zionist policies. Leaving the theater with Mike and his buddies, we felt jubilant. It would be many years until I began to understand the complexities of the real-life story—and then stand in solidarity with the Palestinians.

In the summer of 1957, just after graduation, I auditioned and got a cool job dancing with the Alicia Alonso Ballet from Cuba. Alonso was one of the beautiful ballerinas of color my mother used to show me to prove I could make it. She had been bestowed with the title "prima ballerina assoluta," and she was absolutely one of the best in the world. Born in 1920, she'd been Cuban trained and then did something unthinkable for a budding ballerina: she fell in love and had a baby, Laura, at sixteen! Then both she and her dancer husband went to New York for further training, and her career skyrocketed. Then at age nineteen, her retina became detached and she had multiple surgeries. The doctors told her that if she danced again, she would go blind. She replied if she couldn't dance, she didn't want to live. During her long recovery she learned the role of Gisele while flat on her back and went on to international fame, dancing—with some clever accommodations for her near-blindness—with the American Ballet Theatre and other companies around the world. This was still a time of little public consideration for disabilities. It was only her sheer determination and unquestionable skill that pushed her forward.

Alonso came to Los Angeles with her ballet company in 1955 to perform *Coppélia* under the summer stars at the Greek Theatre. And perform she did. At thirty-seven, she was in rare form, sans peripheral vision and with only partial vision in one eye. As she directed us during rehearsals, she knew us by how we danced, not by our faces, and the notes she wrote on her yellow pad were two inches tall—which she read with a magnifying glass! During that week we performed for audiences of five thousand per night on the gigantic

Greek Theatre stage. Someone led Alonso through the dim backstage to the wings for her entrances. Special lighting was set up to orient her sense of direction. Once she was on stage, she was impeccable. She could do four or five pirouettes and stop on a dime—which is hard for a sighted person to do. Awestruck, I watched her control, her incredible grace, her doll character come to life.

After wearing toe shoes eight hours a day, I'd determined that I was meant to dance with my bare feet on the earth. But Alonso became a role model way beyond that picture my mom showed me. My only regret is turning her down when she asked me to join her company in Cuba. I didn't want to leave my boyfriend. A couple of dancers who did go said they carried messages to help the Cuban Revolution, which had been in process since 1955. I could have met Che! After the revolution, her company was named the Ballet Nacional de Cuba. Alonso took her company to perform for workers in factories. She went into orphanages to train boys who wanted to dance. Some of them joined her company and went on to success in other international companies. I had no idea what revolution meant in my dizzy dance days, but that sounded pretty good to me.

Every career has its ups and down, but my stint in Las Vegas, that neon desert town where I met Elvis Presley, was the pits. Summer was over and all my smart friends were headed to UCLA or USC. Folks didn't look at the training we had at American School of Dance as higher education. Even my dancer friend June was going to UCLA. What was I going to do? My algebra grades sucked. I decided to enroll at LA City College and take some easy classes like psychology. About five weeks in, I got a call for a job dancing as a soloist at the Desert Inn in Las Vegas. Yes! I'm outta here! I was seventeen. I don't know why my parents said yes.

The Geisha Girl Revue was an import from Japan, except for me. It was a third-rate copy of the famous Takarazuka Revue, a troupe in Japan that presented huge, extravaganza theatrical performances, some of them musicals. Our revue looked like the old Radio City Music Hall dances: thirty Japanese geishas with cute white-painted faces spinning their flowered umbrellas, making designs to music. The next piece had us in high heels, running around making more designs on the stage. I was brought in because they needed a soloist who could dance jazz. It was an artistic comedown after Jack Cole, but the worst didn't happen on stage.

Part of our job was in between the shows. Picture the lounge, which needed customers for the music act, with thirty young women scattered around it, looking cute in our kimonos, powdered white faces, and red-painted lips. We were a magnet for men with geisha girl fantasies, who would drift in to window shop, buy us drinks, and hope to buy more. I was green and seventeen, but I could see that we were bait—sitting ducks in a crazy game we couldn't win, sort of like gambling in Las Vegas, where most of the stories are about losers. We were being used. The Japanese girls spoke little English, so they smiled and made polite gestures. My survival strategy was to pretend to speak only Japanese: *wakaranai, wakaranai* (I don't understand).

Vegas was an upside-down town. We worked four shows until two in the morning and then wound down with the lounge musicians and drinks (ginger ale and a cherry for me), breathing in smoke, bourbon, and Vegas tales of lost fortunes until sunup. We slept all day and then started all over again. Big names like Sinatra and Elvis made big money; big-breasted showgirls made fair money; and some great musicians got steady money doing lounge acts. Sex was no secret. Fast weddings, golf courses, over-chlorinated swimming pools, reasonable hotel rooms, and cheap food, everything was a lure for gamblers— little gamblers on one-armed bandits and big gamblers at the tables.

One evening, one of the girls was given a room number in the hotel and told to go upstairs. She came back crying. When the door had opened, a man was standing there naked. She freaked and ran. This poor Japanese woman was a test run. Who was next?! Okay, that's too much. I worked up my nerve and found the producer, a sleazy fat guy who smoked a cigar and looked straight out of a B movie. I told him I was not going to sit in the lounge anymore. He said it was part of the job. I told him, "I am seventeen and you're breaking the law!" I felt proud of myself. It was the first time I stood up for my rights.

My Las Vegas experience taught me it wasn't enough to use my body to dance, to be twice as good. As women we had to be twice as perceptive and have defensive strategies to keep our bodies safe. After making my stand, I had no one to hang with between shows. I was alone, bored, and a little scared to be on my own. I couldn't wait to finish my ten weeks in Las Hell.

EIGHT

Chop Suey

IN SAN FRANCISCO, I WAS DANCING in *The King and I* for the LA Civic Light Opera when Rodgers and Hammerstein were scouring the country to cast their new "Oriental" musical, *Flower Drum Song*. The choreographer, Carol Haney, auditioned us on the stage of the Geary Theater with director Gene Kelly—yes, the movie star—looking on. A few weeks later in Los Angeles, I got the call. My mom, of course, was jubilant. I went to my dad's Texaco gas station to tell him the news about my first musical on Broadway. Without looking up from the car he was fixing, he chuckled and grunted, "Just tell them you're not going."

"No, Dad, I want to go!" That was the first fracture between my life and my parents' world. This was the prize I had trained for since I was four. I was going to New York to dance in a Broadway show.

I'd never been on a plane. In 1958, the pre-jet era, it took eight long hours in the air to get to New York. From my window seat, the Statue of Liberty looked like in the movies. I'd never ridden in a cab before, so how was I to know about tipping the driver? (Sorry, mister.) I'd never seen skyscrapers before, so tall the sun couldn't find the street. I'd never seen so many neon lights, theater marquees, billboards, traffic jams, horns honking, people walking, all squeezed into the famous Times Square, which looked more like a triangle to me. I'd never felt this kind of heat before—a September heat thick as caramel, smelling like car exhaust, sweat, soot, restaurant food, and a hint of garbage. It was hard to draw it into my lungs.

As I stepped out of the cab and onto steamy concrete, I saw a rail-thin Black man in dark, tattered clothes with a cap that covered half his face. He was singing a song I'd never heard before. I didn't recognize the words or the melody. He was singing with his whole body, eyes closed, fingers snapping,

hand scratching the air, pulling a sound from an unseen place. He was singing as if no one or everyone was watching him, totally free and unfazed by people rushing past, walking around him, wanting him gone. This is New York, the cultural mecca of the world. They come here in a hurry from everywhere, to make it. The Black singer's presence was a cockroach, a tiny irritant, a subtle reminder of something they wanted to forget or ignore. But he kept on singing. He wasn't showing off. He wasn't begging. He wasn't asking for anything, not even to be discovered. He was just trying to bring out something he heard from that unseen place, bring it into this crowded, messy, smelly street.

I wondered if he was out of his mind, lost, or both. Did he know or even care if it was Broadway? Why couldn't he sing his song from one of the stages that surrounded him? Was this the only place he could sing it, on the street, this Black man on the Great White Way? He filled me with sadness and admiration. I felt his voice was greeting me: *You're here baby, here baby / welcome to my cool, cruel city, baby, shoo dabba doo.* I breathed it all in as I climbed out of the cab, dragging my luggage, my dreams, my excitement, and my fear into a hotel on the west side of Broadway and 50th Street.

Flower Drum Song was originally a book by the Chinese-born, Yale-educated writer C. Y. Lee. It became a best-seller that captured every immigrant family story, regardless of ethnicity—the culture clash of the first generation with Americanized offspring. Rodgers and Hammerstein were at the pinnacle of the Broadway pyramid. Their shows usually displayed some social consciousness balanced with a strong sense of what would sell. It was good timing for something different on Broadway. They adapted the book and touted it as the first musical with an "all-Oriental" cast. Wow.

But this presented a challenge: Where to find hordes of trained Asian American singers, dancers, and actors of Broadway caliber to fill their stage? In early film, a few Asian actors such as Anna Mae Wong and Sessue Hayakawa caught the system by surprise with their talent and exotic looks. But they were exceptions, and that was before the movie business had solidified what an American movie star was supposed to look like. Then, the heightened anti-Japanese propaganda that preceded and inundated society during World War II meant that "Orientals" were generally portrayed as the enemy, the Yellow Peril. So why on earth would Asian immigrant parents encourage and train their children in a career that only promised frustration

and humiliation? Well, maybe some piano lessons. We like being cultured, but not as a career.

The first generations, while they might have taken jobs as laborers and farmworkers, came with a sense of self and an appreciation of their own culture, music, and dance. I was part of the confused generation that looked Asian but felt American. I felt trapped by that dichotomy and the limitations it imposed. Just like those young Japanese Americans in concentration camps who volunteered to fight in a war against their homeland to prove they were American, the 1950s was witnessing young, crazy artists trying to defy cultural gravity to make it as performers in America. A few were finally rising above the horizon.

Miyoshi Umeki had just won the Academy Award for Best Supporting Actress opposite Marlon Brando in *Sayonara* (1957). But she was Japanese born. She was a charming actress and singer whom Rodgers and Hammerstein found to play their "fresh off the boat" picture bride who played the "flower drum." Pat Suzuki was a California-born nisei who'd already made a sensation as a jazz singer. I'd seen her on Jack Paar's late-night television show. I thought, wow! She's nisei?! She got her start in Seattle's Colony Club and was breaking the mold. In *Flower Drum Song* she was perfect as Linda Low, the brassy nightclub entertainer. Ed Kenney was a tall, beautiful Brown tenor, a Native Hawaiian who sang in Waikiki clubs. Hawaii always had its distinct music and culture, which was exploited and cultivated as a tourist attraction. For *Flower Drum Song* he would be Wang Ta, the leading man, and I was cast to do a very sexy duet ballet with him. Keye Luke (finally a real Chinese) was a veteran screen actor who would play the traditional father, Master Wang. I grew up seeing him in the Charlie Chan movies: he started breaking the mold in the 1930s playing "Number One Son" in fourteen of the more than forty Charlie Chan movies. His "What's up, pop?" line was a breath of fresh air—this young Asian on TV who was bright and spoke perfect English. Now Luke was playing an old man in *Flower Drum Song*.

Filling all the roles with Asians proved challenging, so they detoured with Madam Liang, picking the fair-skinned Black actress and singer Juanita Hall, who'd passed for Polynesian in *South Pacific*, singing the song "Bali Hai." People of color had to be ambidextrous to stay working in this business. Another big detour was the role of Sammy Fong, a fast-talking Chinatown club owner. Somehow they just couldn't find an Asian who could play this role, so they brought in Larry Blyden, a Jewish Broadway actor. Blyden got over by putting on single-eyelid makeup, or what is known as yellowface (like

what Marlon Brando did in the 1956 movie *The Teahouse of the August Moon*). In those days, we Asians winced but did not take to the streets over such matters. We were used to Hollywood passing us over for famous non-Asian actors, like Brando in *The Teahouse of the August Moon* and Luise Rainer in *The Good Earth* (1937). In fact, these actors often gained kudos from the press and public for playing these exotic foreign characters, while we in the Asian community saw them as ridiculous and fake.

Jack Soo was a comedian they found in the San Francisco Chinatown club Forbidden City. They signed him to play the small role of Frankie Wing, but he was also the understudy for Blyden's role. Jack was a funny man who'd created his style of comedy based on his own personality and sense of humor. His real name was Goro Suzuki. He learned to get laughs while entertaining fellow internees in the Topaz concentration camp in Utah. When he left camp, Goro became Jack Soo to pass for Chinese and work clubs. He was a perfect Sammy Fong, but Rodgers and Hammerstein couldn't trust that this real Asian guy could play a lead. When Blyden left the show, Jack claimed the part of Sammy Fong. We were all pulling for him that first night, and he nailed it! Yes! Jack Soo went on to become a successful television actor and comedian on the *Barney Miller* television show, but he never reclaimed his real name.

The night before our first rehearsal, my old friend visited me. Sleeping in a strange hotel room on a lumpy soft single bed, listening to New York street noise, flashing neon illuminating the room, and window fan whirling, I started itching, then scratching. Eczema! No! The first days of rehearsal were always hard, but this job added to the picture a kind of heat I'd never felt before, let alone danced in. The large open windows of the rehearsal hall only invited in more thick hot air, multiplying my itching. I felt like everyone was looking at me, this sweaty, mutant mess.

They had gathered us "Oriental" dancers, singers, actors, showgirls, teens, and children from Hawaii, California, Toronto, and New York. Most were as green and awed as I was. After a few days of rehearsal with choreographer Haney, it was announced that Yuriko, the Martha Graham dancer and lead dancer in *The King and I*, would dance the Mei Li role in the show's ballet sequence; many musicals now had ballets in the middle of the show that would feature all-out dance expression, where there are no words and dance itself tells the story. I got picked out of the chorus to dance the role of jazzy

Linda Low. Wow, I would be dancing opposite Yuriko! Maybe because Haney was a Jack Cole dancer, I fit well with her choreographic style.

A few days later, Mr. Rodgers and Mr. Hammerstein along with Mr. Gene Kelly dropped by to welcome us. Everything froze momentarily. It was like meeting royalty. Soon, they would be part of our everyday scenery, Rodgers and Hammerstein watching Kelly directing us from the audience. Costume designer Irene Sharaff (from *The King and I*) entered the scene to have our bodies measured, matching our characters with her designs and the overall look of the show. Venerable arranger Robert Russell Bennett would drop by to consult with the rehearsal pianist as he created his orchestrations. Each was a master of their craft, adding their genius to the show as a whole.

As part of this unfolding process, I was amazed by the complexities and team effort required to make a Broadway musical from scratch—the book, the songs, direction and choreography, actors, dancers, singers, costumes, sets, and orchestration. We had five weeks of rehearsal in New York, and five weeks of out-of-town tryouts or paid previews in Boston, where we performed the show nightly to live audiences, each day continuing to reshape and refine. Fatigue was setting in on all corners, with ten- and twelve-hour days. It felt like we were a huge, unwieldy ship trying to get to the moon with our lives depending on each person carrying out their task. Haney working with me on the duet with Ed Kenney was a much kinder and gentler experience than working with Robbins and Jack Cole. My confidence was growing, but so was my own perfectionism.

Mr. Rodgers and Mr. Hammerstein weren't smiling. They were vibrating stress and worry and holding lots of meetings and asides with the creative staff. They had a lot riding on this show. Their last two shows had met with a lukewarm reception. This one had to be a hit. This was a ship difficult to captain even for an experienced theater director, and this was movie star Gene Kelly's maiden voyage on a New York theater stage. Could he pull the elephant through the needle's eye? Finally, we opened in New York. The audience seemed to love us. Okay, we jumped that hurdle. But what about the press? The opinions of just a few reviewers had the power to make or break us, no matter what the audience thought. This is the law of Broadway.

I remember celebrating with our cast that night at a party at Sardi's restaurant. Mr. Rodgers and Mr. Hammerstein were there, with all holding their breaths for the reviews, especially the *New York Times*. Some shows are said to have made it only because there was a newspaper strike at the time of the opening. For instance my friend Reiko told me a newspaper strike and

the good audience response had made *Kismet* a hit. We didn't have that advantage.

But of course, *Flower Drum Song* was a hit. And it was a thrill being a part of it. My parents came to New York to see me on the stage of the St. James Theatre for the opening. When they came upstairs into our dressing room, my dad looked around and saw one of my flimsy showgirl costumes, with just a few sequins in just the right places. "You wear this!" he exclaimed.

"Yes, Dad, don't worry, the audience can't touch us from their seats." But it took a lot of nerve for me to walk from the dressing room past the stage-hands to get to the stage in that showgirl costume. Truth is, it was the pretty "Oriental" girls, showing skin, wearing cheongsams slit up our thighs, fla-vored with all that jazz, that got us on the cover of *Newsweek* and me in the centerfold of *Life* magazine.

The R&H machine put us on *The Ed Sullivan Show*.[1] There was the *Flower Drum Song* album, and more. It wasn't a groundbreaking artistic triumph like *South Pacific* and *The King and I*, but Rodgers and Hammerstein were smiling. Their reputation was intact, royalties and movie rights were flowing, and happy investors were now ready to open their pockets for their next musical. The actors and dancers were happy, too. We had a job for at least the next year. For people in this business, that's a long job. We usually roam from one job and hope for the next; that's why they call us gypsies. I got a one-year contract and a tiny raise, and I mean tiny, for being a "lead dancer." My confidence grew, and so did my career expectations. What else was out there for me on Broadway?

Over the ten weeks our cast had been creating the show, we grew to be a kind of family. Life in the *Flower Drum* bubble seemed more real than anything else. We would go home to sleep but only begin to live again when we returned to our bubble. It felt good to be part of this elite community of people bound by a willingness to sweat together for a common purpose, working not for a paycheck but for a different kind of payoff. It takes a certain desire, skill, and determination to bring a story out of the ether of someone's dreams and have it speak, move, sing on a stage. Once you get a taste, to make an audience laugh, cry, think, forget, is like heroin. As a performer in that intense two-hour capsule of suspended reality, you walk with the awareness of a tightrope artist, working in harmony, in concert with others. For me it is the one thing in life that makes me thoroughly awake, aware of everything around me, in the present moment.

In a Broadway show, you're doing around 417 performances a year. You try to make each night new and fresh. In fact, no two performances are ever the same. You are not the same, and none of the thirty or forty other performers are the same. On a bad night, when somebody's had a little too much to drink between the matinee and the evening show, you know it. Or if somebody's boyfriend broke up with them (like mine did), or if someone gets the flu and the understudy is on, you have to pay attention. It's like a ball game, both fun and challenging. After the show settled into a routine, my life outside the theater came into focus again. I was learning what it was like to live in New York.

Yuriko was my New York mother. A few days into rehearsal, she invited me to rent a bedroom in her brownstone house. For many of the underage performers in the show, like Patrick Adiarte and the Ribuca twins, Linda and Yvonne, their mothers actually moved to New York to allow them the opportunity to be in the show—now, that's a big sacrifice. In a way, going to New York was like going away to college for me, but living under Yuriko's roof was a gentler entry to New York life.

Being a modern dancer and soloist with the Martha Graham Company, Yuriko was a serious artist who was highly respected in the modern dance world. But she had learned to straddle that concert world and the commercial world of Broadway. Dance and being a New Yorker made her a different kind of nisei woman than I'd ever known. She was independent, decisive, outspoken. As I mentioned, she'd come to New York straight from the Gila River War Relocation Center in Arizona when she was probably eighteen or nineteen, got a job sewing in a sweatshop, and studied dance with Martha Graham. Graham had choreographed some of her quintessential dance pieces with Yuriko as soloist. New Yorkese has crept into her voice—a voice surer and more strident from years of teaching at the Graham school.

Still, Yuriko carved out a "normal" life with a nisei husband, Charlie Kikuchi, her six-year-old son, Lawrence, and her eleven-year-old daughter, Susan, who performed in the show with us. Yuriko was smart about utilizing all resources to expand their income. Their brownstone was a charming old four-story house on a tree-lined street at 239 East 78th Street, which was on its way to being upscale. The floors were creaky and the walls crooked, but Charlie had built a beautiful traditional Japanese room on the second floor, with a real tatami floor where shoes were forbidden. I remember a party they gave for distinguished Japanese Kabuki actors from Japan after their New York performance. By two in the morning, with sake flowing, the vibe of that Japanese room transformed the normally reserved Kabuki players into

drunken wild men dancing out into the street. The cops came and Yuriko had a lot of explaining to do to keep her guests out of jail.

Yuriko's mother, her kids' *baachan* (grandma), lived with them in a room on the ground floor off the kitchen, so that meant lots of home-cooked Japanese food. *Oishi!* (tasty!). Reiko Sato, my good friend who'd studied with Yuriko at Gila River, was now in town playing a prostitute in the musical *Destry Rides Again*. We had many dinners and long discussions around the kitchen table with Yuriko, Reiko, and Charlie about art, life, and being Japanese in the United States. Charlie complained it was the reason he was passed up for promotions again and again in his job as a psychiatric social worker in the Veterans Administration Hospital. He would write me letters, too long for my attention span, when we were out on the road in Boston. I was too green to know what an intellectual and activist he was. He often talked about a book he was trying to get published comprising stories he'd gathered from camp internees as part of a study on the "Japanese American evacuation and resettlement." *The Kikuchi Diary: Chronicle from an American Concentration Camp* was finally published in 1973. Charlie died of cancer at seventy-two in 1988 while on a peace march in the Soviet Union.

A veteran woman in showbiz, Yuriko kept a watchful eye on me. One day I was sitting in the audience watching rehearsal and the great Richard Rodgers came down and sat beside me. Yuriko appeared shortly and sat next to us. Later she told me that Rodgers always picked "his girl" out of each new show. That was the privilege his success bought him. (Wonder how that would work in the days of #MeToo?) Yuriko wanted to make sure that girl wasn't me. Thank you, Yuriko.

I was getting extra attention from dancing the aforementioned sexy duet on stage. In those days, we didn't know terms like "male chauvinism" or "sexual harassment." Like other young women, I learned to put up with it, laugh it off, roll my eyes, and gracefully dance my way out of compromising situations. We weren't questioning why we had to put up with this discomforting treatment, from whistles when passing a construction site to more dangerous stuff. I grew an extra sense of how to stay out of compromising situations, like weekend parties at the house of a celebrity like Sammy Davis Jr. Being a woman in show business makes you a sitting duck, and it was always open season.

After a couple of months, I was finding my New York feet, and my LA friend Beverly Sandler and I decided to room together. I left Yuriko's

brownstone on the East Side and went across town to an apartment on West 76th Street. There, life-probing conversations with my friend Reiko, who drank one-third of a bottle of Jim Beam nightly, frequently took us into sunrise. We were aware that we were part of a wave of shows about "Orientals." Asians were "in." As you walked west from Broadway up 44th Street, to your left you'd see the St. James Theatre with large posters of Yuriko, me, and other cheongsamed kewpie dolls luring you to *Flower Drum Song*. Across the street at the Shubert Theatre, a huge poster of France Nuyen with her sister prostitutes lured you to *The World of Suzie Wong*. Reiko was in another show farther up Broadway about the Wild West, playing a lone Chinese prostitute in *Destry Rides Again*. We knew this wasn't us, and this sexualized Oriental cultural barrage was influencing public consciousness. But we needed the work—what choice did we have? We had the unfortunate habits of eating and paying rent.

One of the advantages of being a member of Actors' Equity, a union for Broadway actors, dancers, and singers, was the special discount to see Monday-night benefit performances of other Broadway shows. I got to see plays like *Sweet Bird of Youth*, *Raisin in the Sun*, and *West Side Story*. That last was a whole other level of theater, with the powerful story, music, and dance seamlessly woven together. The dancers were believable characters who sang and acted. I left the theater breathless. I wanted to be part of *that*. I heard that they were having a replacement audition and I did my first New York tryout. God, there are good dancers in New York! I saw a different caliber of professionalism and competition. Because I had worked for Robbins, I got picked in the audition. But I found out there was no way to get out of the one-year contract with *Flower Drum Song*. No *West Side Story* for me—at least not yet.

Chop suey, chop suey! Not Hammerstein's most poetic and meaningful lyrics (see photo 10). We were on stage singing it on a Wednesday matinee, trying our best with Haney's satirical choreography combining the cha-cha-cha with the stereotypical Chinese hand movement of chop-chop, poking our index fingers in the air. (Where did that come from, anyway?) I felt that trying-to-please smile pasted on my face as we bowed to the audience, spilling those awkward lyrics over the lip of the stage into the sea of blue-haired ladies who filled the theater. *Chop suey, chop suey . . .* Who *are* these people? What brought them to *Flower Drum Song*? I imagined them buying their package

tickets for their once-a-year excursion to New York City: the bus ride from New Jersey, a dinner (not Chinese), a ticket to a Broadway hit, then hop back on the bus and tucked in before midnight. For most of the two-hour show, we don't have to look at the audience directly, and we don't see how they look at us. But at this moment, singing *Chop suey, chop suey,* we are looking straight at them, serving ourselves up on this platter of a stage. In a flash I saw it: *We're chop suey! Chinese food for White people!*

Not too spicy, not too stinky, not too real. No *lop chong,* no *hom yu,* no thousand-year-old eggs, no thank you! They look so satisfied, so happy with this familiar dish. Chop suey was not what real Chinese eat. It was survival food invented by Chinese cooks to please the palate of the *lofan* (White barbarian). But at that moment, I didn't want to please them. I wanted to shake them up. I wanted to leap off the stage and shout, "This is not me, lady! I'm not your chop suey! I'm a third-generation American-born Japanese from LA! You put me in a concentration camp, remember?!!"

Of course I swallowed my "chop suey" truth moment in silence. It left a bitter taste, but it didn't burn out my ambition. I was hungry for something more. I didn't know what it was. Maybe it wasn't just being in a Broadway show. Later I realized the blue-haired ladies are not bad people. They pay their hard-earned money for an entertaining night out. Nor are Rodgers and Hammerstein evil. They were songwriters and storytellers who climbed their way from Tin Pan Alley to the top of the heap on Broadway. They still needed to please investors. After all, this was show business. And we dancers and actors on that stage—were we sellouts for using our bodies to create the stereotypes that we would be stuck with over and over again?

There was no simple answer. We were all in the game, with our talents, our love of theater, our ambitions, our innocence, our ignorance, our limited worldview on the table. We were all complicit in a system, a cultural machine, that created, influenced, and reinforced tastes, ideas, and values, which were pushed not only all over the United States but worldwide. It was a cultural pyramid, with a very few players who scaled to the top and a lot of us peons scuffling at the bottom. Still, we were in the game, admired, our egos stroked for being part of it. It was also a cultural paradigm alive and in process, with artists pushing a purpose larger than themselves. One year later, in 1959, *Raisin in the Sun,* written by Lorraine Hansberry, was the first play by a Black woman writer and Black director to make it to Broadway. It was a critical and popular success, proving that audiences were hungry for something more satisfying than chop suey. It was happening for Black people, but we

were still stuck in yellowface. Even though C. Y. Lee had his story on Broadway, he was sidelined watching Hammerstein bring it onto the stage.

I finished my one-year contract with *Flower Drum Song*. There was talk that the show would go to London. Maybe my fellow gypsies thought me uppity for turning down an opportunity to work, but I didn't care. Besides, I had a family and a boyfriend I missed in Los Angeles.

There's a Place for Us

RETURNING HOME GAVE ME TIME for a deep breath. No slew of dance classes, no show every night. I was with my family and reunited with my boyfriend, Mike. I also had time to watch the six o'clock news with my dad. Our black-and-white television was filled with news about civil rights. Martin Luther King Jr. was arrested with fifty-one others in Atlanta for sitting in at a Whites-only restaurant in a department store. What? A judge sentenced him to four months in prison. That's crazy! It started me thinking, What would we be in the South? Would I be considered White or Black? I had time to be aware of the world around me.

Like all wannabes in Hollywood, I now had an agent. He sent me on weekly wild-goose chases for acting jobs—spies, prostitutes, geishas. I had my eight-by-eleven photos, my résumé, and my mind made up: I was going to these interviews as myself. I didn't wear a Chinese-flavored dress with a slit to show leg. When they asked me to do an accent, I replied: What kind, be specific? When they wanted long hair, I decided to cut mine in the fashion of the day. I found acting much worse than dancing. With the latter, at least there was the fun of movement and music. At least there was a level of skill required outside of what I looked like.

I didn't need an agent to find out about the audition for *West Side Story*. The dance world was buzzing with it. Will I really get a chance? In 1960, crossing the color line in the South meant the struggle to sit at any lunch counter, drink from any water fountain, sit in any empty seat on a bus. For me, a Japanese American, crossing the color line meant having a chance to be a Shark. The audition took place in a giant rehearsal hall at the Mirisch studios (formerly Sam Goldwyn) at Santa Monica and Formosa Avenue in Hollywood. I'd never seen so many dancers packed into one place in my

life—hundreds of dancers, dressed in their coolest, jazziest, sexiest dance outfits. I was in my basic blacks with long sleeves and turtleneck, and my ancient orange good-luck sweatshirt tied snugly around my waist as a security blanket. I felt invisible in the row after endless row of eager wannabe Sharks and Jets.

There he was, Jerome Robbins, his restless energy contained behind a long table at the front of the rehearsal hall, surveying the stampeding herd of dancers passing before him. Would he remember me? Would he even *see* me in this mass of dancers? I was just fifteen when I'd first worked with him in *The King and I*. Rita Moreno was in that film, too, playing Tuptim, the slave who was a gift to the king. She was a Puerto Rican passing for a Siamese! Now she was going to play a real Puerto Rican, Anita, in *West Side Story*. So I'm thinking: my hair is black—my skin is tan—I could be Puerto Rican. My eyes, well.

Howard Jeffrey, one of Robbins's assistants, was giving us ballet combinations to see our technique. One row of eight or ten dancers would perform and they'd pick one or two to stay, followed by a quick "thank you" for the others. Then there were jazz combinations, with more "thank yous" and a few "stays." The dancers reacted with sighs or smiles. Our fate was determined by dance god Robbins, who was watching from behind the table, puffing on a cigarette. This went on for a few hours, with hundreds of dancers waiting their turn outside. I had several "stays" that day. Wow. I made the first cut.

In the auditions that followed, the numbers dwindled but the demands on us intensified—dancing, acting, even singing. Robbins was a perfectionist, and he knew the kind of material he wanted to work with. It got down to what looked like the finals and somehow I was still in the ring. But there was one more hoop. We all had to do a screen test, just like they did with starlets in old Hollywood. Who would be Sharks? Who would be Jets? In some cases, it was a matter of eye color. Brown eyes for Sharks, blue for Jets. They could dye our hair and put makeup on us, but in those days, there were no colored contact lenses. In my case I'm sure what they wanted to see was whether with the help of Max Factor's Dark Egyptian (Lena Horne's makeup color) and black eyeliner I could pass for Puerto Rican. I did!

The first day on the film was sort of like the first day at a new school. Once again I was the shy outsider. The insiders were the New York dancers who came out of the Broadway show. I knew some of the LA dancers from the American School of Dance: Maria Jimenez, José De Vega, and Bobby Banas, all fabulous dancers who studied there. Robbins's assistant, Howard Jeffrey,

was once a haloed scholarship student we all looked up to at American School.

As it turned out, I wasn't the only Asian in the cast. José De Vega, from the original Broadway show, was playing Chino and *was* a Chino. Yes, there were lots of Chinos in the Caribbean: Chinese and Japanese who migrated as farmworkers to Puerto Rico, Cuba, and other islands. These Chinos intermarried and blended in with the other Spanish, Indigenous, and African mulattos. So José and I being part of the cast was not so farfetched. His father was Pilipino and his mother Guatemalan. He was so cool-looking I often wondered why Maria passed him up for Tony. Of course, then there would be no movie! But more about José soon.

The New York dancers had a different vibe than the West Coasters. On top of their virtuosity and familiarity with the dances, they were rowdy! They were already the Sharks and the Jets, and it seemed like they were checking us out to see if we were up to being part of their gang.

I was used to the rigors of dance, but nothing prepared me for the work that went into making *West Side Story*. Robbins was known to be meticulous, demanding, and sometimes cruel to get what he wanted. We were playing tough gang members, but we also lived the life of a ballet company. During rehearsal days, our one-hour ballet class started at nine, followed by a half-hour jazz class. During the shooting of the film, class was at six in the morning. I had never experienced this level of training at a commercial job, where warm-ups had been one's own responsibility. But for *West Side Story*, it was necessary to keep everyone in top physical condition. We were like a ballet company but with a lot of grit, rowdiness, and grease. I loved the guys' street style mixed with their balletic virtuosity. They were like bullfighters, doing something daring and dangerous, like vaulting that fence but looking so cool and sexy at the same time. For this, they had extra training. Fences were built in the rehearsal hall to simulate the ones they were to climb in the playground scenes. Each morning after our warm-up, they faced the fences, scaling, jumping, and vaulting like Olympic athletes. On breaks the guys played poker and created mischief on the movie lot, becoming real gang members.

After a couple of weeks of rehearsal, divisions began based on the numbers we did together. The Sharks bonded in "America" and "Mambo" for the "Dance at the Gym" scene. The Jets went underground rehearsing and rehearsing the song and dance number "Cool." The Shark girls were often separated from the guys, so Suzie Kaye, Maria Jimenez, and I bonded in our clique, and we had our own leader, the "Queen of the Sharks." She was one

of the few real Puerto Ricans in the cast, an earthy dancer with rumba embedded in her DNA. She was also a worldly, wiseass New Yorker, intelligent and *very* funny. Yvonne Othon, who later became Yvonne Wilder (in more than just a name), was the leader of the girl Sharks and had a viral sense of humor that spread a certain silliness throughout the entire company, even reaching the bosses Robbins and Robert Wise. Her comic relief was often a welcome stress buster on the set. Working twelve-hour days during shooting, the cast was fighting fatigue, injury, and even mononucleosis. The bosses had time anxieties, money anxieties. So, around four in the afternoon when Mr. Wise started self-medicating with his saltine crackers (natural ulcer medicine), Yvonne's crazy antics broke the tension with laughter.

When the opening sequence was being shot with the guys in the New York streets, Yvonne, a tough taskmaster, was running rehearsals with the girl Sharks and Jets. We did our daily morning ballet and jazz classes, and then she would run us through all the dance numbers. Sometimes she taught us some of her own jazz choreography. Occasionally, Natalie Wood would saunter in and rehearse with us as well. All this usually happened before lunch. When our work was done, Yvonne had the authority to excuse us for the day. While the guys were sweating in the sweltering New York streets, we girls were sunning at Santa Monica Beach. Sometimes on the weekends Yvonne would take us dancing at *the* coolest salsa club in LA: Virginia's, near Seventh and Alvarado. That was where the serious *salseros* hung out. There was always a hot band and we danced with anyone who asked us, breathing in the rum and smoke until two in the morning. This was on-the-job-training for "Dance Hall."

Yvonne and I were as different as *café con leche* and green tea. She was an outgoing, zany Nuyorican. I was a quiet, introspective Japanese American. But she turned out to be one of my closest friends and a frequent dinner guest at my family's home. She liked my mom's cooking and actually got my father to laugh and talk. When she went to London to play Anita in *West Side Story*, she entrusted my family with her most cherished dog, an adorable Yorkie named Charlie Brown. Like Yvonne, Charlie made my family laugh. When she came back a year later, she didn't have the heart to take back Charlie Brown. They both became part of our family.

The movie business has a caste system, and you become very aware of your station within it. If you are a dancer, you are at the bottom. Dancers are usually anonymous background performers in movies. We train long, sweat a lot, and get paid little. Stars have their own chairs with their names and their

trailer dressing rooms on the set. During rehearsals when Natalie floated in, she never seemed to sweat; she always looked like a movie star. Rita Moreno was another story. She was a bona-fide star in the film, but Rita sweated a lot. She would show up for ballet class and stay the whole day. She was one of us. She dressed funky, sweat-ready, and wore no makeup. No makeup! I couldn't believe how un-vain she was. I would never leave the house without some makeup, especially when on a Hollywood set. But Rita was totally unafraid to show up with her real face. She just concentrated on the work. Of course, on shooting days, she knew how to look good. She was a real artist and continues to be. But Rita's un-star attitude often worked against her. I remember during "Dance Hall," she was suffering with a sprained ankle. They didn't postpone or shoot around her to give her a break. They just wrapped up her ankle and sent her up on the set. Somehow she made it through, and she got an Academy Award for it.

I think we all had a special pride in being part of *West Side Story*, not only for the artistry that wove together music, dance, and story, but for the profound message it carried about divisions of race and class in America, especially in the 1960s. But the company faced its own contradictions. I remember that the studio reserved a suite of apartments for New York cast members on Crescent Heights and Fountain in Hollywood. A few of the darker members of the cast who were mixed, as many Puerto Ricans have African blood, were told they could not stay at these apartments. I thought it weird that some folks stayed there while their fellow dancers had to move elsewhere. While MLK was protesting in the South, we didn't know how to fight for equal rights in the movie business.

There were other difficult moments. One Monday, after our ballet class, we walked on a set ready to shoot "Dance Hall." Usually the crew and production team were pumping with energy at the top of the day, but today there was a solemn vibe. There was no Robbins pacing the floor, raring to put us to work. An announcement was finally made: Robbins was no longer going to be with us; he would not finish the movie. We would go on shooting without him. We looked at each other, trying to understand. He was fired? They fired Jerome Robbins? How could they fire the boss, the director, the creator of *West Side Story*? It was his baby. But the producers had indeed fired him. He'd just finished shooting "Cool," which went way beyond schedule. "America" took two and a half weeks, and "I Feel Pretty" about the same. The production was too far behind. *West Side Story*'s $10 million budget was considerable at that time, and Robbins's experimenting and innovating was

costing too much. The producers and their bankers were through indulging this artistic genius. He'd set all the numbers, and probably most of the shooting angles, already. His assistants knew enough to help Wise, the codirector, finish. Robbins was gone.

I remember feeling confused. Should we refuse to work without him? Should we sit down in protest? Should we demand an explanation? It felt like the breath was knocked out of our collective body. How could we dance without him, the one who pushed us beyond our limits, the one we strived to please? What was Jerry going through? It was too painful to imagine. Slowly, Robbins's assistants Howie (Howard) Jeffreys and Tommy Abbott nudged us into rehearsal mode. As they moved us into our formations for "Dance Hall," the music rolled and I felt my breath return. As we walked through the beginning of the dance, I thought, okay, these are his steps, these are his ideas, he's put it in our bodies, he's still here. I think we all shared the sense that now we *had* to do our best, for him. We had to deliver this baby for Jerry.

"Dance Hall" was grueling, but it went well. It was designed as a dance competition between the mambo of the Sharks and the cool jazz of the Jets. There were stories about the creation of this piece for Broadway, most importantly that Robbins set it up as a real competition and had the Sharks and Jets rehearse in separate rooms: Peter Gennaro choreographing the mambo with Sharks, and Jerry the jazz dance for the Jets. Then the big day came to show their stuff: a real dance-off. Story has it, when Jerry saw the Shark couples simply march forward, commanding the stage with "Mambo!" he stormed out. I guess the Sharks won.

For the film, Robbins chose me to be one of the three couples doing the cha-cha-cha at that magical moment when Tony and Maria meet in the dance hall for the first time. Everything slows and fades except the lovers, and us in the background. The dance is simple, a delicate cha-cha, à la Robbins. My partner was Bob Thompson. We started shooting the sequence at nine in the morning. Take one: and-one-and-two-three-four, "I just met a girl named . . .," turn, step together. It was seemingly simple to a dancer trained for years in ballet. But for Natalie Wood and Richard Beymer, two actors not exactly known for their dancing, there was lots of pressure. After take ten, it was lunch and the simple dance was not wrapped. After lunch we started again. More takes. Richard is unstable, then Natalie falters. Take twenty-two! It's almost six in the evening. This is the shot, or we go into overtime. Mr. Wise has been crunching his crackers. Dancers are tired. The simple dance has become hard labor. In the background, our arms, once lovingly entangled

over our heads, have become lead-heavy. Take twenty-three. We all do it! Tony and Maria, all of us, it's perfect! But I make the fatal mistake of catching my partner Bobby's eye. Suddenly I lose it. My back to the camera, I start shuddering, then laughing, and I can't control it, I'm hysterical. "Cut!" Oh no, it's me! I've ruined the shot! I've ruined the whole day! My laughter turns into tears, and then I hear:

"We finish tomorrow!"

None of the bosses said the usual friendly goodnight to me. My little hysteria bout just cost them a whopping $50,000, another day of shooting. I felt like a puppy that just peed on my master's new rug. I left with my tail tucked beneath me.

Another embarrassing moment in which I did not exactly feel pretty was in "I Feel Pretty." It was *Or maybe it's fleas!*—the only line in the whole movie that I sang by myself. I'd always loved singing in a group, or alone in my car. So rehearsing the songs "America" or "I Feel Pretty" with Yvonne and Suzie was a lot of fun. Yvonne's voice was chesty and Suzie's was a higher timbre. I was comfortable and secure right in the middle. Our daily rehearsals with vocal director Bobby Tucker were a nice break from what was otherwise hard physical labor. We were well prepared for the recording session, creating the tracks that we would lip-synch to during the shooting.

I thought we were finished singing until the last few days on the job, when they called me by myself to Studio 7—that famed recording studio where months earlier we watched Johnny Green conduct the orchestra for the soundtrack of the movie. That was a thrill, to be right there with the live orchestra blaring out this fantastic score. It was like that first concert my father took me to in Utah when I was five. But now here I was, by myself, a tiny ant in this huge hall. The film was almost finished. They just wanted me to sing for my image on the upper-left part of the screen for "I Feel Pretty." All I had to do was sing those four silly words, "Or maybe it's fleas!" Simple? No!

I had on earphones and heard us all singing, *It must be the heat, or some rare disease, la la la, or too much to eat.* And I'm supposed to chime in, *Or maybe it's fleas.* Somehow, each time they played it, I freaked, I just couldn't get the words out. Come on, I've done this a hundred times with Yvonne and Suzie! But now I'm alone, by myself in Studio 7. Yvonne, Suzie, I need you! Each time they played it, my anxiety level rose. Patiently the male voice said: "Take five, roll it." But my voice just didn't want to come out. "Take nine . . .

take ten . . ." My heart beat faster; it got harder to breathe. I was swearing to myself: "What's wrong with you! Are you scared to hear your *own voice*? Is that the *problem*?" Yes, that was the problem. I was afraid of the sound of my own voice.

Somehow they squeezed it out of me. In spite of myself, "Or maybe it's fleas" is there on the screen for eternity. I decided something that day: I had to get over this fear.

Passing for Puerto Rican in *West Side Story* left me hungry for more. Growing one's talent and career depends on having opportunity, a chance to grow in different roles with increasing demands. Had I reached the height of my possibilities at twenty-one? I fooled myself into thinking: maybe if my name was a bit more ambiguous, a bit less Japanese. So for my very first screen credit I chopped off the "moto" and became JoAnne Miya. But the night of the premiere, when I saw my name on the giant Cinerama screen, I knew a part of me was missing.

TEN

We Shall Overcome

LEARNING HOW TO SING SOLO was not just a matter of learning vocal technique. Breaking my silence was a process of understanding and undoing what put a muzzle on me, as well as my people in this country. My singing teacher, Dini Clarke, worked like a saint to pull my voice from my shyness. At my first singing lessons I shut up like a clam when the next student walked into the studio. I wanted to disappear behind the photos of Clarke's students on the wall, crawl into the curvy body of his baby grand, just disappear.

We did voice warm-ups and built technique, but his magic was getting me just to sing—simple standards at first, carrying me on the chord changes, letting me feel that my voice was part of the music. "You've got a good voice," he stroked. I loved to sing in a group, but why was it so difficult alone? I could dance alone, but could not see myself, this Japanese girl, singing alone. Slowly, I began feeling comfortable voicing words and melodies, forgetting myself in the stories of the songs. I began feeling safe singing in that motherly curve of his baby grand. Slowly, the fun overcame the fear.

Dini Clarke was born in Washington, DC, in 1923, a time when it wasn't easy to be Black. (Has anything changed?) With his talent as a musical prodigy he sailed through Howard University. Though he wasn't as famous as some of his mentors, like Duke Ellington and Billy Strayhorn, Dini was a master musician, a genius of the Great American Songbook. It seemed there wasn't a song he didn't know.

His West Hollywood apartment had a wall packed with a library of those ancient things called record albums. Those twelve-by-twelve-inch jackets were a perfect canvas for pictures of every singer of note. He had me listening to all the women greats of the time. Lena Horne was a bronze singing goddess (and mother of Teddy Jones, the one I turned down for a date in high

school!). She was a beauty, but she had bite and a sense of humor about herself. She could take the "Star-Spangled Banner" and make it sound like she was having an orgasm, in her own humorous, ladylike way. Although she was fair-skinned, she weathered the same prejudices of other Black entertainers and was even blacklisted for her friendship with famed singer Paul Robeson, an avowed Communist. Ella Fitzgerald was a jazz hummingbird who could fly in any direction. In New York I saw her live at the Astor Hotel. She looked like a plump auntie in her Sunday black dress, clutching a plain white hanky she used to wipe the sweat off her brow. Her singing was a workout and gave Count Basie's band and the audience a run for their money as she took us on a musical roller-coaster. Carmen McRae was a hip intellectual jazz singer with a precise, liquid voice and unique phrasing. Dini often talked of subtext, the meaning under the lyrics, and Carmen was a master at pulling irony and humor from the words. She often chose esoteric songs most singers wouldn't touch. A jazz pianist herself, she heard every note around her voice. One night at a local LA club, I witnessed her stop in the middle of a ballad, turn an evil eye on the piano player, and say: "Read my lips." The audience dropped their drinks and froze like an obedient classroom until the pianist crawled back out from under the piano and cool Carmen stepped back into the song. Nina Simone's smoky voice, fierce presence, and musicianship made for a force that went beyond entertaining. She was an angry Black woman and wasn't afraid to show it. I loved songs like "Mississippi Goddam," and "I Wish I Knew How It Feels to Be Free." "Four Black Women" got me wondering: Where are the songs about women like me?

The first time I heard Billie Holiday, I was in my car. Nobody had to tell me it was Lady Day, I could feel it. I pulled over to listen. She didn't have a voice to land a record contract in this age. But when you heard "God Bless the Child" or "Strange Fruit," you knew she'd lived those stories. All the athletic singers you hear today couldn't hold a candle to her. These singers, in spite of all hurdles of racism they faced, including not being able to stay in the hotels they entertained at, fully expressed themselves. I was in awe, but I knew I couldn't be them. I just wanted to find a way to express myself.

One of Dini's greatest teaching tools were his Sunday workshops. He would invite his friends, like famed bass player Ray Brown, to give us the experience of singing with great musicians in front of our peers. I balked at first with that feeling of "Japanese-ness." Eventually Dini treated me like one of his star pupils, a boost to my confidence. He worked to bring out the best in each student, no matter Black, White, pink, or yellow, no

matter if we had money or painted his house to pay for lessons. He created camaraderie, community, and a sense of belonging with all of us crazy mixed-up song lovers. Years later he would do the same at the World Stage at Leimert Park.

Sitting on the stool in the curve of Dini's piano was also giving me a way of seeing the world. He shared stories about growing up in DC, going to a movie theater that was segregated and having to sit in the balcony. He got me talking about my family's incarceration during World War II. From 1961 to 1967, songs and sharing stories connected us as we witnessed the turmoil of the civil rights movement unfolding.

The 1960s brought a new song into the US consciousness—not a pop tune played on the radio sung by famous singers, but a simple song sung by ordinary people trying to do the extraordinary. "We Shall Overcome" gave Black people strength to endure the ugliness of White hate, fire hoses, and police dogs. "We Shall Overcome" gave courage as demonstrators were dragged into paddy wagons. "We Shall Overcome" gave hope and camaraderie in the darkness of prison cells. It was a song of community and commitment to the struggle for equality for Black people. As apolitical as I was, I knew "We Shall Overcome" related to me, too.

It was during this tumultuous period that Mike and I decided to marry. We weren't trying to make an integration statement. Love has pushed integration since the beginning of time. Our interracial marriage in 1960 did turn heads, but it wasn't dangerous. When looking for an apartment, I saw a listing in West Hollywood and called, telling the woman my name was Mrs. Schacht. She sounded friendly and said to come right over. When I got there, she opened her door, took one look at me, and said, "It's already taken." Restrictive housing covenants in LA that had kept Negroes, Mexicans, Orientals, and Jews from living in White areas were banned by the Supreme Court in 1948, but somehow the practice continued. When Mike was in real estate selling homes in the Hollywood Hills, they told him he couldn't sell to Blacks or Orientals. He told them he would sell to whomever had the money. He didn't last long on that job.

In 1950, Nat "King" Cole's big hit "Mona Lisa" vaulted him across racial and musical boundaries internationally. He bought a house in the exclusive Hancock Park neighborhood in Los Angeles. When his family moved in, a cross was burned on their front lawn. Cole was the first Black entertainer to

have his own TV show in 1956, but a year later, sponsors decided Black audiences were a waste of their money and dropped it.

After *West Side Story* I was studying acting to build my skills and my chances to make a living in Hollywood. But acting put me at that same old place of trying to cross the color line. And those dreaded auditions! To this day I do not know how actors endure that excruciating ordeal. I needed work, but there was something rebelling in me, refusing to be the "type" they were looking for. It killed any desire in me to be an actor. I just couldn't find the music in it. In spite of myself, I did land a few jobs which I'd prefer not to mention, but I will, because it was typical of the school of hard knocks for Asian actors. A few of my un-notable bit parts were: a geisha traveling through the Old West on the TV series *Laramie*; a maid on *The Doris Day Show*; a Chinese concubine in the B movie *Confessions of an Opium Eater*, starring Vincent Price; a Japanese spy in Bill Cosby's first series, *I Spy*; and my favorite, a Martian who kills her brother to help White earthlings in *Women of the Prehistoric Planet*. Please don't waste your time looking these up on YouTube. Take my word for it, they were horrible.

Television was now giving us close-ups of worlds we had never seen. In 1961 we were at the inauguration of John F. Kennedy, our first Irish Catholic president, seeing Black opera star Marion Anderson sing the national anthem. That was a big deal then. In 1963 we witnessed a Vietnamese Buddhist monk sitting in meditation in the middle of a Saigon street, then setting himself on fire. He was protesting the persecution of Buddhists by the South Vietnamese government led by Ngô Đình Diệm. In August 1963 we watched hundreds of thousands march on Washington, DC. When Martin Luther King Jr. gave his "I Have a Dream" speech, we breathed in a truth that defined our generation. In November 1963 President Kennedy was killed before our eyes. It was the assassination of the American dream.

It kept coming, wave after wave: the bombing of a Black church in Birmingham, killing four little girls; the Freedom Riders heading South to register Black voters; White sheriffs with vicious police dogs; vicious White people taunting those marching from Selma to Montgomery for their right to vote. "We Shall Overcome" was the soundtrack to this black-and-white drama we watched from our living rooms.

As we saw the America we knew break apart, watched its ugliness and resistance to change, Mike and I were coming apart, too. I don't remember what was breaking us, where the cracks formed, where the arguments I could never win started. I don't think our differences were cultural or political, or

maybe they were. We were a part of something bigger than ourselves that was breaking—breaking out, breaking loose, breaking free from the forms that held us, breaking so something new could be born. Maybe breaking apart was the only way we could become what we were meant to be.

In 1967 the war in Vietnam was raging and I was singing in a nightclub. With 490,000 US troops on the ground and young people in demonstrations marching, I was singing *The girl from Ipanema goes walking*. When Martin Luther King Jr. delivered his "Beyond Vietnam: A Time to Break Silence" speech, I was breaking into a new career. Race riots in reaction to police brutality erupted around the country, the worst in Newark and Detroit making it the Long, Hot Summer of 1967, but I was in cool Seattle. Not that there weren't a Black ghetto and Black Panthers in Seattle. I was just clueless.

Before me there were lots of talented second- and third-generation Asians who wanted to express themselves. Some stood up to their immigrant parents who saw show business as no way to make a living and showing legs as a sin. Nightclubs in Japantowns and Chinatowns were places where singers, musicians, stand-up comedians, strippers, and dancers could fashion their own acts. In the 1930s and 1940s the most famous was the Forbidden City in San Francisco, where mostly White audiences goggled at these exotic, jazzy creatures. It was the yellow version of Harlem's Cotton Club. Blacks had the chit'lin circuit and we had the rice circuit. While performers weren't limited to the Oriental images in movies and Broadway, they often played with those stereotypes via their names, appearance, and costumes. If you wanted success, sex and slanted eyes sold. Some were imitators, like Larry Ching, a crooner who sounded like Frank Sinatra. Others created their own acts, like Jadin Wong or Mai Tai Sing. These rebels braved a lot of humiliation and heartbreak. They broke tradition and took a jab at the racist assumptions that we were still foreigners. Their shows were an in-your-face way of saying, "I'm just as American as you, buddy."

To sing in a nightclub as a woman on your own takes toughness. I could not have done it without a guide, a guardian, a guru, namely Norm Bobrow. Norm was the manager of Pat Suzuki, and had taken her from Seattle's Colony Club (not part of the rice circuit) to the Broadway stage in *Flower Drum Song* in the late 1950s. Suzuki was a rare case who made a crack in the wall that kept Asians invisible in US culture. Not your normal showbiz manager type, Norm was more like a professor, a hip philosopher. Tall and bone-thin, he always wore a smile under his horn-rimmed glasses and toted his

portable Olivetti typewriter everywhere. He was back in Seattle writing a book. When I told him I wanted to sing, he asked his friend Jack Baird, who had taken over the Colony Club, if we could use it as a workshop.

Bobrow was a Seattle celebrity, with a reputation as a deejay, columnist, and jazz impresario who was helping grow the Seattle jazz scene. He worked his trusty Olivetti pumping out publicity and brought out his fans to see this new singer "Jo Miya" (Jo was a nickname he called me). He put together a seasoned group of musicians: Lee Anderson, who played for singers like Sarah Vaughan, on piano; Gerald Brashear on sax; Tommy Joe Henderson on drums; and Rufus Reed, a dream bass player who went on to make it big in the New York jazz scene. That eight months gave me my singing water wings. Armed with classy silk gowns, false eyelashes, and arrangements by Dini's pal Gerald Wiggins, I was a chanteuse. It was my first chance to show who I really was, without any labels. It's not easy piercing through the drinking, smoke, and chatter to capture an audience and make them follow your song. To sing is to be vulnerable. What could be more personal, more *you*, than the sounds that come from your innermost source, your heart? It's a magical gift you give to the listener.

Training with Dini was the foundation that got me through two shows a night, three on the weekends. If I screwed up, there was always the next show to redeem myself. You need stamina and pacing to sing three forty-five-minute sets. Sometimes I could hardly speak after the second set on a Friday or Saturday, but in the thirty minutes between sets, I knew how to restore my voice, or sometimes go out there, voice tired, and just relax my way through the third set. The most powerful part was choosing the songs that I wanted to sing, from standards to the Beatles to bossa nova, which was big then. By losing myself in a song, I could forget any limitations that came with what I looked like, or what others, especially White people, perceived me to be.

Norm wasn't only about promoting my career; he encouraged me to experience Seattle, get to know people. Seattle is a green city surrounded by the waters of the Puget Sound, Lake Washington, and water from the sky. It rained every day for my first sixty days. On a good day I could see the great Mount Rainier from the window of my room at the Claremont Hotel, six floors above the Colony. That hotel room was part of my pay for this workshop period—that and sixty bucks a week. Believe it or not, you could survive on that in 1967. My brother came up to stay for the summer, earning his room by working in the hotel and at the Colony. He was twenty, and exploring Seattle together was the first time Bob and I got to know each other as adults.

Thanks to Norm's persistent Olivetti-pumping publicity, our group was building a healthy following. I sang and got to know a crazy array of characters. Besides the jazz aficionados, there was a Japanese company man who wobbled home every night, Native Alaskans taking a winter break from fishing, gypsies who said I looked like their sister (hmm), and one of the nightly regulars, the avant-garde composer Alan Hovhaness, who stayed until the last song, then went home to write until sunrise. He wrote a cantata for me called *Adoration of Amaterasu*, which I sang with the Canadian Symphony. That was a big deal, me singing with an orchestra!

But there was also a younger crowd, with longer hair and more colorful clothes, who drank more beer than bourbon. They were students from the University of Washington, a mixture of Japanese Americans, Whites, and a beautiful Black girl with a short Afro and bangles dangling from her pierced ears. Her boyfriend was White, and wore a denim jacket with a peace symbol stenciled on the back. This symbol was cropping up everywhere in Seattle: sprayed on bus benches, brick walls, sidewalks. Now he's a walking peace sign along with a Black girlfriend, a double sign of change. Late-night conversations always danced between race and the war. The guys were concerned about the draft, talking about crossing into Canada if they had to. Muhammad Ali had just been convicted and sentenced to five years in prison for draft evasion. I was worried about my brother being drafted.

And these young people were doing more than talking against the war; they were organizing against it. One night, Mr. Peace Sign invited me to march in a demonstration with them. It took me aback. I admired civil rights marchers on TV as an observer, but I couldn't see myself as a participant. Me—marching, shouting slogans, carrying a sign? It was the first time I had encountered people who saw an injustice and decided they could do something about it. I didn't go to the demonstration, but it got me thinking.

What am I doing singing in a nightclub? There's a war going on. People who look like my family are dying. My brother could be drafted. And I'm singing in a nightclub?

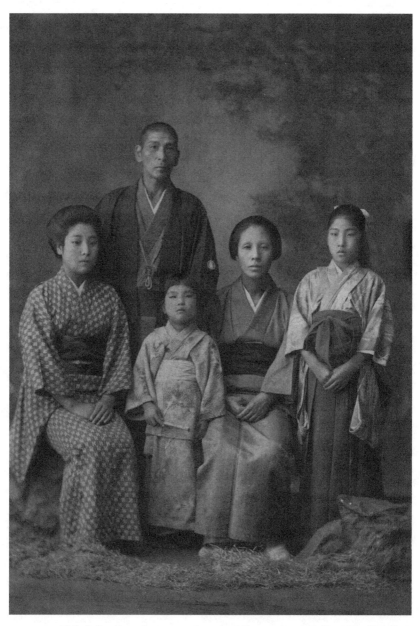

PHOTO 1. Nobuko's maternal great-grandparents in Japan, ca. 1918. Left to right: Nobuko's grandmother Misao, her great-grandfather Sampei Nishimura (standing behind), Nobuko's mother Mitsue, Nobuko's great-grandmother Hatsu, and Nobuko's Auntie Hatsue. Author's collection.

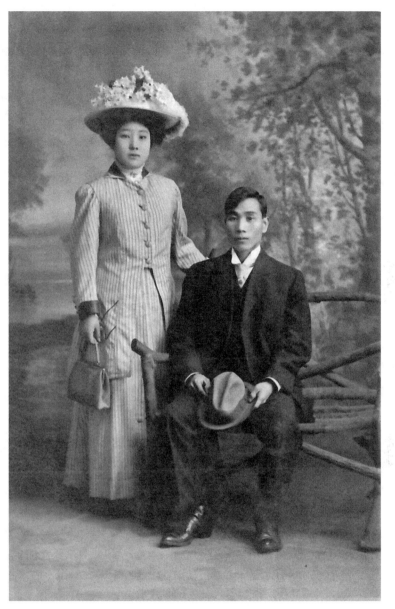

PHOTO 2. Wedding photo of Nobuko's maternal grandparents, Misao and Tamejiro Oga, Seattle, 1912. Author's collection.

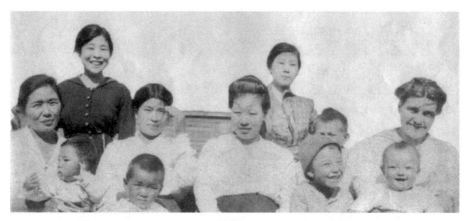

PHOTO 3. Nobuko's paternal grandmother, Lucy, with her sons and Japanese women, Ogden, Utah, ca. 1913. Author's collection.

PHOTO 4. *Deseret Newspaper,* September 24, 1942, featuring JoAnne with her parents, Mark and Mitsue Miyamoto, in Utah, en route to Montana from Santa Anita camp. Author's collection.

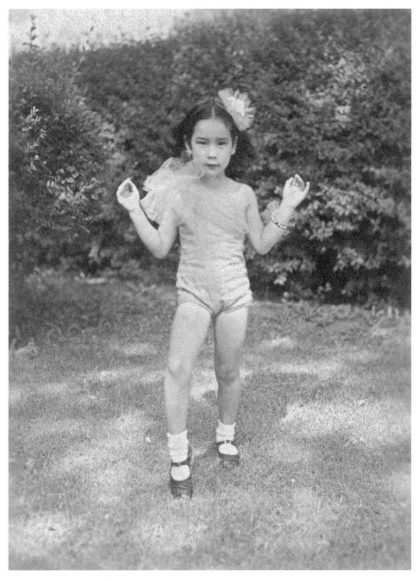

PHOTO 5. JoAnne's (then called JoJo) first dance experience in Ogden, Utah, ca. 1945. Photo by Harry Hayashida, author's collection.

PHOTO 6. The Miyamoto and Hayashida families, Utah, ca. 1945. JoAnne stands in front of her father, Mark. Photo by Harry Hayashida, author's collection.

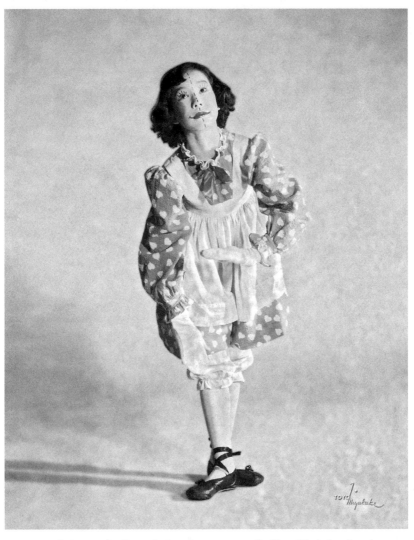

PHOTO 7. JoAnne in her Raggedy Ann dance costume for Nisei Week, Los Angeles, 1950. Photo by Toyo Miyatake, used with permission of Alan Miyatake.

PHOTO 8. JoAnne dancing with Jim Bates as choreographer Eugene Loring looks on, Los Angeles, ca. 1954. Author's collection.

PHOTO 9. Reiko Sato, Jack Cole, and JoAnne dancing in *The Hollywood Palace* variety show, Los Angeles, ca. 1965. Author's collection.

PHOTO 10. JoAnne (front row, fourth from left) on Broadway performing "Chop Suey" in *Flower Drum Song*, New York, 1958. Author's collection.

Second Movement

Power to the People

"STEEK 'EM UP MUTHORFUCKORS, itza Tony Rome!"

Antonello Branca was a revolutionary with a camera. A short, capellini-thin, blue-eyed Sicilian with a bush of black hair and crazy bravery who could talk his way in or out of any situation. At the end of World War II, when the Americans kicked out Mussolini and rolled victorious into war-torn Rome, he was one of those street urchins who chased after their chocolates. Now he chased after stories as a film journalist. His truth-telling often came with consequences. In Italy, after a dam broke, killing thousands, he went there to discover that the authorities had known the dam's weakness and ignored it. He shot, edited, and aired the story before his bosses could stop it, and it got him in big trouble. In the jungle of Angola, he faced down armed soldiers who wanted his boots more than his camera. He told them, "If you take my boots, you might as well kill me." Somehow he escaped with both.

When I returned from Seattle to Los Angeles, I volunteered for the Eugene McCarthy presidential campaign. Yes, I finally worked up the nerve to leave my role as a performer and step into my first act of citizenship. I didn't have the guts to march, but I could call people and ask them to vote. I could lick stamps for McCarthy, the anti-war candidate. He didn't win the Democratic nomination, but I met a new friend, Melonie Finkelstein. She was a student at UCLA who wanted me to meet this radical filmmaker Antonello who shot a Black Panther rally on campus. Like many young folks at that time (including myself), people were questioning everything in life and trying to make hard choices. Melonie's dilemma: go to class (be a reactionary) or not go to class (be a revolutionary); graduate (please her parents and get a job in this capitalistic, racist society) or drop out (be cool and live in a commune). Antonello had just arrived from New York and was making

a documentary about the 1960s Beat and Pop art scene—Andy Warhol, Allen Ginsberg, Roy Lichtenstein, Robert Rauschenberg—called *What's Happening?* for RAI, Italian public television.

In 1968, the world was turning on its head. In April, Martin Luther King Jr. was killed and riots erupted in a hundred cities. In May, French students and workers occupied universities and went on general strike, nearly shutting down the government. In June, Robert Kennedy was shot in Los Angeles, and Antonello was there filming. Every day he was interviewing activists like Kathleen Cleaver, Angela Davis, and Harry Edwards, who in the 1968 Olympics helped Black US athletes create a freeze-frame moment: receiving their medals on the winner's stand with black-leather-gloved fists raised in the Black Power salute.

My first step into a world beyond my own was when Antonello asked me to join him to check out the Black Panthers' political education class. The Panthers' office was on Forty-First and Central Avenue, in South Central. I'd grown up a just few miles west, near Arlington and Jefferson, but to me it was a foreign country. We lived next door to Black families in a nicer ghetto, but in our kitchen my mother and Buddhist auntie, who had survived the cruelties of racism, called them *kuro-chan* (Black people). They greeted them politely on the way to the car and talked about gardens over common fences. But I was told *never* to play with the *kuro-chan* kids. Did the prejudices of my parents' generation arise from Japanese culture's disdain for darker skin, even among their own, because it meant you were a peasant? Or was it US culture that taught us to keep our safe distance? As I grew older, I didn't want to inherit my family's prejudice, but I didn't know how to confront it. But Antonello didn't share my apprehensions. He lived in Rome but didn't do as the Romans do. His life was about tearing down the walls of class, color, and caste. He shunned the state and the status quo. The Panthers were taking a brazen stance against racism and oppression. To Antonello, they were the beautiful people. With Antonello it was easy to say, "I'll go," and wipe away my mother's *never*.

The Panther headquarters was smack in the middle of what was once known as "LA's Black belt," the spine of the African American community, where African Americans lived and built businesses, homes, and churches, constrained as they were by restrictive covenants that kept them out of White areas. During the war, this neighborhood extended from Watts all the way into Little Tokyo as Blacks immigrated from states like Texas and Louisiana to work in the war industry, crowded into spaces left empty by Japanese sent to the camps.

As I stepped out of the Fiat into the night chill, I almost slipped on a tossed beer can. There was no hint of the life that had once danced up and down Central Avenue. Just one block south of the Panther office was the now-dilapidated Dunbar Hotel, once the hub of LA's version of the Harlem Renaissance from the 1930s to the 1950s. Built by a successful African American businessman and named after poet Paul Laurence Dunbar, the once-elegant hotel was a symbol of the progress and dignity they'd been denied, providing a home away from home to touring entertainers like Duke Ellington, Billie Holiday, Lena Horne, Ella Fitzgerald, and Louis Armstrong. Their musical genius filled nightclubs at LA's finest hotels, but they could not sleep in them—and this was LA, not the Deep South. Under the Dunbar's grand lobby chandelier, intelligentsia like Langston Hughes, W. E. B. Du Bois, dignitaries, and elites conversed about the future of Black America. They partied in its famous soul food restaurant. The Dunbar's nightclub was known as the "Cotton Club of the West" and featured top music and dance acts. Beyond its doors, vibrating up and down Central Avenue, Blacks dressed in their coolest fashions and rubbed shoulders with celebrities, Black and White, crowding the jazz scene with its howling saxophones and syncopated rhythms.

By the late 1950s, discrimination laws were changing and Duke Ellington could now stay in Hollywood's Chateau Marmont. The glamour began draining from the Dunbar as integration became the political aim. Black talent left its Central Avenue roots as ambitions migrated to the big screens of Hollywood and the television, radio, and record industries. Central Avenue was being abandoned, its hope-filled songs muffled behind boarded and barred storefronts, swallowed by liquor stores, sandwiched between save-your-soul churches and muzzled into silence by a military-like police force. Just a few miles south, angry embers from the 1965 Watts Riots were still simmering. In 1968, the Panthers stepped in to fill Central Avenue's silence with a dangerous new song.

"All power to the people!" he said politely, without a smile, as normally as saying "good evening." We were greeted by a young Black man in a black leather jacket and black beret. The first floor of the headquarters was an old storefront. A layer of white tried to cover the many layers of paint that hinted at former occupants. Beneath us, a naked cement floor; above, a few rows of dusty fluorescents. The young Panther extended his right hand to Antonello,

who responded with a warm "right on," clasping it in a complicated hand-shake I'd never seen before. On the walls were pictures of their leaders, Bobby Seale and Huey P. Newton. I studied the poster of their Ten-Point Program, their "Ten Commandments," demanding freedom, self-determination, full employment, housing, education, health care, an end to police brutality, the end of wars of aggression, freedom for Black and oppressed people in prisons, and "land, bread, housing, education, clothing, justice, peace and people's community control of modern technology." These demands sounded pretty reasonable to me. There was a poster with that iconic image of Newton on a zebra rug framed by a peacock rattan chair, holding a gun in one hand and a spear in the other. He looked like a king, crowned with his black beret. The Panthers knew how to make a statement.

We were whisked to the back of several neat rows of unmatched chairs, some metal, some wood, with an aisle up the middle. A few people, already seated, were reading a tiny red book the size of a deck of cards. Minutes later, three men strolled in from the night. Before sitting down, they checked out the room, and us. One pulled down the brim of his cap, covering half his face as he slouched in his chair and folded his arms on his chest. It didn't take a mind reader to get their message: "What the f--- are you doing here?" We were in their space, their territory. I tried to be small, be neutral, breathe less air, but there was no way for us to be invisible.

The energy of the room came to attention as a tall leather-clad brother swept into the scene and took the invisible pulpit. His carriage seemed majestic, with a voice to match. "All power to the people."

A chorus responded: "All power to the people."

His chiseled head slowly scanned the room, no one escaping his sight. With Gandhi-like glasses and an articulate mien, he was a believable professor as he continued to deliver his message. "All power to *Black* people."

"Right on," a strong wave rippled back.

"All power to *Brown* people."

Another wave, "That's right, right on."

"All power to *Red* people."

"Yes."

"All power to *Yellow* people. All power to *White* people. All power to the people."

The water in the room calmed. "Right on."

All power to the people? Is it real? Is it possible? It sort of sounds like what democracy should be. Repeating the mantra "all power to the people" was an

interesting way to let it seep into the unconscious, like a chorus of a song that keeps singing in your head. Is this why they are public enemy number one?

"My name is Masai Hewitt, I'm deputy minister of education of the Black Panther Party." More "right ons" sprinkled from the fifteen or twenty people in the room. Hewitt was the perfect mix of street brother and Marxist theorist. He was a former member of the five-thousand-strong Slauson gang who reigned in the area. Bunchy Carter, the former head of the Slausons, started the LA Panther Chapter and was known as mayor of the ghetto. Masai later joined the socialist-Marxist-Leninist organization United Front, and was then recruited by the Panthers. His powerful physical presence captured the respect of the street brothers in the room—and, I imagined, the sisters.

"Tonight we're reading from the Little Red Book, *Quotations from Chairman Mao*. If you don't have a book, we'll give you one. Mao Tse Tung is the great leader of the Chinese revolution. Millions of Chinese people read this same book—for practice, learning, and application."

I thought it interesting that they used an Asian leader as an example for their own revolution. Could Black people from South Central relate to Chairman Mao's Chinese revolution?

"Let's start with chapter 17, 'Serving the People.'"

One person at a time proceeded to read a quotation, then interpret its meaning. Masai would further embellish how it applied to their community and the Panther Party. Words like "cadres," "central committee," "masses," "Marxism," "Leninism," "imperialism," "socialism," and "lumpenproletariat" flew around the room and into my head with nothing to land on. But something beyond words captured me.

Masai pointed to a young man a few rows from the front: "Brother . . ."

The brother rose slowly without taking his eyes off Masai. The Little Red Book looked even smaller as he grasped it in his long, thin fingers. With his head down, after a long pause, he began to read, struggling to make the letters into words: "We . . . should . . . be . . . mo . . . dest . . . and . . . pruuu . . . dent . . ."

Masai inserted: "Careful, considerate, go on brother, I'm listening."

"Guaard . . . against . . . aaa . . . rro . . . gance . . . and . . . rash . . . ness . . ."

Masai's attention guided everyone in the room to hold the brother with their breath, forming words with him in their silence.

"And . . . serve . . . the . . . Chi . . . nese . . . people . . . heart . . . and soul."

The room exhaled. Then Masai, without condescension or judgment, said: "And serve—our community, the Black community—heart and soul. Right on, my brother."

Being a witness to that moment, I got to see the Panthers in a way that most people never would—beyond the posters and propaganda, beyond the newsreels. I saw their caring, their humanity. All power to the people—right on.

Every day with Antonello, my life was expanding. I was crossing borders beyond my little world of movie sets, nightclubs, and theater stages into a living drama. If there was a rally against the war, a community demonstration against police, we were there filming, witnessing, asking questions, coming home, analyzing. I was getting used to stepping into unfamiliar territory and being open to the confusion that rose within me. I was being exposed to people with stories far different from mine. And I was learning about my own oppression, my people's oppression, in the way I learn best: not through books, but through my body, from being present. So when Antonello asked, "Joanna"—he was Italian, that's what he called me—"I want you to help me make a film about the Black Panthers," I didn't need to say yes. I just threw up my hands, let go of everything I knew, and jumped into the water.

Antonello's film, *Seize the Time*, was a dive into the deep waters of revolution with the Black Panthers, but it was also an artistic leap for Antonello. This was his first feature-length film, a docudrama, integrating documentary footage with a dramatic story line. He convinced New York actor Norman Jacobs to travel with us for one year, and to join the Panthers. The film would show how this Black man evolved from a cultural nationalist into a revolutionary nationalist, driven to pick up a gun as a Black Panther. It was the antithesis of Hollywood films: no set script, no big studio money, no soundstages with production team and crew. Antonello raised forty thousand dollars from an Italian investor and talked Fiat into donating two cars. Basically his production team and crew was Raffaele de Luca, his sound man and partner since they were schoolboys, and me, his girlfriend and gofer. I did everything from setting up appointments to commenting on scenes, carrying film, and even assembling costumes. Soon my brother Bob joined us, documenting with his still camera.

My cozy one-bedroom duplex on Curson and Olympic became cozier when Raffaele brought his new wife from Italy, transforming the living room into their bedroom at night. Antonello would liven up our kitchen, shouting, "Steek 'em up muthorfuckors, itza Tony Rome!" while cooking spaghetti carbonara. After dinner, Antonello's always-busy hands would be sketching

in his black Moleskine notebook or readying his Arriflex camera for next day's shoot or writing script notes on his legal pad.

After my brother joined our collective, I bumped into another "never" from my mother. She was nervous about my living with Antonello, even though I was twenty-eight and divorced. It wasn't that he was Italian—I think she would have loved Antonello if I'd had the nerve to bring him home—but rather that living with someone outside of marriage was still a "never" in the 1960s. Antonello believed everything was political, and he was clear about marriage. His love was not going to be controlled by the state or the pope. He loved and cared for his daughter and son, Rebecca and Tomaso, even though he was separated from their mother, whom he never married. For me, marriage was a painful chapter I'd just left behind and children were invisible on my radar. I liked monogamy, but felt secure that our love was the only bond we needed.

"What are you doing? Why all these dangerous things you are filming?" My mother's intuition told her I was pulling against all she and my father struggled for to make a good and secure life. We were not a family that discussed politics around the dinner table. I didn't dare tell her we were hanging with the Panthers. But she could feel I was straying from my career and her dreams for me. My brother's mind was being blown by the idea of revolution, and he dropped out of college. The thought that Julie, my eleven-year-old sister who was swimming toward the Olympics (and would later go to private school to avoid the Blacks at Inglewood High), might become contaminated was too much for her to bear. To show disapproval she used her weapon: "I forbid you from seeing your sister."

That hurt, but there was no going back. I was riding a powerful wave in my life and there was no getting off.

Being part of Antonello's creative process was like playing music with Thelonious Monk, John Coltrane, and the Art Ensemble of Chicago all at once. It was improvisational, spontaneous, guerrilla filmmaking. Antonello was a genius at setting up didactic and humorous situations to illustrate the lead actor's oppression, and seizing opportunities to put him in moments of political importance as they unfolded. I was learning a lot by watching his process. How Antonello convinced the Panthers to be part of *Seize the Time* I will never know. It seemed as bizarre and crazy as a Fellini film, but in this case the actors were real Panthers who already knew how to use the media, like today's activists use their cell phones.

When the Panthers took their shotguns to the California State Assembly in 1967, they were catapulted from a small band of organizers trying to stop

police violence in Oakland's Black ghetto to political rock stars on the world stage. They were Malcolm X's "by any means necessary" incarnate. The civil rights movement unveiled the evils of racism that ruled the South. Now the Panthers were pulling the covers off racism and injustice in cities across the country. They were not all cast from the same mold; they were a mix of African American students, street brothers and sisters, and intellectuals (plus a few paid FBI infiltrators). Like the romanticized figures of Che Guevara and Chairman Mao, their militancy and style were inspiring a generation of young people, students, oppressed workers, and the disenfranchised. They were heroes of the left, building coalitions, speaking at chic fundraisers in Hollywood hill-top houses and New York's Park Avenue, traveling to Sweden, Korea, and China, creating alliances with other revolutionary organizations. They were scrambling to fulfill the role in which history had cast them at this moment. They were doing it with bravado, creativity, savvy, and a style that reflected Black culture. And the world seemed to be moving in the same direction.

Antonello gained the Panthers' trust. Perhaps our film would give wings to their slogan, "Seize the Time," build public support by showing their programs and revolutionary philosophy, and give more star power to their leadership. So, despite the fact they were under daily siege by the FBI's Counterintelligence Program, COINTELPRO, which was infiltrating, arresting, and even assassinating, doing everything possible to criminalize, disrupt, discredit, divide, and destroy the Panthers, they consented to be part of *Seize the Time*. Antonello could not have picked a more difficult situation to build a film around. The pressures of filmmaking are always stressful, but this was like shooting a block of melting ice during global warming. Our subjects were being harassed, arrested, jailed, and disappeared—not in the film, but in real life, in real time. All scenes had to be devised and planned with the Panthers strategically considering not only content and party line, but security and safety.

One of our first shoots was of a recording session with Elaine Brown singing songs of struggle that she had written. It was also my first introduction to Horace Tapscott, jazz composer-arranger and founder of the revolutionary Pan Afrikan Peoples Arkestra. Their music was the very sound of Black revolution with all its improvisational genius. I would later study with Tapscott. Elaine's fingers commanded the piano with the ease of someone who'd been playing since childhood. She was beautiful, like a young Lena Horne, with sharp features and an Afro framing her face. Though still a rank-and-file Panther, her intelligence and bravado would soon propel her into a leadership

position. In 1969 the Panthers adopted a "womanist" ideology, contrasting with their earlier belief that women were subordinate to men and the struggle. They stated that women and men were equals and that sexism was counterrevolutionary. But unlike feminism, womanism put race before the gender issue. Elaine was their perfect example of womanism. She wasn't a soul singer like Aretha Franklin. Her style was more Edith Piaf meets Nina Simone. Her music was simple and bold, and she performed with strength and musicality. One of the songs we filmed was "We'll Have to Get Guns and Be Men."

I was stunned. I'd heard the anger of Black women in Nina Simone's "Four Women" and the pain of the victim in Mahalia Jackson's "I Been 'Buked and I Been Scorned." But Elaine's song offered a daring and dangerous solution. Even if I didn't agree, it amazed me that in nine lines she captured the whole Black Panther story, pulling no punches. I wanted to talk to her, but she seemed unapproachable. She was friendly with Antonello, but I was part of the scenery.

The next scene we shot was the Panthers' Free Breakfast for School Children Program. This serve-the-people program was multiplying throughout their chapters around the country and gaining them support in the Black community and beyond. We arrived at seven in the morning, and children were streaming into the brightly lit hall filled with tables and chairs. Some came holding hands with their parents; others rushed in with older brothers or sisters.

"Good morning children. All power to the people!"

"All power to the people!" The children knew this refrain.

"Right on."

The kitchen was bustling with Panthers, parents, and volunteers, men and women alike, stirring up eggs donated by local grocers, flipping pancakes, serving milk and an orange on every tray. Leather jackets were replaced by aprons and rolled-up sleeves. This was "serving the people" in action. But they weren't only serving food. You could feel the love.

"Brother," a woman called out, "we need more pancakes out here. These children want seconds!"

"Hold on, sister, coming up!" They were all there for one reason: these children, who would one day follow in their footsteps.

A tall, Afro'd, light tan woman, so thin she looked like she needed a breakfast herself, laughed as she approached us. "Honey, these chillin are honnnnngry! We don't want them going to school with empty stomachs like we did. No siree. All power to the people! My name is Peaches, Peaches

Moore. I'm director of the Breakfast for Children program. The office told me you were coming. You must be . . ."

"Antonello Branca. My sound man, Raffaele. And this is Joanna."

"Welcome," she directed a smile at me, "Welcome sister."

She called me sister. It was more than a word, it was a feeling. Did she think I was Black? We were almost the same color. She called me sister.

Antonello was scanning the room. She told him to feel free to circulate. Immediately he pulled out his light meter and he and Raffaele scouted for the best light to shoot. This was 16mm film, not video. I was feeling a bit useless, which makes me uncomfortable, so I asked Peaches: "Can I help?"

"Sure can, sister." ("Sister" again). "Go wash your hands and meet me at the serving line."

Hands washed and sleeves rolled up, I approached Peaches. She took me behind the servers and said: "This is Sister Joanna. She's part of the Italian crew filming today. They're gonna show the world another side of the Panthers. They'll see we do more than tote guns and talk revolution. Yes, sir. They're gonna show the world our Free Breakfast for School Children Program! And Sister Joanna here wants to help."

A brother turned around and handed me a serving spoon. "Morning, sister, you know what to do." Everyone was friendly. I didn't feel odd or different. Serving these beautiful, energetic children was fun and I liked being useful. I was touched that they called me "sister" and welcomed me into their house. Maybe they called every female a sister, or maybe they knew my people had suffered, too.

It was the first time I felt recognized as a person of color, the first time I felt I fit in somewhere. It was just serving children breakfast, but it was doing something needed, relevant, useful. And it gave new meaning to my idea of crossing the color line. I was crossing beyond the borders of my world, seeing the lives and struggles of people who lived not far from me, but had a totally different reality. I was witnessing Black men and women who were *serving the people*, not for money, not for glory or fame. In fact, it was dangerous work. They were taking responsibility for solving problems in their community. They had come to understand that the root of their problems was the capitalist system, with a powerful few at the top, exploiting the labor and resources of people of color and poor Whites at the bottom. Organizing to give power to the people—not just their people, but all oppressed people—was their solution. For these sisters and brothers, serving breakfast for children was putting theory into practice. They had found their power and a sense of purpose in

their lives. Che Guevara said that true revolutionaries are guided by love. And that was what I was feeling at that moment—love.

On September 9, 1969, the police raided the Los Angeles Panthers' Free Breakfast for Children Program while the kids were being served. They threw food, milk, and dishes on the floor, terrorizing the children. They said they were looking for someone, but no one was arrested. Now I saw why the Panthers called the police "pigs." On May 15, 1969, FBI director J. Edgar Hoover had written an internal memo describing the breakfast program as the best and most influential activity going for the Panthers. He saw it as the greatest threat to efforts by the FBI to neutralize the Panthers and destroy them.

The Panthers were paying a high price for their bold stand against a system that has kept Black people as an underclass, with unequal opportunity, and particularly terrorizing younger Black men in one way or another since slavery. As I write this, I think of Michael Brown in Ferguson, Missouri; Oscar Grant killed by police in Oakland; Trayvon Martin murdered by George Zimmerman in Sanford, Florida; Eric Garner choked to death by police officers on Staten Island in New York; twelve-year-old Tamir Rice shot and killed by police officers in Cleveland. Laws have changed, but conditions for Black and poor people have not. The fact is, more African American men are incarcerated today than were slaves in the 1850s.

Because the Panthers were standing up to the system, they were living under terrorism by the government. One day at a rally in Leimert Park I met Geronimo Pratt, part of the Los Angeles Panther leadership. A short time later, he was arrested and would spend twenty-seven years in prison, eight in solitary confinement. It was the first time I learned the meaning of a political prisoner. My dive into unknown waters put me in a position to witness firsthand what it meant to be Black and in the struggle for change in America. It was also showing me the power of culture and media in the process of change.

One evening I came home and Antonello was having a meeting with the Panthers in our dining room / production office. Masai Hewitt and a few other Panthers were sitting around the table, their black leather jackets hanging on the chairs behind them. The duplex was one of those well-constructed 1930s houses with built-in nooks. As I approached the dining room, my right eye caught something black and shiny against the white of the bookcase. My

body and heart stopped at the same time. It was a gun. I'd never seen a real gun before, but I knew it wasn't a toy or a prop. I didn't know it was a nine millimeter; it was just a big gun. Without touching it, I could feel its weight, its power. What was a gun doing in my house?! I couldn't breathe. I dashed through the smoke-filled meeting, hardly noticed. In the dimly lit bedroom I sat on our bed, a simple mattress on a box spring. It was temporary, like all things in my life in those days. My heart raced and my hands trembled. As I held my head I saw books scattered at my feet, books I was reading that were blowing my mind: *Soul on Ice* by Eldridge Cleaver, *The Wretched of the Earth* by Frantz Fanon, *The Autobiography of Malcolm X*. But nothing hit me as hard as seeing that gun in my house.

Under my right foot was the Panthers' newspaper, which propagated their philosophy and worldview. Panthers standing on city street corners sold 250,000 copies weekly for twenty five cents each. Each issue had a powerful front-page poster designed by Emory Douglas, minister of culture. His bold, artful graphics depicted the story of Black people grappling with issues like sickle cell anemia, rat-infested housing, lack of jobs. He portrayed ordinary Black men, women, and even children as heroes, defending themselves from the police with guns. He graphically depicted US imperialism as a slovenly pig with smaller piglets—Israel, West Germany, France, Portugal, South Africa—sucking on its teats. His posters connected Afro American revolutionaries with revolutionaries fighting in South Africa, China, Korea, Angola, and Vietnam, always with guns. I moved my foot from the paper and saw a mother, arms wrapped around a child in self-defense, holding a gun. Douglas was an artist, communicating with their community in a way that transcended language.

I could relate to and empathize with the issues that the Black community was going through, but I didn't quite see myself in any of those stories Douglas portrayed. At this point I was a friend, a supporter, an ally to their struggles; but I'm not Black. I'm Japanese American, with my own set of injustices and culture. I didn't know until years later that Black families in the South often had to have guns in their homes to protect themselves. Now there was a gun in my house.

In July 1969, the Panthers were invited to send a delegation to Algeria to participate in the Pan-African Cultural Festival. They were given a storefront to house an exhibit. When Emory taped the first poster in the empty window, the one with Huey Newton holding a rifle in one hand and an African spear in the other, it drew crowds of young Algerians. Inside, Emory's posters

powerfully brought to life the story of the Black liberation struggle in the United States. Algeria's president, Houari Boumédiène, noted in his welcoming remarks that "culture is a weapon in our struggle for liberation."

The Panthers were riding high in Algeria, but at home they were David fighting Goliath. A few months later, Eldridge Cleaver was in exile in Algeria. The US government's interference through COINTELPRO had fueled distrust and caused a split between the West Coast Newton faction and the East Coast Cleaver faction. The chaos among the Panthers put our film into chaos. Antonello was struggling with the legitimacy of making a film in this desperate situation. Do we support the West Coast or the East Coast? Will the Panthers even allow us to use their footage now? How could we finish the film? How could we show unity and the possibility of a successful revolution given this split? How could this film still be a weapon to help the struggle? We didn't know, but there was no turning back. Perhaps our journey with the Panthers was not just about making a good film. Maybe it was more about what we were learning, what we were a part of, which would change us in ways there are no words for.

TWELVE

A Single Stone, Many Ripples

I WAS IN NEW YORK AGAIN, this time working with Antonello on *Seize the Time*. Ten years earlier, my eyes had been focused on Broadway, that small strip between 42nd and 57th Streets they call the Great White Way, working on my beautiful career. But now I was seeing a different New York. East Harlem was home to Puerto Ricans. These streets grew the music of Tito Puente, Willie Bobo, Eddie Palmieri, Machito, Joe Bataan, Cheo Feliciano, and countless others. Their music had absorbed African slave rhythms, the music of Taino *indios*, and the sounds of New York's rackety subways, taxi horns, and *bochinche* (street talk). It exploded through barrio walls. It belonged to anyone who loved to mambo. It even made it to Broadway. The music and stories of these mean streets had inspired Jerome Robbins and Leonard Bernstein in creating *West Side Story*.

Antonello was filming the Young Lords, who were occupying the First Spanish United Methodist Church on 111th Street. After the church's repeated rejections of their requests to run a Free Breakfast for Children Program out of it, the Young Lords simply occupied it and christened it the People's Church, a name that still sticks today.

The Young Lords Party was fashioned after the Black Panther Party but had its own heartbeat that penetrated like the sound of the Latin clave and moved bullet-fast like Puerto Rican Spanish. Members of the Young Lords rose out of New York poverty, joblessness, gangs, racism, familial pride, and national pride in their homeland, and in 1969 they stood up to do something about it. They started with the "Garbage Offensive" in the summer of 1969,

My song "A Single Stone," dedicated to Yuri Kochiyama and Mutulu Shakur, is on my album *Nobuko: To All Relations* (Bindu Records, 1997).

cleaning up their streets and gaining community respect. Now they were holed up in this only-on-Sundays church, transforming it into a stew of 'round-the-clock activity. It was only a week into the eleven-day takeover and already they had set up the breakfast program, a day care center, health services, and a liberation school. You had the feeling the world would be a better place if the Young Lords took over.

Outside, the New York night was frigid, but when we stepped inside that old brick church we were in the heat of revolutionary fervor. Hundreds of community folk—Puerto Rican and Blacks and Black Puerto Ricans, children and elders—were there to participate in occupying the church. A cacophony of Spanish and New Yorkese surrounded me. Posters and banners shouted "Blacks and Latinos Unite!" and "Free Breakfast Program," and, of course, there was the Puerto Rican flag, draped over the beige walls of the conservative church. The Young Lords were staffing tables, passing out leaflets and petitions, serving food, and wearing the uniform of the day: Panther-like black leather jackets, with their straight or kinky hair topped with berets pinned with a Young Lord button showing a fist holding a rifle and the slogan "Mi tengo Puerto Rico en mi corazon" (I have Puerto Rico in my soul). They had a cool, romantic aura about them, sort of like urban Che Guevaras. The Lords had awakened a sleeping giant in their people, and they were claiming their power. But how long would they be able to hold on? Would their demands be met? With police hovering outside, no one knew. Spirits were high and somehow it didn't matter.

I was used to feeling lost. Lostness was my perennial state—lost in my not-belongingness, lost in being the only, the other. But this time I was lost in suspended time, lost in a moment of possibilities, lost in my plate of *arroz con pollo*, listening to Felipe Luciano, a Last Poet who seemed like the first poet I ever really heard.

A tap on my shoulder pulled me from the dance of words. I turned to see a petite middle-aged woman who looked Japanese. What was she doing here? A pair of winged 1950s glasses straddled her nose, a bandanna wrapped her hair, and a yellow number-two pencil perched on her ear. She could have been one of my LA nisei aunties, but there was something different about her. She wasn't as well fed, and her clothing proclaimed function, not fashion. She had leaflets tucked under her arm and a small notebook in her hand. Was she a reporter? Her face was open with surprise. Maybe she's wondering what I'm doing here too; we are the only yellow dots swimming in this roiling sea of color.

Passing by, a beautiful Puerto Rican woman with a bountiful Afro shouted, "Sister Mary! Good to see you here."

"Esperanza! This is great, isn't it! So many people." Hmmm, this Sister Mary person seemed totally at home here.

Her attention returned and she started directing questions at me like she'd found a rare specimen and was trying to pinpoint it. "What's your name? Are you sansei? Where are you from? What camp were your folks in?" For Japanese Americans, these are shortcut codes that tell a lot about us. Family name: maybe we're long-lost cousins? She guessed I was sansei, third generation. There weren't many yonsei, fourth generations, around in those days. If you were nisei and from the West Coast, your issei parents came from Japan, and probably had something to do with farming or railroads. You were in *camp* as a teen, trying to prove you were American. If you were an older sansei like me, your folks were born here, and you could well have been a baby in *camp* and definitely don't speak Japanese, also thanks to trying to prove you're American. Younger sansei might have been born after *camp*. What *camp*? *Camp* is a thread that strings us together, a marker in our DNA. Though our families spoke little about those dark days, some remembered their block and barrack number in the giant maze that barb-wired their lives. Having been in Manzanar, say, or Gila River was like being from the same village, with distinct geographies and experiences. Tule Lake? Ah, someone in your family was a community leader or considered dangerous, a trouble-maker. *Camp* was more familiar than our Japan roots, which most of us had never seen. So Mary's shortcut questions spoke volumes. *JoAnne Miyamoto— sansei—Los Angeles—Santa Anita Park racetrack . . . Montana . . . Utah— Los Angeles.* Hers was: *Mary Nakahara Kochiyama—nisei—San Pedro— Jerome, Arkansas—Harlem.*

I'd never met anyone who'd been in Jerome. While incarcerated there, she volunteered in the USO Canteen, where she met her husband, Bill Kochiyama, one of the thirty-three thousand nisei guys who enlisted in the army to prove their allegiance to the United States. Bill was part of the 442nd battalion, which had earned more Purple Hearts and casualties than any other in the US Army. After the war, Bill and Mary came to New York, where he'd been born. While many nisei struggled to escape the Black and Mexican ghettos to which they were confined postwar, Bill and Mary chose to live in the Harlem projects. They raised their six children there, became active in the community, and even sent their kids to "Freedom Schools." (What was that like?) Bill worked for an ad agency downtown, while Mary

waited tables at Thomforde's coffee shop on 125th Street (ah, that explains the bandanna and pencil), a meeting place for Black activists and a convenient way for her to be involved in their conversations and concerns.

Somehow Mary and Bill made the leap from the injustices of Japanese American concentration camps and landed in the middle of the civil rights and Black Power Movements. Mary became a friend and follower of Malcolm X. Like many Blacks who traded their slave name for a name that reflected their African roots, she traded Mary for her Japanese name, Yuri. Yuri was in the audience the day Malcolm got shot at the Audubon Ballroom in Harlem. She ran onstage and protected him with her body. Yuri was no ordinary Japanese woman. Yuri was no ordinary human being.

"Do you know any Asian groups in New York?" she asked.

"Not really. I used to know people when I worked here in *Flower Drum Song*"—I was embarrassed mentioning my former life in this context—"but that was a long time ago."

"Wow, you were in *Flower Drum Song*? Did you ever do *The King and I*? My kids were in that show!" She laughed. "Probably every Asian child in New York worked in *The King and I*."

I couldn't imagine her as a "backstage mom," but as I came to know Yuri, soon nothing would surprise me. "I'm just here temporarily from LA, helping to make this film about the Black Panthers."

"Gee whiz, you have to come to our meeting of Asian Americans for Action! They'll want to hear about this." She pulled out a leaflet. "We're planning this demo for Asians to unite against the war." Then she whipped her pencil from its perch and wrote the address and time of the meeting on the back of the leaflet. Her handwriting was remarkable. Japanese Americans are known for their cool styles of writing. Hers was bold, decisive. She also wrote her phone number, "WA 6–7412." To this day I remember it, as does every Black political prisoner she visited and talked to on the phone. I think it should be retired, like the number on Jackie Robinson's baseball uniform. "And you have to come to my house for dinner!" I didn't know that that was the invitation my life had been waiting for.

The years 1968 and 1969 were a period of transition, and not only for me. The whole world was going through a shake-up. You were either clinging to the old familiar or pushing toward the new unknown. The way the Panthers put it, you were either part of the problem or part of the solution. I wanted to be

part of the solution, but I was unsure how. I was crossing a bridge from one world into another. There was no safety net, no map. It was an abrupt departure from everything I'd known and desired. A few months earlier, I couldn't imagine walking away from my career, which now seemed meaningless. On this fragile footbridge my well-trained feet were unsure, but Antonello was there, holding my hand.

In a song, a bridge is a moment after a few verses when the chords depart from the song's flow. It's usually an emotional, thought-filled moment when questions are asked and the soul's longing is expressed. Where was this bridge taking me? Would I someday go to Italy, and live and work there with Antonello? What would I do there? Who would I be in that beautiful ancient city? He had returned to Rome to work on another project to raise money and begin editing the film. I was in New York alone, waiting, beginning to hear my own changes.

I started making music with Tony Caroleo, a gentle soul from Brooklyn who sang and played a mean twelve-string guitar. We were starting to write songs together. Tony encouraged me to write, but I'd never written a song, never expressed my own ideas. I wasn't sure what my own ideas *were* yet, but songs came. We gathered a multicolored group of excellent musicians. We were a rock and jazz fusion ensemble named Sequoia, after that giant tree that lasts forever. A record contract with A&M was in the works. But my heart was fresh with the zeal and arrogance of a revolutionary convert. I kept pushing the band to do a benefit for the Panthers. I pushed so hard that our Sequoia fell on the New York concrete, sending us wounded and scuffling in all directions. At that moment, for me, politics were more important than art.

When I looked back, the bridge was burning behind me, but I was standing on my own ground. Once you see people who are living for their beliefs, not their careers; once you understand that your actions, no matter how small, can help stop a war, or nourish children, or expose police brutality; once you see communities coming alive to stand up for their rights, it's like catching a fever that tells you that you are alive. What you do matters, it makes a difference, it can change the world. There was no turning back. Were my conviction and courage as deep as those of the Panthers or the Young Lords? Yuri was the first Japanese American I'd met on this path. Were there others like her?

Yuri and Bill Kochiyama's Harlem apartment, in the projects at 545 West 126th Street, was a mecca for the movement. Like all pilgrimages, getting there was part of the ritual.

I was living alone in a postage-stamp-size basement apartment at 52 West 91st Street, half a block from Central Park. It had a Murphy bed like the one my parents once slept in, with a Pullman kitchen and a bathroom you couldn't turn around in. Rents were still reasonable. I paid seventy-nine dollars a month.

To get to Yuri's apartment I took the uptown Broadway bus instead of the subway, which I hadn't learned yet. The bus brimmed with students jumping off at the Columbia and Barnard campuses, tired Black and Puerto Rican workers sleeping while riding, mothers clutching their children, hoisting groceries and scrambling for seats, and a boisterous band of Black teens whose energy filled every cranny of the crowded bus. New Yorkers developed a way of tolerating all manner of disturbances around them while holding tight to their center. I wasn't a New Yorker yet.

It was only a thirty-block ride, but when the bus spilled me and most of its passengers onto 125th Street, I stepped into a different world. The train above rattled, and the seven o'clock sky felt heavier, the liquor stores more prevalent, and the street grimier than in my neighborhood. I pulled up the collar of my navy pea coat, hung the strap of my bag across my chest to shield me from the January wind, and walked that last block through Harlem to the Kochiyamas' door. Cell phones didn't exist then, and forget trying to find a working public phone to call and say, "Hey, please come get me!" The only thing I could do was take a deep breath, swallow my fears, swallow those scary Harlem stories, swallow my mother's "you better be careful" words, swallow my woman-alone (and an Asian on top of it) instincts. With my long black mane flowing from my black beret, there was no way to blend in here. My brown boot stepped into an oily puddle—my first solo step across 125th Street—and I tried my best to put on my "don't mess with me, got somewhere to go" vibe.

The walkway up to 545 had benches piled with teens, some smoking, others blowing steam into the winter night with their laughter. They scanned me but paid me no mind. The elevator held a mother with a small child, her pink knitted scarf circling up to two perfect pool eyes set in brown satin skin. As I stepped in, three lanky teens squeezed through the closing door. They greeted the woman and child and gave me a polite nod and a "hey." No boogeyman, nothing to clutch a purse about. They probably knew the Kochiyamas, maybe went to school with their kids. Asians were not such a rare breed at 545 West 126th.

Apartment 3C was not like any home I'd ever been to. It was no quiet retreat from busy New York life. It was a meeting house, a guest house, a

drop-in center, a family hostel where you might find Black and Puerto Rican comrades, acquaintances, and strangers from anywhere in the world passing through, to eat and rest their heads for a night or two, or sometimes weeks. It was beyond comprehension how the Kochiyamas and their six children plus guests managed to live in that compact four-bedroom, one-bathroom apartment. Before long, 3C became my second home. (Later, after I moved back to LA and visited her in New York, I was among those who slept on the utilitarian postmodern couch and on every one of her children's beds.) When you entered, the living room on the right had an ironing board that doubled as a reception table. There sat a phone and a nine-by-twelve notebook that kept a log of every visitor, every phone call, with names and meticulous notes of every conversation in her cool handwriting.[1]

To me, apartment 3C was a movement sanctuary, a place you went to touch truth. I loved sitting in its altar of a kitchen, table layered with leaflets for upcoming rallies and walls postered with images of political prisoners— FREE THE PANTHER 21!, FREE RUCHEL MCGEE, STOP THE WAR IN VIETNAM, CHIMURENGA, ATTICA. 3C was a place of possibilities and responsibilities. You had to pay attention to all the injustices in this world. But we weren't going to change them alone. 3C was a crossroads between folks in the Asian, Black, and Puerto Rican movements, and we had a lot to learn from one another. Yuri set a high bar to be an activist (see photo 13). When she, as a Japanese American mother of six, walked into that East Harlem Church to support free breakfasts for Puerto Rican children, she was saying we all could do it. We all could do something to make a better world.

THIRTEEN

Something About Me Today

THE ASIAN AMERICANS FOR ACTION meeting that Yuri Kochiyama invited me to was held in a dingy office in the fashion district in New York's Lower West Side, a place bustling with workers by day but desolate by six each evening. I was glad to be with my brother Bob, who had just joined me from Los Angeles. Our experience with the Panthers made us curious about this "Asian" organization. The label "Asian American" was new. "Oriental" was what the world called us when they lumped us together. And Japanese Americans were better known for being quiet than for action. Was this group going to be the yellow version of the Panthers?

We stepped into an ancient elevator, a jail-like metal cage, that creaked and bumped us upward, like the fits and starts of our lives taking us to an unknown destination. After our release from its shackles, we walked into the small office and soon knew we had landed in the right place at the right time.

We were strangers, but we were greeted like a long-lost brother and sister. That's what we were. We had been lost from our tribe, severed from ties of family and homeland, wandering and wondering why we could not feel rooted and accepted, why we were still foreigners in the place of our birth. Now we were found, not just because they mirrored what we looked like, but because we were all seeking answers, seeking solutions, seeking justice. We were like severed neurons suddenly awakened, excited in a moment of re-cognition, leaping to re-connect.

An excited Yuri introduced us: "This is the sister I was telling you about! JoAnne Miyamoto."

"Something About Me Today" is on the album *A Grain of Sand: Music for the Struggle by Asians in America* (Paredon, 1973; rereleased by Smithsonian Folkways, 1997).

"And this is my brother Bob. We're both from LA."

They called us and each other brothers and sisters, like the Panthers, like Black people do. At first it was a bit weird, but we adopted the practice, perhaps to identify with the Black movement but also to shock our Asian American "brothers and sisters," even those we didn't know, into seeing ourselves as connected, as family.

Something else about Asian Americans for Action (Triple A) blew me away. The chairs were filled not only with young Asians, but also with elders like our parents. They were actively participating and even leading political discussions. Some were family members, like Yuri and Bill Kochiyama and their kids Eddie and Aichi, Kazu and Tak Iijima and their son Chris, or Minnie Matsuda and her son Karl. I could not imagine sitting in a political meeting with my parents. All nisei suffered from racial hostility and relocation. My parents were alarmed by our sudden turn toward political activism, afraid of us rocking their fragile boat, while the Iijimas and Kochiyamas had found a way of confronting their oppression through activism and engaging with their kids in the process.

Kazu Iijima and her friend Minnie Matsuda started Triple A in 1969. These nisei women had a résumé of activism that even included joining the Communist Party. Kazu was born into a family of rebels. Her father was a Japanese nationalist and writer who struggled to publish his own newspaper in Oakland. He imprinted on his three daughters: "If you believe in something, you have to be ready to go to prison for it." Her mother was also no shrinking violet. She left an arranged marriage with a rich guy, traveled around the world, and wrote a book about it. This was not your typical Japanese family. Kazu was a handsome, round-faced nisei woman with a low, raspy voice and a mole just above her nicely shaped lips. Smoke spiraled from the cigarette in her fingers as she showed us a gold pamphlet that Triple A had just authored about the US-Japan Treaty, titled "Ampo Funsai" (Smash US Imperialism). This educational pamphlet showed me another aspect of people in Japan. Farmers, students, militants, and workers were protesting the building of Narita Airport, which would take land away from hundreds of farmers. The Sanrizuka movement was my first exposure to activism in Japan, where the people physically clashed with police, who, unlike US police, did not have guns, only shields and batons. I remember supporting the campaign by buying one inch of land for a donation. They gave us an actual deed for that land. Damn, I wish I still had that deed!

Next on Triple A's agenda was planning a demonstration of Asian Americans against the Vietnam War. Chris Iijima was one of the vocal leaders

of the New York demonstration as well as the DC mobilization. I remember all of us busing to Washington and meeting a huge contingent of Asians from colleges and communities from the East Coast. It was the first time I marched with hundreds of my own beautiful brothers and sisters all around me, black hair flowing, holding signs proclaiming "I Am a Gook" and shouting, "What do we want? Peace! When do we want it? Now!" It was a gray, frigid day, but I felt warm and powerful to be seen and heard, shouting my beliefs into the ether for the universe, if not President Nixon, to hear. I was moving with my people, marching through DC's Black ghetto toward the Washington Mall, in this sea of humanity, hundreds of thousands of people of all colors and kinds. I felt proud and free. For the first time I felt part of something greater than myself.

It didn't take long for me and Bob to get in the groove. New people were flowing in all the time. I was politically green next to the Triple A folks. I'd put nearly twenty years into my training and career in showbiz. The Panther film was my conversion, my first awakening, to the bigger reality. I was coming from a totally different path than most others. But I was able to drop all my baggage, pick up some leaflets, and dive into the work as a community organizer. I was living an experience I missed even as a child. I didn't have to be "twice as good" to prove I was equal. I didn't have to strive to "make it." For the first time, I wasn't an outsider, a minority, the Other. For the first time I felt accepted just for being me, enjoying being with my brothers and sisters.

I admired Chris Iijima, who was super smart with a political family pedigree. A recent graduate of Columbia University, he was part of SDS, or Students for a Democratic Society, a radical and mostly White organization. Besides Triple A, he was a member of I Wor Kuen, a political group fashioned after China's Red Guard and the Panthers, transplanted to New York's Chinatown. That's a lot of politics for a twenty-year-old. With young Japanese Americans few and far between in New York, I think Chris found his comfort zone with this group of Asian peers. Though he was politically astute and sometimes a little dogmatic, he mostly showed his light side. He was funny and darned sentimental when it came to hanging with his homies. My brothers and sisters didn't just do politics; we loved to party and eat together, especially after meetings. In Chinatown you could get a rice plate with chicken or beef and bok choy for a dollar and twenty-five cents, and a lot of rapping about culture took place over the tables in that steamy café—stuff like being

an FOB (fresh off the boat) or ABC (American-born Chinese—and unable to read the menu). *Juk kok* (full head) meant foreign born and able to speak Chinese, therefore smart, and *juk sing* (empty head) meant unable to speak Chinese. That was me, *juk sing*. Hawaiians also had another name for us sansei who didn't speak our tongue: *katonks* (empty like bamboo).

I got my first taste of the political divisions that would one day slice up our movement when Warren Furutani and Victor Shibata came from Los Angeles to attend a Triple A meeting. Who were these guys? Why did they work for the JACL (Japanese American Citizens League), this middle-of-the-road organization that collaborated with the US government when they threw us into the camps? What did they want with Triple A? The temperature dropped when they entered the office. It was like a war party, a meeting between tribal groups from two competing territories. We expected suits, but they looked like us. A brother large in body and presence, wearing an army jacket, stepped firmly forward, slicing his open hand through the ice toward Chris with a "Hello, bro, I'm Warren Furutani," forcing a power handshake. His second, Victor, in another effort to warm the room, broke a smile through his mustached lips. His tilted beret made me think of a dashing, macho, Asian Che as he reached for my brother in another power handshake.

The temperature warmed little as they endured twenty of us leaning forward, questioning their motives for working for the JACL, whom we considered lackeys for liaising with the US government during the war. Chris's response was uttered in his lawyer-to-be political speak, while Warren's response was equally articulate, but with a style cooler, more Black, and more street than any Japanese American I'd ever heard. Warren explained they were sansei activists doing "serve the people" programs in the LA community, trying to influence change in the culture of the JACL, the largest organization of its kind, which represented thousands of JAs nationally and had a weekly newspaper, the *Pacific Citizen*. Working for the JACL was a strategy to access the greater community and build support for their programs. With suspicions still hovering, Warren pressed on with an invitation for Triple A to come to Chicago for a JACL convention. He wanted us to join activists from the West Coast coming to pressure the JACL to take a stand against the Vietnam War. The invitation hung frozen in the air.

After Warren and Victor left the meeting, Kazu Iijima exploded, transforming from the revolutionary she was into a normal Japanese mother. She was appalled by our rude behavior toward our guests. "How could you treat them like that!" Then she ordered Chris to take Warren and Victor on a tour

of New York the next day. I wasn't on the streets with them or at the dinner she cooked up at the Iijimas' apartment, but she added the magical ingredient that melted humanity into the relationship. Her wisdom brought the East and West Coasts together, cementing friendships that would last a lifetime. By the summer of 1970, we were on our way to Chicago.

FOURTEEN

————

The People's Beat

CHICAGO IS A STONE-COLD CITY known for the Mob, Mayor Richard M. Daley, and its bone-chilling wind, the "Hawk." In 1968, Chicago grabbed the eyes of the world when fifteen thousand Vietnam anti-war protesters vowed to shut down the National Democratic Convention and iron-fisted Mayor Daley unleashed the largest, bloodiest police riot ever seen on television. In December 1969, Fred Hampton, leader of the Black Panthers, was assassinated by Chicago police. This was the Chicago our New York Asian American caravan rolled into that summer of 1970.

We'd come to push the Japanese American Citizens League (JACL) to take a position against the Vietnam War, but Chicago delivered a series of unexpected revelations that began when we landed at the church where we were staying. Warren Furutani, Victor Shibata, and the West Coast contingent were there to greet us with open arms and more power handshakes. They came from all over California: Los Angeles, San Francisco, Sacramento, Stockton, San Jose, Fresno. It was the first meeting between Japanese American activists from East and West, but it felt more like a family reunion, only on steroids. In the social hall, conversations were buzzing over tables with a spread of Japanese picnic foods—*onigiri* made with loving hands, teriyaki chicken, and of course potato salad. That plus trading stories of the work we were doing created instant love. In fact, I've never felt that kind of love before. It was bigger than personal love. It was love of our people, love of who we were, love of who we were becoming.

Though faces and last names were familiar, West Coast style was different from East Coast. Their rhythm seemed slower, skin more tanned, hair flowing longer. Some wore *zori* (sandals), heads tied with *hachimaki* (headbands). Japanese words like *gomen* (short for *gomenasai*, "excuse me") and *benjo*

(bathroom) slipped through their conversations along with "bro" and "sis." I was blown away by an LA-based Asian American newspaper they passed around called *Gidra*, which wrapped political and cultural articles, poetry, drawings, comics, and crazy graphics into one cool package. Who are these crazy, creative, political brothers and sisters?

I hadn't been living in New York that long, but my political involvement made me feel more New Yorker than Angeleno. In LA, I knew the Panthers, but Asians in the movement were off my radar. I pictured places like Little Tokyo as quiet and quaint, clustered with temples and tofu and *manju* sweet shops, where my family took us for Sunday dinners at the Far East Café. I couldn't imagine these young radicals in their jeans, T-shirts, and army jackets infiltrating like weeds, fighting against Little Tokyo Redevelopment, sprouting health fairs for elders, planning pilgrimages to Manzanar. They had a drop-in center for troubled young sanseis who were dropping reds and sometimes overdosing called the Yellow Brotherhood on Crenshaw, not far from where I used to live. They had a house called Asian Hard Core, on Western Avenue near Adams, serving folks who were getting off heavy drugs like heroin and getting out of prison. Asians in prison?! This was not the LA I knew.

JAs on the West Coast had land, planted seeds, owned houses, grew gardens, and lived in communities, even if ghettoed with Blacks or Mexicans. In those days, there were many *nihonmachi* (Japantowns) sprinkled up and down the coast. They had cohesive communities, spaces to create and plant their programs and dreams. It seemed like a promised land. Most JAs in New York once had roots in the West. But in New York we were too few to have a geographic community. We were crowded into a concrete cosmos, shadowed by Wall Street, the United Nations, Broadway, Madison Avenue, and the World Trade Center. There was one Buddhist temple and a Japanese Christian Church. Families tunneled through the concrete by subway to stay in touch. Still, we were organizing, politicizing, breaking silence, and being heard. We were making a crack in the New York concrete and growing a community.

Our experiences were as distinct as our geographic landscapes, yet from Sacramento to Manhattan, we were infected with the same set of beliefs. We were using our experiences and cultural roots to reach, to serve, to organize, to liberate ourselves and our communities, to be an integral part of the bigger struggle to make fundamental change in this country and the world. We called this change "revolution." In Chicago, our big revelation was that we weren't just a smattering of Asian groups on campuses and in communities

trying to stop the war and serve our people. We were a movement—the Asian American Movement.

The next day our gathering spilled into the streets of Chicago. Chris Iijima and I went with a contingent to meet with the Panthers, the political epicenter of the Black community. We wanted to pay homage to their leader, Fred Hampton, and show our solidarity during this time of repression by the Chicago Police Department. The Panthers welcomed us like brothers and sisters, men clasping hands in the Black Power handshake, a physical expression of solidarity. We met in the same office the Panthers had defended from a police attack just months before. Several Panthers had been arrested, and two Party members as well as five officers were wounded. The police torched the room that stored "dangerous contraband"—boxes of cereal that they served in their breakfast for children program. The office was freshly painted and the bullet holes from the police attack had been covered with help from the community. And breakfast was still being served. These young men and women Panthers were beleaguered, but they were carrying on.

Their voices warmed when they talked about their brother Fred Hampton and his words, "the people's beat." They told us how he tuned hundreds of cadres into that beat, getting them to rise at six every day to work out and motivate them to get "high on the people, be ready to die for the people, because we love the people!" He got them ready to serve breakfast, run the clinic, sell Panther papers. The beat grew stronger as he created a "rainbow coalition" with the Young Lords and an alliance that was politicizing Chicago's most powerful gang, the Black Stone Rangers, and a White gang called the Young Patriots. Our brothers Richard Toguchi and Russell Valparaiso of Hard Core were also meeting with the Rangers in Chicago. Hampton had launched a project for community supervision of the police.

Hampton's organizational skills, charisma, and integrity were making him a respected leader who was instilling a sense of pride, dignity, and self-determination in his people. FBI director J. Edgar Hoover feared him as the next possible Malcolm X. And so on December 4, 1969, police assaulted Hampton's apartment on Monroe Street shortly before five in the morning. They seemed to know what Party members would be there, where their cache of guns was stored, and where Hampton slept. It was later revealed that Hampton had been drugged, and so was unable to awaken when they murdered him in his bed. Their automatic weapons dispensed nine hundred bullets, but the Panthers only returned one. At the age of twenty-one, Fred

Hampton had become a sacrificial lamb for speaking out for his people. For two weeks after the onslaught, the apartment was left unsealed by the police, so the Panthers organized tours of the premises and hundreds of community members witnessed for themselves what the police had done. One elder woman left the apartment shaking her head, saying, "It's nothing but a Northern lynching."

The Panthers knew our story: they knew about camp and accepted us as part of the oppressed Third World People within the United States. But being herded to camp seemed to me a smaller injury compared to their struggle. We behaved, kept silent, and some nisei young men made the ultimate sacrifice to prove we were good Americans. In three or four years we were released to face the hardship of loss and rebuilding our lives. Japanese endured through *gaman*. But could we have endured and behaved through four hundred years of slavery, economic hardship, lack of educational opportunity, containment, and police repression that keeps Black people in their "camp" to this day? I think African Americans have something in their culture that gives them super endurance, but I don't know the word for it.

Walking back to the church from the Panther headquarters, a strange vision stopped us in our tracks. A giant tepee stood at the entrance to Wrigley Field, leather skins wrapped around a triangle of poles piercing the sky. I'd never seen a real tepee—so simple, so beautiful. When we approached, we found out it was part of a Native American protest, a cry for decent housing for urban Indians. We must have looked like another tribe to them. They stopped leafleting and invited us to sit in their circle. Some of us sank cross-legged to the ground, while some sat on makeshift chairs.

A silence descended as an elder began to chant. A long pipe was lit and offered in six directions—east, west, north, south, above, below. The pipe was then passed around the circle. I never smoked but drew a breath of the sweet tobacco into my mouth. I looked at the faces in the circle, and Chicago and Wrigley Field disappeared. We were in another time and space. In the circle an elder shared a story. He told us there would be five thousand years of evil, followed by five thousand years of good, and that change would come to be when warriors of all colors of the rainbow came together. It was the prophecy of the Warriors of the Rainbow. We drew in the story like the smoke from the pipe and held it like a secret, deep inside. When it was time to leave, we thanked them and took the story with us as we walked back to the church. I couldn't talk. I just walked, holding the story in me, my feet feeling the earth through the concrete.

We passed through a German neighborhood. A rowdy group of young men watched us from their porch. They threw beer and Coke cans at us as we passed, punctuated with "You dirty Japs! Chin Chin Chinaman!" They brought us back to the unreal world, to Chicago, but we kept our stride. The stones of their words rolled off us without a bruise. This time we had our armor; we knew our story.

Deep in the night, after dishes were done and church tables wiped, "talk story" dwindled and most rolled into their sleeping bags, but Chris pulled his guitar from its funky cloth case. I didn't know he played. He didn't know I sang. He slipped a couple of plastic ring-like picks on his thumb and index finger and began plucking some stray notes, not hunting for a melody. His guitar looked like he'd played it plenty. It was a bit scruffy, like Chris himself. It wore its scratches and scars, but it was in tune and its nylon strings had a mellow sound. He wasn't performing, just cooling down after the steamy day, unwinding the many strings and strands of life we'd wandered through, but not trying to make sense of it. It was too deep for that.

He pressed his eyes closed, drew the day into a sound, and found a rhythm. His thumb plucked a bass line, index finger flicking a chord. He kept working it until it had just the right feel, the right groove, the right pocket. The words began first as a mumble and then flowed with ease through his bearded mouth. You've got to hear a song sung to know it's a song.

Every day . . . I can hear it . . . like a heart that beats . . . it's the people's spirit. His voice wasn't forced or imitative. The blues were naturally embedded from layers of listening to Black music, the likes of Howlin' Wolf, and wearing their pain and the struggle and hope that forged their music. But Chris lent his own sound to it. The brother could sing. He was making a song right on the spot. I'd never heard an Asian sing like that. To me, it was yellow soul.

Every day . . . as the beat gets nearer . . . the people move . . . and the beat gets clearer.

Fred Hampton talked about "the people's beat" to ignite his people. This song was a way to keep the flame burning and spreading. Without trying, I found my voice flowing with Chris's. It was easy to sing with him. I was a natural harmonizer. In that moment we were tuned in to each other, the same energy, the same story.

And we're gonna keep on going . . . we're gonna keep on growing . . . we're gonna keep on flowing, flowing on.

After a while the song was feeling pretty good, and Warren decided that we should sing "The People's Beat" the next day as part of our presentation about the Vietnam War.

The JACL's national convention was held at the posh Palmer House. The mostly nisei and issei who were in the audience were dressed in business attire—men in dark suits and women in dresses. Our breakaway tribe of rebel sansei, unapologetically in our jeans, T-shirts, and army jackets, definitely didn't belong there. I don't think they were ready for us, but they politely allowed us our time to present as agreed. We showed a couple of short films demonstrating the parallel between the use of the atomic bomb on Hiroshima and the war in Vietnam. Then Warren Furutani took center stage with a speech on the matter. He was more than political. He was orating with clarity and conviction to this nisei audience, filling the air with the fire of his words, like a Black preacher. If you were alive and breathing, there was no way you could not take a stand against the Vietnam War after Warren's speech.

Then Chris and I were up. I think we were the closer. The mics needed adjustment, and the sound was a shitty hotel system, with the kind of speakers that are set in the ceiling next to the sprinkler system, but, oh well, it's just the one song. We just stood, feet planted, and sang: *Every day . . . I can hear it . . . like a heart that beats . . . it's the people's spirit . . .*

I guess they were feeling it, especially our crowd, gathered in front of the stage platform, sitting on the floor. By the end they were clapping, not for us but with us, to the beat. Their clapping made them part of the song. And we got them to respond:

> *We're gonna to walk together . . . walk together!*
> *We're gonna talk together . . . talk together!*
> *We're gonna move . . . gonna move!*
> *And we're gonna keep on going*
> *And we're gonna keep on growing*
> *And we're going to keep on flowing . . . flowing on . . .*

It wasn't a great song, but it came in a moment of intense awakening for us as Asian Americans. We were finding ourselves, finding our voices, finding our

way as brothers and sisters out of a communal trauma that had kept us silent, invisible. It captured the spirit of that moment in a way nothing else could—with a song. And like most things that profoundly change your life, you don't make it happen; it happens to you. It was the song we never had, the song we never heard, it was our song. Chris and I were just there to deliver it.

But Chicago had something more to teach us. The high we were feeling from the coming together of East and West, our new connections, our revelation that we were a movement, and our first song came crashing down in a single tragic stroke. Evelyn Okubo, one of the youth organizers from Stockton's Yellow Seed, was in her hotel room at the Palmer House where the JACL convention was taking place. A stranger entered her room and slit her throat. Minutes later, her roommate, Ranko, went up to look for her and became the second victim. Evelyn died. Ranko survived. She still wears her scar as a necklace of remembrance.

This tragedy was Chicago's "Hawk" that blew its icy wind through our lives. The authorities claimed it was a robbery, the killers two Black men that Mayor Daly's finest somehow never caught. We were left wondering: Was it a random act of violence? Was it a hate crime? Was it a threat, a warning, to sever our ties with the Black Panthers? We would never know the truth. Fred Hampton was the Panthers' sacrificial lamb. Seventeen-year-old Evelyn became ours. With this loss, our innocence was sacrificed, our commitment tested. We wept, but we did not run. We stood closer now. Our tribe was bound in blood. We were the Warriors of the Rainbow, and this had to be the end of the first five thousand years of evil.

> *I know there have been other sojourners' souls,*
> *That sang into to the ether,*
> *Who uttered, whispered, hummed, howled*
> *Their melody into the void*
> *Just for the joy,*
> *Just for the woe,*
> *Just for the longing*
> *To tell their story*
> *To hear the wind of their voice*
> *Even by a single, desolate dandelion*
> *Just to say, I exist!*
> *I am alive!*
> *I am real in this world!*

A great auntie clearing rocks from a California field
Singing her unlived dream or unfound love
A grandfather's anvil striking railroad steel
Sparking a song from homeland
Or an unheard melody
That just blew through him . . .
The echoes of these ancestors sing in me
But this time the universe is in alignment
Put me with Chris, a soulful genie with a guitar
A poet mind who knew how to conjure a song
I'm a harmonizer that knew melodies before hearing
This time there are witnesses
A circle of believers from West and East
Yellow pearls gathered in a necklace of hope
They were waiting to hear
We were wanting to sing
We were living the same dream
We were all hungry
Famished for something that had been smothered
Starved for a voice that could fill the silence of a hundred years
And the only thing that could satisfy, that could sum our communal vision
Was a song

FIFTEEN

A Song for Ourselves

CHICAGO GAVE US OUR FIRST SONG, but it stole the life of young Evelyn. We wanted to do something to honor her sacrifice and support her family and her organization, the Yellow Seed. We also wanted to see for ourselves what was happening on the West Coast. We decided to make more songs, do a benefit concert, and get ourselves to California.

As we birthed these songs in my apartment, it became clear to me what a gifted poet and musician Chris Iijima was. He had the ability to capture complex ideas, especially political ones, and humanize them in song, with little apparent effort. None of the songs was a self-hug of the "I'm Asian and I'm proud" variety. They all pointed to something more political, nuanced with imagery, story, and soul. Sometimes we had writing sessions with others in the room—Steve Louie, Eddie Kochiyama—observing and participating in the process. How does this sound? Is this better? Does it say what we want?

Our music was relatively simple: two voices and a guitar, with a focus on the content. But the delivery system, the form, was of equal importance. It had to have the feel, the groove, the funk. Some would call it folk music, but music has a way of defying boundaries. I always felt "folk music" was about other folks. American folk music (White European) is a living tradition that expresses the stories and struggles of the poor and the working class, some of it reaching back to roots in England and Ireland and passed down through generations of singers and players. But the folk revival of the 1950s and 1960s, with the likes of Woody Guthrie and Pete Seeger, unleashed a new generation of singer-songwriters who reflected the political turmoil of the time. Bob Dylan also emerged from this lineage.

Black Americans had a powerful legacy of music from their African roots, evolving from field hollers to the blues and ragtime. Their folk music grew

into jazz, rock and roll, hip-hop. Black music has become America's music (Leadbelly, Louis Armstrong, Bo Diddley, James Brown, Aretha, and on and on). Latinos also had music that defied national and cultural borders, encompassing African (slave trade), Indigenous, and Spanish roots: from tango to bossa nova, cha-cha to rumba, Tejano to salsa, mariachi to *son jarocho* (Desi Arnaz, Xavier Cugat, Eddie Palmieri, Ritchie Valens, Santana).

But where was our music? What is a people without their own song?

Growing up Asian in America, we had the songs of our ancestors, but we no longer understood them. In our quest to be American, we'd often rejected the old music. We grew up hearing other songs that filled our ears and captured us, formed our styles and attitudes, even taught us to move differently. Some were cool songs that we embraced and that spoke universal truths. But they didn't speak to our experiences. They didn't give us a memory line that connected us to our own roots. We learned to see ourselves in those who sang to us. In fact, we wanted to be *them* instead of who we were. We were a songless people. We were missing something that we didn't know we longed for—our own song.

But what was our song supposed to sound like as Asian Americans? Chris and I didn't play Japanese instruments like koto or shamisen. We didn't know much about our people's music beyond its use of the pentatonic scale. We grew up with a range of music, from pop to classical and especially Black music, filling our ears. It became part of our cellular memory. Finally, we decided that to be our whole selves, we had to make music that naturally flowed through us, music that we and our brothers and sisters could relate to, songs that embraced our entire cultural experience.

Chris was twenty-one and had complete clarity about his politics, but was cavalier or in denial about being an artist or wanting to be one. To him, an artist was simply a person skilled in a creative art or a particular field of work, such as bread making or healing—in this case, songwriting. Maybe he didn't want the judgment or the burden of the title. Being successful as an artist in Western culture means holding an elitist, privileged position, elevated and separated from "the people." It was contrary to his political beliefs to be put on a pedestal. For him, music was a fun and easy thing to do. Chris also claimed he never practiced, but he did a hell of a lot of listening. He moved around New York by bus or subway, earphones plugged into a small cassette player, reading the *New York Post*. When Chris wanted to go to the High School of Performing Arts, an elite public school for budding artists, his nisei father, a pianist and a high school music teacher, advised him: "Learn the

French horn. It's difficult to play." He auditioned and got in, then traded the horn for a guitar. He wanted to play like those blues singers Howlin' Wolf and Sonny Terry. They became part of his musical DNA.

For me, it was a total reset on what it meant to be an artist. My whole life had been about training to be twice as good, to be accepted as a tool for the geniuses of theater—to help them tell *their* stories, for *their* audiences, in *their* houses. I'd wanted to rise above and beyond the limitations imposed on my people and be delivered into the Great White Way of showbiz. That was my simpleminded road to equality. But the movement was teaching me that the White capitalist power structure, with wealth acquired by exploiting slaves and workers, and appropriating land and resources from Native peoples, ruthlessly utilized culture to shape the American dream. Though art, music, and theater may arise as creative expressions of "the people," White wealth decides what it wants to support and invest in, what sells and best tells the story *it* wants to tell, and who *it* deems American. Be it popular music, Broadway, or movies, it takes money to produce and promote a product that can reach and influence a mass audience. Artists of color, especially Black artists, have long fought for a place within America's dominant White cultural pyramid, and have frequently been exploited and cheated out of their ownership, rights, and royalties. Working within the system, these artists have helped change what US culture looks and sounds like. At the same time, the most successful become commodities who are manipulated to create wealth for the system, and exert little control over what they create.

In 1970, as activists in the movement, we knew the power of our song was the support of our own communities. Breaking away from the power structure that had kept us invisible, even to ourselves, we claimed our own space, a horizontal open space, to recognize ourselves, proclaim our own voice, a voice for and about our own people. My reason for doing art was now bigger than myself—we were even afraid to call it art or to call ourselves artists (some called us "cultural workers"). We were immersed in the community, participating, connecting, growing relationships. I freed myself to start from zero. Who am I as a Japanese American? Who are we as Asian Americans? What complications, and cultural concoctions, exist in that space between? The sheer fact that we were breaking silence to make our own song was breaking out of the bestowed "model minority" status that separated us from our Black and Brown brothers and sisters. Our song declared our existence. Our song smashed stereotypes. Our song spun our own identity. Our song held our memories, beliefs, visions. Our song was a weapon. Our song, and the

way we sang it, was an act of liberation. A simple song now had a powerful new purpose—and we were exploring how to use it.

The songs came quickly. We had stories to tell. "We Are the Children" was our first intentionally written song, an homage to the struggle of our immigrant grandparents with a vow for ourselves to *leave our stamp on Amerika.* "Something About Me Today" was an awakening to our love of community, and for me, awakening to myself as an Asian woman. In "Yellow Pearl," Chris transformed us from the yellow peril into a yellow pearl—from a minuscule minority to proclaiming, *We are half the world, we are half the world!*[1] Some songs looked to other struggles that we supported and identified with, like "Jonathan Jackson," about the young Black man of that name who was killed while trying to free his brother, the political prisoner George Jackson. Chris had already written "Vietnamese Lament," a song from the point of view of a Vietnamese defending his homeland. All the songs reflected the world that we lived in as politically aware Asian Americans.

With our handful of newly written songs, plus a few Beatles and Dylan covers, we had a full set. We were nervous and wondered if we could fill the New York Japanese Buddhist Church on West 105th Street—the objective was to make enough money to get us two one-way tickets to Los Angeles. In Chicago, we'd sung just that one song—we were an afterthought on the program. Now it was all on us. Chris later told me he threw up before the concert.

We could hear the buzzing of the crowd through the curtain. The stage was small, the sound system borrowed, and the lights barely lit us. We tried to look casual and cool sitting on our two stools, Chris on my left, balancing his guitar on his thigh. It was a different kind of crowd than I had ever performed for. The audience looked like my family. In fact, they didn't feel like an audience. They were like us, our brothers and sisters, activists, artists, students, family members. For the first time I was singing with a brother, someone who shared my experiences. For the first time I was singing songs I'd helped to birth, singing ideas I believed in. For the first time I could sing with my full force, my whole being. I was free to sing *me.* These songs came out of our collective experience. These songs were a sum of our communal vision. What did it mean for our audience of brothers and sisters to see two of their own singing back their stories, their cry for change for Asian America in 1970? It was cathartic, a moment of symbiosis. We were singing a song of our people. We were singing a song for ourselves.

As it turned out, that first concert did earn us enough money for two one-way tickets to LA. We were trusting we'd find our way back. Our West Coast organizers in the movement—Warren Furutani, Jeff Mori, and Harvey Dong—pulled a tour together from LA to San Francisco, with stops in Modesto, Fresno, Sacramento, and I can't remember where else. It was the beginning of many tours over the next three years. These were not rock 'n' roll tours; they were spartan and proletarian. We stayed in collective houses, slept on couches and floors, schlepped from gig to gig in VW vans, and dined on exotic cuisine unheard of in the Big Apple, for instance Mago's teriyaki-guacamole burgers in West LA, or plate lunches at Suehiro's in Little Tokyo, with choices from column A or B, always with a portion of potato salad, a very JA thing. In East LA we ate spectacular, giant burritos that served as dinner *and* lunch the next day.[2]

We sang in community centers, churches, universities, rallies, and even in prisons! I never knew there were Asians in prison. Once we sang at a prison, I think it was Lompoc, and our group smuggled in Chairman Mao's Little Red Books to distribute among the Asian prisoners. I guess the plan was when they got out of prison, they would be ready to "serve the people." We also sang at house parties and hung out deep into the night, the best way to get to know our fellow comrades in the movement. Our travels helped to establish a trade route of crash pads between Cali and the Big Apple, hosting many a West Coast traveler curious about our New York movement (see photo 12).

Traveling light with just a guitar and two voices made us easily available for gigs small and large. It's amazing how many gigs you can book when money is a minor concern. Our main purpose was to help spread political consciousness among Asians. We were like troubadours or African-style griots who sang stories and carried news from town to town. We felt a lot of responsibility as performers: not to separate ourselves, to be accessible, and to represent the ideals we were singing about. One of those ideals was women's liberation. There was much talk and evolving of practices in our movement to develop leadership and voice among the sisters. Brothers were cleaning house and even cooking!

One day Chris said to me, "You've got to talk. You've got to start introducing some of the songs." No. I liked to sing, but please don't make me talk. I put the blame on my cultural inheritance. Women's oppression was so ingrained in Japanese culture that it was commodified and stereotyped in Western culture. Even if it wasn't true that our mothers were good, obedient, silent wives with equally obedient daughters, we accepted it as normal and

good to keep our mouths shut. But the truth was, I felt I had nothing to say—with words. In school I deftly avoided talking. I could shrink, disappear, become dust before a teacher's eyes. I never raised my hand, never thought I had the answer. When called upon, the answer came slowly, softly. I was missing the confidence gene when it came to talking. Ask me to grand jeté across a stage, but don't ask me to talk! Performing in Seattle as a chanteuse, I went from song to song without the need to talk. The audience didn't seem to mind. Better to keep your mouth shut than pretend you're comfortable and cool, pretend that you have something to say. So why do I have to talk now?

Chris didn't buy it. Not only was it politically important, but, as he put it, "The sisters need to see you talk."

Damn, I knew he was right. It was my responsibility, my duty, my challenge, my right—yes, my right—to open my mouth and not only sing, but speak my beliefs. Come on, show some courage, your fighting spirit, you can do it. Women can and do hold up half the sky. "Okay, I'll try."

It came in small spurts. First, I sort of copied Chris's dialogue, his intros. Little by little I got used to it, took it on a little more, and found my own way of speaking. Okay, it's not so hard, and I finally realized I *did* have something to say.

We weren't the only musicians spurred into existence by the movement. There were others who were musically more experimental and grander in scale. I remember an event we were invited to in Long Beach. There was this Asian American band that had the normal keyboard, drums, bass, and sax—but wait, in the middle of it, a koto. The koto player was a classic beauty who looked like she fell right out of a Japanese scroll, sitting behind her instrument, straight-backed as if still bound by an *obi*. Holding a wooden *bachi* in her hand, her strokes on the thirteen strings accented, yet gave contrasting flavor to the chords Benny Yee was playing on the keys. The saxophonist, Dan Kuramoto, took his solo, but then the koto slid in and June Okida took over, humbly but boldly improvising on an instrument that wasn't made to speak with that kind of freedom. It was ear-boggling. Then a young Johnny Mori entered, head wrapped with a *hachimaki*, wielding sticks in both hands and making martial-arts-like movements as he yelled *kiai* and struck a drum. I'd only seen this drum in Japanese samurai movies. It was called a *taiko*. This combination of traditional Eastern with contemporary Western instruments was a new phenomenon. They called themselves Hiroshima, an in-your-face

reminder of the US bombing. And to top it off, a young female singer. She couldn't have been more than seventeen. She dressed with a splash of Japanese style and had a belting voice that commanded both Japanese and English, with soul. She waved her arm with a flourish, slid her mallet up a stack of bells, threw her head back, and sang. She was dynamite. In fact, her name was "Atomic" Nancy.

It's no surprise that the San Francisco Bay Area, home to the Beat generation, had a robust jazz scene, and the most avant-garde player was the saxophonist Gerald Oshita. I remember he invited us to join him in a performance work he was staging with the modern dancer Sachiko Nakamura. Chris was assigned to play the stand-up bass, which he seemed to enjoy—at first. Gerald was playing some very out-there tones, which Chris responded to with a shoulder shrug and some random plucks on his bass. Then Sachiko entered the darkened stage, dragging an endlessly long white cloth behind her. She began wrapping the cloth around me, then around Gerald, perhaps symbolizing White dominance or something like that. Then she headed for Chris. His head was turning left and right trying to find me, or an exit. He wasn't ready for this avant-garde shit. When she lassoed him with the cloth, he realized he couldn't run and started to laugh. He kept laughing as the cloth mummified him and his bass. I can't remember the response from the audience, but Gerald and Sachiko seemed pleased. After all, it was jazz. After that, Chris was more careful what he said yes to.

Another West Coast band we encountered in the Bay Area was Yokohama, California, fronted by a half Japanese and half Pilipino youngblood, Robert Kikuchi. His rock-oriented band was using the kulintang, a gong-chime instrument from the southern Philippines. But one of the most impressive musical expressions I saw in LA was the aforementioned *taiko. Taiko* groups are as common as karate today, but in the early 1970s, when I first saw Kinnara Taiko, a group of JA brothers *and* sisters doing martial-arts-like, synchronized moves, playing their drums with the spirit of samurai, yelling *kiai* at the top of their lungs, it blew my mind. It was breaking our silence, our invisibility, moving with our whole body, our whole being, saying, "I'm here, I'm alive, and I am powerful!" *Taiko* was setting a new heartbeat for our community. I remember seeing Qris Yamashita, a sister, taking a solo. I loved how she moved, wielding her *bachi* just like the guys, her body sinking deep into a lunge, taking command and pounding out her cool rhythms. This was breaking stereotypes in a big way. The "quiet Americans" had found a booming voice to reclaim our identity.[3]

The movement was also attracting professional musicians. In New York on December 6, 1970, Chris and I were performing at the Asian-American Reality Conference at Pace University. Holed up in the dressing room, as usual we were rehearsing and scrambling to figure out our set. A male student organizer ushered in this Asian guy with a guitar and introduced us to Charlie Chin. As he bowed out he said, "The program's running long."

What's new? This was a two-day conference pushing for Asian American Studies in a time when New York universities were refusing to address our needs. This was the final event, with a full program of speakers, including Grace Lee Boggs, the keynote. We were last, as usual. We made a little small talk with Charlie as he took out his guitar. As he warmed up, it became obvious that he was an excellent player. The waiting continued until our worried organizer broke in again and said: "We don't have time for two acts." We looked at each other, each ready to bow out, and Charlie graciously offered, "Look, you two go on and I'll back you up."

Charlie was a seasoned musician with a hell of a lot more experience than us. He was in a band called Cat Mother and the All Night Newsboys. If you've ever heard Buffalo Springfield's "Blue Bird," he played banjo on that track. He didn't need to have learned our songs; all he needed was to see Chris's left hand to know what chords and fills to play. He almost made us sound like a real band. Charlie's style was different from ours. Some songs were super romantic and easy to harmonize with, like "Sister of the Bride," and had nothing to do with being Asian. Some were wildly comical commentaries, like the "Only Asian American Cowboy in Montana Blues." But Charlie was a riveting raconteur armed with cynicism and wit that can only be developed through years of direct experience, like being the only Chinese American bartender in a Greenwich Village hangout. This forced him to become an expert on all things Asian. He was also a self-made scholar who would indeed become an expert on all things Asian, and just about everything else.

As we began exposing Charlie to political rallies and meetings, he was always wary of our political idealism, but used his street savvy to expose us in turn to real-world experiences, like singing in Central Park—not for an antiwar rally but for tips in our open guitar case. We made forty bucks on a single Sunday afternoon! He eventually influenced Chris and young Eddie Kochiyama to experience the day-to-day—or, rather, night-to-night—realities of bartending. We never wrote songs together but continued to back each other up. From then on, we were a trio on many of our tours. Audiences got a big kick out of this die-hard New York Chinaman.

Nothing was "normal" in our lives. We weren't thinking of a future career for ourselves. We weren't interested in living in a nice apartment and going to movies on the weekends. In fact, we prided ourselves on humble living, which gave us more time and freedom to organize. We were about creating a better future—for everyone. We were in study groups reading Marx and Engels's *Dialectical Materialism*, the Revolutionary Workers Collective's pamphlet *A Beginning Analysis of the Woman Question*, and other books I would never read alone. We were planning demonstrations, making leaflets, showing films. And we were always aware that our phones were tapped by the FBI.

Some dedicated activists were going to Delano to help the build Agbayani Village, a retirement home for the Pilipino farmworkers who started the grape strike in 1965. Later, their organization, the Agricultural Workers Organizing Committee, led by Larry Itliong, merged with the National Farm Workers Association led by César Chávez and Dolores Huerta and became the United Farm Workers. In the years-long grape strike they picketed and leafleted markets across the country, getting ordinary people to stop buying grapes until their fight for better working conditions and livable wages was won in 1970. I swear I didn't eat a grape for five years, and when I do eat one today, it always reminds me of those farmworkers.

Out of the grape strike, Luis Valdez created a theater group to perform short *actos* (skits) dramatizing the struggles of the farmworkers. These small plays were staged on flatbed trucks in the fields for the workers, to encourage them to participate and join the union.[4] Chris and I were on fire. How could we create theater for our struggle? We collaborated with Warren Furutani, who headed an organization in LA called Third World Storefront, one of the only multiethnic organizations that existed then. It was located at Ninth Avenue and Jefferson in the middle of the Black and Japanese community (see photo 14). We went to work and created *Goddam the Pusherman!* It was a series of skits with songs about the drug epidemic that was killing and jailing our brothers and sisters. Our actors were activists who relished putting their ideas and bodies on the stage.

The star was Victor Shibata, a Storefront member, who played the Pusherman. Joining us on stage was Rene "Peaches" Moore, the sister from the Panthers who'd first called me "sister." A singer and songwriter who accompanied herself on an autoharp, she took her nickname "Peaches" from Nina Simone's song "Four Women." She was one of two Panthers wounded by the five thousand bullets of the police raid at the LA Panthers' office on December 8, 1969, when three Panthers and six police were injured. Peaches

was the brave soul who waved a white flag and stepped out of the building to end the raid. She'd lived real drama.

We had a full cast and we took the show right into the belly of the monster: the California Institution for Men in Chino, California. Crazy? There we set up a stage and the band, put on our costumes, and performed for Asian, Black, and Latino brothers—as well as the White Nazi group the Aryan Brothers. Intense! It was a show with a lot of humor and fun. It showed the contradictions of infecting our own communities with drugs. But the big finale was when we left the prison and found all our car tires punctured. I guess we'd struck a nerve among the prison guards. Making political art means taking risks. But at least we didn't have to face five thousand bullets.

Culture played an important role in the struggle for San Francisco Manilatown's International Hotel (I-Hotel), the scene of one of the largest, longest (lasting from 1968 to 1977), and most intense struggles for affordable housing. It brought together activists, artists, and communities of all stripes. In the 1920s and 1930s, the I-Hotel was temporary housing for Pilipino and other Asian migrant farmworkers during the off-season, and then became the permanent home for many elder *manongs* (Pilipino men unmarried because of anti-miscegenation laws) for fifty dollars a month. Urban renewal's plan to expand San Francisco's business district displaced thousands of residents, almost disappearing the ten-block Pilipino American enclave adjacent to Chinatown. One of the last remnants was the I-Hotel. It was another example of America displacing and erasing the cultural spaces of people of color and the poor. But our movement took a stand. It was power to the people in action.

That's when I first met fabled Pilipino poet Al Robles, a central character in the fight to save the I-Hotel. He was a rare spirit, devoted to the elder *manongs*, who ran a community center where they hung out, ate, and talked story. His eloquent and soulful verses captured their stories and the Pilipino American experience. Many artists and cultural organizations joined the long struggle against evictions. Kearny Street Workshop, Everybody's Bookstore, and Jackson Street Gallery moved into the hotel's basement, not only helping to pay rent but churning out posters and presenting readings and music to orchestrate a cultural voice for the story and the struggle of the I-Hotel. Radical artist-organizers from KPFA radio Norman Jayo and Tarabu Betserai (the latter of whom later would become very important to

me) broadcast from the hotel, giving blow-by-blow descriptions of the struggle, attracting thousands to demonstrate against the final evictions. In those early days of the movement, it was a lesson in the power of activism, art, media, and community. In August 1977, despite the human barricade of three thousand demonstrators, the last 55 of the 197 tenants were evicted by 400 riot police. Yet the struggle continued. In August 2005, a new I-Hotel opened with 105 affordable units for seniors—a deep lesson in the meaning of "protracted struggle."

While the West had wide-open spaces in which to stretch and grow ideas and organizations, in New York, our bright ideas often gestated in small, dark spaces. Basement Workshop at 22 Catherine Street was a Chinatown cellar, a dank cave where we sweated in the summer and froze in the winter. Its darkness held secrets and struggles we could only imagine. A collection of thirty young activist-poet-artist-rebels, aged sixteen to thirty, crammed into that cellar for noisy meditations on what it meant to be born into a place we never belonged. It was a womb where we could transform our self-hatred, self-doubts, and desires to be someone else. Like salty pickles, miso, and thousand-year-old eggs, we needed darkness, pressure, and time for fermentation. We needed a hundred years in America, three generations of racism, marginalization, and exploitation. The Basement Workshop had enough space for us to birth our new selves.

Some folks got the bright idea to use the songs that Chris, Charlie, and I were singing as a core around which to gather other expressions of what it meant to be Asian and American in 1970. It would be an album, not recorded but printed, with drawings, poems, and short stories. Inspired by the LA-based *Gidra* newspaper and UCLA's *Roots* journal, we invited Asians throughout the nation to send us their reflections, images, words, stories. It took a year to harvest our collection in our basement, our cave, to confirm that we were not alone. An Asian American awakening was happening everywhere.

How to shape a visual aesthetic from such a vast array of drawings, poems, stories, cartoons, and graphics? Our group had different skills—some visual artists, some literary. Some, like activist Rocky Chin and poet Fay Chiang, knew how to write a grant and got us three thousand dollars! We organized into committees in order to collaborate and play with ideas. We weren't trying to please the outside White world. We weren't trying to prove we were good, talented Asians. We weren't trying to be accepted by anyone but ourselves. It was us speaking to us. From our struggles—and we did struggle—

we expressed collectively what we never could have individually. That Basement cellar womb was the place that transformed the yellow peril into a yellow pearl. It was golden, like us. It wanted to be seen.

The final collection was stacked, instead of bound, in a yellow box the size of a record album, which allowed each page to be used as a poster (and thus easily lost, making a complete copy of *Yellow Pearl* a rare collector's item). That yellow box contained the fury and joy of a young generation finding its voice for the first time—words, music, and visual expressions of our once-invisible selves in bold black on shades of yellow. We were definitely thinking outside that little box in the Basement. How many creatives before us had been rejected by publishers, seen as unmarketable by producers, ghettoized, discouraged by parents, stifled by cultural gatekeepers who refused to allow us into their club? We were finding our own way to publish, distribute, find our audience. Like our forebears who cleared California land for farming, we were clearing our own path, creating our own community spaces.

Part of the fun of being in the movement and making projects like *Yellow Pearl* was that we had no road maps or recipes. We were learning by doing, creating as we went along. We were open to work, to struggle, to finding solutions together. It wasn't an exclusive club; the door was open to everyone who wanted to join. Money didn't seem to matter. If we believed in something and wanted to make it happen, somehow we figured out a way. We were discovering how, as activist James Boggs described it, to make something out of nothing. What we learned from that chaotic, creative moment put many of us artist-organizers, from the East and West Coasts alike, on a life path to use art in a multitude of ways, to see ourselves in and transform the world around us.[5] It was like someone let the genie out of the bottle—and not one but many genies came bursting out. There was no putting us back.

SIXTEEN

Somos Asiáticos

MY BROTHER BOB AND I HAD NOW MOVED UP from our basement shoebox into the first-floor apartment of the brownstone at 52 West 91st Street. It was bequeathed (sublet) to us by a friend of our first-floor room-mate, Carol Demas. The former occupant had a flair for interior design. The large parlor room had fourteen-foot beamed ceilings and a giant fireplace. The walls of the room where I slept were painted dark brown, and the beams on the ceiling were painted white. Some people thought it dreary, but I loved it at night, when I looked up from my bed. The dark walls disappeared and through the white beams I saw imaginary stars in the sky of my mind.

Facing the courtyard was a picture window that Speed, our inherited orange tabby, climbed in and out of with ease. (Speed was a tough New York cat, but when I took him to LA he got hit by a car.) The small kitchen, which seemed large after our downstairs Pullman, had exposed brick walls in which a few cockroaches lived. The midnight-blue bedroom where Bob slept had a window filled with the leaves of a flourishing green apple tree planted in the courtyard. It was a cool place for $103 a month!

That apartment served as a drop-in center and crash pad for sojourner brothers and sisters, a rehearsal studio, and once, a safe house for Panther fugitives Zayd Shakur and Denise Oliver. It also became the place my brother and I hosted weekly Friday-night gatherings, a party house for Asian Americans. On weeknights one of our regulars was Eddie, the fourth of the six Kochiyama kids, then sixteen, with ears and eyes wide open and a step ahead of his peers. He went to meetings and worked with our Asian com-rades who were in college and beyond. Growing up in Harlem had given him the skills to deal with pretty much any situation. Eddie was present at many of our rehearsals and all our performances. He was witness to our creative

and political discussions and our squabbles. He and Chris Iijima often entertained themselves by smoking cigarettes and making jokes about their sister—me—into the night. Around three in the morning, Yuri would notice that her sixteen-year-old was missing in action and telephone: "Is Eddie with you guys?"

"Yes, Yuri. He just left," I'd lie. "He should be home soon."

"Eddie, you better get your butt home."

He'd reluctantly throw his backpack over his shoulder and leave, usually with Chris, who also lived uptown. I never figured how he got through school on four hours of sleep a night. But maybe *this* was schooling for him, just like it was for us. His other school was Charles Evans Hughes High, where he was involved in the Third World Student League, an arm of the Young Lords Party. Once again a step ahead, in 1972, one month before Nixon normalized relations with China, Eddie got a chance to visit China with a progressive student delegation. He was one of two high schoolers in a group of twenty-five college activists.

At the time I was working at a radio news service, a "real job." I was thirty and had never worked a nine-to-five. A few months earlier, to make money I'd gotten my first real job experience working for a lawyer, which ended abruptly when he tried to make a pass at me. (We didn't use the phrase "sexual harassment" then.) I walked out of that office before he had time to blink an eye. But Third Word Media News (TWMN) was different. This quasi-political business was the brainchild of Black entrepreneur Charles Moore, a former photographer and TV producer who wrote a book about the Panthers. "What we will be doing is to get the word of our minorities out," he said. "This means that Third World Media News will try to show the White American world the positive aspects as well as the problems of the non-White American's life." Under the wing of the United Presbyterian Church's Ecu-Media Services, TWMN was an independent radio service that gathered daily news feeds; radio stations around the country could call in and pick up stories they wanted to use. It was just like the majors, API or UPI, but this was about people and communities of color. We were located at 120th and Riverside in a building called the Interchurch Center, which contained all manner of service and faith organizations, including missions that served around the world. We called this place the "God Box."

From our perch on the nineteenth floor, we had a magnificent view that looked over the Hudson River and New Jersey. At first my job was secretarial, but Mr. Moore noticed my connections in the Asian community and my

interest in media, prompted by my experience working with Antonello. He also knew I was singing with Chris and gave me time off to tour. He trained me in how to collect stories through the phone, how to do live interviews, and cut-and-splice editing skills. He even sent me to a journalism class at Columbia University (where I learned I was meant to make songs, not report news). Soon my job expanded into work as a reporter, along with a minuscule staff of a couple of Black sisters, who included Ibidun Sundiata, a friend of Yuri's and member of the Republic of New Africa, and a Latino brother.

From the nineteenth floor of the God Box, I learned the power of radio as a relatively inexpensive and quick way to reach audiences. Being an activist in the Asian community gave me access to stories. When Eddie returned from China, he did an interview that showed an unusual view of Communist China through the eyes of a young person. On the one hand, the delegation got to meet Chou Enlai and the Central Committee (Mao was sick) and visited a People's Liberation Army base where soldiers were practicing accuracy by launching grenades at a Nixon target (I didn't report that). On the other hand, they were invited to play a game of basketball against the Women's National Team. Eddie explained: "Our players were taller, except for me, and more street-wise. But the Chinese women played differently. No one was a show-off. They worked together, sharing and playing as a team. And they kicked our butts. When they invited us to challenge their national ping-pong team, we decided to decline the offer."

Nixon had not yet gone to China to shake the hand of Chairman Mao, creating a frenzy of interest in all things about Communist China, when we got the story up. A curious reporter called me, asking, "That was a great story. Where did you find that guy?" I told them I had my sources. Being an activist was my secret weapon.

I posted other stories about a college campus demonstration against the Vietnam War and got another call. They said they weren't picking up stories about anti-war demonstrations anymore. Like, "don't waste your time on this stuff." That was a wake-up call for me. I saw how the media can be manipulated by political and corporate sources. Our movements had learned to utilize the media to bring the truth before people's eyes, from the violence toward the civil rights movement to the Panthers and the Yippies (Youth International Party). We tried to utilize the media to educate and show what was going on. When the powers that be saw how media reports fed into the social unrest that was destabilizing the country, they put a lid on it, ignoring and blacking out events to shape another story. On today's news you don't see

coffins or body bags of US soldiers coming back from the Middle East, like we did during Vietnam. They learned to take hold of the media. Now we have the internet and social media. When will they put a lid on that?

To an outsider, New York can seem like a heartless metropolis, but actually it is a multitude of small communities, from East Harlem to Chinatown, each with distinct personalities, cultures, and ecosystems. In my Upper West Side neighborhood at 52 West 91st, you could walk a half block to your right past a row of brownstones and be at Central Park. If you walked left five blocks, you'd arrive at the Hudson River. I loved hearing the *congueros* gathered in the schoolyard across the street, playing their drums into the night. They were the soundtrack for the many Puerto Ricans, Dominicans, and Blacks who lived in the neighborhood, peppered with *bodegas* (markets) and Cuban Chinese restaurants. It wasn't unusual to bump into Brother Lee (Lee Lew Lee), a tall, skinny-legged sixteen-year-old Chinese and Black mixed-blood, rank-and-file Black Panther, selling his newspapers and politely bowing and thanking supporters with "All power to the people" (which would later become the title of his documentary film). Or to hear Pedro Pietri, who would cofound the Nuyorican Poets Café (now an institution), standing in the middle of busy Broadway foot traffic, wearing a draggy dark long coat and dark hat, hair drooping downward like his eyebrows, spouting his poetry he didn't call poems, like "Puerto Rican Obituary," to passersby. I mean, my neighborhood was alive with flavor.

In the 1970s, New York was in a fiscal crisis. Landlords in poorer neighborhoods such as the South Bronx, Harlem, Brooklyn, and the Lower East Side who were unable to pay taxes and upkeep often abandoned their buildings. Urban renewal had caught up with the West Side's prime property. Landlords and speculators were buying up the large apartment buildings to build high-rises, pushing out poor Puerto Ricans, Dominicans, and Blacks. Many of these buildings stood empty for years. Even my brownstone changed hands and the new landlord (who suspected we were subletting) was doing everything he could to move us out so he could push the rent sky-high. (He didn't know who he was messing with. We were in the movement!)

My brother and I started noticing demonstrations near our place, with Latinos and Blacks leafleting and chanting: "We won't move! We won't move!" Operation Move-In, working with El Comité, was demanding affordable housing in our neighborhood. They called urban renewal "urban removal"—specifically, moving out the poor to move in the rich. Operation Move-In was going to do something about it. In the night, Operation Move-In

would break into an empty building, fix the plumbing, connect the electricity, and move in a bunch of families. Crowds of supporters would gather outside, police would come, and landlords would threaten, but it looked bad on the six-o'clock news to see hordes of poor families with children being forcibly moved out of these buildings in the middle of the night. Bob, Chris, a bunch from Triple A, and I started joining these demonstrations.

At the same time, the Friday night gatherings at 52 West 91st were going into overflow with more than fifty Asians every week. We needed a drop-in center for Asians on the West Side, outside of Chinatown. Maybe we could liberate a storefront? A few us, including Chris, Bob, and myself, decided to pay a visit to El Comité, just down the block at 88th and Columbus. Federico Lora, Esperanza Martell, and other members were down-to-earth, friendly, and open to helping us. The walls of their office were covered with colorful posters reflecting campaigns for Puerto Rican independence, as well as local issues like urban removal. They took us around the neighborhood just like estate agents. One of the places they showed us was a storefront at 88th and Amsterdam. It was boarded up but looked about the right size.

"It's a good location. Subway around the corner, bodega down the block, no money down, take it!" said Federico. So we did. On the night of the takeover, our crew of Asian ninjas rallied with El Comité and Joe, the mayor of the squatters. Joe was a Puerto Rican Paul Bunyan with a crowbar. He drove a tow truck and was used to heavy lifting. Within minutes he broke through the metal gate, and he and the guys stripped the boards from the front window. Then Joe gave us sisters some shovels and brooms and we began to clean. We were nervous as hell that we'd get arrested. We were ready but the police never came. So with the help of our neighbors, El Comité, we staked a claim for the West Side's Asian American drop-in center.

We "quiet Americans" who were taught time-honored traditions—don't take too much, don't be noticed, don't bring shame on the family, and don't steal!—*liberated* ourselves a storefront! Along with it we *liberated* ourselves. For the next few weeks, a small crew headed by brother Bob, who had the fire and muscle to lead the charge, continued to work to create our space, removing the wall plaster down to the bare bricks. It was looking pretty cool. Chris always seemed to show up late or had something else to do, like sleep. Handiwork was not his thing. We were dreaming as we breathed in the lead-filled paint and plaster. Bob designed the front window to look like a television screen one could look into. We wanted to show films, have readings, stage speakers, hold political education classes, and generally have a place to

hang out. Many alliances grew here, including romantic ones. What to name it? We wanted something strong, something political, something revolutionary. Finally, we decided on a phrase Malcolm X uttered after Kennedy was assassinated: Chickens Come Home to Roost.

After that, El Comité would call us (we even had a phone) and ask: "Are the Chickens going to come to the demonstration tomorrow? Can the Chickens sing?" We became *el pollo*, The Chickens!

El Comité and Operation Move-In were having success, moving hundreds of squatter families into rent-free housing for months, even years. The squatters' movement was not only answering the immediate need for affordable housing; it was sparking hope and daring within and around our community that opened us to new possibilities. Other progressive organizations were sprouting like mushrooms in the neighborhood—a karate school that taught women martial arts, a women's center run by White radicals, a Spanish class, and eventually THE DOT.

Jimmy, an underfed African American hippie in the squatters' community, had a dream to start a coffeehouse. A half block from our apartment on the southwest corner of Columbus and 91st Street stood a large empty storefront. By night Jimmy and my brother Bob would guerrilla their way into construction sites to liberate the large spools that construction cable was wound around. The next day they'd return to the same sites and ask for nails and wood, which they were freely given. Each night they rolled in more spools that turned into tables. Each was painted a bright color and surrounded by assorted crates and found chairs. This place of circles was THE DOT, the squatter community's coffeehouse and cultural center. Here Chris and I were introduced to the world of music called Nueva Canción.

Soon musicians from Puerto Rico, the Dominican Republic, and Argentina were playing at THE DOT, which was filled with squatters, community folks, and us Chickens. Pepe y Flora, Roy Brown, Estrella Artau, Suni Paz, and many more were a part of this new song movement that arose in Latin America as well as Spain and Portugal in the late 1950s and the 1960s and became a voice of resistance against political dictatorships and the treatment of rural Indigenous peoples, who were being discriminated against and marginalized. In Chile, Violeta Parra collected more than three thousand songs from Indigenous communities. Other musicians began embracing these folk forms that merged politics with music. In 1970, when Salvador

Allende was sworn in as the first socialist to win the presidency in Chile, he encouraged their movement with a banner that read: "You can't have a revolution without songs." When Allende was deposed in a bloody junta in 1973, the dictator Augusto Pinochet outlawed many Andean instruments to suppress the popular Nueva Canción movement. There was too much power in their songs.

I wore down my record player needle listening to *Cuba Va!* (Grupo de Experimentación Sonora) and Victor Jara of Chile. Sometimes I read the translation as I listened (a painless way for me to learn a little Spanish). Their songs were political, but their lyrics were poetic and beautifully crafted in the tradition of Pablo Neruda and Federico García Lorca. Everything sounded better in Spanish. You could feel the love of their favorite mountain or the sorrows of a campesino, the melodic tenderness, the fire. But their truths needed no translation. The melodies and rhythms directly pierced the heart. I even worked up the courage to sing Jara's "Plegaria a un Labrador" at THE DOT. Singing his song, I could feel his passion, his heart. When he was killed by the junta, his hands that once played the guitar and wrote passion-filled poetry were severed. I was devastated. These musicians whose music fed the fire of struggle in their homelands faced violence and terror just for singing a song.

Audiences at THE DOT were kind and accepting of our music, even as we sang in English. It felt like Nueva Canción was the place our songs belonged, and their support spurred us on. One day, Chris came to 52 West 91st with an idea he carried like a precious gift in his hands: "I started a song in Spanish . . ." It was a brave and exciting idea. We didn't speak or sing in Japanese, and here we were going to sing in Spanish.

By that time, my brother had returned to LA because our father was sick and needed his help at the gas station. I had a new roommate, a former member of the Young Lords. On the cover of *Palante* (1971), a book about the Young Lords, is a beautiful, strong woman with a proud stride. Her beret is cupped over her full Afro, with a small star stylishly pinned on it. Her black leather jacket glistens in the sun, and her full lips offer a hint of a knowing smile that says *venceremos* (we will win). That's Aida Cuascut—my roommate. Aida was recovering from her split with the Young Lords. Like me she was a little older, with more life experience. Still a revolutionary with a firm belief in Puerto Rican independence, she was trying to figure out her future. How would she continue serving outside a political organization? How to support the protracted struggle to better the lives of her people? These were

questions we all would face. Eventually she returned to Puerto Rico to go to medical school and become a people's doctor.

I was nightly bringing home a bottle of cheap wine to drown the depressing stories I was working on at TWMN. She liked the wine but was fed up with the stories. After I told her about ethnic weapons, the government's secret study on diseases that could affect specific populations of color, she told me: "Stop freaking me out already with these stories!" Aida was teaching me more practical things, like how to cook the perfect *arroz con pollo* and make Café Bustelo, Puerto Rican style. I still have in my kitchen drawer that muslin sock with a metal ring that you put the coffee in and pour the hot water through. A little twist of *limón* and some sugar—mmm, *perfecto!*

Now she was helping Chris finish our first song in Spanish. When we sang "Somos Asiáticos" at THE DOT, people went crazy, both the Latinos and our Asian brothers and sisters.[1] The song opened their hearts and drew our communities closer. Now we were *familia*. People now talked to The Chickens when they saw us on the street. I joined the free Spanish class at the squatters' building. It was the first time ever I felt I was part of a neighborhood.

Now we could sing in Spanish at Operation Move-In takeovers (you can see us in the Third World Newsreel film *Break and Enter*). And more songs came: "Venceremos" was based on the words of José Martí, a poet who fought for Cuban independence. "Morivivi" is about a flower in Puerto Rico that appears to die when you touch it, but then comes alive again. "Gracias" is a tender thank you for the affection we received from the surrounding community. Soon we had enough for a short Spanish-language set and found ourselves singing at more Latino gigs around New York than Asian. We were even invited to sing for a Puerto Rican Independence Day event at Madison Square Garden. I never felt smaller in my life. We were like ants singing at that giant arena filled with twenty thousand people.

Pepe and Flora were regulars at THE DOT. They worked for the Puerto Rican independence movement, on both the mainland and the island. They were professional artists, yet they sacrificed much to work for their beliefs. When they took the stage at large venues, or at THE DOT, they knew how to raise the roof. It didn't matter if you were Puerto Rican or not, you had to get on your feet to sing and clap with them: *Que bonita bandera, que bonita bandera, que bonita bandera, la bandera puertorriqueño!* Pepe and Flora wanted to record us doing a couple of our Spanish songs and put it on a 45 rpm record to share in Puerto Rico. This was our first time in a real studio.

We were surrounded by seasoned Puerto Rican musicians playing traditional *cuatros* with congas, bass, even a flute player. They were older guys dressed in guayaberas (traditional short-sleeved shirts with pleats running down the chest). They had played too many wedding and dance hall gigs but were still kind to these two green *asiático* musicians. When the tape rolled, they made it easy for Chris to lean on their notes as they danced familiar rhythms on their four strings. It was a thrill for us to play with them. We recorded two sides: "Somos Asiáticos" and "Venceremos."[2]

Pepe and Flora's label was called Coqui Records, named after a tiny frog native to Puerto Rico that makes the cricket-like sound: *coqui! coqui!* (I recently went to Hilo, Hawaii, and learned those frogs have made their way to Big Island and are driving people crazy.) Pepe and Flora's plan was to take us on tour with them to Puerto Rico to perform for the MPI Party, the Movement for Puerto Rican Independence, but it didn't work out. I don't know if it's true, but I heard that they played our songs on jukeboxes around the island.

There were other squatter communities around New York—in Harlem, the Bronx, and the Lower East Side. This just happened to be my neighborhood. We *asiáticos* of Chickens Come Home to Roost stepped into a struggle to make lives livable for our neighbors and ourselves—circles of brown, yellow, black, red, and white, an archipelago of cultures. At THE DOT we shared many music nights with Pepe and Flora, drinking wine, inhaling a puff or two, and sipping Café Bustelo with Espi, Manny, Federico, Orlando, Ana Marta, Aida, and us Chickens, talking smack, planning, dreaming, and railing about our frustrations. We were growing a community, growing our souls, and growing new songs. In the middle of New York's concrete jungle, we were building a liberated zone, a space that welcomed dreams and the music that came with them.

Here I learned that community building is a living process that grows in layers over the years, but also something can be achieved in the three minutes of a song. And that song can keep singing its truth within us long after the music stops.

> *Nosotros somos asiáticos y nos gusta cantar para la gente*
> *Hablamos la misma lengua porque luchamos por las mismas cosas*
> *La lengua de libertad*
> *Líricas de amor*
> *Canciones de la lucha*
> *La música del pueblo*
> *Yo para tu gente, tu para la mía*

We are Asians who like to sing for the people
We speak the same language because we struggle for the same causes
The language of liberty
Lyrics of love
Songs of the struggle
Music of the people
Me for your people, you for mine

I recently visited New York and made a pilgrimage to my old neighbor-
hood at 52 West 91st. I knew THE DOT was gone, and the squatters, but I
went anyway. I hardly recognized the 'hood I once knew, now full of high-
rises and high-rent apartments. On that corner just down the street from 52
West, at 91st and Columbus Avenue, now stood a McDonald's. I was pissed!
I stared long and hard to visualize THE DOT, to hear the echo of *congueros*
that once filled sweaty summer nights. Then I realized, those songs still sing
in me. Some I still perform. Maybe it's true for everyone who was part of the
squatters' movement as they moved on with their lives to continue their work
in New York or Puerto Rico or elsewhere. Like THE DOT, this McDonald's
is just temporary, but what we learned working, Latinos and *asiáticos*
together, is always inside us. Perhaps it's like the morivivi plant that appears
to die, but is reborn—elsewhere, the ground is fertile and the need and the
seed are there ready to bloom.

SEVENTEEN

Foster Children of the Pepsi Generation

"HELLO, THIS IS YOKO. I want to speak to Yellow Pearl."

Her name was Japanese but her straightforward, commanding attitude was not.

"Well—'Yellow Pearl' is a song we sing, but we call ourselves Chris and JoAnne. Excuse me, who is this?" I usually fielded calls for gigs, so I grabbed a pen and the yellow pad where I logged information.

She brushed aside my words and went on. "I'm Yoko Ono."

I started writing.

"John and I . . ."

I dropped my uncooperative ballpoint. *That* Yoko? As in John Lennon, the ex-Beatle, and Yoko? I was curious why rock's royal couple, who staged a "bed-in" for a week as part of an anti-war demonstration, would be calling us. How did Yoko even get my number?

"We are cohosting *The Mike Douglas Show* next week and we want Yellow Pearl to perform a song."

I had no television, but I knew Mike Douglas had been an afternoon staple for housewives since the early 1960s. And this was NBC, national television. So where did they hear about us? We had no album, we were on nobody's charts. Was it even politically wise for us to do this?

"We shoot the show in Philadelphia. You come to our house and we'll drive there together. Oh, and Bobby Seale and Jerry Rubin are also doing it."

Oh, I get it. It's another John and Yoko demonstration. The revolution *will* be televised. Why not? We agreed to do the show.

When we arrived at 105 Bank Street, their West Village loft, Yoko greeted us at the door, turned, and pronounced over her shoulder, "Yellow Pearl is here, John."

Chris tried to explain again: "We're not Yellow Pearl; I'm Chris and this is JoAnne," but it was useless. Yoko had it in her head that we were Yellow Pearl, and that was that. She was a master of the media, and she was probably right: Yellow Pearl would have been a good name for us.

John and Yoko's lives and bodies had been on display in every magazine rack around the world, so we entered a picture we'd certainly seen in some magazine. John was on a huge raised bed, sort of like a throne, and above him a television hung from the ceiling. He was talking on the phone. Not talking—arguing: "They'll be on the fucking show or we're not showing up!" He slammed the receiver down. After the two of them conferred in lower tones, Yoko pronounced with confidence, "Don't worry, John, they'll call back. They can't do the show without us." Yoko Ono is Japanese, but aside from our common origin, we are from different planets.

We found out that *The Mike Douglas Show* would have to bump a Black singer to make room for us. We told them we didn't need to be on the show, but they wouldn't have it. We then realized they were testing the muscle of their fame against the muscle of corporate media. Chris and I just happened to be tiny pawns in the game. And the queen was in charge.

Yoko was Japanese, but she was coming at social activism from a totally different angle. Chris, John Lennon, and I came from working-class families. Yoko was born into Japanese nobility—with a banker/former-pianist father and a samurai-class mother. Yoko even went to school with Prince Akihito. But she also experienced the US bombings of Tokyo and childhood hunger and humiliation, growing her into an anti-war rebel and artist.

The atomic age generated radical avant-garde art forms in Japan that rebelled against totalitarian rule and embraced individualism. The Gutai group was "art with no rules." Butoh dance also came from this era. I had heard of happenings, which were interactive. Example: a white happening in which people came to a dinner dressed in white, sat around a white table with white chairs, ate white food like tofu and rice, from white dishes, without talking, and then left. *Fini*. Yoko was a transnational avant-garde conceptual artist who hung around with people like John Cage, Merce Cunningham, and Andy Warhol. Her art for the Mike Douglas show was breaking a teacup at the top of the show and pasting it together by the end.

Yoko was right. *The Mike Douglas Show* couldn't go on without them. While the Black woman singer bumped from the show was probably in tears,

we were in a white chauffeur-driven Lincoln limo heading to Philly. In the front were John, Yoko, and Jerry Rubin making jovial conversation. In the rear were Chris with his guitar and me looking at this weird movie in front of us starring John and Yoko. Chris leaned toward me and muttered: "Nobody's ever going to believe this. I think John is her biggest art project." We made the decision there and then to sing "We Are the Children." It was our chance to say who we are on national TV. Let's go for it.

In Philly, everything was waiting for the arrival of John and Yoko. As the car stopped, fans rushed around it. It was a struggle for them, and us, to get into the studio. Once inside everything sprang into double-time. We were rushed into a dressing room, where we dropped our stuff. Chris grabbed his guitar. An assistant briskly led us onto the set, already warm from blaring lights. We begin to rehearse our song:

> *We are the children of the migrant worker*
> *We are the offspring of the concentration camp*
> *Sons and daughters of the railroad worker*
> *Who leave their stamp on America*
>
> *Foster children of the Pepsi generation*
> *Cowboys and Indians*
> *Ride, red men, ride*
> *Watching war movies with the next-door neighbor*
> *Secretly rooting for the other side . . .*

"Excuse me." A man in a suit, the director, steps out from the darkness. "What other songs do you have?"

"How many do we get to sing?"

"One."

Chris and I look at each other. He responds: "Then we're going to sing this one."

The suit, trying to be tactful, "Well—some of the words—you know—the housewives in the Midwest might think them subversive."

Subversive? They've got Jerry Rubin of the Yippies and Bobby Seale of the Black Panthers on this show and he's worried about *us* being subversive?

"Those lines about watching war movies—rooting for the other side—what else can you sing?"

I'm feeling like Chris and I are two stray dogs trapped in a pen. I notice Mike Douglas and John Lennon sitting in the interviewer's section, shifting in their seats. We are "the problem," stuck in this muddy moment, holding

up the cameramen, who need to take their five-minute union break, holding up the audience, who've been waiting outside the doors for two extra hours while we drove from New York to finally see John Lennon in person. We are the problem holding up the whole show.

Then John Lennon pops out of his chair and steps in to mediate. Trying to find a realistic solution in an unreal situation, he knits his hands together, lightly pleading to us: "It's just a couple of lines, can't you just fudge the words a bit?"

What? He *didn't* say that, not John. Does he know what he's asking? I'm thinking, come on John, you wouldn't change "strawberry" to "raspberry" or "revolution" to "evolution" because someone told you to. Hell no!

Then the director-man in the suit continues to squeeze us: "What else do you have?"

Suddenly I get this weird feeling. It's hot and red and rises in me like mercury, zero to 110 in a millisecond. My arm fills with a superhuman power, fist clenching, index finger pointing like an arrow at the man in the suit. Then a roaring voice pierces through with a force: "YOU! YOU PUT US IN CONCENTRATION CAMPS AND NOW YOU'RE SAYING WE CAN'T SING THIS SONG!"

Everything on the soundstage freezes, like one of Yoko's conceptual pieces that she hadn't planned. Lennon, Douglas, the director in the suit, even Chris, frozen by the ice and fury of the words, still suspended in midair.

"YOU! YOU PUT US IN CONCENTRATION CAMPS AND NOW YOU'RE SAYING WE CAN'T SING THIS SONG!"

The ice cracks and the words fall and I glance at Chris, who is looking at me in disbelief, like I had just lost my mind. My focus shifts to my hand, still in a fist, the slightly jagged, unpolished nail on my index finger now pointed upward. Oh my god. That was me! The one with no words, the one with no answers, who never loses her temper. No, maybe it wasn't just me. Maybe it was more than me. Maybe I was just a channel, a megaphone, a microphone for all those who've been silenced, muzzled, subverted, compromised, told in so many words, "No, you can't say that." That roaring voice is all of us shouting: "You put us in concentration camps and now you're saying we can't sing this song!"

I turn and walk toward the exit sign—exit to where, I don't know. Tears begin to break. No! Don't break now! You can't break now, you have to walk back to New York.

The man in the suit is tailing me. He isn't directing any more. He isn't speaking for NBC or the sponsors anymore. He isn't trying to protect the

housewives of the Midwest from the words of these two Asian American saboteurs. He is busy trying to remove the arrow of blame I aimed at him. "No, I didn't do it! I didn't put you in a camp!"

He's trying to placate me, show what a good, reasonable, upstanding, generous human being he is. "You can sing any song you like!"

I stop just short of the exit door. I view my hand, which seems to be cramped in the pointing position. I examine it, thinking, *Ah, this finger has power!*

During the show, we sang "We Are the Children," the unabridged, uncensored version, leaning heavily on *Watching war movies with the next-door neighbor / Secretly rooting for the other side.* The final line, we sang with vengeance:

> *And we will leave our stamp on Amerikkka*
> *Leave our stamp on Amerikkka . . . Amerikkka . . .*

Mike Douglas and John Lennon approached us on camera, clapping and smiling, exhaling sincerity and relief that this moment was almost over.

"You wrote that song?" asked Douglas.

"Yes, mm-hmm." As if he didn't know.

"Very clever, those lyrics: watching the war movies, rooting for the other side. Right, John?" trying to erase the stain of censorship.

The victory was brief and not sweet. I felt my muzzle return as I bit my tongue. I don't believe NBC got any hate mail from housewives in the Midwest. They were exposed to Jerry Rubin, who tried to levitate the Pentagon, and notorious Panther Bobby Seale, who had, in fact, been muzzled in a Chicago courtroom, and we were no closer to revolution.

John and Yoko may have won their battle with corporate media in 1972. But years later, after the 9/11 attack, when planes pierced the World Trade Center towers, Clear Channel (now iHeartMedia), owner of more than twelve hundred radio stations, the largest conglomerate in the country, sent out a memo to its stations with "suggestions," a "gray list" of songs *not* to play. Among them was John Lennon's "Imagine."

EIGHTEEN

A Grain of Sand

WITHOUT US PUSHING, OUR MUSIC was reaching people beyond the Asian community. Gerde's Folk City, which called itself the first "honest-to-god folk venue in New York," was established in 1959 in West Greenwich Village. This was where Bob Dylan got discovered in 1961. As lore has it, he first sang "Blowing in the Wind" there. Gerde's was an influential music club where old-timers like Pete Seeger, Sonny Terry, and Brownie McGhee played, as well as rock innovators like Jimi Hendrix. Gerde's was the launchpad for Elvis Costello, Simon and Garfunkel, Peter, Paul and Mary, Joni Mitchell, and more.

Chris, Charlie, and I played Gerde's on a Monday guest night. The lingering layers of bourbon and cigarette smoke took me back to my nightclub stint in Seattle. No food was served on Mondays, and I remember rehearsing in the kitchen surrounded by stacks of dishes and pots and pans (we had not moved up in the business). But we weren't doing Gerde's to get discovered. We'd already discovered the folks who wanted to hear our music. It was a new experience that allowed our brothers and sisters to see us in a legitimate venue that was outside our normal purview. It was also a new experience for Gerde's audiences. They were used to White and Black performers, but it was something else for them to see Asian American musicians singing in "their house."

I'm reminded of what Luis Valdez, founder of Teatro Campesino, once said after he was introduced at a gathering in Europe: "This is what an American looks like." At that time, most White people still perceived us as aliens, foreigners. They had no idea what we thought, believed, or experienced. And they had no idea what our music would sound like. When one of these "you speak English very well" people asked me how long I'd been here, I couldn't help but respond, "Three generations, how about you?" The nice White girl meekly said, "Oh, me too, my grandparents came from France and

Germany." Right. So, like it or not, we had a secondary mission—to represent, to be a voice for our people to the outside world.

Events and rallies about the Vietnam War also took our music and our presence to new audiences. Most American war protesters had never met a Vietnamese person, so when Chris sang his song "Vietnamese Lament," they saw them for the first time as human beings:

> *You're fighting for freedom and that's your first care*
> *So tell me bright soldier when I get my share*
> *The women are raped and the children are maimed*
> *My country's enslaved but her spirit's untamed*
> *And this is one war that you'll never win*
> *My people won't run from your M16's din*
> *And you can't quell something that's rising within*
> *Go 'way soldiers of khaki and tin*

Singing about Vietnam also tied us to our own oppression and cry for liberation. For three major wars we were the face of the enemy. We were called "minority" so often it was tattooed in our mind and spirit. We were minor, minuscule, insignificant, and therefore powerless. So for us to see this tiny dragon-shaped country with people who looked like us, fighting a righteous cause to throw off the yoke of colonialism and imperialism, it took us beyond the "isms" and made it real. It was David and Goliath, the war of the flea, incarnate.[1] They were fighting for their self-determination, their humanity, enduring hardships—and kicking ass. And we said, "Right on!"

We could see ourselves in them. I was inspired by the women of the National Liberation Front hoisting their M16s. I was proud of Madame Binh, who represented Vietnam at the Paris Peace Accords to end the war. This was a living movie that told a different story about who we were and who we could be. The Hollywood movies we grew up with always showed us that the White Americans were the good guys and always the winners. This time *we* were the good guys and *we* were winning. Latinos had Che Guevara. Blacks had Malcolm X. Finally we had our hero—Ho Chi Minh. We were proud to march through the streets of LA's Little Tokyo as the Van Troi Anti-Imperialist Youth Brigade, taking on the name of a Vietnamese martyr.

In LA we were invited to perform at an educational forum about the Vietnam War at another folk club that Bob Dylan once dreamed of playing, the Ash Grove. It was smack in the middle of West Hollywood, and presented many of the same acts as Gerde's. Musicians Black and White—

Lightnin' Hopkins, Johnny Cash, Muddy Waters, Doc Watson, Taj Mahal, Ramblin' Jack Elliot, The Byrds—graced that stage. Young artists like Ry Cooder came there to learn from these greats of the folk or roots traditions, calling the Ash Grove the "West Coast university of folk music." Its owner, Ed Pearl, went beyond his role as a folk impresario to support his political beliefs. Panthers often held meetings in his lobby. Pearl's presentation of films and speakers about the Cuban Revolution led to demonstrations by angry Cuban exiles. A series of mysterious fires eventually shut down the club in 1973.

At this particular event, Pearl was presenting a group of Vietnamese students who were in the United States as part of a government program. They took a risk to speak about what the war was doing to the lives of people in Vietnam. Chris and I would open the program, and singer Barbara Dane was the headliner who drew the crowd. Barbara had a voice made for singing. She was born in Detroit and raised with a blue-collar consciousness. As young women, she and her sister were active labor organizers and Communists. Singing labor songs helped her organize. But Barbara could sing everything from folk to jazz. She was White, but she became a sister when she sang the blues. She absorbed the feeling and the attitude of the Black women singers by listening to them. She said, "What I was learning from them was women's attitude toward life." Her musical talent matched a fierce dedication to racial and economic justice. Like Paul Robeson, Eartha Kitt, and many more artists in the 1950s whose careers were stunted by the McCarthy-era anti-Communist witch hunts, Barbara paid the price for her beliefs. But her "pick yourself up by the bootstraps" attitude kept her going. In organizing against the Vietnam War in the 1970s, she was joining the GI coffeehouse movement, supporting and organizing soldiers against the war and helping GIs write their own songs about their experiences. We were in good company at the Ash Grove.

A few months later, Barbara Dane reached out to us. She wanted us to record an album for her label, Paredon Records. We had no illusions about trying to push ourselves or our songs into the mainstream. No record company in its right mind would be interested in us. Our music found its power and purpose in the Asian American community, an invisible market that was useless in their books. A record deal would be a capitalist venture that would require us to think about making songs that would actually sell records and make

money—mainly for the record company. We saw that as derailing us from our real work of using our music to reflect the Asian American struggle, creating a voice that was part of the cultural renaissance in the Asian American community. Simply put by Chris: "It would take the fun out of it." But learning more about Barbara and Paredon stopped us in our tracks.

Paredon was inspired by Barbara's participation in the International Protest Song Meeting held in Havana in 1967, which brought together political musicians from fifteen countries. She wanted a way to share and document this music that reflected the liberation struggles that were shaking up the world. Between 1969 and 1985, she and her husband, Irwin Silber, writer and editor of *Sing Out!* and later editor of *The Guardian*, undertook a venture that would record nearly fifty albums. Barbara was the producer, and Irwin ran the business. Paredon presented political music from all over—Latin America, Angola, Vietnam, Thailand, Palestine. Irish rebel songs, songs from the GI Resistance, and even speeches by Huey Newton, Che Guevara, and Ho Chi Minh. One of my all-time favorite albums was *Cuba Va!* by Experimental Sound Collective (Grupo de Experimentación Sonora). Barbara's son, Pablo Menendez, was one of the musicians in that band. He was fifteen when she took him with her to Cuba. He decided to stay, went to school there, and has remained a Cuban and a musician.

Paredon was a small operation that worked out of Barbara and Irwin's Brooklyn home. Working with minuscule budgets, she recorded in small studios. Some were field recordings she recorded herself on a Nagra. She produced, wrote liner notes, put together the catalogues, worked with graphic designers, and delivered the copy to the printers. Later she told me their record distribution consisted of her and Irwin filling orders from individuals and small record stores, even running the packages to the post office themselves. Paredon was a do-it-yourself operation.

The final kicker was Barbara's own album, *I Hate the Capitalist System.* How could we go wrong with that! Plus, her offer came at the right time. We'd been touring for three years. Chris and I were squabbling with disagreements that always evaporated when we got on stage. But tension brewed from our lives wanting to go in different directions. Politics was pulling Chris into an organization, Workers Viewpoint. I wanted to go home to Los Angeles. If I was going to be in the movement for the long run, I needed to dig my roots into my community. The chemistry of our musical relationship would be hard to match, but I was beginning to feel like a cheerleader. We had to move forward to keep growing. Unlike most albums, *A Grain of Sand*

would not be an entrée into a career but a finale, a way to document the work Chris and Charlie Chin and I had done together.

The recording was a proletarian venture. We had two and a half days in a no-frills, compact, sixteen-track studio aptly called Sweet Sixteen, with Jonathan Thayer engineering. That was all the budget allowed. Most of the songs were recorded the way Chris, Charlie, and I performed them, except we had the rhythms of Attallah Ayubbi on congas. Charlie did some over-dubbing on bass and added some nice touches with a flute on "Somos Asiáticos." Most songs were done in one take, two at the most. Chris liked to tell the story that his voice cracked on "We Are the Children" and he wanted to do another take, which would have taken all of four minutes. But Barbara insisted the first take was fine. Chris shrugged and we pressed on. He later said that flawed moment became one of his favorites on the album.

The song I most enjoyed recording was "Free the Land." Our friends from the Republic of New Africa, Mutulu Shakur and Attallah, always greeted us by saying "Free the land," implanting that mantra in our consciousness. Chris picked it up and made it into a song. Having friends like Eddie Kochiyama, Attallah, and Mutulu sing on the track made it a real people's song. Indeed, it was a people's album in every sense. Karl Matsuda and Arlan Huang, artists of the Basement/Yellow Pearl collective, volunteered to do the cover. There were no liner notes from a famous music critic; we wrote our own statement about the work in a booklet insert. When I reread it recently, I chuckled at its politically rigid language of the time, especially because the songs are simple and human, more poetic than propaganda. In essence, I still agree with its treatise on using art for social change, with three main elements at its core: *content*: the story, the message we want to communicate; *form*: the delivery system, the style, the tempo, the feel; and *context*: where and for whom it is performed.

We were always aiming to write a good song, a song with depth and universal meaning, a song that might last a while. Though we didn't have the exposure or audience of Stevie Wonder or John Lennon, for the Asian American community, our songs helped make a crack in our wall of silence. With the chord changes of some of the songs published in *Yellow Pearl*, people in our movement could now learn and perform them. It surprises me that I still enjoy singing some of those songs, with new layers of meaning that come with time. Now it's a form of memory of our movement that still rings true today.

In the 1990s I reached out to Barbara Dane about the masters, wondering if they were in storage in someone's leaky garage. "They are," she replied, "but

the whole Paredon collection was just donated to the Smithsonian Institution." That meant *A Grain of Sand* would be preserved and distributed forever by Smithsonian Folkways as part of Paredon's fifty albums that document the musics that helped push political movements throughout the world during the 1960s and 1970s. We are in good company. The Smithsonian was nice enough to give us a master that allowed us to print and distribute *A Grain of Sand* with Bindu Records, a company I started in 1996 with Derek Nakamoto.

In 1997, Chris, Charlie, and I started doing a series of reunion concerts. The first, at UC Berkeley, was in honor of Yuri Kochiyama. It had been almost twenty-five years since we made *A Grain of Sand*. As usual, we had one rehearsal, and it felt like our last gig had been a week ago instead of twenty years ago. As we walked on the stage of Wheeler Hall, the audience was a weird mix of gray-haired movement comrades and college students our children's age. Many students in the five-hundred-seat auditorium had their notebooks open, pens in hand, probably enticed to the concert by professors who promised extra credit. They were there to study these OGs they'd read about in their Asian American studies classes. I think they were surprised we weren't on walkers and canes. After the third song, their notebooks were on the floor. They were listening and laughing. The songs, written a quarter of a century before, still had meaning for Asians, some of whom were fourth generation, some immigrants. I think they were surprised at songs about the Black struggle and our Spanish songs and stories about our adventures working with Latino communities. But the music still had the funk and the feel that young people could relate to. We showed we weren't ready for our rocking chairs; we could still rock on our own.

After I left New York, Chris began teaching at Manhattan Country School, a collaborative learning community with kids from kindergarten through eighth grade. He was a born teacher and always found a way to use his music. Each year he created a musical that his kids performed. He married Jane Dickson, also a teacher, and they had two boys of their own. He went on to law school and taught law at the University of Massachusetts and later at the University of Hawaii. Hawaii was a place his hapa-haole boys could fit in. Even as a law professor he brought out his funky guitar and carved new songs from his experiences and love of Hawaii. The troubadour in him was still alive. I think of Chris as our James Taylor—he was a great songwriter.[2]

In 2005, Chris died of a rare blood disease at the age of fifty-four. The young filmmaker Tadashi Nakamura made a documentary, *A Song for Ourselves*, capturing his life and his music. Tad had the next-generation musicians DJ Phatrick, Bambu, Kiwi, and Geologic make a mixtape with cuts from *A Grain of Sand*. I was happy that young folks could find a way to make our music relatable and relevant to their peers, adding their own rhythms and rhymes.

NINETEEN

Free the Land

MFALME WAS HIS NAME WHEN I MET HIM. It means "king" in Swahili. It was the third of four chapters in his short book of names. Each name was a world of experiences, a transformation of consciousness.

It was Yuri Kochiyama who introduced us. When you hung with Yuri, you never knew where she would take you—you just knew it would change you. It was early in 1973 and we were meeting with the Republic of New Africa (RNA) in the noisy cafeteria of Harlem Hospital, where conversations would be difficult for the FBI to monitor—something that had to be considered in those days. Two brothers, Mutulu Shakur (Jeral Williams at the time) and Mfalme, warmly greeted Yuri with a salutation, "Free the land!" They were all "citizens" of the Republic of New Africa. This was not a country, but rather a vision that emerged from the 1968 Black Government Conference, an extension of Malcolm X's strategy based on revolutionary nationalism and international law. They saw Black people as an oppressed colony within the United States and declared independence for all people of African descent in it. They defined five states of the Black Belt South (Alabama, Georgia, Louisiana, Mississippi, and South Carolina) as their national territory. The RNA even had "consulates" in New York, Philadelphia, Chicago, Pittsburgh, San Francisco, Los Angeles, Cleveland, and Washington, DC, and began meeting with foreign governments, including the Soviet Union, Tanzania, Sudan, and China.[1] It sounds like a wild idea today, but they were trying "by any means necessary" to liberate their people from oppression through a UN plebiscite and cession of land to nonviolently establish the Republic of New Africa. Thus their mantra, "Free the land!"

Mfalme was six-foot-three, a Zulu warrior in a black leather jacket. He hovered over Mutulu, whose demeanor was friendly and who greeted me as

"sister." I guess he trusted I was cool because I was with Yuri. Mfalme, on the other hand, barely acknowledged me with a wordless nod as we all slipped into the curve of a large booth. He kept his distance as he folded his lanky frame under the table. (Later he told me he thought I was "high yellow," a light-skinned Black woman.) Mutulu and Yuri jumped into plans for their demonstration before the UN. After a while, she proposed the idea of Chris and me singing at the rally to attract Asian American supporters. Mfalme listened, hands knitted, head down. He communicated with Mutulu in a coded, cryptic language of their own involving eye contact and precise, meaning-filled cadences. I felt like a foreigner trying to follow.

On the day of the UN demonstration, Asian Americans joined the Black community in support of the RNA. In the shadow of the UN we marched holding bold signs—"We Demand a Plebiscite!" and "Free Political Prisoners" (see photo 15). We listened to fiery speeches demanding a plebiscite from the UN. In the background I saw Mfalme's tall frame scanning the crowd, arms folded, doing security. As the emcee of the program, Mutulu did his best to introduce us as Asian brothers and sisters in the struggle. At that time in New York there was little contact or interface between Blacks and Asians except for Yuri, whom the Black community now claimed as one of their own. Chris and I knew the best way to express who we were was through our music.

At the start of "We Are the Children," the audience of Black Nationalist revolutionaries looked at us politely. As the song unfurled our history—*We are the children of the migrant workers / We are the offspring of the concentration camp*—we could feel them warming to us. By the time we sang *We are a part of the Third World People who will leave our stamp on Amerika!* they were with us all the way. That song wasn't one of my favorites, but the final moment was powerful and we belted it out, with feet planted and fists piercing the gray sky: *Amerikkka . . . Amerikkka . . . !* I felt the force of our ancestors come through us (see photo 16). The crowd erupted, "Right on! Free the land!" We were no longer foreigners or outsiders. We were brothers and sisters. With a simple song and the presence of our small contingent of Asian Americans, a bond of solidarity was formed, just like Yuri knew it would.

As the sun waned and the rally thinned, Mfalme became fully present, with a smile that took over his whole face, revealing the perfect sliver between his front teeth. I was surprised by the one-hundred-and-eighty degree turn from his attitude at the Harlem Hospital cafeteria. He spoke to me as if seeing me for the first time, and I guess he was. Now he was my tall shadow,

assuring Mutulu, Yuri, Chris, and my Asian comrades he would be responsible to see me home. Okay, who is this brother Mfalme?

I was gently separated from my flock. I don't know why, but I didn't resist. I laughed off a twinge of embarrassment and parted from my friends. Mfalme and I were a spectacle of opposites walking into the chilly sunset. In those days, seeing a Black man with an Asian woman was far from normal, even in New York. We were close in age—I was thirty-three and he was thirty-two—but he seemed older. We were both Scorpios. He was born on the same date as my father, October 23. Otherwise our worlds were as far apart as the Bronx and Los Angeles. As we started the long walk from the United Nations to my apartment on West 91st Street, we filled the distance with our stories. At Central Park and 59th, we decided to take a cab. A commanding figure, he pierced his forefinger into the twilight sky, but cabs with empty signs whizzed by as if he were invisible. He chuckled, stepped back, and gestured to me, "I think you better do it." I took his place, barely raising my hand, and a cab pulled over. I gave Mfalme an "Oh I get it" look and we jumped in. That was my first lesson in "Life for a Black Man 101."

He wanted me to know his story, not from his ego, but as part of a bigger story his people lived, like he was giving me something I needed to know. His closely cropped head made him look like a majestic ebony sculpture. He was hard *not* to look at, yet he seemed unaware of it. He was good at talking story, a humble homegrown philosopher with a rusty voice. He wanted my stories, too, mining for our places of connection to deepen our understanding of who we were in the world and why we had come together at this moment.

Peter Jeffreys was the first chapter of his life. He was the fourth of six children of Claude and Lyla Jeffreys, migrants to New York from North Carolina during the Harlem Renaissance in search of opportunity and human dignity. His father found work as a cabbie and his mother was the superintendent of the Harlem apartment house where they lived. Her seamstress skills earned her extra dollars making fashions for the ladies in her building.

By the time Peter was born, they had moved to the Bronx. It was still "a nice place to live," but as he grew up, the Bronx was coming down. With a vengeance, drugs shattered the fragile color alliances among poor Irish, Blacks, and Puerto Ricans. As a boy, when he came home crying, his mom would send him back out the door: "You go out there and stand up for yourself." Growing up, he thought he was an ugly duckling, but Peter was gifted

with artist hands. While I was with him, he started a quick pencil drawing of my face that amazed me with its subtlety and detail. But the school's White teachers and administrators were blind to the talents of Black boys. It seemed their job was to stifle their ambitions. When Peter was caught in scuffles with Puerto Rican boys, he always caught the blame, being the darker.

In summers he escaped the heat and hard streets when he and his siblings traveled down South to visit Grandma Annie. She and her husband had gone from being cotton sharecroppers to owning two city blocks in Raleigh, North Carolina. Annie grew her own food and ran a boardinghouse and a restaurant that fed more than a hundred people a day. In Raleigh, Peter experienced plenty of love, freedom, and an abundance of Grandma Annie's good cooking. "She always made sure we had some change in our pockets. I thought we were rich!"

Peter X, the second chapter in his life, began the day he heard Malcolm X speak. "I was seventeen. My older sister Anne took me." She had a good job in a bank but worried for the brothers. Malcolm spoke truth to all generations who knew oppression. Even their mother came to hear Malcolm, and she wasn't afraid of giving him feedback.

Peter was ready to drop his "slave name" and the oppression tied to it. The X symbolized the unknown, what he could become. Peter X became part of a nation that embraced rather than rejected him, a nation that promised dignity, order, and purpose to his life, a nation above and beyond America: the Nation of Islam. From 1958 until the day Malcolm X was killed in 1965, Peter X was a devoted foot soldier and a bodyguard for Malcolm. Malcolm was his mentor, his guide into manhood. He told me, "Malcolm taught me how to see with more than my eyes."

Peter X was a good Muslim, helping to set up several mosques for the Nation along the East Coast. He married a Muslim woman and fathered Craig and Aisha. He became disciplined, responsible, filled with a sense of purpose. He developed a successful business painting apartments, developing a team of Black painters who worked with swift and precise efficiency. He enjoyed blowing the minds of his well-off White customers. "They never saw Black folks move so fast. They tried to slow us down by offering us coffee and lunch. We knew what that was about." Walking the tumultuous and danger-ous path of political and spiritual consciousness with Brother Malcolm

formed him. In the bitter split between Malcolm and the Nation, he stood steadfast with Malcolm.

On the afternoon of February 21, 1965, he was in a taxi heading for the Audubon Ballroom on 166th Street and St. Nicholas Avenue. Malcolm was speaking to his Organization of Afro-American Unity. Peter was late. Over the radio, Peter heard the breaking news: Malcolm had been shot.

The moment Malcolm X died, Peter X died. Guilt was a word not strong enough, pain a well not deep enough. Malcolm's followers split in all directions, and Peter X went down. He was lost, he became nothing, less than nothing. As a being with no name, he lived a life of forgetting. He sank into the dark dens of subterranean Harlem, sharing heroin needles in the squalor of shooting galleries. He zigzagged in and out of jails, but he was learning, even at the bottom of despair, beneath the shadows of shadows, that brotherhood existed, humanity existed. Still, he could not escape his conscience.

One day in a prison cell, filling his time making art, he began to remember who he once was. "I was in prison when it finally hit me: Is this what Malcolm would want for me?" He would have died for Malcolm. Now he had to live for him, to carry on his work.

Mfalme, his life's third chapter, was his reemergence among the living. Reconnecting with Malcolm's vision, he became a citizen of the Republic of New Africa. Serving others was a way to heal himself. He understood the suffering of Black people, the wounds of the Black man. He knew what it was to be at the bottom. He got a job weaning people off heroin, the drug he knew too well. "The system is flooding our communities with drugs to make us passive victims. We're turning them around and making revolutionaries."

When the sun rose, we were still sitting on the steps in the frigid hallway of my brownstone at 52 West 91st Street, our words surrounded by steamy clouds. The gray light of a new day seeped through the frosty windows of the front door. I don't remember eating or drinking a cup of hot coffee, but we were awake and warm with our stories. We didn't venture ten steps to go inside my apartment. We weren't ready to enter that door yet. At around eight o'clock, he checked his watch: "I have to go." He had to be at work at the Lincoln Hospital Detox Program.

I was touched by his journey—that after all he'd lived and lost in his thirty-two years, his spirit was intact. He had a sense of humor, a love for life, and a love for good people, even White people, whom he no longer viewed as devils. His anger was focused on his political work. He wasn't bitter.

A few days after our meeting, we were in that free-falling moment—that mindless, magical, vulnerable moment when the heart begins to open, to trust, to fall in love, into the unknown. Just when I was beginning to feel comfortable in the free fall, he confessed to me there was another woman, the woman with whom he lived.

No, no, no. It didn't take me long to figure out: I'm the other woman. Maybe it's not too late. Maybe I can gather my wits and water wings and swim out of this pool. I told him, "I'm getting ready to leave New York. I've got boxes filled with three years of my life packed up and ready to ship. I'm getting my one-way ticket to LA. I'm getting out of here, I'm gone."

"You can't go yet."

It was true, I couldn't go. I knew I was trespassing, first without knowing, then knowing. But I couldn't leave. I knew it was wrong, politically wrong. We were building relationships between our communities. Now I was taking a Black man away from a Black woman.

"I want you two to meet."

What? I resisted at first. But then, I thought, it would make her a real person, someone I couldn't imagine away.

Bahija was kind and tolerant—too tolerant. I couldn't understand it. I would have been infuriated. I would have screamed to the rooftops. "Get out of here! I don't want to see you. I don't want to know you! Get out of our lives!" But she was willing to endure an intruder more than I was resisting intrusion. Maybe that was a way to keep him. She knew him, they lived in the same world. I was the outsider, again. For the next several weeks, I lived in the uneasy state of being a lover and an intruder. I was a tourist in his world. There was more he wanted me to know—the truth of who he was, his virtues and his flaws, his fault lines. He wanted me to know his world.

Mfalme didn't go to college. He earned his master's degree in Street Knowledge. In the following days he took me through Harlem, through the streets he walked and worked with Malcolm, who called Harlem The Casbah. Passing by a gutted brownstone, he said, "See this house. I used to shoot up in there." During the hopeful heyday of the Harlem Renaissance it might

have been the elegant home of a well-off Black Harlemite. Now it was a place where the hopeless tried to forget their dreams with a needle or at the bottom of a bottle.

"Esther Phillips, the singer, used to hang there when she was down. Li'l Esther, we called her, a nice sister."

At St. Nicholas and 125th Street, we stopped at Thomforde's ice cream shop, where Yuri waitressed and participated in political meetings between serving. She said Malcolm X would often hold court there over a banana split.

At 125th Street and 7th Avenue, just short of the Apollo Theater, he showed me a storefront that stood out among the faded Harlem shops and liquor stores: the National Memorial African Bookstore. It was *the* reading room for the civil rights movement. Lewis H. Michaux established the bookstore in 1932. Now it was packed floor to ceiling with two hundred thousand books containing the history, culture, and politics of Black people as well as other people of color. Michaux believed, "knowledge is power and you need it every hour." When it was on Lenox Avenue, Malcolm used the storefront as a backdrop for his speeches, and Peter X was with him, doing security. Michaux was still teaching and preaching as we wandered through the store. It finally closed in 1974, and Michaux died in 1976 at the age of eighty-two.

Though tattered, Harlem still bristled with daily protests against a federal building to be built there. The cultural memories of Langston Hughes's poems, and music from the Apollo and the Cotton Club, still echoed. Harlem was a space with a sense of history, hope, and belonging. But the Bronx, the place just across the river where Mfalme was born, past the great Yankee Stadium, was another story. It felt like a different country.

The day seemed too cold and gray for a tour, but Mfalme had a spring in his step as he guided me through the Bronx sidewalks, avoiding shards of glass, fallen bricks, discarded TVs, heroin needles, crushed Coke cans, jobless men holding court on porch steps, and kids playing in giant ruins of gutted buildings. It was beyond a decayed city: it was an urban war zone. The Cross Bronx Expressway had sliced through a once-thriving middle-class Jewish, Black, and Puerto Rican community and took the heart out of it. A tree may grow in Brooklyn, but the few I saw in the Bronx weren't healthy enough to bring charm to the charred buildings hollowed by fires set by landlords for insurance money. The domino effect of White flight, free-falling property values, greedy landlords, and crime left behind taggers with spray cans screaming in graffiti upon graffiti: "Broken promises!" "I'm here! I'm alive! Gimme respect—a decent life!" Some of the tags were crude, some colorful

artworks. Who knew that soon—by the mid-1970s—young people of the South Bronx who felt abandoned by the system, and even by the movements and their leaders, would seek a new way to channel their energy from the violence and despair of this wasteland and turn it into a creative force. The sounds and rhythms became beats and scratches woven with bullet-fast words and physicality. They turned their world of nothing into something today we call hip-hop.

"Hey Craig!" Mfalme caught sight of his son walking on the other side of the street. He ran to catch him and brought him over to introduce me. Craig was fourteen. His open smile mirrored his father's. He was polite toward me but a little puzzled. Watching him walk away, Mfalme confessed, "I haven't been much of a father to my children. I hope they understand one day, I'm doing what I do now to make them a better world." I couldn't imagine living in the Bronx, but to him, it was his turf, his world. He wasn't abandoning it; he was trying to change it. With property values low, new construction was going up, and part of Mfalme's organizing work was with the Coalition for Minority Construction Workers, confronting and "educating" construction companies to give jobs to the Black and Puerto Rican workers living in the Bronx. Forcing them to change was dangerous work.

We were heading toward the hospital named after the president who helped end slavery. Lincoln Hospital was, in fact, built in 1839 to receive ex-slaves escaping from the South, and had changed little since then. Lincoln was where Mfalme was born, and it now housed the drug program where he worked. As we walked toward the building, people greeted him and thanked him for helping them to get clean, for saving their lives. I could see the respect and love they had for him.

Lincoln Detox Center was a revolutionary drug program, and not just because Black Panthers and Young Lords did a "takeover" of Lincoln with community support to establish it.[2] It was revolutionary because of the *way* they approached the drug epidemic that was debilitating the Bronx. They were thinkers who understood the continuing systematic oppression of Black people, from slavery to drugs to mass incarceration (thanks to an influx of drugs from Southeast Asia). They were refusing to replace heroin with methadone, yet another addiction that would tether them to the system. It was Mutulu Shakur, Mfalme's comrade, who learned about acupuncture as a drug-free means of detoxing when Yuri Kochiyama suggested it to heal his son's injury. Mutulu spearheaded the strategy to use acupuncture to wean and clean the body of drugs. He became a doctor of acupuncture and set up

a training program for a cadre of acupuncturists. Lincoln Detox pioneered the "five point auricular" protocol that is now used internationally as a drug-free treatment. An important part of the healing process was understanding the circumstances and oppressive systems that lead people to drugs. That was Mfalme's area of expertise. He was a counselor who led their political education. He wanted to turn them from victims into revolutionaries. China's revolutionary barefoot-doctor tradition of acupuncture as health care for the rural masses was thus taking root in the Bronx. While the program was embraced by the community and even visited by a UN delegation that recognized its groundbreaking work, Lincoln Detox was constantly under attack by the hospital administration and the government. (It was eventually closed down in 1979.)

One day Mfalme took me to the movies. One of his best friends met us as we were standing in line for tickets. He introduced me to Fry, a soft-spoken handsome man with a sweet demeanor who also worked at Lincoln Detox. From the balcony the music of Curtis Mayfield bumped us into a groove. It was an action-packed movie about a Harlem drug dealer, a Black-on-Black movie like nothing I'd ever seen. From the balcony, I could see the whole theater was filled with a Black audience and they were all participating like they were part of the movie. The movie was *Superfly*, Hollywood's first blaxploitation film, directed by a Black man, Gordon Parks Jr. As the three of us stepped out of the theater into the flashing lights of Times Square, Mfalme informed me, "That guy—Superfly—was Fry! The story was based on his life." Far out.

Mfalme was a scientist when it came to racism. He had highly developed sensors from years of experience and introspection. He confronted racism, even among his own comrades, poking holes in their colonized minds. "You are blacker than me, but you call yourselves Puerto Rican." Racism did not make him hate White people. He accepted and enjoyed people as human beings first. His friends told me, if he liked you and you were wronged, no matter what color, he would lay down his life for you. He was Muslim because, he said, in Islam "it doesn't matter if you are Black, White, or Yellow." He believed Islam was the one place everyone was equal, no matter what color or class you were. I had never known a Muslim, but I heard they prayed five times a day—though he didn't. I knew they didn't drink liquor—but he did. But one rule he faithfully abided by: he did not eat pork. "Pig" was something he detested. He avoided it like, well, "the pigs," a term that had grown into use with the Panthers. He wouldn't contaminate himself with food that was cooked on the same grill or even in the same kitchen as pork.

His mother told me, "He'd shoot that poison in his arm, but he wouldn't touch bacon." It wasn't hard to figure that his repulsion regarding the "pig" represented something much deeper.

Out of respect for his obsession, I tried to give up pork as well. As it is one of Asian people's favorite, most succulent meats, this was no easy feat. On the first day of my decision, I was put to the test. Mfalme was a conga drummer, and it was the first time he joined Chris, Charlie, and me for a gig, at Hunter College. After the concert, there was a reception with refreshments. The centerpiece was a luscious mound of steamy white *cha siu bao*, my favorite pork-filled bun. It was tug-of-war between my love of *bao* and my love of Mfalme. And it was a close call. I managed to carefully peel off enough of the fluffy bun saturated with the pungent aroma, avoiding the pork, to satisfy my gluttonous pleasure. It was close, but Mfalme won. I've stayed away from pork to this day.

One day he asked me, "Don't you have another name? I can't call you JoAnne."

I did have another name, my Japanese name. Most of us have Japanese middle names, names we took for granted but never bothered to claim, as we strived to be Americans. I'd looked at my birth certificate countless times but never saw it until now: "First name: Nobuko; middle name: JoAnne; last name: Miyamoto." Nobuko was my real name! It was always there—I just hadn't seen it. I'd pushed it to the middle, almost squeezed it out of existence. He made me see it for the first time. I researched further and found it meant *spirit* or *faith*.

"Nobuko!" He clapped his hands and raised them to the sky. "Yes, that's you!"

Becoming Nobuko transformed how I saw myself. A name has power. It's the first label put on us. When said out loud it has a sound, a vibration, a history, a series of connections and relations. In the 1960s and 1970s, many Blacks changed their names as a political statement. Mary Kochiyama became Yuri. Her daughter Lorrie became Aichi. When I took on Nobuko, my life and values as JoAnne shattered. When Mfalme or anyone called me Nobuko, I breathed in a new image of myself. I felt rooted. I felt whole. Committing myself to my real name meant asking others to participate as well. You don't just put a new label on yourself and expect everyone who has known you to jump on the bandwagon. Some stumbled for a few weeks, but eventually got reprogrammed. Others were stuck on JoAnne, rolling their eyes, like I was asking too much. Most difficult was my mom, even though

she was the one who put Nobuko first on my birth certificate. In time she adjusted. For those who couldn't transition I learned to be forgiving. But I knew I was now Nobuko.

Our relationship was part of the community building between our movements. The camaraderie with Mutulu and Mfalme and others in RNA was even celebrated in a song, "Free the Land." Mfalme with his congas played on the *A Grain of Sand* album. Music was part of bridging our worlds. But I was finally finding the will to do the right thing and pull myself away from Mfalme. I bought my plane ticket, mailed three years of boxes back to Los Angeles, and said my goodbyes to my comrades. With plans for short returns for concerts and events in the works, I was finally going home!

Then I found out I was pregnant.

I was thirty-three but had never felt my clock ticking, never contemplated having a child. Not that I was against it, someday. From this place of never, I surprised myself with a feeling of joy. He was happy, too. In that ethereal, timeless, imaginary, impractical place it somehow felt okay, it felt good, it felt right, even though everything about it was ostensibly wrong. We came from different worlds, but there was something real, something solid, between us. Perhaps the only place our two worlds could exist together was in this child.

At this point, I didn't care about getting married. Antonello had two children with his partner without being married. But this caught me off guard. What did I really want? What did a child need? I was afraid to want Mfalme, to want anything from him. His relationship had severed, and I tried living with him in the Bronx, but life was unstable, his political work difficult. Could I raise a child in this rocky terrain? I needed distance to decide. But beyond what we could see or know, something deep was shaping our lives.

Before I left, he took me to visit his mother, with a bouquet of roses. It was Mother's Day and he loved his momma. Mrs. Jeffreys concealed her confusion at her son bringing a Japanese American woman to her house. But I guess she expected just about anything from her Peter. The apartment was a gallery of framed family pictures with a scattering of pieces of art. "I did that when I was in jail," he said of a sculptured, king-like head.

His mother stood tall and slender. The apron she wore didn't hide her dignity. I noticed the centerpiece in her kitchen, a sewing machine. It wasn't a Singer, like my mom's, but a professional power machine, threaded and

ready, with piles of material around it. Both our mothers were excellent seam-stresses who made clothes for all their children. As the superintendent of their Harlem apartment building, Mrs. Jeffreys shoveled coal in the winters but still showed up at the children's school looking regal in her tailored dress. Sewing was a skill she passed on to all her four boys and two girls. In fact, Mfalme told me, she gave each of them a power machine when they gradu-ated from high school. Ms. Jeffreys ran a trimmings shop in the Bronx. She was a hardworking entrepreneur.

Before leaving, he told his mother I was pregnant with his child. She didn't flinch. Folding her arms, she took a long look at me, neither friendly nor hostile. I couldn't imagine what she was thinking. "How old are you?"

Feeling like a bad child who should know better, I replied, "Thirty-three."

She broke into a smile and asked, "What took you so long?"

What Will People Think?

CROSSING THE COLOR LINE IN THE OUTSIDE WORLD is one thing, but doing so within one's family, one's community, is something for which you can never prepare. I had committed the cardinal sin for a Japanese family, a dreadful act that would have lifelong consequences. My love for a Black man would bring shame to myself and my family that would weigh us down like an anchor to the bottom of the sea. But my dilemma was double. In those days, single mothers were nonexistent, invisible, unthinkable in our community. If indiscretions happened, and of course they did, couples who got pregnant got married, at least for a while—some for a lifetime. Japanese people didn't need a shotgun: our weapon was tradition, our weapon was shame.

I was at Senshin Buddhist Temple down the street from the University of Southern California. All I knew about Buddhism was from a book I loved, *Siddhartha*, written by a European, Hermann Hesse. My friends in the movement thought Senshin's minister, Reverend Masao Kodani, was a cool guy. A sansei born in Watts, he grew up hanging with brothers. The closest thing he got to religion was when they took him to the Pentecostal Church. He liked the music. In college he took a turn and decided to become a Buddhist priest. His father freaked: "Two worst professions, priest and lawyer!" Undeterred, Reverend Mas (as we affectionately called him) went to Kyoto and immersed himself in Buddhism as a Japanese tradition. He returned as a priest assigned to Senshin, and he came with some revolutionary ideas. While Japanese Buddhist kids sang "Buddha loves me this I know" to the tune of "Jesus Loves Me," he was getting folks to return to chanting in Sanskrit and Japanese.

The temple's blue-tiled sloping roof looked familiar. Then I remembered: Senshin was the temple where my Auntie Hatsue and Uncle Fred were

members. This was the place where I was sent to Japanese school! When I was ten, I had no desire to spend Saturdays learning Japanese and writing hiragana. I wanted to learn ballet. But here I was, twenty years later, returning like a homing pigeon (and I hate pigeons). I was returning with a life question, a "to do or not to do" question. I was returning from three years in New York to plant my roots, to do my work, here in this community where I came from, in this place I wanted to belong. I didn't want to be an outcast in my own community.

"I'm pregnant," I blurted out, "and I don't know if I'm going to get married." Mas looked at me, showing no signs of judgment. We were sitting in his office. The sun shined on his plants through the small window. The shelves around him were filled with Buddhist books. There were messy piles of paper on his desk and an IBM typewriter he could swivel to for writing his sermons. He wore a navy-blue cotton kimono jacket over his white shirt and black pants, always ready to do rites for a sangha member who died at home or in a hospital. This is what ministers did on days that weren't Sunday. His left hand laid gently on the arm of his office chair, palm up and open, in casual meditation pose. Hugging his wrist was an *ojuzu*, a bracelet with twenty-six beads, a miniature version of the 108-bead formal *ojuzu* that priests meditate with to remind us of our 108 delusions. We were the same age, but he was wiser than me. Priests need to be wiser to help us with our messed-up lives.

"So, what do you feel?" he threw gently back to me.

What did I feel? I felt panicky. I felt scared. I feared how my family was going to react. What will the Japanese community think of me? I'd never worried much about what my people thought of me, but I was worrying now. "He lives in New York. He's in the movement, the—Black movement. He's Black." There, I said it. I said it out loud and the walls didn't fall down. I'm still breathing. And Reverend Mas is still sitting there, palm relaxed and open, smiling gently, nodding his head.

"What will people think of me?" Meaning our people, these *chanto, chanto* people who do things just so. They cultivate perfect gardens and put three flowers in a vase and make it look like art. And here I am, breaking their rules, breaking their code. I am their bull in a china shop, ready to break their delicate pottery.

He chuckled, "Oh, they'll talk about you at first, but after a while they'll forget, and you'll be like everyone else." My breath slowed. He knew them. Maybe he'd broken their rules, too. "So what do you want to do?"

"I feel like I should keep the baby." I didn't know why, but I had this feeling. I needed to keep this baby. I had been pregnant before, had an abortion before. But something was different this time. There was the love, yes. But it was a love surrounded by uncertainty, suspended in an unknown time and space. We lived in different worlds. It was hard to see myself in the Bronx raising a child. I wanted to be here, to work with my community, near friends, my family, if they'd accept me. I couldn't see Mfalme living here. His work, his value in the movement, was in New York, in the streets where he'd walked and worked with Malcolm X. But how would I support my baby and myself here? I had no job. Nothing made sense, absolutely nothing. "I want to keep the baby."

He turned his palm over on the arm of his chair. "Don't go against your feelings."

My next hurdle was much higher. It was a wall with no ladder to climb to see the other side. How would I tell my family? I knew this was the last and the heaviest "never" on my mother's list. Parents have different ways they show their love. Some show it with cooking. Some with presents. My mother's way was sewing. Perhaps she was relieved or happy that her prodigal rebel daughter had returned home. She was sewing me a pair of pants and called me to come for a fitting.

There was no getting around it. I was four months pregnant and couldn't fake thinness. I didn't want to fake anything. As she draped the blue wraparound pants on me, I knew I was caught, lassoed, corralled like a wild horse with no escaping. This was my moment. She was on her knees next to the double bed where she and my father slept, holding a few pins in her lips for the fitting. My heart was racing so loud the sound was vibrating off the room's gray-green walls.

"Mom, I don't think these pants are going to fit me for long." The pause couldn't have been fuller. There was no easy way to deliver my words, no way to soften, no use trying. "I'm going to have a baby—the father is a wonderful person. I'm happy, I'm in love. Mom—he's Black."

My mother heard each word like knives cutting through skin, cutting through bones, through wishes, dreams, her fearful heart. She sank deep into the rug, pins falling from her mouth. My first impulse was to say I was sorry, but I wasn't going to apologize for this baby I already loved. This was my mother who had supported me, who gifted me with her efforts, her time, her

insight, her love, to achieve my dream/her dream/my dream. I wanted and needed her, most of all, to understand what I was going through. This was the hardest decision of my life. I wanted the miracle of her acceptance.

From her shock she growled, "You did this because I married your father." At first, I didn't understand. Then I realized she thought the pain of my rejection as a mixed-blood child was why I was doing this. Somewhere deep in her mind, she had carried this all these years.

Her next words were, "What will people think?!" It was a pronouncement that came from a deep tradition that kept our people, for better or worse, in their social order. "What will people think" was also in my DNA, but something more important was driving me to cross beyond it as an unspoken dialogue with my mother unfolded.

What *would* they think? I'm a failure, you're a failure. Do you think they'll think it's a shame, this Japanese woman with this Black man? Why is it a shame? What *are* these people thinking? Why do they think that way? What do these people know, anyway? What do they know of the mystery between two people? What do they know of the hearts and minds of two people? It's not just black and white or yellow. What about the blues, the teals, the indigos, the saffrons, the violets, the verdant greens? They only see the outside—I said in my mind.

"What will I tell your Auntie Hatsue?" My mom's sister, her *neisan*, was her cultural and moral compass. She married a man from Japan, and she had one beautiful, proper daughter, Kay, who married a professor at USC. Kay and I began on the same starting line, but somehow my track went south, went haywire, went rogue. "What will I tell the family? What will people think?"

The dialogue I couldn't dare utter aloud continued in my head: You think the world will not accept this mixture? It was okay when my grandfather married a woman with auburn hair and alabaster skin. It was all right when you married his son. But I'm stepping down instead of up. This puts me in a different position in the pyramid—White on top, dark, darker, darkest on bottom.

We want to keep our distance. We want to live our lives in the delusion that we are better than Black people. We want to keep our distance because deep down inside, we don't want to be treated as they are treated. That's it, that's it! It was bad enough how Japanese were treated. Now my baby child will bear an even heavier burden. There is racism in my people. There is a caste/class system. But what will get us beyond that? Maybe she's trying to

protect me. But she can't understand. I'm ready—for the joy and the pain. My child is not a burden. It's a gift. My heart was pulling her. I wanted her to cross over this wall, this wall that divides, this line of color, this senseless construct that limits our humanity. It's just a wall of people's thinking. It's not made of stones or wood or concrete. You can walk through it if you want to, make it disappear with what you're thinking, or not thinking. Mom, please—cross that wall, cross that line. You can do it, you can do it.

But the wall inside her was too high. I left her in the bedroom, on the floor, a moat of tears around her. She stayed there for three days and nights. My father, usually the voice of reason, said with a bitterness that never quite left him, "Look what you've done to your mother!" I left without knowing if I would ever see them again.

The next few months I shuttled between Los Angeles and New York, between the angst of uncertainty and moments of hope. How would I live with my decision to have this baby? Could I, should I, live in New York? Would this be another child Mfalme would see across the street or across the country and say, "I hope he or she understands I'm doing this to make a better world for my children." Would this Afro-Asian child suffer from an absent father? How could I fill that gap, make a living, be a mother, and still work to make change for my community and for the bigger world?

Mfalme came to Los Angeles to visit my world and maybe imagine himself in it. The contrast between New York's concrete jungle and LA's neat bungalows, jade lawns, and tree-lined streets made him whoop, "I'm going to tell my New York brothers and sisters to drop their leaflets and their guns. This out here is liberated territory!"

He brought along Mutulu, and they spoke "Free the land," spreading their New York vibe and revolutionary spirit to Asian and Black movement brothers and sisters. Our relationship was growing new bonds and alliances. Sparks ignited when these two streetwise political New York Black brothers did a talk with youngbloods at the Yellow Brotherhood. Struggling with a drug epidemic and conflicts with young Blacks, they soaked in their wise words. Mfalme's drummer spirit came out when he was pulled up to join with *taiko* players at the wedding of Linda and Henry Omori. He was easy for my community to love, but it was still hard for me to imagine him living in LA. What would he do here? I feared his sense of purpose might wither in the LA sun.

On his return, Mfalme started a new chapter in his life. The man Malcolm X had sent ten years before to Dar es Salaam, Tanzania, to train to be the movement's spiritual leader had returned. Imam Tawfiq called Malcolm's followers together. Fulfilling Malcolm's vision, they were going to build a mosque in Harlem. Mfalme was bestowed his fourth and final name: Attallah Ayubbi. Attallah, "gift of God." He was doing salat (praying) five times a day. He stopped drinking and smoking, even eating meat. He was clean, once again the pure warrior spirit he longed to be. He now signed his letters, "Striving toward righteousness, Attallah."

One day he called to tell me what I did not want to hear. "Bahija is pregnant. With twins."

A silence hung between us. I could feel him struggling for a way to make things right, to imagine the unimaginable, to make life match his striving for righteousness as a Muslim.

Without his having uttered the question, I silently answered. No, I could not be Muslim. No, I could not be a second wife. I could not embrace or pretend to be a believer, submitting even for the sake of our child to come. I had stretched my life to its limits. To become Muslim was going too far. I could not be both who I was and who he needed me to be. He knew in his heart without my saying: I had to follow my own path now.

Bahija already had two young children. Now she would have twins. I would have one to care for. I would have the support of my community. I would find a way to make it. "You should marry her. I'll be okay."

Of course, I wanted him to be there with me when I delivered the baby. I wanted something to be normal. But Attallah was embroiled in urgent business with the mosque. He couldn't come and he couldn't explain why. So my brother stepped in and became my guardian angel. He went to birthing classes with me. He checked on me in the middle of his pool-cleaning route when my time was near. We shared an apartment over a garage on Arlington and Forty-Third Street. The front house was occupied by a collective consisting of Warren Furutani, Marc Kondo, David Murai, Tatsuo Hirano, and Larry Iba, all movement brothers eager to prove they were not male chauvinists. They devised a system where we each put in seven dollars weekly for food, and everyone cooked once a week. We ate well on seven dollars a week! They respected my desire for healthy brown rice (not an easy change for Japanese) and the absence of pork, so my baby would be pork-free. They even bought me a used washing

machine so he could have real diapers. We called our place the Arlington Lounge. I didn't have my own man, but I was not lacking male energy.

Around the corner, up the alley, my old friend Bobby Farlice, who'd played a small part in Antonello's film, and his wife, Njeri, lived in a loft-storefront. They had a beautiful little girl, Ochun, who was the sunshine of the neighborhood. Their building had a row of storefronts occupied by artists—the painter Alonzo Davis and his brother Dale, a teacher and artist, and Larry Clark, a filmmaker. In our one square block, we had a cool Third World community.

The baby was two weeks late and I was on my couch, feet raised, on doctor's orders. Dale Davis was coming by daily to check on me. I'd shake my head: it doesn't want to come out!

"Want come to the student dance with me tonight? I have to chaperone." Dale was the most popular teacher at Dorsey High. It sounded like a crazy idea, but I was down and desperate.

The dance was going full throttle when we entered the dimly lit gym. A group of Black students (Dorsey was mostly Black and Japanese) greeted us with surprised looks. "Hi Mr. Davis, is this your wife?!" I looked like I had swallowed a giant watermelon.

Dale put on his Buddha smile, "Nope."

"Is this your fiancée?" they pressed politely.

"Nope." Dale was not giving it up.

They weren't giving up either. "Is this your girlfriend?"

"Uh-uh." He whisked me away, savoring the moment. Mr. Davis just upped his rep with the kids at Dorsey High.

He walked me and my watermelon onto the dimly lit dance floor that had one of those spinning glass balls that make you wonder which side is up. I moved gingerly to get my bearings. Marvin Gaye's "I Heard It through the Grapevine" was the perfect warm-up. I just swayed, holding my twenty-pound watermelon in my hands. Then things got turned up with The O'Jays' "Love Train," and I was gaining confidence, my watermelon moving with me. By the time things kicked up with Stevie Wonder's new hit, "Superstition," Dale and I were rockin' with the whole room. I could see some of the teachers watching with jaws open, ready to dial 911. But I was feeling fine, and Dale and the baby were feeling it, too.

Dale's idea worked. The next morning, just before sunrise, on December 10, 1973, my baby thought it was a good day to rock into the world. Bob zipped me to the hospital and coached me through eight hours of Lamaze breathing, fussing with nurses, watching fetal monitors, and waiting for

the late doctor. I'll never forget the look in his eyes when Bob held the baby in his hands. "It's a *boy* and look at those big feet!" That day, Bob became Uncle Bob.

As a dancer, I was familiar with pushing my body, but nothing prepared me for that wrestling match with nature called birthing. I knew most women experience and survive it, but that didn't keep me from feeling scared, confused, vulnerable, dependent, stripped of my dignity, and uninhibited from uttering noises, grunts, and growls that I never knew were in me. At the end of the match, I knew I'd experienced a miracle. It was an ordinary miracle that people the world over experience, but this was my miracle. Attallah's missing the moment pained me. Why couldn't he be here? What was so important? But the miracle was undiminished. The miracle's name was Kamau.

It was a name carefully chosen in the tradition of his father. He taught me that names not only have meaning, but are mantras that carry the power of intention. Kamau means "quiet warrior" in Swahili, and it also has meaning in Japanese: "to be concerned." I wanted him to have a Japanese name too: Shigeki, "straight growing, green flourishing tree." And finally, his last name, in Arabic, Bin (son) of Attallah Ayubbi. Kamau Shigeki Bin (son of) Attallah Ayubbi—a big name with noble intentions to grow into.

Twelve hours later they put me in a wheelchair and rolled me out into the world with a baby in my arms. I panicked. Wait! How do I take care of this fragile, new little being? How do I feed it? How do I wash it? Then another miracle happened. My mother appeared at our front door, with a big pot of chicken soup. It was the first time I'd seen her since I left her crying on her bedroom floor. I don't know how she knew, but her timing was impeccable. She made the sudden leap from fear into joy. An unspoken understanding filled the gap between us as she threw herself into grandmotherhood. She held Kamau in her knowing arms, showed me how to change him, how to bathe him, and how to endure the first excruciating days of breastfeeding. Like many things in my life, I could not have done it without my mother. And she could not have grown her soul without Kamau stretching it. From then on, there was no talk of "What will people think?" It wasn't about color, it was about love (see photo 17).

TWENTY-ONE

Some Things Live a Moment

Some things live a moment
A week, a day, a year
Nothing lives forever
That's clear

Some things in a moment
Can forever change
How you see, how you live
Will never be the same

WHEN KAMAU WAS TEN WEEKS OLD, I got the call in the middle of a cold February night. I could hear from the scratchy background that it was long-distance.

"It's Bahija."

I knew she had just birthed her twins, and that she and Attallah soon would be married.

"Attallah's been shot."

I heard the words but could not grasp the meaning. She slowed, giving me portions I could swallow.

"He went to a meeting—in Brooklyn—at a mosque—they were ambushed." Her voice pressed through the darkness. "He's dead."

Her words forced my mind into denial. Dead? How could Attallah be dead? Just a few days ago we'd talked. He wanted to know when I was going to bring the baby to New York. Just yesterday I got a letter. How could he be dead?

He was not in our physical presence, but he was in our everyday lives. The movie in my mind saw him, walking and talking in the broken Bronx streets, fast-forwarding to a time when Kamau might walk with him. Hard as it was, I pictured his life with Bahija and the new babies, putting together the imperfect puzzle of our lives. We were all connected in a daily cloud of uncertainty, a roller-coaster of joy and disappointment, pain and forgiveness, knowing this was somehow meant to be. Now birth and death became one.

I fathomed what I could not bear. Attallah is dead. All the tomorrows flashed through me. He will never see Kamau. He will never hold him. He will never shine his love on him. Kamau will never know his father.

I couldn't swallow. I couldn't breathe. I couldn't break. I had to hold myself together. I told Bahija: "I'm coming. I'm coming to New York."

Kamau stirred, maybe thinking it was nursing time. Or maybe he felt something, like a giant glacier breaking in our lives. I turned on my bedside light to look at our son asleep in a corner of his hand-me-down crib. I went to gather him, so small, so warm, so alive, his little legs stretching against his blanket. I needed to hold the part of Attallah that was still here. As my bare feet felt the cold floor, I knew my life would never be the same.

I had been trying to go to New York so Attallah could see the baby, but it was deep winter and Kamau was too small. Why didn't I do it? Why didn't I go? Now we were there, not just for the funeral: I needed to feel a spark of him.

Harlem never felt more bitter. It was snowing, so I put Kamau in a sling over my stomach and wrapped us both inside the fur of my old beaver coat. I needed to walk the streets where we once walked, the place he called the Casbah, the place he walked with Malcolm X. This is where I could feel him. This is where his spirit lived.

My friend Marc Kondo took us to the funeral parlor. He was one of the last people to see Attallah on his last day. Attallah had dropped by Marc's 124th Street apartment to welcome a young Los Angeles brother, Tatsuo Hirano, who was going to start an internship at Lincoln Detox to be an acupunturist. As Attallah left for the Brooklyn meeting, his eyes caught a photo of Kamau pinned next to the door. He smiled and gave Kamau a kiss before he stepped into the frigid February evening to take the subway to the mosque in Brooklyn. That was Attallah's last goodbye to his son.

At the Harlem funeral parlor, Attallah's body was laid in a casket and wrapped in a shroud of white linen, in Islamic tradition. All I could see was his face. It was the same chiseled features, the same Jeffreys forehead. But he didn't look the same, he didn't look like himself. The lively spirit that was Attallah was gone. Marc took the baby child from me and made a circle over Attallah's body. Kamau cried out. Maybe he knew what he had lost.

I went to see Bahija. We were from different worlds, but now had much in common. We were both new mothers with babies who had the same blood.

We both loved the same man. We both were widows. There was no animosity between us, only sorrow. A bond of love and pain wove us together.

The Jeffreys family took us in as their own. Mrs. Jeffreys said, "I should have known, when all these children came into the world, someone had to leave." She didn't figure it was her Peter. He was only thirty-three. Kamau and I stayed in their Bronx apartment, the first of many pilgrimages.

His mother didn't go to the funeral. She'd had enough of funerals. Out of four sons, three were now dead, one from cancer and two by the gun. I remember her taking me to the closet in her bedroom. She showed me Attallah's left shoe. A single shoe is all she kept from each of her three sons. I wondered how many single shoes in mothers' closets there could be in South Central, Harlem, DC, Detroit, Chicago. I wondered how many Black children grew up without knowing their fathers. I wondered how many Black women raised not one, but many children by themselves. I remember thinking, no, vowing I had to make up for this loss.

Imam Tawfiq requested to see me. He was the one Malcolm X had sent to Dar es Salaam, Tanzania, years earlier, to be trained as his imam. He was the one who returned and pulled Attallah and Malcolm's other close followers together for the unfinished mission of building Malcolm's mosque in Harlem. He was the one Attallah went with to the meeting at the Brooklyn mosque. He was the one Attallah gave his life for. Tawfiq wanted to see Attallah's child. He wanted to talk to me about what had happened. I went with a sense of both duty and dread. There are some things too close, too terrible, too painful to know.

We arrived at Imam Tawfiq's apartment as the sun was leaving the day. I took off my shoes at the door, a familiar custom among Japanese and Muslims. He led me to his spartan study, where we sat on the floor, surrounded by books with titles flowing in Arabic script that I could not understand, just as I could not understand why Attallah was gone, absent, missing this moment to be with his child.

Wearing a kufi skull cap and long jacket, the imam was washed in shades of blue along with the whole room. It was the blues of trouble, the blues of heartache, the blues that can only be sung about. Much had transpired in the few months since Tawfiq returned and bestowed upon Attallah his new name, inspiring a renewed spiritual practice of five daily prayers, cleansing and purifying himself. In his letters and phone calls to me I felt his optimism in preparing for the next phase of his life journey, reconnecting with Malcolm's vision.

Tawfiq told me about the mosque they were building as part of Malcolm's legacy.[1] "We went to Brooklyn just for a meeting. When we got inside the mosque, we were attacked, ambushed. Four people were killed. Two from their group, two from ours." The imam seemed as astonished and lost as I was. He left the room and came back with a dark blue leather coat, the coat he wore that night. He stretched it open and showed me the seven bullet holes that had passed through the coat.

"I don't know how I was spared."

I felt nothing but dread. I clutched Kamau closer. I had no thought of justice, only remorse. I didn't know what to ask. I couldn't fathom a reason to kill over building a mosque. All I could say is, "How could this happen?" (At that moment, we didn't think it was the government, we didn't know about COINTELPRO, which had eliminated many Black leaders, destroyed the Panthers, and disrupted our movements. To this day, we don't know who did it or why.)

Imam Tawfiq did everything to humble himself and assure me that Allah would protect us. But nothing could console me. Before we parted, he gave me these words: "The strongest steel comes from the hottest fire." I left clinging to Kamau and those words, hoping they would help get us through the days to come.

Some called Attallah a martyr, a fallen warrior. It took me years to understand, Attallah was meant to be there at that moment. He lived his life striving for justice, to better the lives of Black people. It was not a sacrifice. It came from his love of life, his love for people, his love for all of us. He gave his life to build a mosque. He gave his life to defend Imam Tawfiq. He did what he wished he could have done to save Malcolm. The last kiss he planted on Kamau's picture was not for him alone. Attallah was going to Brooklyn to make a better world for all his children.

How to Mend What's Broken

WITH THE LOSS OF KAMAU'S FATHER, our revolutionary brothers and sisters on both coasts stepped up with extraordinary communal support. Kamau was born from the love of more than two individuals. He was a child of the ideals and dreams of two movements, two struggles for a just, pluralistic society that cares for all people, especially the most vulnerable. It was a moment our beliefs were put into practice.

I had little time to grieve. Grief and love occupied the same space within me as I cared for my baby. He filled my loss. He was the miracle that could make me smile. I swallowed the knot of pain in my throat and had to move on. The wound never disappeared. It became a hidden part of who I am. Little Kamau's spirit seemed untainted by the tragedy surrounding him. He brought joy to the Arlington Lounge and it seemed to ripple into our community. Auntie Wendy—my friend and one of many movement aunties and uncles—was always close for company and good cheer. Even nisei parents like the Nagatanis were hospitable to us, inviting us for summer swims. It gave me hope that we wouldn't be shunned by the Japanese community.

The day I spent at the Department of Social Services to apply for welfare and food stamps was the day I realized I was a Black mother, a single Black mother. I had the worries of a Black mother. How would the world treat him? How could I protect him? How could I teach him to defend himself? How could I, as a Japanese American woman, raise him to be a Black man? How will he know all of who he is without knowing his father?

Trips to visit the Jeffreys family in New York became annual pilgrimages, helping to fill the empty space Attallah left behind in both our families. We often stayed at their apartment at 239 East 169th Street in the Bronx. I still remember the address by heart because it was such a hassle getting there by

subway and bus, wielding Kamau's stroller through winter snow or summer's sweaty heat. We slept in their living-room couch on a foldout bed, with Attallah's sculptures watching over us. We relished sitting at their Formica kitchen table with Grandpa, eating Mrs. Jeffreys's yummy Southern-style homemade broken biscuits soaked in stewed tomatoes, enjoyed with her perfect fried chicken. She never seemed to sit down. She was always cooking, serving, while grilling me on the benefits of green tea and asking for a teriyaki chicken recipe.

We welcomed bigger family gatherings with Attallah's siblings, Arnold, Jamila, and Anne, whose basketball-tall boys towered over us. There we shared our *ore*, a Japanese gesture of gift giving, which was always boxes of crispy rice candies mixed with almonds from a store in LA's produce district, which displayed pile after pile of a variety of nuts and a huge sign outside that said "Nuts To You." There was always a flow of lively Black on Black political discussions circling the room, with brother Arnold and his trusty camera documenting the affair. Many years later, when we gathered after Grandpa Jeffreys passed at the age of a hundred and five, the kids—now towering adults with their own children and busy lives—said they remembered looking forward to those crispy rice candies from "Nuts To You." Funny, the little things that tie us together.

Grandma Jeffreys taught me the part of raising a Black child that was proper grooming, something I never mastered. "What are you doing with that child's hair?" she called me out.

"Mmmm, nothing much." I was into au naturel. I thought his curls were cute, but they were growing into tighter locks.

"He needs some oil in that hair. Come here, child."

She always sat on the same chair in the living room, which framed her like a throne. She was our queen mother. With cooking done and Grandpa washing the dishes, she sat with her long fingers knitted together, resting on her lap. We loved to sit at her feet and listen to family stories. It was a lesson in Black history in America. She took us from the slavery of her grandmother— whose master punished her by rolling a rocking chair over her hands— through the hopeful years of the Harlem Renaissance, which was in full swing when they came to New York from Durham, North Carolina.

Like many Black families, their sons were an endangered species. Mrs. Jeffreys's eldest went to prison because he wouldn't rat on a friend. After his release, he died of cancer. Her next son, a successful costume designer for Harry Belafonte and Sammy Davis, was shot by a lover. And now Attallah, whom she still called Peter, was gone. The only son left was Arnold.

There was the common bond of our mothers as super seamstresses. Attallah's older sister Anne, who'd introduced him to Malcolm X, sewed the wedding trousseau for Malcolm's bride, Betty Shabazz. After she raised her kids, she graduated at the top of her class from New York's Fashion Institute and went on to work in the Fashion District, running the sewing room for designer Frank Composto. Brother Arnold always sported a new creation that he'd designed and sewed himself, and even Anne's son, Malik Sealy, who became a famous basketball star in the NBA, designed a line of fashion. His life's bright light was snuffed too early by a car accident when he was only thirty: another giant loss to the family. We shared all these ups and downs in the warmth of 11G, in the Bronx, where life seemed fragile.

Silver-haired and still handsome, Grandpa Jeffreys was a cabbie and always asked what kind of car I was driving. He was losing his hearing but kept up with the world with the news on TV and a *New York Post* on his lap. He vowed never to return to the South, but Southern politeness never left him. He always insisted on driving us to the airport. The first time I was in his cab, we sat in the back seat. In his ID picture, I saw Attallah looking at me, with the same eyes and the same prominent Jeffreys forehead that Kamau inherited. It pained me that Attallah's path was not to have an ordinary job and get to live to a hundred and five like Grandpa Jeffreys.

Attallah's comrades took us under their wings, making sure Kamau would know him and inherit Attallah's *tumba*, a bass drum from a conga set he often played. After his funeral, they did a Santería ceremony for him, where they swore they heard him playing his drum. Those Afro-Cuban rhythms were part of who he was. Attallah once told me if he didn't get to play his drums at least once a week, he didn't feel right.

Mutulu Shakur and his wife, Afeni, always had a house full of kids Kamau could play with, including a rambunctious child who would become the rambunctious rapper Tupac Shakur. Our *A Grain of Sand* album, with the Republic of New Africa song "Free the Land" with Attallah and Mutulu singing the chorus, was always on the turntable in their house. Mutulu loved to tell me Tupac grew up knowing all the words to our songs. Ha, right!

Mutulu assumed the role as Kamau's godfather and has remained a part of our family. Besides his work at Lincoln Detox, he set up a clinic in Harlem serving the community with acupuncture and midwifery. But his leadership in the Black liberation struggle made him a target of COINTELPRO. Mutulu and Yuri Kochiyama worked together on freeing political prisoners,

and in 1986 he became one. For more than thirty years he has endured long bouts of solitary confinement, while losing his son, his wife, and eight rejections of parole. Still, when I visit him at Victorville Federal Prison in California (a maximum-security prison complex, part of which ICE now uses to jail undocumented immigrants), I am amazed that his first concern is for others. While fighting for his own clemency, he advocates for a truth and reconciliation commission in the United States like South Africa's. He is one of the most spiritually evolved people I know. To me, Mutulu is our unrecognized Nelson Mandela.

We had a small taste of COINTELPRO ourselves. Kamau was six months old and my brother Bob had moved out. One day I came home, opened my door, and found my house upside down. Every drawer, every cupboard, every closet was wide open. All my things were on the floor: clothes, linens, books. What had happened? Was it a robbery? I was alone, panicked, holding Kamau tight, not knowing whether to run or stay. I came to my senses and phoned our neighbor, Bobby Farlice, from down the alley. He ran over and we went through the house together. The back door's lock was broken. There was a little money on the table. They didn't take that. My Nikon camera was on the bookshelf. They didn't take that. Then on my desk, we saw a pile of my file folders open, like someone was taking pictures of their contents! It wasn't a robbery. It was the police. What were they looking for?

Ten years later, someone gave my brother a script written by an ex-member of the LAPD's Asian tactical squad. The screenplay included a scene of police breaking into the apartment of a Japanese American woman singer involved in a conspiracy to kill Hirohito. The writer goes on to describe plundering her house, and, yes, photographing her files. Then one cop says to the other, "Looks like a nigger pad to me."

The Kochiyamas, our New York family, always offered us a place to stay in their apartment on 126th Street, but I hated pushing Jimmy and Tommy out of their beds. When Kamau got a bit older, we stayed at their daughter Audee's place. She had an apartment down the hall from her sister Aichi. Their children, Zulu and Akemi, were a few years older, mixed Black and Japanese kids with similar hue and hair. They were perfect cousins for Kamau. One time, Zulu took Kamau around their Harlem neighborhood, proudly introducing him as his little brother, confusing some neighbors with the sudden appearance of this new Kochiyama kid.

Over time, I noticed Kamau had a way of sniffing out other mixed children, be they a combo of Black with Asian, Mexican, or European. There was an instinctive camaraderie that had no explanation. They just knew they were different. At that time, American-born Afro-Asian children were still rare. During World War II, there were children born of Japanese war brides and Black servicemen, some raised in the United States and some raised in Japan.[1] But like the Kochiyama daughters Aichi and Audee, I was raising Kamau in the sociopolitical context of the movement. They were children of the revolution.

We were learning to live across the color lines, spanning two coasts, two cultures, and two movements. Weaving together these relationships became our family, living through our shared sorrows, struggles, and joys, and our common beliefs. There's a legendary African bird, sankofa, that looks back at the past to know the future. Kamau needed these two wings to help him know where he came from, and to guide him toward what he would become.

How to mend what's broken
How to make it new
How to find the hope
To follow what is true

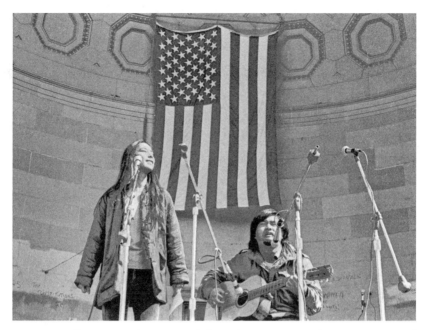

PHOTO 11. Chris Iijima and JoAnne/Nobuko perform at Martin Luther King Day, Central Park, New York, 1971. Photo by Bob Hsiang.

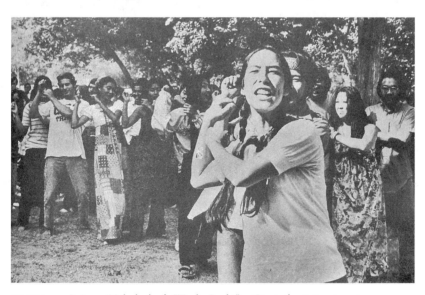

PHOTO 12. JoAnne/Nobuko leads "Tanko Bushi" at Cincip (an Asian American community gathering), Los Angeles, ca. 1971. Photo courtesy Visual Communications.

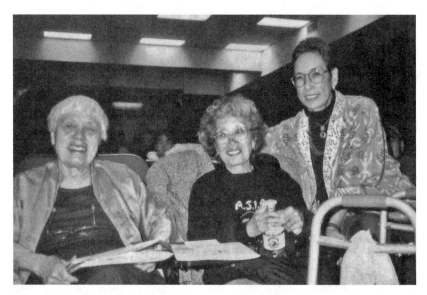

PHOTO 13. Grace Lee Boggs, Yuri Kochiyama, and Nobuko, UCLA, 1998. Photo by Marji Lee, courtesy the UCLA Asian American Studies Center.

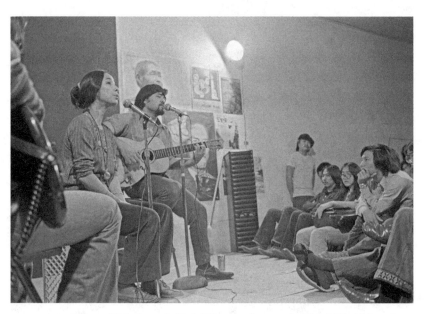

PHOTO 14. JoAnne/Nobuko and Chris Iijima perform at the Third World Storefront organization, Los Angeles, ca. 1972. Photo courtesy Visual Communications.

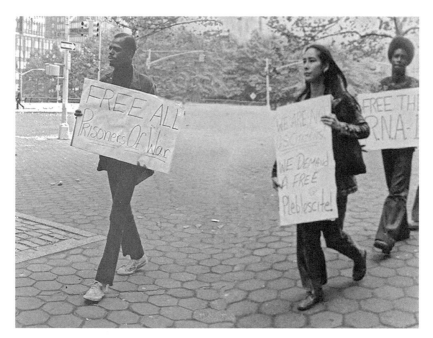

PHOTO 15. Attallah Ayubbi and Nobuko march in a Republic of New Africa demonstration at the United Nations, New York, ca. 1973. Author's collection.

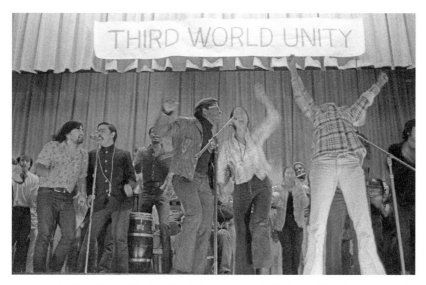

PHOTO 16. Chris Iijima, Charlie Chin, Mutulu Shakur, Nobuko, and Peaches Moore at the Third World Unity Concert, Los Angeles, 1973. Attallah Ayubbi is visible in the rear, behind Mutulu Shakur. Photo courtesy Visual Communications.

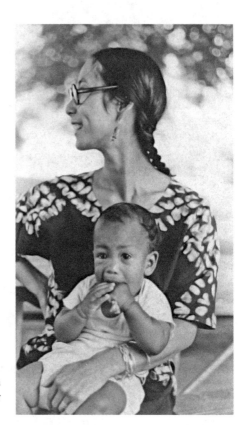

PHOTO 17. Nobuko and son
Kamau Ayubbi, 1975. Photo by Mary
Uyematsu Kao, used with permission.

Third Movement

TWENTY-THREE

Women Hold Up Half the Sky

MY LIFE HAD RADICALLY CHANGED. Being Kamau's mother was an integral part of my identity, my reason for being. I had a bigger purpose: to change the world he would live in. How could I use my skills as an artist? I vowed that having a kid would not stop me from being active in the movement, from making music, from doing my work. I nursed Kamau for two and a half years, so he was never far from me. Whatever I did, he had to be a part of it.

How was I going to do it? A reality check: welfare, food stamps, and Section 8 was not cutting it. I had to earn a few more coins. A friend suggested that I teach dance. Sisters in the movement wanted a dance class in the community. I'd never wanted to teach. There was a secret part of me left over from my elite training that believed artists who teach can't make it in the real professional world. But the truth was, I didn't know how to teach, and the movement was far from the professional art world. We were trying to create an alternative to that world, so learning how to teach dance to non-dancers seemed like a good start.

My friend and I went to talk to Reverend Mas at Senshin Temple to see if we could use the social hall there for a dance class. Reverend Mas regarded the temple as a dojo, a place to learn about Buddhism, and he saw the arts as a way to practice its principles. He showed me Senshin's social hall, the older building that was the original temple when it was established in the early 1930s. The small stage with a gold velvet curtain was once the *naijin*, the altar space, now filled with an array of *taiko* drums handmade by members of Kinnara Taiko. They were also studying *gagaku*, an ancient musical form, with Togi sensei, a master from Japan. The hall could hold four hundred people for social events. It was an open space with a high ceiling and an old

sprung wood floor. It was the floor that got me. It was perfect for bare feet, a perfect space for a modern dance class.

Without my asking, Reverend Mas handed me two keys, one for the social hall and one for the gate to the parking lot. "Just become a member of the temple." I was stunned. How could he trust me, a stranger, a stray cat? This man who gave me the courage to be a single mother was now giving me the keys to the temple? Now he was inviting me to become a member of the temple. For me it was more than a place to teach dance. Reverend Mas was giving me a community.

What's so hard about teaching dance? I'd been trained by the best. Even though I'd been mostly singing for the past five years, dance was my first language. But this was teaching dance in a different context, for a different kind of folk, for a different purpose. The students were political organizers, teachers, social workers, artists, filmmakers—all non-dancers, not headed to be professionals. They wanted to get healthy and find a way to express themselves. Should that mean I drop my highest standards? I still wanted to give them proper form and technique, and most of all, a taste for the sheer joy of dancing.

I had to learn to slow it down, break it down, read their abilities and their bodies, be clear, be patient, be compassionate. Later I learned they had another name for me besides Nobuko. They called me Novocain, because that's what they needed after my class!

Kamau and I were both growing up in Senshin's social hall. While I was learning to teach, he went from crawling to walking, and then running free in that huge open space. When I started experimenting with choreography, he danced with us. When I collaborated with Kinnara, he wrapped himself inside his favorite blanket and learned to sleep through the din of *taiko* drums on that wooden floor.

My dance class was teaching me more than how to teach. Other women with children were joining the class, giving Kamau friends. Teaching gave me a means to heal myself and build a community with others. The classes were growing: two classes with nearly forty students weekly, probably because it was so cheap. Though I needed to make a living, I also wanted to make it accessible to anyone who wanted to come (a principle and habit that hasn't changed), so folks made a donation, whatever they could afford. Later I had a book with their names, and I set a nominal monthly price. It looked busi-

nesslike, but no one was excluded for lack of funds. Most members were women, but there were a few brave men. Because of the two worlds Kamau and I were a part of, the classes reflected the complexions of our friends. We were bringing change to our Japanese American temple.

Following my Tuesday-evening class was a ballroom dancing class that was popular with nisei. One night the teacher came a bit early and was taken aback at the sight of our sweaty Asian and Black crew. We were invaders, but thanks to Reverend Mas, we weren't going anywhere.

Kamau was by nature open and friendly, but around age five, he noticed he was sometimes treated differently from others. One day, a temple member, thinking he was a neighborhood Black kid playing in the social hall parking lot, asked him what he was doing there. "I belong here; that's my mother!" He was right. Eventually the ballroom dancers and temple members got used to us. We were making Senshin more colorful—in more ways than one.

In the movement, we spoke of reclaiming our identity, our roots, but claiming my Japanese name was just a start. At Senshin, Kamau and I were becoming part of a community, participating with its traditions: dancing at Obon to remember our ancestors, pounding mochi (rice cakes) for the New Year, and more. Since I was there several days a week, I absorbed Buddhism through ordinary conversations with Reverend Mas, which always ended up as a teaching. Often those teachings turned into a new song, or a new concept I brought into my work.

My training had been in the Western arts—especially ballet, with its leaps and legs aiming upward, defying gravity. Now I was teaching in the shadow of a temple with a downward-sloping tile roof and a philosophy that emphasized humility, checking one's ego. Martha Graham, Jack Cole, and Jerome Robbins all borrowed from Asian dance and theater. They were rebels and explorers who created a modern dance and jazz vocabulary anchored in the earth. Now I could bring what I learned from them into my community and explore my own ideas.

Having a space that I could use in exchange for a simple *ore*, a monthly donation, allowed me the freedom to experiment. Working with Kinnara Taiko with friends Wendy, Johnny, George, and Qris was my first collaboration. I loved the *kata* (moves) of *taiko*. They reminded me of the martial arts. We dancers wielded the *bachi* (drumsticks) and learned the *kata*. The drummers learned to move through space like dancers. Our collaboration created a piece I titled *Sonyu* (1977). I thought the drummers handled the choreography pretty well, but we dancers, though we had the moves, didn't have the

power of function—hitting those drums to make sounds like real drummers.

I began creating short dance pieces. The first was aptly called *Women Hold Up Half the Sky* and featured my dance class (see photo 18). Just as my class was feeding the hunger for personal expression, we had audiences wanting their own reflection. Community events and colleges were eager to present us, and sometimes even pay us! We were making our own recipe from scratch. We had no grants and we were no divas. We mopped the floor, made costumes, spread publicity, shared babysitting, and rehearsed. While I was often overwhelmed, I was also pleased at what I could do and what we as a community could do. And I loved teaching. I loved getting a creative idea and being able to carry it through. Having a kid, even as a single mom, was not an impediment.

I was always pressing to raise the level of art created within our community. I had seen films of ballets created in Communist China, ballets of high quality like Ballet Theater or the Bolshoi. How did China create revolutionary art? Did they train revolutionaries to be artists or did they get artists to be revolutionaries? I guessed we had to do both. I began inviting professional Asian American dancers and artists into our community setting. I found they were happy to find a space at Senshin, and ready to use their talents to explore themes relevant to their experiences and their culture. Plus, they loved performing for audiences that understood them. We were cookin'! Senshin was a space like no other; it was our temple of the arts.

The social hall was once a temporary shelter, a safe space for our people returning from camp. If that floor could talk, it would tell us stories of what it was like in Manzanar, Poston, and Tule Lake, how it felt to return without a home, afraid to go grocery shopping in the LA streets alone. They slept and showered there, cooked, cried, laughed, and talked story in the same kitchen where we made tea for our rehearsals.

Now it was my shelter, too, a place that held our history, our traditions, a safe space to grow my child. It was the first time I ever felt rooted. Senshin gave us a womb to birth new ideas, to sing unsung stories, to leap without looking, to fall without breaking—and get up again on bare feet that knew every squeak and splinter of that beautiful wood floor. Reverend Mas gave me more than a room of my own. He gave me a sacred space to share, to learn, to grow, and to create a voice with other artists.

TWENTY-FOUR

Our Own Chop Suey

BENNY YEE'S PARENTS OWNED A LAUNDRY—one of those mom-and-pop Chinese laundries in your neighborhood where the family lives in the back and the kids help out after doing their homework. Did you ever talk to them? Did you think about the fact that they woke before dawn and didn't close until long after sunset? They knew enough English to be friendly and tell you how much to pay, but their shop was hot as hell in summertime and the smell of cleaner chemicals seeped into their skin. I bet you didn't know some of those laundry folks were poets or scholars with dreams that evaporated like the steam rising from their hot irons. The Yees wanted their kids to be cultured. They never took a vacation. They worked and saved, saved and worked, until they could afford to buy a plot on which to build a laundry with an apartment on top. They designed a special space in their apartment for a piano, and not just any piano, a *Steinway baby grand*. Benny and his sisters all learned their scales and played Bach and Beethoven on that baby. But Benny heard another kind of music in his soul, and he was going after it.

Benny and I had a band, Warriors of the Rainbow (see photo 19). Our first version in 1975 included drummer Danny Yamamoto, horn player Alan Furutani, percussionist Bobby Farlice, and traps and *taiko* drummer Kenny Endo, who would go on to train in Japan and become a world-renowned *taiko* master. Kenny and I have a blood bond, literally. In a gig at La Peña in Berkeley, we were doing "Somos Asiáticos." Kenny was shaking his home-made maracas fashioned from an old Coke can filled with rice. As I went into the last verse, Kenny's can slipped from his sweaty hand and became a flying missile, landing on my left eyebrow. It shocked me, but I managed to keep on singing, *Yo para tu gente, tu para la mía* . . . When I bowed, blood dripped to

the floor. Kenny was mortified, but now when he tells that story, he declares, "We play until we bleed!" I still have the scar to prove it.

Through the 1970s and 1980s, Warriors of the Rainbow toured locally and nationally at conferences and college campuses. We later worked with phenomenal musicians Russel Baba, E. W. Wainwright, and Gary Marshall.[1] One of my best musical memories was in New York, at a benefit for the revolutionary group ZANU from Zimbabwe. Produced by Mutulu Shakur, we played on the bill with Eddie Palmieri and Gil Scott-Heron. I could have died and gone to heaven!

Word about Warriors and my dance class got around, and we got a call from East West Players, a theater spearheaded by the actor Mako. They had a ninety-nine-seat theater in East Hollywood where Asian actors performed known works by Caucasian writers and new plays by Asian American writers. East West was both an avenue into "the business" and a community theater where Asians could tell their own stories. I wasn't interested in resuming my "career." My work was about creating a radical alternative to that system. Some older actors I'd known from my former life thought I'd lost my mind when I became a revolutionary and rabble-rouser, but now we found ourselves at a common intersection.

East West Players had received a grant to present plays free for the public at ten parks in LA County. They invited us to write a musical. A musical! That was a leap. And Benny jumped: "Let's make a rock opera!" The title was on the tip of his irreverent tongue: *Chop Suey*. Chop suey is, as I mentioned previously, a dish invented by Chinese cooks to please White folks. It was the Rodgers and Hammerstein song that made me realize that *we* were chop suey to White audiences. Now we had a chance to turn that idea around. Here's the Yee and Miyamoto version of chop suey, our own Asian American dish!

We knew little about writing a script. We figured we'd push the story line forward with music, lyrics, and movement—songstories. In the words of Orson Welles, we had the confidence of ignorance. But more than that, we had a mission. Creating within our own community gave us a safe space for our learning-by-doing experiment—a bold, loud, crazy musical about a young girl growing up in Chinatown and wanting to get the hell out.

Black artists were always out there pushing the envelope. In New York I saw the musical *Ain't Supposed to Die a Natural Death* by Melvin Van Peebles, a series of "in yo' face" stories about Black street life, done freestyle with song and choreopoems. Van Peebles, who'd directed the groundbreaking film

Sweet Sweetback's Baadasssss Song, first mounted the show in Sacramento, then got it to Off Broadway, then main-staged it. It was a new kind of brash Black storytelling that went beyond protest. It was *presence*.

I knew mounting a musical with live musicians, actors, singers, dancers, sets, costumes, lighting, and the works was not easy. I'd been in a Broadway hit and a flop. Even with famous composers and directors and big bucks, it was a high-risk business. But we had nothing to lose. With East West Players, we had a lean, mean team with practice at making sets and costumes, and doing lighting. Everyone gave time, sweat, spirit, and talent, knowing we were creating something we never had when we grew up: our own people taking the stage and telling our own stories.

We had grown too accustomed to a culture that centers White folks as heroes or losers, working class or upper crust, coming of age, falling in love, making mistakes, making it big. We tried to see ourselves in their stories. We measured ourselves with their ruler—the shape of our eyes, the color of our skin, the size of our breasts, et cetera. We'd been peripheral or invisible. We were the sidekick until Bruce Lee kicked his way into stardom, not from America but from Hong Kong. Most of us weren't aware enough to be angry at our invisibility, but it ate away at us. Lack of self-esteem drove some young Asians to drugs, to dye their hair blond, to use Scotch tape to make their eyelids double. Some who took the path of self-destruction were called the "suicide generation."

Chop Suey was a way to make ourselves visible. It was a declaration that we exist. It was a way to look at ourselves, our people, our struggles, our traditions, but also look at how we had changed, what we were becoming. Creating and witnessing our reflection on stage was an act of self-empowerment. Telling our story was a way to shatter the myths, (re)define ourselves. In our first version, what we had was Benny brewing some cool music and me helping on lyrics, directing, choreographing, and performing. We made a handful of pretty good songs that supported a thin storyline. It was a forty-five-minute musical revue more than a musical. But a seed found its ground.

The overture rocked and Benny sang from the pit and set the stage:

> It was gold rush days when they first came,
> you know they built the railroad.
> They huddled together through all kinds of weather,
> they were strong and oh so bold.
> It was self-defense and a good business sense,
> paint it red and trim it with gold.

The dream of a prosperous life
was buried inside of them.

Chorus:

Hey now.
Let's go down to Chinatown! Drums they beat,
dragons dancing in the street.

We created characters that we all knew. Remember that rude Chinese waiter at your favorite San Francisco Chinatown restaurant? Well, we put him on stage. Michael Paul Chan nailed him, barking at customers: *Whatchu want?! This is my day job and my night job.* A chorus of singing waiters tried to coach him into politeness: *Can I take your order, pleeeeze? Can I take your order, pleeeeze?*

I had been around enough activists in New York's Chinatown to know what it was like for the women who worked in sweatshops sewing clothes they couldn't afford to buy. Marilyn, Denise, Momo, and I crisply sang their woes: *We have to sweat—inside the shop—no windows here—we can't look out.* Then we wove the waiters and seamstresses together in contrapuntal melodies. It still stands up, if I say so myself.

Atomic Nancy, the original singer in the band Hiroshima, was going through her punk rock phase. She performed the character she created while waitressing at her parents' Little Tokyo restaurant, the Atomic Café. We put her rebel self on stage with the number, "Make It Kinky for Me Chinky!" and blew people's minds.

But it was Deb Nishimura's voice that struck home as she belted out the soulful ballad "American Made" (see photo 20):

People look at me, what do they know, what do they see
All I want and need is to belong, but they can't believe
I'm American made, just like you and I wanna say,
American made, it's my home and here I stay,
American made[2]

We created three versions of *Chop Suey*, each time a learning, growing experience, each time with some new artists adding their touch. At East West we had young talent and pros stepping up to bat. John Lone was born in Hong Kong and trained in Chinese opera. He looked like a movie star and soon became one. If you ever saw *The Last Emperor*, that was him.

At a *West Side Story* reunion I bumped into José De Vega. When he'd played Chino, his hair was slick black. Now it was silver and his skin lay on his bones like he was chiseled. I took a chance and asked him if he'd like to play the father in *Chop Suey*. He jumped, "Yes, if I can sing." Shoot, I'd write him a song.

My dear dancer friend Reiko Sato reappeared at the perfect moment, like the genie she was. A veteran of dance and the stage, she came and reminded me what I forgot.

Sab Shimono was a seasoned actor who came in and put on his director's hat for us. He told me something that I never forgot, especially in hard times: "You are a success because you are still doing it."

Chop Suey prompted all kinds of people to step up. Mike Kan, a young activist from the University of Oregon, saw the show at LA Trade Tech and took it upon himself to produce it in Oregon. He put together a coalition of twenty-three grassroots organizations and sold enough tickets to bring twenty of us to Eugene and Portland. There was not one empty seat the three nights we performed. People of all ages came to the show, thrilled to see our imperfect but exciting musical that captured images and stories about them. It was an electric grassroots moment. We didn't need helicopters on stage to wow you, no Hollywood to give us barrels of money and tell us what sells. Everyone on the stage and in the house felt it. *Chop Suey* was authentically us.

The *Chop Suey* project put us through growing pains. We needed more than box office to pay artists, rent theaters, make costumes, promote. We needed more than belief that telling our stories was important. We needed support, structure. Cheryl Lange, an African American choreographer, suggested we go for a grant from the National Endowment for the Arts. What? Take money from the very government we railed against? She schooled me. It was public money from *our* taxes. Artists of color have been denied access to funds, just like our people lacked access to loans to grow their businesses, or buy a house outside the ghetto, or have the right to vote. Access to funding for art that serves our communities is a right.

Benny remembers us going to Washington, DC, to make a presentation to the NEA. After we showed them a video of *Chop Suey*, they wrote us a check for ten thousand dollars. That was peanuts compared to Broadway or Hollywood, but for us, it was gold. We had to grow up and become a nonprofit corporation, with a board of directors, an employer identification

number (yikes!). A name jumped out of Benny's brain: Great Leap. He borrowed it from the Chinese Cultural Revolution's Great Leap Forward. We dropped the "forward" (thank god). *That* cultural revolution turned catastrophic and took things backward, putting many of China's artists and intellectuals in reeducation camps. But in 1978 we were Great Leap, a legal nonprofit arts organization.

Great Leap was one of many smaller cultural arts groups of color that grew out of the 1960s consciousness movements. We and our allies swam upstream against the tide of larger cultural institutions like the LA Music Center. The African American musician and producer C. Bernard Jackson was a visionary leader who understood our role as culture makers in that moment. He took over a Masonic temple near Vermont and Pico to create Inner City Cultural Center (ICCC), whose theaters and rehearsal and dance spaces welcomed artists of all colors. He was doing multiculturalism before the word was invented. The Pico-Union area had gangs and drugs, but once you walked through the doors of ICCC, you were in the creative, color-filled world Jackson envisioned. Jack, as we called him, had an eloquence and a noble heart that encouraged collaboration and artistic excellence among artists of color. Hard as it was, we were doing something important that would have impact beyond our own communities. Together we had a bigger mission. We were painting a more realistic picture of America.

Jack died in 1996. The stress of keeping the lights on at ICCC, with too many artists to support, was too much. I saw him as our Malcolm X of the arts. If this country had a minister of culture, for me, it would have been C. Bernard Jackson. Then you wouldn't need a president.

What Is the Color of Love?

I have a son and colors run through his bloodline
Into his crayons, pencils, charcoals, watercolors
Painting his toys, notebooks, walls, furniture
Painting a world he wants to live in

AS AN ARTIST IN THE ASIAN AMERICAN COMMUNITY—teaching, creating, rehearsing, and sometimes touring—I brought Kamau along for my crazy life. He was adaptable, taking in culture and artist friends. He was part of my identity, but he had his own. As a mother of a mixed-race child, I had to find places and spaces for Kamau to experience all of who he was.

We made our first pilgrimage to Manzanar concentration camp in 1976, when he was three, almost the same age as I'd been when they put us in Santa Anita. Maybe he would remember little, but I wanted him to know his people's story. I wanted it to be in his body memory. We camped out with Warren Furutani and Victor Shibata, who first started those community pilgrimages in 1969. We brought *taiko* drums and food; we heard speeches and we danced in a circle the "Tanko Bushi," a traditional Obon dance we all knew, to remember our ancestors. In April, snow still sat on the Sierras. The white monument pointed to the sky as we entered the grounds and saw traces of the blocks and barracks where ten thousand people were imprisoned, fending off frigid winters and fiery summers, and always the sand—sand blowing through the cracks and crevices, sand blowing in their food, their clothes, through their minds. Now it was blowing through us.

We honored the dead at the stone-bordered cemetery that contained the graves of children and elders. Kamau played among the rocks and boulders in what was once a Japanese water garden built by issei. We found a strange pit filled with broken dishes. Before they were released, our people broke the

My song "What Is the Color of Love?" is on my album *Nobuko: To All Relations* (Bindu Records, 1997) and a new version is on *120,000 Stories* (Smithsonian Folkways, 2021).

government dishes and buried them, like they buried their memories. The pilgrimages were just beginning to dig up the profound injustice carried out by the US government.

Forced removal is not only a part of Japanese people's history. It is a thread running through America's history—removal of Native people, Africans, Mexican braceros. Now it's happening with Latinx people, even separating children from families. Having been a child in camp and now a mother, it's too horrible to imagine, but it's happening. In the 1980s our Redress Movement activated our community and made the government listen to our stories, forcing them to apologize and redress with financial reparations. Today groups like Tsuru for Solidarity are standing up for those seeking refuge and trying to close down the camps.

Kamau was carrying the experiences of Japanese as well as African Americans within him. How could it become not a burden, but something that deepened him? He started out in life as instant love and good at friend making. But as he grew, he seemed quieter, maybe growing into his name "quiet warrior." My wise girlfriend Niki said, "Don't worry, he's listening." And he was asking questions, questions I never asked.

He was six when we were at Venice Beach, building sandcastles with our friend Hamilton Cloud. Kamau rubbed the sand off his hands and looked at me: "Mommy, I wonder what people think, seeing two Black guys and a Japanese lady?"

We got a good laugh from that one.

After we moved from our collective house at the Arlington Lounge we lived in a triplex bungalow apartment on Rodeo Road, near Crenshaw. It was a mixed Black and Japanese neighborhood, just down the street from Holiday Bowl, a cool bowling alley with a twenty-four-hour coffee shop that served Japanese udon noodles at night and eggs with a choice of grits or *cha siu* over rice any time of day. Its parking lot had a giant brick wall with graffiti painted in stark white that said: REVOLUTION! When you walked in, passing through the bowling alley, you might see a Black league playing, and by the time you finished your noodles, a Japanese team would be on the lanes. At the pool tables Blacks, Chicanos, and Asians played together. One of the owners, Paul Uyemura, a balding man with burn scars and a patch over one eye, told me that after coming out of camp he wanted a place where folks of all colors could come together and have a good time.

But things weren't so peachy at our apartment. To get to our place, we had to pass the apartment of a stay-at-home White woman, the wife of a Chinese man who left quietly in the morning and returned quietly at night. When my friends passed by her place, she'd grumble loud enough for us to hear: "Black people coming in and out all the time!" We put up with it, but one day, Njeri and her daughter, Oshun, did a little voodoo. She picked up a pile of dirt and dumped it in front of her door.

One Saturday morning, the woman passed my back door to take out her trash and her grumbling got to me. I swung open my door and stated, "Excuse me, is there something you want to say to me?" Kamau heard and came close.

She dropped her wastebasket, put her hands on her hips, and aimed her hatred at me and Kamau. "You should be ashamed of yourself for having a Black child!"

I saw red. Without thinking I went for her. How could she say that in front of my child! I got in her face, ready to grab her. I caught myself. The only weapon I could muster were words: "*You* should be ashamed at saying that when *you* have a Chinese husband!" I stormed back to the kitchen, slammed the door, my heart beating so loud Kamau could hear it. I was in a heap on the floor. Why couldn't I shield him? Why should any child have to hear this? I don't know where her words landed in his seven-year-old psyche, but the "quiet warrior" in him consoled me: "Mommy, is there something wrong with that lady?"

When I got it together I decided to take the high road. I sent a letter to my Japanese nisei landlord, explaining my neighbor's racist comments and continual harassment. I asked them to tell her to desist. If not, I would get a lawyer to do it. A couple of weeks later I get a letter—with an eviction notice. They were asking *me* to leave. These nisei, who were forced from *their* homes out of hatred and racism, were asking *me* to leave! They said they didn't want any trouble. Yes, Kamau, there's something wrong with a lot of people.

At eight years old, Kamau came home from school with another question: "Why do people hate Black folks so much?" I didn't know how to answer. But I hoped he'd never run out of questions.

When he started school, I thought he would benefit from being at the Marcus Garvey School, an all-Black school at Fifty-Fourth Street near Crenshaw that concentrated on the three R's and a heap of Black history. One day I went inside to pick him up. The hallway was bustling with Black children and their mothers. As I took Kamau's hand, a boy surveyed us. He

looked up at me, down at Kamau, and back up at me, trying to reconcile the picture. Then he said nice and loud: "Is *that* your mother?"

Kamau defended, "Yes, that's my mother!"

"You are all mixed up!"

We learned to laugh at how people saw our "mixed-up family." But somehow, I didn't feel welcome to participate in that school.

So, how to find a place we both could be who we were? One place was Community School, near Fairfax and Venice, a very diverse three-hundred-student magnet school where kids called teachers by their first names and parents had to participate. The principal happened to be an old grammar school friend, Sandy Hoskins, an African American who immediately encouraged me to start an arts program. I did. Artist Senga Nengudi, sculptor Maren Hassinger, jazz musician Roberto Miranda, poet Jack Grapes, and more weren't teaching art—they were bringing the artists out of the children.

Another place was Leimert Park. My old neighbors Dale and Alonzo Davis were owners of Brockman Gallery, the heartbeat of a place folks called "The Village." Walking on Degnan Boulevard, Alonzo's giant mural with Black imagery and his iconic arrow pointed the way. *Djembe* drums, John Coltrane, and Bob Marley were the soundtrack as you passed by storefronts featuring African crafts, colorful textiles, jewelry, books, clothing, and art. Sweat from the bodies of participants in an African dance class steamed out of a storefront near the hair-braiding salon. The Museum in Black told stories through relics like tribal masks from Africa and "Whites only" signs from the South. When you touched actual shackles that slaves were forced to wear around their necks and ankles, it made slavery real.

In 1967, not long after the Watts Riots and police siege of the Black Panther office, Alonzo and Dale had the audacity to make a gallery for Black art in Leimert Park, a neighborhood that was once off-limits to Blacks because of housing covenants. When the ban lifted in 1948, middle-class Blacks and Japanese began populating it, and, of course, Whites began exiting. (Now, with the metro and gentrification, they're returning.) Finding a sense of belonging felt easier among African Americans. Alonzo and Dale named the gallery after their great-grandfather, Brockman, son of a slave owner and a slave, who when freed married a Cherokee woman. They were "mixed up" too. At a time when Black Nationalists were dropping their slave names, they claimed Brockman to honor their family history.

Brockman's vision was large. They got funds from a federal program called CETA (Comprehensive Employment Training Act) to hire artists—and not just Black artists, but Latinos, Asians, like the band Hiroshima, and more—to do their art, perform, and get paid year-round, like normal people. What a concept! They rented storefronts that flanked Brockman from a Jewish landlord who liked what they were doing and turned them into live-work studios. Their windows were filled with powerful images that reflected on us as we passed by. Festivals at Leimert gathered Black Villagers from all around LA, flowing with a cacophony of rhythms and aromas: brothers and sisters with Afros, dreads, braids, dashikis, crocheted hats blaring Black Nationalist colors of red, black, and green, sisters crowned with African head wraps. It became and still is an urban Black Village, a cultural mecca constantly changing, morphing, growing, sprouting from its roots through the concrete.

Like all children, Kamau had a natural creative force flowing through him. He was always drawing with pencil, with crayons, with watercolors, in and on his notebook, his skateboard. He was never bored. Even at boring board meetings and rehearsals he just took out his notebook to draw. Of course I wanted him to be an artist. We didn't have to go to the big LA County Museum for our art. It was here on the street level, the people's level, in the Village. The art of Charles White, David Hammons, John Outerbridge, William Pajaud, and many others were part of Kamau's natural landscape. He could even hug the wooden sculptures of Elizabeth Catlett. I saw the importance of the visual arts to those kept invisible or painted with negativity in our society. What he saw was saying not only that Black is beautiful, but that it is complex, it is intellectual, it is mystical, it is diverse, it can speak to anyone. It is a way to heal, to be whole.

Kamau blended with the other Villagers. My sister-friend Njeri was fairer than me, a striking blue-eyed Nefertiti who claimed her blackness and no one questioned it. Her child Oshun and others—Malik, Tranell, and the twins Precious and Lady—were Black kids that came in all hues. Everyone had stories as complicated as ours. The kids inspired me to write a song for them about rock-paper-scissors, the game that in Japanese we call *jan ken po* (see photo 21).[1] When we were rehearsing it, the twins heard my name and christened me Obiwan ka Nobiko! Soon I became a board member at Brockman. I guess I blended in, too.

Here little Kamau could look up to "Big" Kamau Da'aood, Leimert's poet laureate and wisdom speaker with the voice of god. He could hang around people like unsung legend Juno Lewis, a humble genius instrument maker

and composer of "Kulu Se Mama," the title song of John Coltrane's final album. A Muslim merchant, Fadil, once a diamond cutter who now traded African textiles, would take time to talk story to a young brother even if he didn't buy anything. These Black men knew well how to fill the empty spaces of too many disappeared and endangered Black fathers.

The Village remains a place chosen, envisioned, and self-determined, a place driven and divined by the unlimited possibilities of art, particularly Black art. The Village is a cultural mecca, a liberated territory where the Black community feels safe, free to be themselves. In that moment the Village gave Kamau and me a refuge, a place we could both belong.

> *Blue, green, orange, violet*
> *Olive, caramel, hazel, chocolate*
> *Color the world you want to live in*
> *Color the world you want to live in*

Talk Story

OUR HARD WORK TO CREATE a voice and a presence for Asian Americans was being mirrored in the larger community. In 1983, it was the new Japanese American Cultural and Community Center (JACCC)—five stories, with a gallery, office spaces, a huge plaza designed by Isamu Noguchi, and a gorgeous 880-seat theater. In Little Tokyo, where a lot of mom-and-pop stores and restaurants were disappearing, we had a cultural anchor that said "we are here to stay." It was touted as the largest ethnic cultural center in California, and I was invited to be an artist in residence, along with koto player June Kuramoto from the band Hiroshima; *taiko* player Johnny Mori, also from Hiroshima; and photographer Patrick Nagatani. Thanks to a grant from the California Arts Council, we got a monthly stipend, almost like a "real job." And I could mount a performance at the Japan America Theatre! I was in heaven.

The premiere at the Japan America Theatre (now called the Aratani), was the Grand Kabuki from Japan. I remember watching from the balcony with Kamau at my side. Kabuki is Japanese high art—a form of theater with operatic storylines, stylized movements, lavish costumes, painted faces, dramatic stage effects, and both male and female characters played by men. I was awestruck. Even Kamau got into it. How could Great Leap even think of performing on this same hallowed stage?

As I learned, Kabuki's roots in the early 1600s were not so hallowed. It was a song-and-dance theater form that originated among women street entertainers (aha!), some of whom were prostitutes (probably to support their art). It became popular and brought all classes of people together—until it was banned because of the prostitution. In 1629 it was hijacked by males who performed both genders (they stole it from us!). It was still ribald and

popular, and still associated with prostitution. Kabuki was finally tamed and formalized in 1673. Today it is Japan's treasured art form, admired the world over.

How to keep from being intimidated? I figured we had to be as brazen and free as those first women creators of Kabuki (sans the prostitution). The beautiful thrust stage was calling me to do something big. I wanted to make an Asian American modern ballet with original music. *Journey in Three Movements* was about the transition from immigrant to American. It was the most musically complex composition I'd yet attempted.[1] I was a madwoman, with synthesizers and sequencers filling my dining room, trying to channel the composers I'd once danced to. I challenged myself to sing the narrative song as well as join my fellow performers in dance. We had a first class team with Derek Nakamoto, our music director and producer, pushing himself beyond the pop music field, using the arranging skills he'd gained from mentor Michel Colombier; Donna Hokoda Ebata, our part-time administrator and producer working to raise money; and José De Vega, our choreographer.

If I was Great Leap's mother, José became its father. After *West Side Story*, he spent years in Italy working with Danza Contemporary di Roma. Back in Hollywood, he was again stumped by limited roles for brown-skinned actors. *Chop Suey* gave José a taste of artistic freedom, though little money. He made a living as a gardener—not like my dad, but an indoor kind with clients like movie star Sidney Poitier. *Journey in Three Movements* allowed José to use all his creativity, both as choreographer and as director. His Zen-like aesthetics made me feel we could do anything.

My dance class had produced some solid dancers, and top-notch professionals joined us. These included Louise Mita, from New York via Hawaii, a gifted dancer and choreographer and a genius at teaching youth. Another was Young Ae Park, a Korean-born dancer and choreographer who'd studied the movement of molecules in biology at UC Irvine, but seeing Merce Cunningham redirected her love of movement to dance and a master's degree from UCLA's World Arts and Cultures department. Male African American dancers Raymond Johnson, Deanar Young, and Daryl Copeland jumped in. Natalie Wise, Wallis Lahtinan, Trudy Walker, and Janet Saito, a teacher in the LAUSD (LA Unified School District), completed our multicultural corps. Most people don't realize what it takes to create dance. I love dancers because they are rare creatures who spend a lot of time, energy, and money to perfect their craft. Their dance lives are short, and they are never given ample credit for making the impossible seem easy, beautiful, magical, joyful. I thank

them here for the time we sweated together creating *Journey in Three Movements, Sonyu, Bridge,* and more, all of which were danced on the JACCC's stage and beyond.

We were on a roll, and sometimes a roller-coaster. We were raising the perception of what "community art" looked like. At the same time, the field was changing, or perhaps better put, a new field was being created because of groups like ours. The California Arts Council gave us technical assistance in administration—fun stuff like budgeting, grant writing, reporting, marketing, and sending us to booking conferences. Artists often have part-time jobs to support themselves. Spending time at the Great Leap office with Donna was my day job. We had to have savvy and strategy to survive in the long term.

But we didn't all survive. The AIDS epidemic hit the arts community with a vengeance. It seemed like every week, another friend or colleague in the dance community died. In 1987 José De Vega was diagnosed with HIV. We were creating a new musical, *Talk Story.* Directing would be too taxing, but he still wanted to perform. We had understudies, Alberto Isaac and Dom Magwili, who only once stepped in for him.

"Talk story" is a Hawaiian pidgin term that means talking about people or situations around the kitchen table or on your front porch. Our show *Talk Story* took that concept and made it into an Asian American musical odyssey: a nightmare of a Korean immigrant abused by her White boyfriend in "I Dreamt I Was Helen Keller Last Night!"; a mixed-blood Mexican and Japanese girl's dilemma in "Schizophrenic"; a crew of young Asians who claim "Twenty-Second Street Beach" their hangout; a day in the life of an Asian family's "Family Business," and more (see photo 22).

José was gay, but identified as Pilipino masculine man coming out of a long history of discrimination and racism. He wanted to talk story about the *manong,* the elder men who spent a lifetime single because of laws that kept them from bringing a woman over from the Philippines or marrying a White woman. On weekends they would go to dance halls for recreation and the rare chance to hold a female. The "Pilipino Tango" narrative had a funky bass line, backup singers, and a tango.[2] It was a sexy, poignant showstopper. José breathed into it a sense of compassion and dignity that the *manongs* deserved.

Talk Story toured three Islands in Hawaii. José made it with us all the way. We did a run at Theatre Artaud in San Francisco and six weeks at the LA Theater Center (LATC). He was getting thinner, more frail. We recorded

Talk Story for Pacifica Radio, produced by Maricel Pagulayan, and José nailed it. In an interview on KPFK I played "Pilipino Tango," and a few minutes later Johnny Otis, the famed bandleader who was deejaying the next show, popped in and asked: "What was that song? I want to play it on my show!"

A couple of months after we did the LATC run, José went into the hospital. He had brought his artistry, his stories, and his generous heart to Great Leap and the community. He lived with AIDS and pushed himself until the end to make his story heard, not in an egotistical way, but to say, we exist, our lives matter. José is now an ancestor. I don't want him forgotten. I'm glad his voice and his people's story was captured and preserved in "Pilipino Tango":

> *I close my eyes, music fills my ears*
> *Before you know it, my true nature appears*
> *My pockets may be empty, but my heart is full*
> *When I hear*
> *The Pilipino Tango*

In the early 1990s, a new kind of art making was exploding onto the scene. Solo artists were finding unique ways of telling their own stories in and on small stages, storefront spaces, black-box theaters, parking garages, bridges—any place that augmented their message and their audience. Performance art had emerged in the 1960s, as artists broke through the canvas using paint, word, media, and body to challenge the system. It was naked, political, anarchistic, rebellious, and mostly White. Now, for artists of color, solo performance was a perfect fit for those with little finances for big productions. In 1991 I saw Amy Hill in *Tokyo Bound*, a show she wrote comparing the bathing fetishes of her two parents—her Japan-born mother and her Swedish father. Stout, with large, drooping hazel eyes and a full-chested voice that didn't need a microphone, she defied expectations and wagged her otherness in our face. And she was funny as hell, making us laugh at her situation and our own. Dan Kwong's *Secrets of the Samurai Centerfielder* (1989) was about growing up half Chinese and half Japanese in a household with "three sisters and a nuclear reactor for a mother." With fun, physicality, and insightfulness, it showed the complexity and craziness he lived through coming of age as an Asian American male. Amy and Dan were telling their stories in ways I never thought of doing. Were there others like them? Maybe there was a way that Great Leap could serve more artists who wanted to tell the Asian American story in their own ways.

A Slice of Rice festival filled two whole days with a score of artists, each doing a fifteen-minute solo piece, and we packed the Barnsdall Gallery

Theater in Hollywood. These "slices," side by side, offered a panoramic view of the diversity of the Asian American experience. It broke open that little box that had long contained us Asians in the mind of America. It showed the uninhibited imaginations of a plethora of young artists who articulated their stories in their own ways (see photo 23). The LA Music Center on Tour Program took a mini version of *A Slice of Rice* into schools. We were reaching fifty thousand kids a year, from wiggly kindergarteners to high schoolers. We were entertaining while being exposed to LA's diverse youth. Of course they loved Dan's baseball story, and another Asian male football story by Calvin Jung. They got the identity struggles that Louise Mita rapped and danced about being Japanese growing up in Harlem. But I was surprised that they could also be captivated by the artistry of Young Ae Park's abstract dance piece, and dancer Long Nguyen's devastating childhood story of witnessing a monk burn himself in Vietnam. Art works! After our forty-five-minute shows we had fun and deep Q&As with kids who had never seen an Asian perform. It felt like we were making a difference with these youngsters.

Soon we were touring colleges and universities, reaching young Asians and others who were trying to figure out who they were in this world. Q&A was always part of our performances, not just for feedback but to break the wall between performer and audience. They also had stories they wanted to tell. After an *A Slice of Rice* performance at Cal State Northridge, a group of Vietnamese students surrounded us. "Can you do a workshop with us? We're part of Club O'Noodles. We do shows on campus." Hung Nguyen and his cohorts bounded with energy. "Just one workshop!"

One workshop turned into more than a year with them. What had I gotten myself into? No pay, no grant, no timeline. I had protested against the Vietnam War and these were kids who'd lived through it. I was struck that their harsh experiences didn't brew bitterness. They were resilient, fearless, and funny. And they had *stories*. How could I help them share these stories? As I graduated from being workshop leader into codirector with Hung, I wondered how we could pull these students into a theater ensemble. How could we sculpt their stories into a full-length piece? It would be healing for the Vietnamese community to see and illuminating for others. That's what theater can do: help people experience, see, through another's eyes. Then they aren't "others" anymore.

Every Saturday at Senshin we worked together. My experience teaching non-dancers proved useful, since warm-ups with breath and body were foundational for mining their stories. As untrained actors, telling a story collec-

tively was easier. Sometimes moving bodies on the stage can say more than words. Because they knew each other well—some were even cousins—it was safe to go deep. A few had been on the same boat fleeing Vietnam, children stashed under tarps, girls with faces smudged with dirt to keep them from being raped by pirates. We found a hilarious way to relate their first encounter with McDonald's, ordering French fries. JV, for his part, remembered being hungry, his house emptied piece by piece to buy food for the family, with only a picture of Ho Chi Minh on the wall. One day he found a treasure: a small packet of salt. He carefully opened the packet, wetting his finger with his tongue, then dipping it into the salt. Looking at Ho Chi Minh, he sighed: "chicken"—another dip—"beef"—another—"pork." Each imaginary bite was in defiance of a man he thought destroyed their home, their livelihood, their food.

It was a learning-by-doing process. I recently discovered there's a name for it: devised theater. Everything was made from scratch. With zero budget, their own clothes for costumes, and an impressionistic set made from old Vietnamese newspapers, they made something quite magical, funny, poignant, and artistic out of nothing. Performing *Laughter from the Children of War* for the Vietnamese community in LA and San Jose was nerve-wracking. Many in their parents' generation were fiercely anti-Communist, unafraid to shout their protest. When the house dimmed and the curtain rose, the blue light revealed our self-made set of crumpled newspapers hanging from the rafters. From the paper-blanketed floor, the children awoke in slow motion, taking the stage. In a few moments I could feel the audience soften into the magic. They were laughing, they were crying at their own "children of war." It was their story, finally told.

Our work together transformed us all. Many went on to use our techniques as workshop leaders, developing new stage works, including *Stories from a Nail Salon* (1999), which some of the former Club O'Noodles students worked in. Hung Nguyen earned his doctorate at Columbia University's Teachers College, spreading meditation among teachers and leaders. JV returned to Vietnam to become an actor and producer, telling stories through film. For me, working with Club O'Noodles revealed a powerful way to give a community a voice to tell their own stories.

TWENTY-SEVEN

Yuiyo, *Just Dance*

LIKE MOST ASIANS BORN IN AMERICA, my experience was a weird mix of being drenched in American culture, yet not accepted by it. The same applied to my artistic training and work experience. In songwriting I used the contemporary musical forms that I was familiar and comfortable with. In 1984, my comfort zone was challenged by Reverend Mas: "I want you to write an Obon song in English."

Obon is one of the most important rituals in the Japanese Buddhist tradition that we've maintained in our one hundred years in the United States: the remembrance of ancestors. We may not speak Japanese, we may not know how to cook traditional Japanese food, but we love to put on our *happi* (festival jacket) or *yukata* (cotton summer kimono) to dance in the circle of Obon. In Japan, Obon happens in mid-August, when folks return to their hometowns, clean their family graves, and offer incense and flowers. Then they gather at a temple to make music and dance, sometimes all night or for a few days. Here Obon festivals are celebrated at different temples from the beginning of July until mid-August, so families can visit one another's temples to renew friendships, and maybe get their kids hooked up. In Japan, where dancing lasts into the night, it used to be one of the rare unchaperoned moments. I'd heard that many marriages are made and babies born nine months after Obon.

In America we danced to tapes of scratchy old records from Japan. The scratches were part of the ambiance. Most of us sansei couldn't understand the words, but it didn't matter. The scratchy music from our homeland was like eating smelly *tsukemono* with hot tea poured over cold rice. It was comfort food. But it mattered to Reverend Mas. He wanted an Obon song in English so young people would know why they were dancing.

"Mas, I don't know anything about Obon music! I'm not the one to do this."

He ignored my pleas. He handed me a plastic bag with a bunch of cassette tapes containing various styles of the Japanese folk songs and told me: "Listen!"

This wasn't an ask. This was an assignment. There was no way to say no. Senshin had taken me in like a stray cat and given me a home. Even a rebel sansei like me feels a sense of *on*, obligation. But this was more than an assignment. It was an act of trust. There had been a handful of other Obon songs written in the United States, but this would be the first in English. Would it offend the elders? Would it sound weird to hear English inserted into this traditional folk style? Would I be locked out of nirvana forever if I failed to do this right? Possibly, probably, and yes!

I spent the next couple of weeks listening to the tapes, then grilling Reverend Mas for Japanese wisdom and words. We finally came up with a title: "Yuiyo," meaning "just dance." Meaning, throw away your ego, don't show off, don't worry what others think about you. Just dance. Reverend Mas was teaching me a lesson at the same time. I had to just write the song in the best way this sansei misfit could. The hardest part was trying to find the right-sounding English words with the right meaning. Unlike English, the Japanese language has no diphthongs, lots of syllables, and the "r" sounds like a soft "d." Composing the music was a bit more fun. The most fluent in Japanese music at Senshin were George Abe on *fue* (flute) and Johnny Mori on *taiko*. For shamisen, a stringed instrument akin to a banjo, I got Doug Aihara, who played rock guitar, to get his *baachan's* (grandma's) shamisen out of the closet and learn the simple plucked lines. I convinced three or four brave young women to chant *kakegoe* (response singing). I knew my own voice could never sound like the traditional women singers. So I had to get over it and just sing (see photo 25).

The song's first test was playing it for Reverend Mas. Would he accept it or hate it? Would he take away my keys to the temple? At first he had his eyes downcast. Maybe he'd laugh if he saw our ragtag Japanese American band struggling to sound like our grandparents. Did our English verses mixed with Japanese choruses sound screwy? It was his idea, after all. How could this even compare with the traditional "Tanko Bushi"? He began to nod his head—to the rhythm. Okay, that's good. There was a crack of a smile. It's danceable, right? Okay, is it okay? "Not bad," he said, finally making eye contact. Yes! It passed!

My next test was when Reverend Mas sent me to teach "Yuiyo" to the Obon dance teachers. They have a special system of preserving and spreading the dances to temple members. Each of the eighteen temples in California's Southern District has a couple of dance teachers who gather early each year to choose and review the dances they will do during the summer Obon season. They are the memory keepers of these old dances that were brought over from Japan. A few weeks before Obon, they teach and refresh with members who come to practice. Most people don't come to practice. They come, stumble into it, and "just dance." That's what I usually do. Now Reverend Mas wanted me, this outsider, to teach a new dance to these old pros. He didn't introduce me or explain anything about the song; he just threw me like a sheep into a den of wolves. Of course they were very polite, greeting me with reserved smiles. But I'm sure they were thinking, Who is this stranger teaching us this weird new dance with English words!

I had worked with Senshin's dance teacher, Grace Harada, and we choreographed the piece mostly using the vocabulary of normal Obon dance moves. But I wanted to add something that honored this land we were dancing on. I brought in simple steps of the Native American Friendship Dance as the opening movement. Even though people would not know it, they were making homage with their bodies.

We recorded the song and it was danced for the first time in 1984 in each of the eighteen Obon Festivals in Southern California. Later all the temples came together in a special "Gathering of Joy" with a thousand people on the plaza of the Japanese American Cultural and Community Center in Little Tokyo to play "Yuiyo" live. Sculptor Isamu Noguchi had designed the circle of bricks on the plaza for Obon, but I'd never seen it used for that purpose before. In the center of the circle, a *yagura*, the square platform that musicians play on and the community dances around, was being built. It had been trucked over from a temple, and was now being assembled and raised by the hands of men who knew where all the screws belonged. That day they were also training younger folks on how to raise it. Obon would only survive here if the young embraced all aspects of it.

I wasn't yet used to being shrink-wrapped in a *yukata* and *obi* (traditional belt). It's fashion origami, wrapped, tucked, and tied to define the limits of one's gait, while the rectangular sleeves emphasize movements of the arms. What was traditionally sexy for Japanese women was not what was in front of her torso, but that dip in the back that reveals the nape of the neck. The squeeze of the *obi* took the singing breath out of me. My feet were clinging to my *geta*,

three pieces of wood with a black velvet thong—an additional challenge to my moves and my balance. Japanese women have a special kind of fortitude to look graceful in that getup. And those slippers are not made for climbing the ladder of the *yagura*! Our fledgling sansei musicians, wearing *yukata* and *happi*, clumsily climbing and hauling up our instruments, were a sight.

The sun was setting as the community finished a round of the traditional dances—dances embedded for centuries in our body memories. Now it was time for the new dance, the weird song in Japanese and English. We were on the island of the *yagura*, looking out at four giant concentric circles surrounding us like *ojuzu* (prayer beads). My knees were shaking. Then Reverend Mas's lively opening chant broke through: *Namo amida butsu, tada odore!* The shamisen players struck their first note, settling into the pattern, not in perfect precision but close enough. The *taiko* punctuated their rhythms. My ribs pressed against my *obi*, finding the air to sing. And it was on!

> *Sunset . . . sky turning indigo*
> *Moon and stars begin their evening dance*
> *Circle in the sky*
> *Voice of wind, rhythm of trees*
> *You can feel it if you dance . . . just dance.*
> *Anno mama—yuiyo! Sonno mama—yuiyo!*
> *Konno mama—yuiyo! Tada odore—hi hi!*

A cosmic ocean danced around me. The sleeves of women and young children waved in the evening breeze. Brave men wearing *yukata* kicked up their *geta*. Teens in *happi* coats kicked up their tennis shoes. Elders danced with babies in arms. A thousand souls moving, carefree, smiling, dancing—*yuiyo!* Just dance.[1] Watching the cosmic dance, tears of wonder and gratitude rose in me. I let go and sang into the indigo sky. We were all connected—those in the circle and those gone before us. We were all moving as one.

That song didn't come *from* me. It came *through* me. It was coaxed from me by someone who was far wiser and trusting. It floated on layers of songs, dreams, circle dances, and cycles of time. It was just the right moment to birth a Japanese American Buddhist song in English, and I was the lucky one to deliver it.

Somehow, Columbia Pictures got wind of this giant circle of Obon with a thousand people at the JACCC plaza. It was just what they needed for the

finale of the movie *Karate Kid II* (1989). The music coordinator called me and said they wanted to bring "Yuiyo" to the screen. I met with the director, John Avildsen, and the producers. I could feel they were courting me. It was a little weird. They were just too nice. It was the first time Hollywood had approached me for a job. It was also my first time working on the other side of the camera.

They wanted authentic Obon—people, not professionals, in traditional dress, et cetera. They gushed respect for Japanese culture (the film's story, however, is set in Okinawa, where the Obon music is a different style). They thought they had found in me someone they could work with, someone Japanese but American, someone savvy about Japanese tradition who had worked in Hollywood and knew what it wanted. What they wanted was three hundred Obon dancers from the community. Yes, I can do that. They wanted the musicians and those *taiko* drummers. Yes, no problem. They wanted the dancers in traditional dress. Yes, we can do that. I told them the song was not exactly traditional. The verses were in English. They didn't seem to hear that. They hired me as songwriter and choreographer and paid me more than I'd ever earned in a day. The producers were happy. The music coordinator was practically drooling on my arm.

I had enough money to bring on José De Vega (he was still alive then) and Louise Mita to assist. They knew the ropes. I got Johnny Mori and Reverend Mas to play *taiko*. Our plan was to go to three temples and recruit one hundred dancers from each. Then I got a phone call. The producers wanted to meet me.

They opened again with respect for tradition, then proceeded to inform me that those white and black cotton kimonos wouldn't read well on the big screen. They asked if we could get the dancers to wear colorful silk kimonos, their own kimonos? I told them, it's summer, it's hot, the tradition is cotton. They pleaded. I told them I'd go to my community and ask. The community said okay, fine, sure, they were willing to do that. José, Louise, and I went to the three temples and asked each dancer to bring a couple of their own silk kimonos so we could choose the best colors. Then another call came from the producers. They wanted me to deliver a tape of the song to Bill Conti, the film's music composer. He lived in Hancock Park, a gated community not far from my house. They wouldn't let me in the gate. I had to leave it with the gateman.

Then a week before the shoot, I got another call. In a final production meeting they told me we'd be doing the dance to a click track. I paused, knowing a click track just gives a beat without music, to keep people in time. Wait a

minute, I said, why a click track? We have the music. They said, because Bill Conti is going to write the music. I said, Bill Conti? He doesn't know anything about Obon music! That music, which I wrote with Reverend Mas, goes with the dance. That dance goes with my music. They said, Conti had the option, it was in his contract. Which means, in addition to him writing the score, he gets royalties for writing the song. I said, that song doesn't belong to me. It's part of the Buddhist tradition, it belongs to the community, it belongs to the dance! Aren't you the producers? They said yes. I pushed: "Don't you have the last say?" Yes. "Well," I countered, "just tell him you're using the original music." Then my mind slowed way down. I got it, I saw the picture. They wanted the big finale for their film. They wanted to get three hundred dancers, with ready-made choreography, in their own silk kimono costumes, on the set. That saved them oodles of time and money. They didn't give a shit about Obon! They didn't give a shit about being authentic if they were going to have Bill Conti write the song. They wanted a village, they wanted those three hundred dancers on the screen.

At that moment I realized I didn't give a shit about this Hollywood movie. I didn't give a shit about the money (even though I could sure have used it). Something else was more important. That song, that dance, and my community were connected. And I wasn't going to let them take it apart. Suddenly, it became extraordinarily easy to stand up and say: "Well, if you don't use my music, you don't get the three hundred dancers." I walked out of their office, and I didn't have to look behind me to know their mouths dropped wide open.

I went to tell the film's stars, Nobu McCarthy and Pat Morita, what happened. They got it. I told José and Louise if they wanted to do it without me it would be okay. I went to the temples and told the dancers the same. Everybody agreed to back me up. We don't do the dance if they don't use our music. We were solid.

A few days went by, then I got a phone call from the music coordinator. He was not so nice now. His drooling had turned to ice. He said the producers had changed their minds. They would use my music.

The shoot proceeded on schedule. They bused in the three hundred dancers from the Buddhist temples at the crack of dawn. Movie shooting schedules are grueling, with a lot of wait time in between takes, but our Japanese community, many of them elders, including my mother, were cooperative, thrilled to be part of it and having a good time. The first couple of days I was engrossed in moving around the three hundred dancers. Then I realized, hey, they're

bringing them in at six in the morning and they're working them until six in the evening, twelve hours. That's against union rules. I told the assistant director, "Extras can only work ten hours. You have to give them overtime pay." (Overtime for three hundred people for three days is a lot of moolah.) They'd thought they could get away with it; these nice Japanese wouldn't notice they were being cheated. Then the production folks gave me the big freeze on the set—no smiles, no small talk. I just did my job. I didn't care.

The movie finished and I was invited to the premiere. John Avildsen, the director, gave everyone a gift, a yellow sweatshirt with our name and our role in *Karate Kid II* on it. Mine said "Nobuko Miyamoto—choreographer." He wrote me a note thanking me for my contribution and acknowledging that I was fighting for the best artistically. At the end of the film when the credits rolled, I saw: "Nobuko Miyamoto—choreographer." No credit as composer. Those assholes! To this day I do get music royalties, which means I am legally acknowledged as the composer and with Reverend Mas as co-lyricist of song. But not giving credit? I guess it was their petty revenge for me, the on-set troublemaker.

My credit was not worth fighting for, but I did get a lesson from this venture: Asians are looked at as pushovers in Hollywood. In general, people have to swallow their pride and accept this treatment for the money or to get ahead in the business. Since I wasn't interested in a movie career, it was easier to resist and demand what was right. I had little power as an individual, but with the community behind me, I could make a stand. Being in the movement prepared me for that *Karate Kid II* moment.

TWENTY-EIGHT

———

Float Hands Like Clouds

I LIKE TO TELL PEOPLE I had an arranged marriage, just to mess with them. It was—not in the traditional sense, but in the cosmic sense. Our friend Norman Jayo was the soothsayer. He knew which sticks to rub together to make fire. A Pilipino comrade who lived in Oakland, Jayo was a radio producer, writer, organizer, and genius renaissance man. Tarabu Betserai Kirkland was his match, his soul brother.

Jayo knew I was working on a musical called *Holiday Bowl* about that bowling alley on Crenshaw, the hangout for the Japanese and Black communities. I already dreamed about the opening: a big musical number with bowlers on the lanes. Among the crazy cast of characters who hung out at the alley and the coffee shop, there was romance—a sansei guy and a Black sister. Tarabu was also working on a musical, *Juke Box*, a struggle against urban renewal in an Oakland neighborhood (sound familiar?) centered on a restaurant owned by an interracial couple—a Black man and a nisei woman. Jayo conjured our meeting.

On Tarabu's first visit, I thought it fitting to take him to Holiday Bowl to confer on our two projects. We parked in the lot underneath the REVOLUTION! graffiti and walked in through the cacophony of bowling balls, finding a quiet corner in their Japanese restaurant. I ordered sushi. He ordered green tea. That's when I learned he was nearing the end of a forty-day fast. Forty days—I can't fast for three! No wonder he was so thin. He had just returned from a writing retreat in Mammoth where he fasted and worked on *Juke Box*. I can't write when I'm hungry.

He was a martial artist who woke daily at half past four in the morning and crossed the Bay Bridge to do tai chi with his *sifu* (master teacher) in San Francisco's Chinatown. Shaving his head was part of his daily practice. He

228

shined, in more ways than one. Mere sushi would not sway him from his discipline. I could feel his *chi*. Yes, I had just met Tarabu.

In his hometown of Buffalo, he was born Albert Kirkland, the last of nine children and the only surviving son of Albert and Mamie Kirkland, both refugees from the Jim Crow South, part of the Great Migration. His father, a steelworker, died of a heart attack when Albert was nine. When I met his mother, I was impressed by his loving treatment of her. She was a short and sturdy woman, with feet that had known lots of walking. At seventy-seven, her many miles of hardships had left her with a lively spirit and a quick wit that told me she was grounded and comfortable with who she was. She had her own kind of *chi*. I could see they had a special bond. His sister Margaret had taught him about music. While some were getting hooked on drugs, he was getting hooked on jazz. At sixteen he was painting a mustache on his baby face and dipped a hat over his Afro so he could get into Buffalo's downtown jazz clubs. He heard all the greats—Miles Davis, Lee Morgan, Wes Montgomery, Horace Silver, Nina Simone.

Buffalo was a Black and White, hardscrabble town in a downward postindustrial spiral. Its claims to fame were nearby Niagara Falls and frigid weather. One chilly gray May day, Albert Jr., a cross-country runner for Bennett High, was poised in his blue and gold shorts at the starting line at All High Stadium. He felt something brush his left shoulder, then something wet on his neck. He looked up and saw snowflakes. It was May, and snow was melting on his bare shoulders! The crack of the starter's pistol pierced through the gray air and he bolted. As he pushed his body through the flakes of snow, his mind went into hyper mode: "I—don't—have—to—live—here!" He was running at All High Stadium, but after he finished at Canisius College he was bound for sunny California.

In 1971 the Bay Area not only had sunshine but was aflame with flower children of all colors. The first time Albert saw a Black and White couple walking together, hand in hand, it blew his mind. He was in the cradle that birthed the Free Speech Movement, the Third World Strike, Black Power, Yellow Power, and Chicano Power. His Oakland apartment was down the street from the Black Panther office, where Indian spiritual guru Muktananda took his daily walk showering blessings with his peacock feather. One day he saw the guru tell the Panthers: "What you are doing, very good, but you need spirituality!"

In the Bay Area, Albert was an early practitioner of transcendental meditation. He studied trumpet and Afro-Cuban drumming. He found his voice in radio. On KPFA he interviewed folks like Bob Marley, Angela Davis, and

Imamu Amiri Baraka, shared music he loved, and chronicled stories like the people's struggle against eviction from the International Hotel in San Francisco. He and Jayo spearheaded a revolution inside KPFA radio to establish a training program to bring people of color into radio. Somewhere along the way he found his new name, Tarabu, which means "music is love" in Swahili. His chosen last name, Betserai, connotes "to help or assist." Both are such suitable monikers.

I was forty-seven and he was thirty-seven when we met. I recognized that a Black man's timeline is accelerated, but I still thought he was too young for me. Anyway, I had just closed one love chapter and decided it was easier to be an art nun and continue my role as a single mom. Tarabu and I would be friends. I even helped him through his first love relationship with a White woman. He turned me on to my first computer, an Apple Macintosh with a nine-inch screen. I introduced him to the liver flush, one of my health routines. We became good friends.

One weekend I was in the Bay Area and Tarabu talked me into joining him for morning tai chi. It was five in the morning, bone cold and still nighttime as far as I was concerned. We walked through Lake Merritt Park, where the geese were still sleeping. We climbed the steps to a beautiful marble gazebo that was made for music concerts, but a perfect space for tai chi. I watched him from behind, gray wool cap warming his smooth shaved head, black sweats hanging on his thin frame. He planted his feet a foot apart on the white marble, took a breath, and paused. With the lake shimmering before him, he reached his arms around the universe, calling it into his body, and calling me to follow. He exhaled a white cloud into the indigo sky. His left foot opened and the dance began: *Parting Wild Horse's Mane—White Crane Spreads Its Wings—Grasp Sparrow's Tail—Float Hands Like Clouds*. I'd been a mover all my life, but this was deep knowledge with Asian roots. Tarabu moved with graceful precision in patterns prescribed by ancient *sifus*. He was a black cat on white marble, making the sun rise. As I became his shadow, I knew I was falling—there was something too special about this guy.

As it turned out, while I was still dreaming about *Holiday Bowl*, Tarabu finished *Juke Box*. He asked me to play the wife in the interracial couple, but I was reluctant because of my schedule. Then he took me along to a meeting with Danny Glover, whose stardom had just been launched in *The Color Purple*. He was in the middle of shooting *Lethal Weapon*. Danny agreed to play the husband and would fly up on weekends to rehearse. Oh my god, if Danny Glover would do it, I certainly could! *Juke Box* was produced on stage

at Laney College on August 23 and 24, 1986, and simulcast live on KPFA. It was an innovative idea—a radio play with great music, live actors on stage, and sound effects, like the old radio shows. Jayo directed, and Tarabu wrote the script and some amazing music. It was hot! With Danny Glover and a stellar cast of Berkeley's best singers and performers and special guest Attallah Shabazz, Malcolm X's daughter, the show was a sellout.

We rehearsed on weekends when Danny was free, but sleepy from his work shooting films. He had just become a big star but still kept his feet in the community. (And he could sleep anywhere: in a chair, on a couch, sitting at a table. Later we found out he had narcolepsy.) I was also sleepy from our weekend shuttles, but I admired the way Tarabu worked, tai chi in action. I loved his song. We had a running joke. He'd say, "You're going to marry me someday." My standard reply was, "No way!" But one Sunday night, as he walked me to Southwest Airlines, Gate 22 at Oakland Airport, I asked him, "Is your mom coming from Buffalo to see the show?"

"Yes."

"My mom's coming too. Are your siblings coming?"

"Yes."

"Mine too." And without thinking I added, "Maybe we should get married after the last show." I don't know where that came from. I had no intention of getting married again. Tarabu had talked about coming to Los Angeles to live with us. In fact, he had a job offer in LA to be KPFK radio's station manager. But we never talked about marriage. Tarabu laughed and left me at the gate.

It was a practical idea, a sensible idea, a logistically easy way to make our wedding the finale of *Juke Box*'s run. Tarabu was in his car when the impact of my impulsive proposition hit him. He ran back to the gate and caught me just before boarding. "Did you really mean that?"

"Yes!" I said, shocking myself.

I was a person who always seemed to break from normal. Sometimes you have to disrupt the normal to make the world you want to live in. Kamau and I made a crazy colorful patchwork of a life that was our normal. Now this special person was filling a space I never thought possible.

We married with three rituals: a Christian ceremony done by Tarabu's sister, Reverend Margaret; a Buddhist ritual led by Reverend Mas with Tarabu taking three sips of sake from a lacquered cup, my mom taking three sips, then me exchanging with his mom; and finally we did tai chi together— me in my bare feet and slightly tipsy from sipping sake in the ninety-five-

degree heat in Berkeley's Tilden Park. But tai chi energy kept us grounded. All these rituals were foundational as we embarked on our journey to unite our two families, with our different histories, cultures, religions, and spiritual practices. Tarabu's mom was unflinching in her acceptance of her new daughter and grandson. She came to Senshin Temple's New Year's Day service and loved Reverend Mas's talks, but eating sashimi was a no-go. My mom was relieved to see me marry, no matter what color. She saw Tarabu was an honorable man, like my father, and was happy for Kamau to have a real father.

Tarabu was undertaking a difficult option, giving up his life of seventeen years in the city he loved for the woman he loved. Plus he was taking on a teenager. It seems Black men have an easier time accepting someone else's child, but in our case, he had to take on the burden of our story as well. Tarabu had missed Kamau's cuddly, cute, lovey stage. At thirteen he was still polite and quiet but showing signs of his warrior independence. During one of the bimonthly haircuts I gave him, he grabbed the electric shears from my hand and demonstrated his skill in cutting designs into his squared-off Afro. Wow! That was the last time I gave him a haircut. Soon our bathroom became a barbershop for his friends, who paid him a couple bucks for a cool design in their buzz cuts. He was a teen.

Of course, I was nervous about how Kamau would react to Tarabu. Kamau had been my anchor, my reason for being, and my greatest gift. Though he had to put up with my crazy life and artistic mission, we had our own rhythms and internal language. We'd survived lean times to make a full life together. When I told him Tarabu and I were getting married, he said, "What? Now I'll have two people telling me what to do!" Without further conversation he walked out of the house and jumped on his bike. "I'm going to Jerome's." He needed time to digest this disruption to his life.

Yes, it was a disruption, but I knew it was a good one that would settle us and give us stability. I knew Tarabu would be good medicine for Kamau, but I didn't realize how hard it would be for me to loosen our bonds to make space for Tarabu. It meant creating new habits, like consulting Tarabu before making decisions. We also had different ways of communicating. Tarabu is very direct. I am indirect, dancing around the edges before making decisions. The difference between his low-context and my high-context way, I later learned, was based on deep cultural patterns. Japanese people are very high context. Our difference was not a matter of color, but culture. We both agreed on important things, like peppermint soap, brown rice, and not eating pork.

Tarabu had experience fathering the children of his girlfriends, some of whom became his lifelong children. But Kamau did not always show appreciation for getting homework help and having someone to throw a ball with. This sometimes hurt Tarabu's feelings. He was in fact a gift, fulfilling what Kamau's father could not do. A couple years went by and Kamau came home with a good grade on a poem he wrote. He gave it to Tarabu to read. It was sort of a tribute using Tarabu's bald head as a metaphor. It was called "My Bright Shining Ball."

A rare smart thing I did earlier in my single motherhood was to buy a house—well, half a house, a duplex. Together with Donna Mori, who also happened to be a single mother with a beautiful Black and Japanese daughter named Aisha, we begged and borrowed to buy our duplex. We both were part of a movement that deemed owning property capitalistic. In the 1970s, we turned up our noses at some cheap properties. But years of being a vagabond, kicked out at a landlord's whim, taught me a lesson: as Billie Holiday sang, "God bless the child who's got her own."

The side-by-side 1930s creamy-white stucco dwelling on Highland Avenue near San Vicente was not far from LA High, my alma mater. Although it is on Highland, we call it Lowland because the rich folks live in the big houses up toward Hollywood, and we live near the end where the smaller houses tend toward a place called "The Pit," a Black and now Latino neighborhood stigmatized as a place for drug use. I first rented the two-bedroom railroad flat from Rodger Takemoto, a nisei who took me in as a government-supported Section 8 renter. A year later, when he told me he was going to sell, I said, "No, please, let me try to buy it!" For some reason he said yes. Later Reverend Mas told me that Rodger's brother, a Buddhist minister, told him that I saved Rodger's life. What? Evidently Rodger, whose house was across the street, appreciated the time when his wife went on vacation to Australia and he was home alone with the flu, and I happened to take him some chicken soup and carrot juice. I don't think it saved his life, but maybe he didn't mind having me as a neighbor. He lowered the price and took it off the market until I could get the money together.

Moving into someone else's house is hard, even when you're doing it for love, especially when a kid is involved. But Tarabu showed amazing confidence—not to mention an artist's eye and a fearless handyman instinct, all of which went far to turn *my* house into *our* house. After one of our first dinners

with the three of us sitting around the old oak table that my mom bought us at her church yard sale, he said, "I hate this yellow kitchen." Rodger had built the cabinets and painted them yellow, and had Sears install matching yellow floor tiles.

"Me too," I agreed.

"And what's under that ugly green rug in the dining and living rooms?" He didn't wait for an answer. He got up, foraged for a screwdriver in our tool drawer, pried off the metal strip between the kitchen and dining room floors, and pulled up a swath of the rug!

"Hey, what are you doing?" Thinking, this is going to be a mess that will be hard to repair.

"Wow, there's a nice floor under here." He continued to rip up more green rug. I was out of my chair trying to stop him. "Let's get rid of this ugly rug and redo the floor."

I hated but tolerated that rug, because any house-beautifying task that big was beyond my abilities and pocketbook. Besides, I was too busy with my work to think about it. But Tarabu was undaunted. "I can get this done in three weeks." Mind you, all while stepping into his role of station manager of LA's radical, unruly KPFK. The first day on that job he was in the back patio at five in the morning doing tai chi, plus wielding Shaolin swords, then meditating! He was working up his chi like he was going into battle, which he was. Still, Tarabu had the energy and desire to make a better home for us.

This was the project that showed us who Tarabu was. Getting to the beauty of the floor meant that absolutely everything in the living and dining room—couch, bookcases, dining room table, chairs, desk, and an old, heavy upright piano—had to be moved into the hallway or the bedrooms of our railroad flat. We lived that way not for three weeks but for three months. Turns out there were broken slats in the floor. He didn't know how to fix them, but had the patience to figure it out. When the wood was perfectly sanded, he didn't put on the normal two coats of Varathane, he put on five!

The result was a sheer beauty that still greets us when we open our front door today, after thirty years in a house where we do not wear shoes. This premiere effort was followed by more—a kitchen redo, the transformation of the garage into a studio. Tarabu was our fearless leader and I was a good follower. As for Kamau, well, he was a teen. It was fun and darn hard work. Eventually, Kamau painted a mural with a huge *I Ching* circle on a large wall in our backyard. Ours is a house made by our own hands, all because of Tarabu.

Unlike me, Tarabu was good at getting to know our neighbors. He learned their names and took the time to talk to them. He asked for advice from Rodger across the street, who had a garage full of tools from decades of working at Sears. If he didn't have what Tarabu needed he asked his neighbor, Larry, an African American elder and handyman who also had a tool-filled garage. In our neighborhood, these good friends were called Mr. Rodger and Mr. Larry. Being retired, they were happy to lend a hand and give plenty of advice. We weren't just fixing our house: we were building a life as a family and becoming part of our neighborhood.

Tarabu stepped into our lives like he stepped onto the marble circle at Lake Merritt, bringing his love, using his chi. He transformed our backyard into a garden dojo, a place for that daily morning practice that continues to sustain and bind us.

> *Float Hands Like Clouds*
> *His tai chi feet gliding on the marble*
> *Capturing my heart*
> *Carry Tiger to the Mountain*
> *He let me know for certain*
> *This time was forever*
> *We would never part*

TWENTY-NINE

—————

Deep Is the Chasm

ON APRIL 29, 1992, just around the corner from our house, a Black man-child poured gasoline on a store. A neighbor pleaded with him, "Stop! Stop!" But he could not. Something had taken over his hand, a power he had never known. He struck a match to burn what he thought he could never own. Fire burning up Normandie, fire burning up La Brea, fire burning up Crenshaw, fire burning like a virus through LA's veins. Was this James Baldwin's "fire next time"?

Gathered in the middle of our street with anxious neighbors, Tarabu and I watched the plumes of smoke rise around us, worried for our homes, holding our garden hoses, ready to dampen our roofs and extinguish falling embers.

The brutal police beating of Rodney King caught on home video camera (years before cell phone cameras) became a TV mantra that circled in our psyches, unleashing new insults upon old wounds. The "not guilty" verdict of those officers struck the match, and a few hours later LA was burning. For three days, our TV never slept. We watched the media's marathon of madness in LA's streets. Gil Scott-Heron was wrong; the revolution *will* be televised. The brutal beating of King was part of an unbroken history of repression, a rite of terror passed from slave owners to the Klan to law officers. It remains a threat and an untreated trauma for every Black and Brown man in America, including in our family. The Black anger that screamed for attention did not target the LA Superior Court that systematically doled out injustice, or the banks that refused business loans. It struck at a beef closer to home—the 735 Korean-owned markets, gas stations, and liquor stores that

My song "The Chasm" is on my album *Nobuko: To All Relations* (Bindu Records, 1997).

236

peppered South Central, an explosive cocktail and a daily reminder for the Black community of racism and economic inequities, plus cultural ignorance. (Koreans blindly entered the African American community via loans to buy, cheaply, local businesses that Blacks had long been locked out of as potential owners—loans that would create local business and economic growth.)

What started as an explosion of Black anger was not contained in the ghetto, like Watts in 1965, but traveled with speed due north toward the Hollywood Hills. My husband was driving on Wilshire Boulevard, once christened the Miracle Mile, which had transformed oil wells and the La Brea Tar Pits into an upper-class, car-friendly shopping center with high-toned modern and art deco architecture. But on April 29, Tarabu witnessed mobs of people on foot, mostly Latinos (maybe refugees from war-torn countries), ripping security bars off storefronts and dancing in and out of businesses liberating things they wanted, needed, or could never afford. Besides couches and televisions, the most looted items were Pampers diapers and liquor. For some it was a wild party. In Black communities, businesses put up signs that read "Black Owned" and had neighbors protect them. On La Brea around the corner from our house a videocam recorded my friend Joe Goodman's music store being emptied, its contents loaded onto a truck, a criminal robbery by opportunity. Then there was the frightening television image of Koreatown store owners who were left unprotected by the Los Angeles Police Department, on their rooftops armed with rifles. For them it was all-out warfare.

The three days of madness left 55 dead, 2,000 wounded, 3,600 fires set, and 1,100 buildings destroyed. The mayhem was quelled, but the fury was not. The smell of smoke still clogged the air, but I wanted to see for myself what was left of LA. My friend and art partner Magda Diaz ventured with me, camera in hand. We wanted to capture images for a performance piece we were working on. We made our way to the riot's center through streets that looked like the end of a gigantic bad party, littered with emptied television boxes, liquor bottles, and plastic debris snowed upon by ashes. We went to Florence and Normandie, where the riot ignited, then proceeded deeper into South Central, where larger stores owned by Koreans had burned to the ground and were still smoldering, like the mood of the people on the streets. Angry eyes followed me driving my beige Dodge van with Magda hanging out the window shooting video. We were trespassers in a war zone.

I stopped at a light and a young Black man who looked like Kamau, but a shade darker, stood his ground, glaring at me with fire in his eyes. To him I was

the enemy. There was no way to say, "Hey, you could be my son!" He could hate me freely because he didn't know me. He could hate me because I resembled the yellow woman he gave his money to at the corner store, the woman who never smiled at him, the woman who came from a custom of absence of expression and maybe a custom of racism. He could hate me because of her lack of English. The yellow woman never asked his name and followed his every move even though he came with money daily for his bottle of Coke. He could hate me because he too never knew her name and didn't know that her shoulders grew stones from fear that she might die like her two countrymen store owners, and she was always angry at being the loser in the game of hide and steal.

He could hate me because a yellow woman, just thirteen days after the King beating, killed a young sister, Latasha Harlins, before she could put her money on the counter for that lousy carton of orange juice. He could hate me because that woman, like the police who beat Rodney King, was set free. The young man knew if the reverse were true, he would be dead or forever behind bars.

The fire in the eyes of the young man who looked like my son would not be extinguished with my words. The red turned green, but I could not leave that scene behind me.

This is where I live, in this intersection, in this place between, in this space of both. I cross the street from one world to another every day, every hour, with my Black husband, my Black and Japanese son. I have had the chance to learn the differences and similarities. I embrace the joys and carry both burdens. We listen and learn around our kitchen table from all our stories. Our stories are what bring us together, make us family. As an artist, I wondered what I could do to bring people together, to know more than their own story (see photo 24).

What can a song do?
Can it stop a bullet
Can it tell the truth
Can it help the homeless
Can it talk to the youth
What, what can a song do?

A disaster was declared. Fingers pointed. Community leaders gathered. Commissions created. Police practices questioned. Racism, excessive force,

and codes of silence revealed. Committees on race relations made. Cultural differences, poverty, and gangs blamed. South Central had a name change and became South LA, a place where things were going to be better. Rodney King's response was a simple question we're still trying to answer: Can we all get along?

But simple is never simple once you drill into histories of oppression and mixtures of cultures in a capitalistic system that thrives on competition and individualism, and is built on slavery and genocide—that divides to conquer and control. I had my own questions. How could that young Black man who looked like my son know my story? How could I know his? If the Korean storekeeper had known Latasha's story, would she have pulled the trigger? I'd heard an ancient saying, "You can't kill a man whose story you know." I began wondering, How can we share our stories across our color lines?

We'd already seen the effectiveness of putting the stories of Asian artists on stage together in *A Slice of Rice*. Could putting Asian, Latino, and Black stories next to each other help de-ghettoize our minds? We were on a journey to find out. *A Slice of Rice, Frijoles and Greens* provided an intersection we don't normally have in our daily lives. That's what art can do.

Paulina Sahagun grew up with two languages and two cultures. Her work drew from both sides of the US-Mexico border, from training and working in a *teatro* that was part of the movement in Mexico. She was both an Aztec princess and an American-born *pocha* who used physical humor to illustrate the contradictions of her two worlds.

Chic Street Man was a rare blues man who had a way of weaving song and narrative that opened your heart to the most painful of stories, like his grandma who became mute after being raped by a White man. She found her voice again when she picked up a guitar. She taught Chic to play and passed on a kind of loving forgiveness that would pierce the heart of even the most hardened White supremacist.

Lynn Manning, who started the Watts Village Theater Company, was blinded by a bullet at age twenty-three. With his dark sunglasses, he strolled onto the stage like the powerful judo champion that he was (former world champion of blind judo), unassisted. His feet stopped at the cross of the rope taped center stage that told him which way was front, and he slowly revealed the violence that led to his sudden blindness. He blew the audience's mind.

Arlene Malinowski broke the perception that "all White people are . . ." Her words and sign language communicated another kind of discrimination. She was a child of deaf adults (CODA), and a translator and protector for

parents who are dismissed or mistreated as stupid because of the strange way they speak.

D'lo, a pioneering transgender Tamil–Sri Lankan American actor and comedian, performed both self and mother coping with the transitional confusion of gender and culture with humor, compassion, and rare insight.

These artists along with our Asian team were on a mission! We did together what we could not do alone. It expanded Great Leap to become a multicultural organization and grew our community. Touring schools and universities nationwide, we sparked conversations on race and difference. Putting stories of people of color and the differently abled side-by-side made the mind jump to make its own connections, laugh at our ignorance, and see our common humanity, without preaching. It was a nonconfrontational way of sharing. The form itself was democratic. It did not dilute us or diminish others; it expanded us. We were using art as part of a process to undo "divide and conquer," exploring ways to help us "get along."

Can it kill the hate
Can it stop the fear
Can it give you hope
Can it make you hear
What can a song do?

THIRTY

To All Relations

IN 1992, THE SAME YEAR AS THE UPRISING, October 12 was Columbus Day, the celebration of the quincentenary of the so-called discovery. For Indigenous people it marked five hundred years of conquest and genocide, not only in the Americas, but around the world.

The American myth made us see the "discovery" through the eyes of the European. And of course, we weren't taught about Pope Nicholas V's Doctrine of Discovery of 1452, which declared "war against all non-Christians throughout the world." It sanctioned "conquest, colonization and exploitation of non-Christian nations and their territories." It promoted pillaging and capture of pagans to put them into "perpetual slavery."[1] The consequence of that doctrine shaped the world we live in today. Our so-called education also left out the part that Columbus was an ambitious, greedy, tyrannical guy who used torture and humiliation to rule and subdue.

October 12, 1992, was a moment to dismantle the myth. Many in the movement planned demonstrations and educational events in opposition to the commemoration. John Funmaker was a spiritual leader who formed the Iron Circle Nation, which included many tribes. (There was a traditional trend within the movement that criticized his more international approach.) In San Pedro, California, they created the Many Winters Gathering of Elders, calling together tribes from all directions and opening the way for non-Indians to listen to Native wisdom.

Since the early days of the Asian American Movement we had political and spiritual kinship with Native peoples. Japanese American fishermen from Watsonville boated in supplies to the 1971 Native occupation of Alcatraz. Activists like Mo Nishida, Kathy Masaoka, Tatsuo Hirano, and

others took medicine and supplies into the 1973 occupation of Wounded Knee in South Dakota. (I wasn't able to go, being six months pregnant, but I experienced a harrowing police chase and got arrested for driving American Indian Movement leader Russell Means to a meeting!) In 1992 Mo Nishida helped organize with John Funmaker what was called the 50/500 Run, a 220-mile run from Los Angeles to the Manzanar Pilgrimage, commemorating fifty years since camp and five hundred years since Columbus. This continued on for years.

Chavela was a spirited sister who did the run and invited me to come to the Gathering of Elders in San Pedro, California: "Bring a long cotton dress. I want you to do the sweat lodge." The year 1992 had been a heavy one. Our streets were scarred and our souls still in recovery from the uprising. We needed spiritual wisdom. We needed this moment of healing.

As Tarabu and I climbed up the hill to Angels Gate, the smell of the ocean mixed with the aroma of fry bread. The tips of three tepees grew larger as we approached the top of the rugged hill that looked to the Pacific. The simple but mighty tepee architecture pierced the blue sky, saying, "We are here. We have always been here." Chanting and drumming pulled us toward a crowd circled around a large skin-covered drum and a group of mostly young men, led by a couple of gray-haired elders. This was not the movies; it was rough and real. You could feel the pride in the young ones knowing their songs. Like our circle of Obon, it was not performance, but ceremony.

We passed a roped area with a hut made of bent poles covered with blankets. It was the sacred sweat lodge, the *inipi*, off-limits to the many visitors. Outside, people were standing in line for the free food and fry bread. Some had brought blankets to picnic on and for children to sleep on. It felt more like a village than a park. A large group gathered inside the arbor around a fire that had been burning for four days. This was the final day of the gathering. We were a mixture of colors, but Native Americans and Chicanos seemed to be the majority. Some were sitting on the few benches wrapped in jackets and blankets, but most of us were on the lumpy grass.

The speakers were elder spiritual leaders from different tribes. Some had come from great distances. The drums dimmed and the talks began. Before each elder spoke, they did greetings in their own language, but many spoke the sacred words, "*Mitakuye Oyasin,*" all my relations, from the Lakota

nation. (The Wounded Knee struggle had created allies among Native people.) Each spoke with calm, sometimes weaving their language through their talk. One elder, after saying "*Mitakuye Oyasin*," explained, "not just the two-legged, but the four-legged, the winged, the water people—Mother Earth, Father Sky—friends, families, enemies—all relations." My breath slowed and the four o'clock wind blew through me. We were in eternal time. "*Mitakuye Oyasin*" rolled over me again and again, and the full meaning of "all relations," so simple, yet profound, sank in. I began to realize that the roots of the inequality and violence of our world went far beyond our political system. We live in a deficit of spirit, easily divided and disconnected not only from each other, but from our very source, Mother Earth.

Columbus and the colonial process did everything to erase Native people, their language, and their culture from this land, yet five hundred years later, they were here teaching us. It made you think, what would America (or Turtle Island) be like if Native people remained its caretakers, and accepted us as "settlers"?

The sky was turning indigo and ocean mist surrounded us. Chavela found me and told me to change. I put on my *yukata*, the only long cotton kimono I had. I felt trepidation as I approached the *inipi*, taking my place at the end of the line of twenty women, a few elders among the young, all brown skinned. I wanted to be last in case I needed to leave. I feared I would be claustrophobic.

The instructions were specific. We entered the *inipi*, crawling clockwise in a circle on our hands and knees. I could feel the heat from the pile of hot lava rocks in the center. When our circle was complete, we sat shoulder to shoulder, cross-legged. More glowing lava rocks were brought in. When the opening was covered with blankets, I had to control my panic. Eyes open or closed, I had never been in such blackness. Water was poured over the rocks. A wave of hot steam hugged us. It was hard to breathe. An elder began to chant a song. A chorus of women responded. We were there to purify ourselves, our sweat cleansing our minds and bodies, testing our endurance. I feared I could not last. Somewhere in the middle my body was burning. I could not breathe. I moved to get out, but someone pushed my head close to the ground. The slightly cooler air was a relief. Somehow, I endured for the final act. I followed the women and crawled out, exiting clockwise, a ritual of rebirth.

Was I reborn? I don't know, but I went home feeling like the axis of my world had shifted. In the next few days, a song came to me, "Mitakuye Oyasin":

To all relations—Mother Earth and Father Sky
To all relations—every nation, every tribe
Every family, every stranger, every friend and every foe
Every form and every creature
To all relations[2]

Songwriting is a curious process. Sometimes it's a journey and you don't know where it's taking you. You hear something in your head—a melody, a rhythm, a fragment, a phrase, a hint that asks you to follow and figure it out. Sometimes you just wait and listen for it. Sometimes you have to work hard on it, like a puzzle with a thousand pieces. "To All Relations" came to me so quickly, so clearly. It flowed through me, like I was just a medium to get it out. It happens once in a rare while. You hear it later and wonder, "Did I really do that?"

Our music director and producer Derek Nakamoto had a musician friend, Duncan Pain, whose grandfather was Wallace Black Elk. In our recording Duncan weaved in a prayer in Lakota. Then Black Elk did a ceremony to bless the song. It wasn't just an honor; it gave me a sense of responsibility to use it well, to use it in a good way.

Mitakuye Oyasin
We're in the circle of oneness

THIRTY-ONE

Bismillah Ir Rahman Ir Rahim

"HEY MOM."

It seemed like just another Sunday-morning call from his college dorm. Kamau was an art major at San Francisco State University, a school that was within our means. He was close enough to come home for holidays, but far enough away to try his own wings at age eighteen. He was familiar with the Bay Area. During high school he'd worked as a summer camp counselor in San Francisco for my friend Jeff Mori's organization, Japanese Community Youth Center (JCYC), where he learned the importance of being part of a community and serving others. At SF State, our former Arlington Lounge neighbor Bobby Farlice worked for EOP (Educational Opportunity Program) and was his guardian angel. Having a community cushion is important for young people trying to find their way in the world.

Kamau gave us relatively few problems during the perilous teen years, except that time in high school when he danced in a rap group. The manager enticed them with cool jackets and a trip to Atlanta to a rap convention, filling him with a crazy dream that was veering him from college. No way! Tarabu and I nipped that one in the bud.

Right after high school he had the privilege of being one of five youth of color chosen to be part of a documentary film project about South Africa, *Uncommon Ground*, directed by Amie Williams. It was the summer of 1991, a few months after Nelson Mandela was released after twenty-seven years in prison. They toured the country and met with leaders of the African National Congress just before the referendum that would end apartheid, a profound historic moment to witness. In Grahamstown, each youth stayed with a family in a poor Black township. Each shot a short segment for the documentary coached by Ben Caldwell, our filmmaker friend from Leimert Park who kept

us connected to our kids via weekly video conferences. Kamau filmed a traditional rite of passage for a young man who received teachings from elder men in the village, survived alone for a week in the bush, and then was circumcised and celebrated while running through the village. For Kamau, this immersion into the cultural and political realities of a changing South Africa was a rite of passage in itself. On their way home at a stopover in Rio de Janeiro, we got a phone call: "Hey Mom," he begged, "please, can I stay an extra few days?" He got a taste of his first warm shower in a month, sun over blue ocean, and a glimpse of a "young and lovely girl from Ipanema." No way!

But on this morning's call, Kamau's voice had a different tone: "I just took my *shahada*."

"What?"

"My *shahada*. I'm Muslim."

The memory of the middle-of-the-night phone call nineteen years earlier hit me with a force. It wasn't Islam—it was what Islam took from us. Was there something I missed? Why did I not know what he was going through? Was becoming Muslim a way to connect with his father? The embrace of Islam by African Americans in the 1960s was as much political as it was spiritual. It distanced them from the Christianity that had enslaved them; it brought order and discipline that supported their liberation. As Muslims they connected with their roots in Africa.

But 1993 was not a good time to become a Muslim. Only a few months earlier, on February 28, 1993, the first terrorist attack on the World Trade Center had occurred, killing six and injuring 1,042 people. It was an act of vengeance against US support of Israel and intervention in the Middle East. The accused perpetrators were from Muslim countries.

I handed the phone to Tarabu. He always handled things with more finesse and wisdom.

I remembered Kamau's eighth birthday, when I bought him his first two-wheel bike. Watching him ride away on the sidewalk, he was first a little shaky but by the end of the block was riding free with joy. I knew someday he would ride away from me. I knew he would have his own journey. How far would it take him? What if I lost Kamau?

He left the dorms and started living off campus with roommate Takeo, my old friend Patty's son. He was going to school, struggling to get into the art classes he needed, working part time for JCYC, and learning yoga and

meditation. I thought that would give him balance. I was still conflicted about him being Muslim, but I trusted his instincts for goodness. Kamau was stretching his wings and was stretching me, too.

Then another phone call: "Hey Mom! I'm taking a semester off from school. My friend Muhammad [my stomach contracted] invited me to Morocco. I can stay with his family in Casablanca." This was not the black-and-white movie *Casablanca* with Humphrey Bogart and Ingrid Bergman or the Marrakesh where hippies hang out. This was 1994 and Morocco is an Arab country in North Africa, a Muslim region.

I held my breath until he returned safely in December 1994 for his twenty-first birthday, with a stronger sense of confidence and a small cache of souvenirs, pictures, and stories of his adventures and homestay with the humble Muslim family who generously cared for him in Morocco. We had a holiday full house with Mamie, Tarabu's Christian mom, visiting, and Kamau finding space to do salat (prayers) five times a day. None of us ate pork, thank god. I mean, Allah. And then Christmas dinner at Uncle Bob's, with wife Deb and two young boys all trying to understand Kamau, the Muslim.

It wouldn't be New Year's Eve if we didn't hear Reverend Mas's last service at Senshin Temple, talking about the Japanese custom of cleaning our houses and minds of the last year to make room for the new. Practicing non-attachment was what I needed most now. As usual, Reverend Mas was open and conversed easily with Kamau about his "surrender" to Islam.

The African American holiday Kwanzaa was spent at Krishna's.[1] That day Kamau brought a new young woman into our home (Kamau had had few girlfriends). Her given name was Angel, but her Muslim name was Malika. With a chocolate complexion and beautiful eyes accentuated with mascara, she leaned against our refrigerator and explained in an angel-like voice: "We met once in a shopping mall while we were in high school." Out of the blue she'd called Kamau, and he'd invited her to go with us to Krishna's.

As a Sikh, Krishna wore white clothing and a white turban, and lived in a household with white walls and white furniture. As we sat in a circle on Krishna's floor on this seventh day of Kwanzaa, the large white living room, which was also her yoga studio, was vibrating with the vivid colors of African patterns, kente, and mud cloth worn by her guests. As Krishna lit the last candle—representing Imani, or "faith" in the Swahili language—she read, "We believe with all our hearts in our people, our parents, our teachers, our leaders, and the righteousness and victory of our struggle." We blessed the youngest and heard words of wisdom from the oldest, our Mamie, who was eighty-six at the

time but could leap up Krishna's stairs and was happy to dance the bump when called upon to do so. Our circle was Sikh, Christian, Buddhist, New African, and now Muslim. That was our family, that was our community.

On February 17, 1996, we got another phone call: "Salaam alaikum, Mom." His voice was up, excited.

I was learning to respond, "W'alaikum salaam."

"I just got married!"

"What?!"

He laughed. "I'm married."

"What? Who did you marry?!"

"Malika. You met her when I came down during winter break. She went with us to Krishna's. She's Muslim. Imam Yassir said Muslims like marrying young."

An imam he'd known only a few months had encouraged him to marry? My temperature hit the ceiling. An imam led Attallah to his death. Now Kamau was living his life on the advice of a stranger, an imam?

"We've been writing letters. We were both fasting for Ramadan. I had this vision."

I had my visions too. But I now saw that Kamau made his important life decisions without us. His leaps were bold, sometimes without looking at the landscape around him. Part of it was listening to his own voice, becoming his own person, but part of it, I think, was having two strong people like me and Tarabu for parents. He didn't want to go against what we thought was good for him, so he didn't ask. Or maybe he was living his life in a way that was beyond our understanding—maybe beyond his own. He was following his path, leaping with his whole being, leaping with his faith.

This was too much for me to take in silence. I went to Oakland. I wanted to talk to that imam face to face. He had no right to make decisions for my son. He didn't know anything about Kamau, about us, about his father. He had no right.

Before the arranged meeting, Kamau wanted to take me to a *dhikr* (circle of remembrance), their Saturday-evening gathering. I had never been to a religious Islamic gathering with Attallah. I didn't know what to expect. All I wanted was to talk to that imam.

Entering the small storefront mosque on Forty-Sixth Avenue in Oakland, splashed with prayer rugs wall to wall, I was in a foreign country. People sat

shoeless on the floor, men wearing the kufi on their heads gathered in one area and women draped in hijabs and loose clothing clustered in another. Kamau introduced me to the women first: some were Middle Eastern elders and some were younger, a mixture of Black, Brown, and White, some wrangling young children. They greeted me warmly, "Salaam alaikum." I responded: "W'alaikum salaam." After he introduced me to his male comrades, I sat cross-legged with Kamau, head uncovered, conversing among the men.

When Imam Yassir entered in a loose gown and a green turban, everyone stood. As he made his way to the front, Kamau stopped him to introduce me. He was very gracious and said, "Please sit wherever you are comfortable." The custom of separating men, who are normally in front of the women for salat, was softened to make me comfortable. But I told Kamau I would join the women. I wanted to feel what it was like to be a Muslim woman. Seating the women behind the men was justified for modesty's sake, so women bending over during salat would not distract the men with their behinds. Hm, really? You mean men, in this very disciplined religion, can't control their thoughts and emotions?

Though I was a stranger, the women put me right among them and squeezed shoulder to shoulder, showing me how to fold my hands across my heart for the first position of salat. I loved the sound of the call to prayer, the male voice piercing the air and pulling us into sacred space. Being a dancer, I was used to following and anticipating movement. I didn't understand the words or why I was bowing again and again, but I was following. The music and Arabic words were unintelligible, yet moving.

After salat, Imam Yassir gave a talk explaining some of the stories in the Quran. It wasn't telling people what to do. It was guiding by storytelling and gentle humor. After the talk, a large circle was formed. By then, the space was filled by forty-five or fifty people. Imam Yassir grabbed a *ginbri*, a crude version of a banjo, which he began to pluck to a bass beat. The sound of *qaraqib* (rough hand cymbals) cut through, and Yassir began leading a call-and-response from the circle of men and women. People were now standing, palms open to the sky. *La ilaha Il Allah* (there is no God but God). The chanting of songs was building an energy. As the chanting continued in layers, people were bringing bottles of water and placing them in the middle of the circle. They believed the vibration of the chanting would bless their water. Children began dancing in the center, and a few individuals began slowly spinning. It was like a rough version of the whirling dervishes, but this was Oakland.

When we left the mosque, my mind was spinning. This was not what I had anticipated. My images of Islam, however limited, were shattered. Kamau's father was a Sunni Muslim like Malcolm, but this was a different Islam. Kamau had become a Sufi of the Naqshbandi Order—lovers of the poet Rumi, music, and the mystical journey into being one with God, Allah.

I later met with Imam Yassir at his house. He was from Morocco, and a former champion swimmer who now taught swimming in Berkeley. He sometimes did gigs with the folk instruments he played. He played on an album with one of my favorite Cuban musicians, Omar Sosa. His wife was Jewish and a potter, but also a Sufi. By then my fire had cooled, but I still expressed my shock and concern that one imam took Kamau's father to his death and now another imam was encouraging my only son to get married to a stranger. He profusely apologized. Yes, Islam encouraged adherents to marry young, but he explained that he'd thought they'd known each other since high school. An apology could not erase this misunderstanding that put Kamau's life on a challenging path—even though ultimately it was his choice.

Kamau's next phone call did not surprise us. They were having a baby. She arrived during a rocky time of adjustment. She was a joyous, beautiful gift. Her name, Asiyah, meant "a house with strong pillars." She was a baby holding her young parents together. And she did it with all her might. They had their faith and Sheikh Hisham, spiritual leader of the Naqshbandi, guiding them.

"Jihad" was a word that people were growing to fear. But Kamau explained that the real jihad was the internal one. It means spiritual effort, the struggle against one's ego, the effort to carry out one's responsibilities. For Kamau and Malika, jihad became each other's spiritual effort, especially with more children to come. The next one was Muhammad, a hard name to live up to. Krishna looked at him and said, "One day he's going to be a Buddha."

A phone call in 1999 made me see where Kamau was in a totally different way. He wanted Tarabu and me to come to Oakland for his first talk at Jummah (Friday congregational prayers). It was hard for me to imagine Kamau talking in front of a group of people. He was always the listener, the quiet warrior. Would he be nervous? *I* was. He was wearing a green turban with a spire that

they say helps to reach heaven. Beneath his gold-rimmed glasses, a faint mustache and a beard now tickled his chin. Many have said his chiseled look echoed Malcolm X's, but his talk was gentle, natural, guiding us toward inner harmony, peace. Peppered with Arabic phrases and "the prophet Muhammad, peace be upon him," he was learning his own style of storytelling as a form of teaching. As I watched his talk unfold, I saw a new Kamau. He was my child but not my child. He was a seeker on his own path. He was on his spiritual journey to become an imam. When he finished, he headed for us. His face broke into that familiar big smile and a laugh that said he didn't take himself too seriously, and suddenly he was my Kamau again.

I remember when Attallah asked me to become Muslim. It felt too far from my culture and I wasn't going to do it just to please him. Now Islam was as close as my heartbeat. For generations, my family learned to live with the schism of Buddhism and Christianity, allowing radical differences like God and no god without making it a big deal. In Japan, great-grandmother Hatsu, a devout Buddhist, took my mom and her sister to a Christian church because someday they would live in America. My Mormon grandma Lucy's love for Harry Miyamoto probably got her excommunicated. My mother's love for Kamau got her over her fears about color. Now Tarabu's Christian mom, Mamie, can go to a Buddhist temple and hear Kamau do a Muslim grace before eating dinner. Living with the schisms of race, culture, and religious beliefs are becoming common for more and more of us each day. It is the opportunity we have in our pluri-ethnic nation to understand, coexist, and expand. But the world was moving in another direction.

At six in the morning on September 11, 2001, a phone call interrupted my morning sadhana (yoga) practice. It was our next-door neighbor, Doc Frazer. His morning meditation was watching the news. "Turn on your television!"

Black smoke from the wounded north tower of New York's World Trade Center billowed into our bedroom. I cried out to Tarabu, who was in our backyard doing tai chi. Chic Street Man, who'd slept over after a Great Leap performance at UCLA, heard me. We three stood stunned, watching a plane slice through the South Tower. Through the chaos of replays and heroic rescues, through the smoke and ashes, stunned broadcasters started using the words "attack . . . terrorist . . . terrorist attack."

At 6:37 a.m. Pacific time, the unthinkable happened: a plane crashed into the Pentagon. It was not a Hollywood movie. A plane crashed into the

Pentagon! Panicked newscasters breathing smoke and ashes remembered February 1993, the first bombing of the Word Trade Center—the first *terrorist* bombing of the World Trade Center. The journalists mentioned *Muslim* terrorists. Dread filled me.

Where's Kamau? Where's our family? *Where's Kamau!* Call Kamau. Kamau was on his way from Oakland to San Francisco, where he worked with underprivileged kids who face death on their streets every day. Malika was home with Asiyah and Muhammad and their Moroccan Muslim neighbor. They are okay. They are okay.

At 6:42 a.m., all commercial flights were grounded. At 6:43 a.m., Chic rented a car. He was going to drive to his wife and son in Seattle. At 9:59 a.m. New York time, just before the South Tower fell, Chic and I, still glued to the TV screen, saw two people jump from the tower, holding hands like two angels. We witnessed the selfless bravery of firefighters and citizens trying to save lives in the inferno. There were many angels.

Becoming political taught me that terrorism is an act of the powerless trying to be heard. That day, the whole world stopped breathing as we watched the World Trade Center, the pinnacle of capitalist power, smolder and then fall, looking small and fragile on our televisions. Many more buildings would fall, pillars of ancient civilizations erased forever. Many lives of innocents fell on that day; many more would be lost in Iraq, Afghanistan, and beyond, fighting for control of oil, taken hostage, tortured, imprisoned, held in limbo. There is no end to the falling.

I had to go outside to breathe, to escape the smoke and ashes of my fear. Outside my back screen door, I clung to the railing. I looked up at our Los Angeles sky. It was strangely still and would become bluer from the next three days of no planes flying. I looked down at my old gardenia bush. It had been dormant for months, but today a single flower pressed its petals against the morning mist, pushing toward the rising sun and breathing its sweet scent into our smoke-filled lives. It didn't hold back its beauty. It knew the world needed a perfect gardenia on this day.

The next day, my friends in the National Coalition for Redress/Reparations (NCRR) called for a candlelight vigil in the JACCC plaza in Little Tokyo. They knew that what happened to Japanese Americans the day after Pearl Harbor could happen to Muslims. The first revenge attack happened in Mesa, Arizona, against a Sikh man in a white turban who was mistaken for

an Arab Muslim. It was not a good time to be Muslim in America. A new kind of hate was brewing: Islamophobia. Now I had a personal stake in the matter.

In 2002, NCRR sustained their support for Muslims by doing a series of breaking-the-fast events during Ramadan, the forty days of fasting from sunup until sundown. At that point, most Americans had never met a Muslim, and knew little or nothing of their faith and their practices—only the violence echoed on the news. I began making a space to bring together Muslims with people of different faiths in workshops to share our traditions and explore commonalities. We joined NCRR's breaking-the-fast event that invited Muslims to break fast at Senshin Temple. Kamau came down with his family, which now included a baby girl born a month after 9/11: Noora, which means "light." For some reason, the imam they had expected to lead the call to prayer to break fast canceled. Kamau was asked to lead.

Senshin's *hondo* (chapel) was packed with Senshin members and Muslim families grateful for the solidarity expressed by the Japanese community. My group stood circling the edges of the audience performing poetry of solidarity. Reverend Mas led us in a Buddhist chant. Then it was time for the call to prayer, to end the long day of fasting. Kamau strode to the front and stood for a moment with eyes closed, his long fingers clasped before him. He seemed amazingly at ease as he cupped his hands behind his ears. He didn't voice the call in the beautiful way of the traditional muezzin. He sang it in his own voice, simply, with grace: *Allahu Akbar, Allahu Akbar.* He was doing it before Reverend Mas, before the community who knew his story, who nurtured him, who watched his first crawl and then his first walk in Senshin's social hall. Now he was twenty-nine with three children, and we were watching him step into his new role. *La ilaha ill Allah.* At the prayer's end he opened his eyes and broke through the moment with that Kamau smile: "Let's eat!"

In March 2003, under false accusations regarding nuclear weapons, the United States invaded Iraq, hurling its high-powered bombs and rockets in a long rain that would equal in deaths and destruction many Hiroshimas. As we watched the post-9/11 world of revenge and retaliation unleash sectarianism, terrorism, oil hunger, and greed, we gathered. Every week for a year we came together in Senshin's social hall—artists, poets, healers, activists, spiritual seekers, Muslims, Buddhists, Christians, Black, Latinx, Japanese from here and Japan. We answered the violence with our poems, addressed the

divisions with our stories, and met fear and grief with our performance of the show *Sacred Moon Songs*. We made East West Players our sacred space and used art as a means for healing and unification for our many communities. Perhaps we were like my single gardenia breathing its sweet scent into a smoke-filled world.

> *The moon, it disappears*
> *But I know it will return*
> *Like peace—like love—like hope*
> *It will return*
> *Shalom, heiwa, paz, salaam alaikum*

THIRTY-TWO

The Seed of the Dandelion

The seed of a dandelion
Scatters in the sky
A windblown weed a wildflower
Let it fly

I HAD BEEN STUDYING YOGA with my dear friend and master teacher of
Kundalini yoga, Krishna Kaur. At half past four in the morning we did sad-
hana, morning practice during the ambrosia hour, chanting as the sun rose.
That, along with doing tai chi with Tarabu, was keeping me strong and
healthy. In November 1999, I went to Cuba with Krishna Kaur's organiza-
tion, the international Black Yoga Teachers Association, with seventy prima-
rily Black yoga teachers and practitioners, to share yoga with 150 Cubans.

Cuba was inspirational. The fact that this tiny island nation just ninety
miles from our shores could mount and maintain a people's revolution was
an incredible feat. In the movement we romanticized Che and Fidel as heroes
overthrowing dictator Batista's corrupt government, which had allowed US
companies to own sugar and coffee plantations once run with slaves, and
controlled Havana as a haven for organized crime. The revolution empow-
ered workers and the poor, ensured people a place to live, offered free educa-
tion and free medical care, and produced some of the most highly evolved
music on the planet.

We were breaking the embargo and blockade that started in the early
1960s and still exists today. We brought in medicine, supplies, and equipment
along with small gifts of yoga mats, clothes, shampoo, soap, and aspirin,
which people lacked because of the blockade. Hardships didn't dampen their
enthusiasm. Most of the participants were doctors and medical workers eager
to add yoga to their natural healing tool kit.

The Cubans we met were energetic, resourceful, and willing to sacrifice for
their revolution. Given the shortages of meat, truck fuel, and fertilizer, they
started small organic farms close to the city so that markets could flourish
with vegetables and fruits. Havana was picturesque and those 1950s cars were

beautifully restored. But those cars and the cabs we rode spewed carbon monoxide. Our classes were on an open hotel rooftop in Cojímar, just outside of Havana. Tour buses circled the hotel with engines running, fumes rising to the rooftop, and we were breathing deeply. I was so high on the people, the music, and the culture, I didn't notice, but when we landed in smoggy LA after two weeks in Cuba, I couldn't talk.

Not a whisper, not a hum, not a word. Okay, I'm tired, just rest a bit. But I was silent not for a week, not for a month, but for more than a year. For me, it was forever. Your voice is something you are born with, something I took for granted. Now my song was silenced. Kaiser doctors had no answers, no clue, no cure. Was it physical or emotional? Did doing yoga in Cuba make me a victim of environmental pollution? I tried not to sink into panic, but time went on and nothing worked—neither voice therapy, nor herbs, nor acupuncture. I always thought I would be able to sing longer than I'd be dancing. How could I live without my voice?

My friend Donna Ebata, Great Leap's first manager, figured I needed an extra push. She put me together with two women artists, PJ Hirabayashi of San Jose Taiko and singer Yoko Fujimoto of Kodō, from Japan. "Oh my god, Donna, I can't sing with Yoko! She has a voice of a goddess!" But Donna raised some funds, and from 2003 to 2007, PJ, Yoko and I came together in periodic retreats. They helped me work through my fears, my ego, prying open my voice with their sisterhood and love. The Triangle Project, as we called ourselves, gave us an opportunity to explore how each of us as women artists used music to deepen our cultural ties and create change. PJ and her husband, Roy Hirabayashi, established San Jose Taiko in the early 1970s, one of the first US *taiko* groups along with Senshin's Kinnara Taiko. PJ, a powerhouse shaman drummer, has helped spread the spirit of *taiko* all over the world. Yoko, born in Tokyo, grew up in a postwar Japan that was being Westernized. She joined Ondekoza and later Kodō, groups that claimed the *taiko* drum as a way to invigorate traditional Japanese culture. In the remote island of Sado they lived a communal life, trained in Japanese folk forms, and ran twenty-six miles a day! Yoko found her powerful voice singing traditional folk music. We started out at about the same time and had parallel stories to tell as women music makers. It became a musical theater piece, *Journey of the Dandelions* (see photo 25).

Yoko invited us to come to Sado Island in the Sea of Japan to rehearse and explore. I had never visited my motherland, Japan. I had written Obon music, music for dances to remember ancestors, but I had never gone "home"—or

was it my home? Was it a place I could claim, or would it claim me after three generations? I looked forward to exploring more traditional rural life in Sado, but there was something else I needed to do in Japan, something I almost feared. I wanted to meet my mother's family, the descendants of those who lived in her stories. I wanted to see the place where she spent those years with her grandparents.

Before I went to Japan, I asked my Auntie Hatsue if she would write a letter to introduce me to our relatives. "No! They'll come here and want us to take them to Disneyland!" This was a strange response from my enlightened Buddhist aunt. Her "no" was a little too emphatic. Maybe it wasn't about Disneyland at all. Maybe she was afraid of what our relatives might think of Mitsue's long-lost renegade child. I already knew I wasn't a real Japanese. Other Japanese kids had told me so. But I knew I wasn't White, either. Then I went and had a Black child and married a Black man. And this child turned into a spiritual seeker who became a Muslim. Oh god! Oh Buddha! Oh Allah! Maybe I shouldn't try to see my Japanese relatives after all. Maybe it would be too much for them to digest, to be asked to accept someone who'd drifted so far. Maybe I'd morphed into a different breed, a mongrel, a poi dog, a race whose blood is a river with too many tributaries. Maybe I'd sailed too far from my roots to ever belong.

My fear that I would never have another opportunity like this pushed me not to accept my auntie's "no." I would not accept that invisible, unspeakable wall that divides us, that delusional wall that only needs a single brick removed for it to fall down in a messy pile and reveal the complicated mosaic that we are. That's where I live, in that beautiful, messy space. I've learned from it, thrived because of it. Something in me wanted my relatives to know the truth of who and what our family had become in our hundred years of separation. I wanted the courage to meet them as my whole self. Maybe this would not change the world. Maybe it would create shock, chaos, or disorder at first. Fears and old beliefs would be unearthed. But when the dust settled, we would live on ground more solid, more open, more free.

I had to meet them, even if they rejected me. I had to let them know Mitsue's child existed, that she remembered them, kept their letters, told me stories of her happy days with her grandparents, and was openly angry when America's atomic bomb killed her cousin in Nagasaki. I became more determined to speak my truth to my family. I was not ashamed of having my Black child and now a Black husband. If Japanese culture and my family shunned

us, so be it. I would have tried to put a human face on who we have become in this changing world.

My old roommate June Baba lived in Tokyo, and helped me to do some research. She found my family's phone number. They welcomed my coming.

How would I explain to them who I was? I didn't speak Japanese. I didn't have the words. I decided to make a photo album that told of my family's hundred-year journey. It started with that old black-and-white photo of my mom and her sister Hatsue, clad in kimonos and surrounded by their family in Fukuoka. It ended with a photo of my son and his family, his bronze smiling face topped with a kufi and his wife in a hijab with his four children. We'd traveled a long way in a hundred years.

A younger family member, Shinji Nishimura, was assigned to meet me in Tokyo. My friend June wanted to meet him with me. But before we left for dinner, she warned me, "Japanese people can be very racist!"

"I know, I know, June. That's why I made this book." That didn't make June feel any easier. She was more nervous than I was. We met Shinji-san at a nice Tokyo restaurant. His English was excellent—he had worked for a Japanese firm in Los Angeles for nine years. I wanted to show him the book right off, as an introduction, but June pushed my arm down, whispering, "Later."

Midway through dinner Shinji said, "The family is anxious to meet you. They want to know if you are vegetarian." They wanted to please me. But would I please them? I went for the book again, and again June pushed my arm down. Finally at the end of dinner, I looked at June and pulled out my beautiful photo book with the tea-green cover. June's eyes grew big, her smile forced. With a sweep I laid the book before him. "This is my family's story."

Shinji opened the cover. He recognized the picture with my grandmother and her sisters, with great-grandparents who were his as well. June pressed her leg against mine, watching for Shinji's reaction to my mother's marriage picture to my half-White father, then me with Tarabu, and finally Kamau, our son, with his family. Shinji tipped his head, puzzled. I looked at him directly and pointed, "My son," without apology (see photo 28).

He closed the book and nodded his head. June and I were turning blue from not breathing. Was I going to be banished, disowned, disinherited from this family I never met? What's the verdict? Shinji looked up and smiled.

"Our family, very international!" June and I almost fainted. I hadn't given them enough credit. They weren't frozen in time like that old picture. They had changed. We had changed. The world had changed. Yes, our family, very international. Yes, our family, very human.

Shinji flew with me to Fukuoka and took me first to the house of his father, my great-uncle Nishimura Kenpachiro. As soon as he slid open the bamboo gate and I stepped out of my shoes to enter their house, Kenpachiro-san led me to make *oshoko* (incense offering) at their family *butsudan* (altar). Thank Buddha I'd practiced that ritual at Senshin Temple! Sitting on the tatami floor, his wife, a tea master, did an informal tea ceremony for me. I sipped from the coarse *cha* tea bowl three times and he told his wife: "She's on *Roots* journey." Far out! Alex Haley's *Roots* (1976) had made an impression all the way in Japan. Kenpachiro-san somehow knew why I was there and took me under his wing.

Our epic family story began to unfold. Kenpachiro grew up with my mother and her sister in their grandparents' house. Kenpachiro's father, Kengo, was my grandma's wayward brother, someone missing in all my mother's pictures. Kenpachiro told me, "Your great grandfather was once a millionaire in the coal business." Kengo, the only son, drank and gambled away the family fortune (and invested in two movie theaters in 1915!). When he left his wife and son, my great-grandmother Hatsu arranged to raise Kenpachiro in their house. She told the mother: "You are free, we will take care of your son." The family needed a male to carry the family name, and Kenpachiro sadly never saw his mother again (even though he learned, too late, she lived not far away). I learned that my great-grandmother was part of the Mihara clan, a samurai family. Contrary to the lore of obliging Japanese women, she was the family matriarch and of a rank and class to make decisions, like arranging to marry her beautiful firstborn to my grandfather in America after the family lost its fortune.

Kenpachiro-san began our roots tour the next morning, with his son Shinji as our translator. We drove to Kurume, a town in Fukuoka-ken, known for its artisans—the place of our original family home, the place where my mother grew up. Their house was no longer there, but we ate in a restaurant across the street where we could imagine it from the window. The rice they served us had speckles of yellow millet and Kenpachiro refused to eat it. He said it reminded him of the war, when they were starving and forced to eat millet. He remembers standing in his wife's family's yard on the morning of

August 9. He looked up and saw two suns. It was the atomic bomb over Nagasaki that killed forty thousand people in an instant, among them the cousin he shared with my mother. He then ordered Shinji to take me to see Hiroshima on our way back to Tokyo. He wanted me to understand the suffering ordinary Japanese people went through during the war.

We next made a pilgrimage to my great-grandmother Hatsu's temple in Kurume. She had built an *ohaka* (tomb) for her daughter after her suicide returned her to Japan as ashes. Hatsu's grief blamed my grandfather, saying he was a drinker and womanizer. But my mother told me that Misao never loved the man she had to marry. She learned to carry out wifely duties—cooking, cleaning, washing—but he was older and she was never happy. After her only son died, she drank the bottle of Lysol to end her grief. I was standing on the earth where my mother's joys and sorrows were born. In my coat pocket I clenched the small vial of my mother's ashes I'd brought with me. I wanted to unite her with her mother. But Misao's ashes had been moved to her husband's family cemetery, following tradition, in Tachiarai.

We drove an hour to Tachiarai, the place that was once my grandpa Oga's family farmland. Like many second sons, my grandfather would not inherit land, so he left to try his fortune in America. The house, larger than most city houses, was now densely surrounded by other houses. I walked through the same wooden *torii* gate my grandfather and great-grandparents walked through. I was walking through time.

The house looked worn, but I cherished sitting on its old floor and drinking tea at the same table as my grandfather's family. The nephew who lived there, a teacher-scholar, remembered my grandfather, Tamejiro. He seemed to know about my family in the United States, even after a hundred years of separation. He opened a book that was lying on the table. Each page had a black-and-white photo of a man with Japanese writing beneath the picture. He moved the book closer to me and turned a page, like an offering. I recognized my grandfather as a young man! He turned another page. That's my Uncle Fred! What were they doing in this book? The relative explained that this book told the stories of each person who had left their village, where they went to live in America, and which camp they were interned at. Wow, we didn't just leave on that boat and disappear. Our families at home in Japan remembered us, missed us, suffered for us. And we knew so little about them. We got busy surviving, trying to be American. We did not realize that our separation created trauma on both sides.

My grandfather's mother, a great-grandmother whose name I don't know, lost two sons, one to America and other to São Paulo, Brazil. One cold winter, she ended her life by jumping from a bridge into an icy river.

Just a mile down the road we drove past a large castle. The sign said "Mihara Clan." That's the samurai family of my great-grandmother! We backed up the car and jumped out to see the large estate. The Ogas and the Miharas came from the same town. Samurai were upper class, but farmers, being landowners, were just under the samurai class. One could see how my great-grandmother figured she'd found a good husband in Grandpa Oga for my grandma, Misao.

Kenpachiro-san knew I wanted to see an *osento* (public bathhouse) from my mother's stories. Instead, he took me to an *onsen* (hot spring) in the mountains, much fancier than my mother's neighborhood water hole. It was a traditional *ryokan* (inn) with natural mineral water in a large modern indoor spa-like pool. After bathing in separate men and women's pools, we shared a luxurious meal, sitting on tatami, dressed in the *yukata* they gave us, then retired early. It was a long day's journey through the past. I was ready to sleep.

In my small room, the single futon on the tatami floor was firmer than a bed. I loosened the belt of my *yukata* and crawled under the *kakebuton* (quilt). Adjusting the bean-filled *makura* (pillow) beneath my head, I breathed in the fresh straw of tatami. This is how they slept, my ancestors. It was mountain-top quiet, with only the sound of light wind brushing the night. But sleep was not coming. I was awake with my heart full of family stories and my head reeling with Japanese words I couldn't understand. As I was fading from the darkness, a woman's voice floated over my futon. It almost brushed me. The voice was not in my head. It was in the room. She spoke Japanese, but I understood: *Watashi o yurushite—yurushite—forgive me.* I shot up, rubbing my eyes and reaching through the dark for the source of the words. But I could only feel them in my mind. I laid down and waited to hear more. I waited, waited for morning, trying to understand what had just happened. Trying to understand this journey that I had put off all my life. I was reaching back for more than myself. I was reaching back for my mother, the young girl who lost her *okaasan*, the mother she barely had a chance to know. I was reaching back to find out why Misao would abandon her girls, even in her sadness, even in

her pain of losing her son. I knew it was her, my grandmother, who spoke to me (see photo 1).

In the morning, I sat on the floor with Kenpachiro and Shinji in the beautiful dining area, eating a breakfast spread on a lacquered table: fish, tofu, pickles, and an array of traditional food that my grandmother might have served. Kenpachiro-san asked how I'd slept. I looked at him and knew I could speak the truth. He was eighty-seven and there was an ocean of difference between us, but at that moment he felt closer than a father. I cried as I told him of the voice I heard. "It was my grandmother. She wanted my forgiveness. Why did she leave my mother and her sisters? Were they less important than Ta, her son?"

After a long pause, Kenpachiro-san said, "You see those pictures of our loved ones we hang in our house? After fifty years we take them down. It's time. You must forgive." I breathed in deep his words, his wisdom, his kindness. Even though I didn't entirely understand his answer, I was and always will be grateful for Kenpachiro-san.

When we returned to Fukuoka city, I spent a day with my women relatives at the family complex, admiring the cherry trees as they were giving me gifts of old kimonos and fans. These were no shrinking violets. In their eighties and beyond, they were *genki* (strong and lively). They ran the households and their men. I kept looking at Chizuko, a flower arrangement teacher, whose smile and shape of face reminded me of Mom's sister, Auntie Hatsue. Communicating in a language between Japanese and English, I told her: "You remind me of my Auntie Hatsue."

"No," she said, "you look like your great-grandmother Hatsu."

"No, no," I said, "*you* look like Auntie Hatsue."

She stopped me. "When I first saw you, I got shivers. You look like your great-grandmother, Hatsu. You even move like her, make gestures like her."

I was stunned. All these years I've learned never to expect to be accepted as Japanese, especially in Japan. But here I was in my family home, in Fukuoka, and Chizuko-san was telling me I looked like someone I'd never met, whose name I never knew. They let me know I belonged to them. No matter how far I've traveled—through time, distance, culture—I'm part of them. I am Japanese!

Before I left, I told the women my mom's story about the stringed instrument that her Auntie Mitsuka used to play called the *biwa*. When she sang with it, people passing by stopped to listen. Before I could finish the story, Takayo had sprinted to the back of the house and returned with the very same *biwa*. I was shaking as I held it in my hands. I tried to hear its music in my head. It had been a hundred years since my mother heard its song, but its vibration still continued in me.

This was the end of a pilgrimage, a healing I made for my whole family: for Grandma Misao, for my mother, for my husband and son, and for all my grandchildren. In Japan, Obon is a time when people return home to visit family graves, dance in a circle, and remember their ancestors. It happens in August, but February 2003 was my Obon. I was a *tampopo*, a windblown dandelion, returning home.[1]

> *Through all the forces*
> *Through the shadows and the light*
> *The unknown forces*
> *Dandelion*
> *Okagesama de . . .*

THIRTY-THREE

I Dream a Garden

RECENTLY I'VE BECOME A GARDENER. I got tired of looking out my front window at my brown lawn that we're not supposed to water because of the California drought. The city was giving out money to remove lawns and replace them with water-saving landscapes, so I jumped at the chance. I found a young man with a strong back and a smart brain surrounded by dreadlocks who loved to grow food. Lawren Atkins had been a schoolmate of Kamau's and had helped grow a super Garden of Eden at Crenshaw High School long before it became environmentally cool.

I enjoy stepping into my little plot to pick arugula, kale, and cucumbers for my dinner salad. I figure I'm eating organic, saving money, saving gas, and saving—well, I have to confess, it took two years of watering before I grew one very expensive orange. Gardening also teaches me things. For instance, composting: burying all my food scraps, my garbage, with *bokashi*, a Japanese method to transform it into perfect soil. It's the highest level of recycling. Then there's weeding. One day I was working with a long screwdriver to dig out a clump of crabgrass that had no end. The root had many tributaries growing in many directions. It was impossible to get it all. Then it hit me: this is where the movement's idea of "grassroots" comes from! It's a powerful form of people's organizing that's impossible to stomp out.

My passion for the garden started when Grace Lee Boggs, longtime political activist and philosopher, invited me to Detroit. If you don't know who she is, check out the documentary *American Revolutionary: The Evolution of Grace Lee Boggs* (2014). As early as 1970, I'd heard of her. She was a Chinese American married to James Boggs, the Black radical autoworker who wrote

264

The American Revolution: Pages from a Negro Worker's Notebook (1963). They were a revolutionary couple who wrote many books together.

Grace was the keynote speaker at the 1971 Asian American Conference at Pace College, but Chris, Charlie, and I had been huddled in the dressing room trying to figure out how to wing our first set together, so we missed her talk. I knew little about her, but thought it pretty cool that this Asian woman, like Yuri, was significant in the Black struggle. To us fledglings, we looked up to her as a movement "heavy."

In 1999, Chris, Charlie, and I had brushed off twenty-five years of cobwebs to perform a series of reunion concerts around the country. By then, Chris had traded life on Manhattan Island for a law professorship on the isle of Hawaii. "Charlie" Chin had uprooted from New York's Chinatown and Queens to raise his son in San Mateo, California. When invited for a gig, we'd meet at the destination and, like old times, run through a rehearsal, then boom, onstage again. This time it was at an Asian American conference in Ann Arbor, Michigan, outside of Detroit.

We'd just finished our set when an Asian woman elder charged up to us. She had a sparkling smile and a crown of silver hair with cool diagonal bangs, and wore a vintage blue padded silk Chinese jacket, the kind we used to wear in the movement days. Grace's eyes danced with the enthusiasm of a teenager, not an oldster of eighty-five. "That was just great! You have to come to Detroit. You have to see what we're doing here!" I had the feeling: when Grace asks you to do something, you do it. Her 1998 autobiography, *Living for Change*, was being sold at the conference. I bought a copy and waited in line for her to sign it, along with a bunch of young Asians who treated her like a rock star. Who is this Grace Boggs? What drives this elder activist, who has seen the rise and fall of so many movements, to keep her hope, her enthusiasm, her smile? The answer might be in the book, but I also knew I had to go to Detroit.

My first visit was in early 2000, just after a major snowfall. The city appeared bleak, but mounds of fresh snow kept it from looking hopeless. Neighborhoods with a single house or two on a block seemed like white farmland. My second visit sans snow revealed the ruins, the rubble, the abandoned, pockmarked Black neighborhoods that once thrived with jobs in the auto industry. One of the most eerie sites was a mammoth building with sixteen stories of shattered windows that used to be Michigan Central Station, a intercity passenger rail depot. Closed in 1988, it was now occupied by drug users and the homeless. Central Station, which once reached for the stars, stood as a symbol of the failure of Detroit's industrial revolution.

Grace took me around in her shiny new blue compact car. Riding with her was scarier than a Coney Island roller-coaster; other cars made way for this revolutionary oldster and her unpredictable U-turns and lane changes. Grace showed off Detroit like a proud mother shows off her children. It was her kitchen, her laboratory, her classroom, but most of all her community. I think many Detroiters saw Grace as Black because of her marriage and political partnership with James Boggs, plus her column for the Black weekly, the *Michigan Citizen*. After her husband died in 1993 Grace stepped into her own limelight, drawing many Asian Americans to learn from Detroit. I think she wanted the Black and White city to know us as well. Dedicated activists like Scott Kurashige and Emily Lawsin moved from LA, dug in deep as community organizers and scholars, and even started their family there. In 2011, Boggs and Kurashige cowrote *The Next American Revolution: Sustainable Activism in the Twenty-First Century*.

In the midst of decayed, obsolete Detroit, politicians and billionaire developers were making a land grab in the primarily Black inner city, with the help of huge government subsidies, supposedly to solve the city's woes with things like a casino and a sports arena. But Grace showed me another Detroit full of dreamers and doers, urban visionaries, artivists, and gardeners—the grassroots. Living in the fallout of deindustrialization, these Detroiters weren't just creating jobs. They were seeking a new way to live in the twenty-first century. The general alarm had not yet gone off over global warming, but residing in a city polluted by industrial waste made them see the importance of living in harmony with Mother Earth to create an economically and environmentally sustainable future.

One of the first people Grace introduced to me was Paul Weertz, a science teacher at Catherine Ferguson Academy, a public high school for teen mothers established by Black visionary educator Asenath Andrews. They called him Farmer Paul because he planted a different kind of learning in these young mothers. The nursery where the girls put their babies while they schooled needed a sink. He showed them how to install it. "Is that all there is to it?" the girls responded. He wanted them to know that breastfeeding was natural and good for their babies, so he brought in animals—a goat, a cow, rabbits—to observe and care for. To feed the animals, they planted alfalfa in an unused field. When I visited the school, the girls were building a barn. Yes,

a barn! They were hammering, sawing, climbing, learning about electricity, plumbing, math, physics, and farming, but most of all they were learning self-confidence. Nearly all of them went on to college and didn't become pregnant again. Farmer Paul was raising a crop of mighty gals.

Then Grace put me in the hands of Gerald Hairston, a former autoworker whose family, like many Black people, had migrated from the South. After he was laid off, he found his deferred dream in a garden. While we toured his gardens in his beat-up car, gray-bearded Gerald told me how he spent years in his departed mother's old house staring out at her barren backyard. That was his first garden. Now his dream was to transform all of Detroit's empty lots into organic gardens. He started the Gardening Angels, a group of mainly Black Southern-born elders who planted gardens not only to grow healthier, affordable food for themselves and neighbors, but to grow respect for nature's process among young people. Gerald's many projects became part of the Detroit Agricultural Network, which promotes urban agriculture as an integral part of Detroit's healing.

After hearing James Boggs speak, Jackie Victor and Ann Perrault, two White women life partners, were inspired to create Avalon International Breads. They learned to make bread and devised a business plan. With a loan from Ann Arbor's Zen Temple and a storefront on Willis Avenue in Cass Corridor, they set out to create a business based on the Buddhist principle of "right livelihood"—right relationship with the Earth, right relationship with employees, and right relationship with the community—using local organic ingredients. Supporting community organizations and causes, Avalon became a go-to place for morning coffee and meetings. It attracted other small businesses to the area, jump-starting a vibrant community that was spreading.

Detroit also attracted creatives and planners. Kyong Park, an artist and professor of architecture, had left New York to immerse himself in this "shrinking city." He set up his International Center for Urban Ecology and worked with students, architect advisors, and the community to devise a plan for Detroit's East Side. Adamah, "of the earth," became a plan with urban agriculture at its center, comprising greenhouses to provide food year-round, animals, grazing land, a dairy, and a shrimp farm. Windmills would generate electricity, canals would provide recreation, and there would be co-op housing. Even though it didn't happen, these seeds might grow anywhere. Park's big thinking intersected with the big thinkers at the Boggs Center, who were growing Detroit Summer, a project to "rebuild, redefine and respirit Detroit

from the ground up." It was a multicultural, intergenerational movement to create organic gardens, encourage urban art, and develop youth leadership.

Before long, Jenni Kuida, Great Leap's manager, and her husband, Tony, joined me on my Detroit trips. We put our hands into the earth with local teens, helped to restore an old house, went to meetings, and shared free meals and meetings at the Unitarian Church. Tony wanted to make a mural with the community. Jenni was a consummate organizer who knew how to make things happen, and they did. Detroit had a plethora of devoted activists and artists using their skills to solve their daunting problems, such as playwright Shaun Nethercott of Matrix Theatre, young poets like Angela Jones and Kibibi Blount-Dorn, and musicians like Joe Reilly, who grew up in Detroit Summer and became leaders and "solutionaries."

Grace put me together with Ashley Kyber, artist and landscape architect. She was a friendly, fearless, White Amazon of a woman who had the talent and grace for making herself at home with all manner of people, including Gerald Hairston. She'd understood the recipe that Grace was brewing and jumped in deep. We started dreaming together. We were from different cultures, towns, and disciplines, but spoke the same language.

A plan took root for a ritual event on August 3, 2002, to bless the land and celebrate the urban gardening movement on the grounds of Genesis Lutheran Church, where Gerald was a member. Kyber created an amazing garden stage. Kids wove branches for a backdrop where gardener leaders could share stories. Ashley was a magician with materials. On the ground she created a giant I Ching symbol, trucking in a load of crushed car window glass she got for free. I say "magician" because I could actually dance on this glass barefoot!

I wanted a way for the whole community to participate, and what better way than dancing in a circle, like our ancestors. Gerald's story inspired the song "I Dream a Garden." This being Detroit, we had to have a gospel choir sing it. Somehow this Japanese girl summoned the guts to ask the Genesis gospel choir. They were gracious and willing and didn't look at me like I was a crazy invader. In Detroit the Japanese circle dance of Obon found new purpose with gardening movements inspired by "Tanko Bushi," the Japanese folk song. I wove in the Native American Friendship Dance, and of course it had to have some Motown! We were digging with the Temptations' walk. It sounds weird, but it felt good dancing together.

Just before we mounted the event, our inspiration, Gerald Hairston, suffered a heart attack. "I Dream a Garden" became a tribute to Gerald, who had

birthed many dreamers who would continue to plant seeds in different ways, like those grass roots spreading in many directions.

Grace didn't coddle herself because of her age. Her curiosity and quest for answers challenged all of us to keep up with her. We took a scouting trip to Appalachia for a potential project and stopped at a friend's house to sleep. Grace and I had to share a double bed. And not just a double bed, but a wiggly, wavy waterbed. The next day I was sleep deprived from trying not to move, but Grace was raring to see Appalachia's strip mines, polluted streams, and super prison. When I was ready to put my head down at night, she was still in conversation and downing a beer with young activists.

Grace's world had no boundaries. We were in the early stages of 9/11 and the Iraq War, and Dearborn, part of metropolitan Detroit, was home to the largest population of Muslims in the United States, heightening her concern about Islamophobia.

Grace also put me in a circle with elders rooted in the civil rights movement. John Maguire, president emeritus of the Claremont Colleges, was an original Freedom Rider in 1961 and close colleague of Martin Luther King Jr. He and Grace were creating Beloved Communities, based on King's philosophy. A project of the Institute for Democratic Renewal, Beloved Communities was an initiative that aimed "to identify, explore and form a network of communities committed to and practicing the profound pursuit of justice, radical inclusivity, democratic governance, health and wholeness, and social/individual transformation."[1] Through Beloved Communities, I met theologians Dr. Vincent Harding and Nelson and Joyce Johnson of North Carolina, who were using Truth and Reconciliation to address the 1979 Greensborough massacre of five justice organizers by members of the Ku Klux Klan and the American Nazi Party. I met artists such as Bernice Johnson Reagon of Sweet Honey in the Rock; Kathy Sanchez, a potter from Tewa Women United of New Mexico; and organizers from environmental movements such as Anthony Flaccavento of Appalachia, who helped tobacco farmers transition into organic food growers with cooperative distribution. These historic and mind-expanding meetings were held at the Alex Haley Farm in Clinton, Tennessee. We could bring younger folks, so Kamau and Shobo (a priest from Japan) became part of this vast think tank of changers. We were wading in the water of the long struggle for human rights and dignity in this country, plus new challenges such as climate change and Islamophobia. Spirituality was at the core of the civil rights and Indigenous peoples' struggles. One of

Grace's themes during this period was, "These are times to grow your soul," and she was helping me grow mine.

Members of Beloved Communities were in a planning process in LA, and Grace "assigned" me to create an arts workshop to demonstrate the power of art and creativity as a process to take us beyond the binary paradigms that have trapped us in a world of us and them, confrontation and violence. The workshop turned out to be a two-day, twelve-hour retreat. The first day we started at six in the morning at Senshin Temple with people sharing their morning practices, from meditation to yoga, making lunch, and ending before dinner. The next day, starting at that same time, we walked four blocks to Masjid Omar Ibn Al Khattab, the mosque across from USC, to open with salat. One of the twenty-one participants was Mayumi Kodani, Reverend Mas's daughter, who wrote:

> "To All Relations: The Art of Weaving Faiths" began with a day of exercises that would by turns make us feel silly, joyful, solemn, like children, and like a quickly congealing unit. We did exercises that loosened up our voices and bodies, such as breathing and stretching movements; creating a whole body gesture to express our names; and breaking into groups to create a human moving sculpture.... By the end of the first day, I found that as a group, we were relying less and less on learned rules of behavior than we were on a sixth sense of a collective energy. We had also become a kind of family.[2]

That sums it up better than I could. Thanks, Mayumi. And Grace hung in there for the whole thing! I was seeing community art as part of a larger picture. Art, the creative process, is a form of pure energy. When used with people with common or uncommon backgrounds, it can be a powerful elixir to spark personal and communal transformation.

I was connecting with a host of other amazing artists and organizations entrenched in communities, from Alternate Roots to Roberta Uno's New WORLD Theater. In my work as a mentor with National Institute for Directing and Ensemble Creation, I would meet and train with artists from Palestine to South Africa, Nicaragua to Japan, New York to New Orleans, Native Americans to Native Hawaiians, sharing our work, voicing our stories, defining our values, developing more artists. We are everywhere. We are a field of work, part of a tradition of culture makers with high consciousness coupled with creative intelligence, working our magic—in communities, in

places of conflict, in spaces that need healing. And we need more, more, more, spreading like that stubborn crabgrass.

Grace lived through the historic period when radicals thought revolution would happen through unified effort under one revolutionary political party overthrowing the capitalist system. But she was now witnessing and contributing to a different kind of movement for social transformation. This movement has no center; it is everywhere on the planet, connected not by "isms" but by ideas, practices, that push us toward our humanity, toward fairness, toward caring for our places, our communities, our Earth. We are largely invisible, under the radar, yet our numbers are multiplying. It is easy to be alarmed by the backlash of White supremacy, motivated as it is by fear of losing privilege and power, but people of color and allies are becoming the majority. We are anchored by our roots, but open to the new. This movement with no center can't be stomped out. Our doings and beings are too diverse. From Standing Rock to #MeToo to Black Lives Matter, we are making an impact because we don't give up. We can bring down moguls, corporations, dams, leaders. We are resilient, we persevere, we persist like that tenacious crabgrass in my garden.

In 2006, I got another one of those phone calls from Kamau: "I'm moving to Michigan." What?! It was another leap of faith—this time with a wife, three kids, and another baby on the way. He wanted to study with Shaykh Hisham of the Naqshbandi Sufi order, who had a center in Burton, Michigan. I thought he was crazy. What saved him was his faith. Beaumont Hospital in Detroit needed a Muslim chaplain, and Kamau got into their training program.

He found a path where he could use his faith, serve others, and make a living. Eventually he got a chaplaincy at the University of Michigan Hospital in Ann Arbor. This meant I could visit them once or twice yearly and share Grace with the family, especially with my grandkids. Even though they would not understand all of who she was, they could feel her love and energy and find out more when they were ready. Grace would say, "Tell your kids that they are geniuses." And she meant it.

In 2014, we all drove to Detroit to see Grace for what would be our last visit. We stopped at Avalon International Breads to get her favorite brioche pastry. It was a chilly December, but some things had changed. The amount of snow had noticeably decreased since my first visit in 2000. Global warm-

ing was making its impact in Detroit. And Grace was no longer coming to the door to receive us, or chatting with us in her old armchair covered with a crocheted blanket. She was now in a wheelchair, surrounded by her 78 rpm record collection and a pile of books. I was surprised she was reading Jeff Chang's book about the history of the hip-hop generation, *Can't Stop Won't Stop* (2005). It was a perfect description of Grace. She never stopped learning or dreaming. She continued to remain open, ready for change, even at ninety-nine. But now we were seeing Grace not only as a political being: she was a light, a spiritual being. I snapped a photo of her sitting in her wheelchair with a shiny Mac computer on her lap, thinking, this is a perfect "Think Different" image, not for Apple, but for all humanity (see photo 26).

She gave me one last assignment before we parted: "You need to write your book. It will change your life. It did mine." Grace, the teacher, had another lesson for me. She had shared so much and pushed me in so many ways to use my creative process. Now she was pushing me once more—not to do, but to stop doing and reflect.

Grace Lee Boggs, after a century of "living for change," made her homegoing on October 5, 2015. At the end of her Detroit memorial, people streamed into the Detroit neighborhood following a brass band in a New Orleans-style "second line" parade. If there was ever a "saint go marching" for Detroit, it would be Grace. But I will always remember her dancing in a circle at Genesis—dreaming for her broken city, for what some people might think was impossible:

With your hands, with your hearts
With this land we can make a new start
I dream a garden

Mottainai—*Waste Nothing*

GRACE BOGGS SHOWED US that "think global, act local" was more than a slogan. While people of color struggle with racism, global warming is also on our backs. It is all interconnected. The victims of New Orleans's Katrina and Puerto Rico's hurricanes are a testament to that fact. Our complicity is intertwined with the way we live—our cars, our conveniences, our food, where we get our energy. We all play a role in this planetary imbalance with our choices, small and large. How to break it down to bite size so people will see that relationship?

I was particularly interested in how to do that in my own community. It came in a flash—*waribashi!* Those ubiquitous disposable wooden chopsticks that we all use and toss in the trash. We're cutting down forests for *waribashi!* Trees are the lungs of the planet. This is an issue directly connected with my culture, and anybody who eats Japanese food. Reverend Mas had been talking about the wastefulness of their use at our temple events. We could switch to bamboo, a fast-growing renewable version. But cultural habits are hard to break: the temple ladies find it difficult to switch from Japanese wood to Chinese bamboo. One day I visited Senshin's kitchen. Reverend Mas had discovered packets of *waribashi* stashed in a drawer. He was cracking them in half and throwing them conspicuously into the trash. My, my—so violent for a Buddhist priest! I joined in, but maybe there was a better way to get the message across, and to more people.

My second flash—a music video! A catchy song with images using humor to convey useful information will show people how they participate in a convenience that harms the planet. Without pointing fingers, they'd realize they have a choice to BYO chopsticks, and feel good that their small action was making a big difference to the planet. We even did a campaign, promoting a

pair of portable chopsticks that could fit in your pocket like a pen. It was a good fundraiser at first, but we realized we weren't in the chopsticks distribution business.

Ideas are cheap, but making a music video is expensive, especially for a small, tight-budget organization like ours. We'd never done it before, and that's what made it fun. But how to explain to my board? How to explain for a grant? This project does not fit into their neat little boxes. How can we leap beyond those boxes? We can't afford to wait for a grant when each year the temperature is rising! The quickest and freest way was to convince a group of friends to each give me $500. I went to Stan and Mary, Warren, Amy, Jenny, Bruce, Niki, Maricel, Mike, Hung, and Leng, and we put together $5,000! A fraction of the cost, but we had to show people what we were talking about.

"B.Y.O. Chopstix," like most Great Leap projects, happened because artists and community pitched in. Dan Kwong directed and Derek Nakamoto was music director. To reach young ears, rapper Luke Patterson, who worked at the Great Leap office, wrote some rhymes. Yuki Ishii created a wild costume for my ghost-of-dead-chopsticks character, and Dick Obayashi let us shoot for free in his restaurant, Azuma. "B.Y.O. Chopstix" was on YouTube by August 2010.[1] Thus began Great Leap's journey producing Eco-Vids, music videos putting people of color and our culture at the center of an environmental issue. Sustainability seemed to be the territory of dedicated White people who had the answers, but for our ancestors, it was a way of living. They were caretakers of the land with Traditional Environmental Knowledge. What had we lost? How could we re-mind ourselves? How to use art to renew our culture's wisdoms to address today's environmental needs?

Mottainai is a Japanese word that essentially means "waste nothing." We lived this long before "reduce, reuse, recycle." Wangari Maathai, a Kenyan political environmentalist and Nobel Prize winner, heard the word when she spoke in Japan. It reminded her of African values; she was spreading the word *mottainai* around the planet with her talks. Her organization, the Green Belt Movement, has planted millions of trees in Kenya. "Mottainai," our next Eco-Vid, would connect across the world! (You need grand ideas even if they don't pan out.) "Mottainai" sparked conversations in our community with young people asking their grandparents about its meaning.[2] It coincided with conversations on how to make Buddhist temples greener.

Artists have always been *mottainai* people, living on little, using and reusing what's in and around us. We are the "lost and found" of our society. We dig through discarded, forgotten waste—not just things but also our stories,

our heartaches, our mistakes, our cultures—and use our love energy and imagination to transform it into something meaningful, beautiful, useful; something you can savor, dance to, laugh or cry with; something to awaken and strengthen you, even give you courage. Art can help us see what we didn't previously notice. It can heal and change our inner world in order to change our outer world. Anyone can be an artist. Everyone is creative—creating is what we were born to do. It's a way of doing things, a process. Just ask Quetzal and Martha.

I got a call from Quetzal Flores of the band Quetzal when I was struggling with the next Eco-Vid, "Cycles of Change," a song about the virtues of bicycling.[3] I think we might have met at a gig in East LA. Quetzal asked if I'd come and be part of a discussion at their record release of *Imaginaries*. At KPCC radio, they performed their album live. Quetzal's guitars led the tightly arranged acoustic ensemble into a universe of sounds. Juan Perez, their driving heartbeat of a bass player, also played a stringed instrument that was a transformed Cuban cigar box! Tylana Enomoto's classically trained violin pushed into liberated improvisations. And wow, Martha González was a song goddess. An excellent percussionist, she at times stepped onto a small wooden platform to dance out her rhythms, making the band visually interesting. Each musician used their multifaceted talents to the max. Their soulful sound skillfully spun their Latin roots into unlimited inventions of beautifully composed songs. Many of their politically rich lyrics were in Spanish, which I didn't need to understand to understand their music. They were *fuego*! Fire!

Quetzal Flores and Martha González are "artivists" who somehow manage to weave their art, activism, family life, and community into one package. That album, *Imaginaries*, won them a Grammy, yet they must straddle worlds to keep their feet planted in the East LA community. In their extended family everyone seems to be a musician, environmentalist, artist, or all the above, sharing childcare, resources, gigs, and more.

Back home I was struggling with the bicycle song. My wheels were stuck. Maybe it was something I couldn't, or wasn't, supposed to create alone. Hm, would Quetzal be interested? He didn't yet know me or my work, but I took a chance. In a nanosecond he said "yes!" Our first session in their living room birthed the premise for the song, "Cycles of Change," with me, the "bicycle fairy," convincing Martha, the working mother, that life on two wheels would make her hectic life healthier, happier, and much more fun for her and

her family. I knew she would nail it. Quetzal shared that Martha had been a child actress on Paul Rodriguez's TV show. Quetzal would be in it. And we needed a child who was easy to work with. Quetzal suggested their son, Sandino. Dan Kwong, who was directing again, and I worried that at seven he might be too young to take direction. Wrong! Sandino was extraordinary and continues to blow our minds with his exceptional musical talents and intellect. We hit the jackpot with the whole Flores family.

We recorded the song in their home studio and even shot some scenes in their apartment (with Quetzal cooking in the background—in rhythm, of course), then loading their bikes onto the local metro and biking in a park. Martha has a comedic flair, and Dan did his crazies animating her and me flying on my magic bike in the video. It all flowed naturally, with food, fun, creativity, and community. We didn't go viral like we should have, but hey, it's still out there ready to ride a distance. That's the beauty of YouTube.

But sometimes it's not making the project that is the most important; it's making relationships that will push you forward. We were now *familia*. Quetzal said: "I've got plans for you." This time he invited me to a fandango class that he and Martha were teaching at Plaza de la Raza. Fandango is a traditional convening from Veracruz, Mexico, a community gathering with participatory music and dance. The music, *son jarocho*, is a mix of Spanish, Indigenous, Mexican, and African influences that jumped from Cuba to Veracruz. Quetzal and Martha have been part of the *movimiento* helping to spread fandango to Chicanx and Latinx communities across the United States.

When I entered the small theater, their class was in process. Quetzal approached and put in my hands a *jarana*, a small, handmade guitar. "Play!" he commanded. I obeyed, stepping into the circle of *jaraneros* gathered around a wooden platform called a *tarima*. My fingers struggled to recall chords I'd learned on the ukulele, but I felt safe strumming with others. A singer—not Martha, the professional, but a community person—broke into a verse, her voice becoming more confident as others sang a response. Martha slung her *jarana* behind her and stepped onto the *tarima* wearing her black pumps with small straps. She stomped out a simple rhythm, *Cafe con pan— cafe con pan*, and pulled me up for a try. Oh, I get it, we are the drumbeat for the song! In the circle of more than twenty, there were no observers. Everyone was participating, learning, playing, and it was big fun. I can see how fandangos can be addictive, carrying on through the night. It hit me that this is sort of like Obon, but in that tradition, the musicians play on the central platform, the *yagura*, and people dance around it.

As I left the class, I thanked Quetzal and threw him an idea: What would happen if we put fandango and Obon together? Another "yes!" But it wouldn't be enough to bring the practices of fandango and Obon together in one space. It needed a *song*. How to bring these two distinct cultures, with different rhythms, chords, styles, and histories, into one song? Before we started, I wanted Quetzal and Martha to meet Reverend Mas. As usual, he had wisdom to offer. We came away with a title: "Bambutsu—No Tsunagari" (All Things Connected). He also gave us a challenge that set our cultural compass: "It shouldn't be a fusion, but a conversation, with each form staying true to itself."

The song was waiting to come. I churned out some verses and a simple musical introduction working with Sean Miura's shamisen, Danny Yamamoto's *taiko*, and of course George Abe's flute. Quetzal jumped in with his *jarana* and the conversation began. He got César Castro, born in Veracruz and bred on *son jarocho*, to write Spanish lyrics together with Martha. This young maestro can make up lyrics on the spot and has a voice that doesn't need a microphone. A few rehearsals wove our song into completion, with Atomic Nancy singing a Japanese feel into our lyrics and me and Carla Vega backing her up with *kakegoe* (shouts). We recorded "Bambutsu—No Tsunagari" in Quetzal's home studio.[4] It's got soul, it soars, it's asking for a dance. Elaine Fukumoto, head Obon teacher of the Southern District Buddhist temples, is steeped in Obon tradition, but not stuck in it. She helped us with choreography that wove fandango with Obon moves.

We were messing with tradition, but then I stumbled on this thought by Uchiyama Takeo, director of the National Museum of Modern Art in Kyoto: "Tradition is not simply preservation. It is that element in creative art which does not change at its core but changes constantly in its expression."[5] Yes. We were being authentically us, expressing our traditions in the context of the communities we shared, neighborhoods we grew up in, common histories we lived through. And now we have a common need: to maintain and sustain our communities.

Our songwriting process started in June 2013, and a few weeks later, Leslie Ito, executive director of the JACCC, gave us their Noguchi Plaza to do our gathering on November 8, the day after Día de los Muertos, the Mexican remembrance of the dead, was celebrated in LA. Yes! Obon remembers the dead, too. Then we got Lluvia Higuera to design our first postcard to invite our communities. Esteemed visual artists Jose Ramirez and Qris Yamashita gave us the use of their art, figures that portrayed fandango and Obon, and

Lluvia pushed those two words together and gave us our official name, FandangObon!

So how would we get our communities to participate in this experiment? We needed workshops. We started at my community base, Senshin Buddhist Temple, where folks are always game, then at Eastside Café in El Sereno, where Quetzal's father and sister Angela had a beautiful community space that held *son jarocho* classes. As it turns out, Quetzal's father, Roberto Flores, was a revolutionary Brown Beret in the Chicano movement back in the day, and had worked with some of our Japanese American activists who were part of the Eastside Collective in Boyle Heights. One of our core organizers of FandangObon, Kathy Masaoka, lived in that collective, and we found out she babysat Quetzal and his sister when they were children. Of course we're already *bambutsu* (connected). On top of that, Quetzal had worked on the crew in the JACCC Theater. He's a cultural weaver, that one.

The Flores family was deeply influenced by the Zapatista movement in Chiapas, Mexico, which is reflected in the values of Eastside Café: "We believe in community-based organizing that is interdependent, pluri-ethnic, and asset based. . . . We rely on who we are and what we can do."[6] All this to say, FandangObon started out with a flash of an idea, without funding, but grew from who we are and what we can do. We had resources within and around us to birth this idea and give it wings. As we progressed through our journey we discovered the many ways we were already connected. It was a continual process of those connections being revealed.

That first FandangObon brought together more than a couple hundred people. Of course, being so soon after the Día de los Muertos observance, many of the fandango players were loopy from too much partying. But on that day, Latinx folks learned "Tanko Bushi" and Japanese folks stepped onto the *tarima* to stomp out rhythms to "La Guacamaya." It was thrilling to see the generations and cultures participate, with kids—Sandino, Maya, Sarah, Rocket, and Zoe—singing "Mottainai." FandangObon worked!

I thought the experiment was over, but FandangObon was just getting started. People wanted it again for next year. In the meantime, the Japanese community picked up our theme song for their summer Obon festivals. Thousands danced "Bambutsu—No Tsunagari" at their Obons. True to folk tradition, if people like it, they spread it. "Bambutsu—No Tsunagari" began to have a life of its own.

FandangObon uses participatory arts as an organizing principle, at first bringing together the Mexican and Japanese communities, then expanding

to invite African Americans and more. All our cultures once used participatory music and dance traditions to give thanks, summon rain, bless crops, seek healing. Feet drummed into the dust, merging with the earth. Our ancestors understood we were part of its ecosystem, not the ruler of it. FandangObon's focus is not only to deepen relations between us; it does something for the Earth. A simple song spun us on a journey.

THIRTY-FIVE

Black Lives Matter

Dirty secrets lie in the shadows, waiting for the light
Talking story round kitchen table, clear as black and white
How many lives have been taken?
How many names we don't know?
How many young men in cages
With dreams nowhere to go?

IT SEEMED LIKE EVERY DAY there was another story in our morning paper about a Black man, a Black kid, or even a Black woman killed by the police. Then there was the 2015 slaughter in the church in Charleston, South Carolina, that spilled all over our kitchen table. Most elders over a hundred aren't interested or aware of such matters. But that's not my mom, Mamie.

Having Tarabu's mother live with us during Buffalo's winter months from mid-December until mid-May for more than twenty years was a gift that put me next to a century of US history and a special kind of wisdom. Mamie Kirkland crossed over in 2019, when she was 111, but her spirit is still a strong presence in our lives. Mom was a fashion queen. I mean, she had her own style. She could wear a sparkly hat that *nobody* else could get away with. She was a smart shopper who loved a sale at Macy's and going with me to the Hollywood Farmers Market on Sunday. That's when she was 100. When she was 106, Mamie strolled into the kitchen with a walker, which she'd finally agreed to use, singing the 1940s Duke Ellington song "Don't Get Around Much Anymore," ending with a burst of laughter. Mamie had slowed down but she still got around, and she took me with her.

Mamie was anything but normal. A four-foot, nine-inch spitfire, a living rock of ages, she survived all manner of hardships. Born in 1908 in Ellisville, Mississippi, she was seven when her family was forced to flee to avoid her father's lynching. She lived through the 1917 East St. Louis race riots, sur-

My song "Black Lives Matter" is on *120,000 Stories* (Smithsonian Folkways, 2021), and the music video is at https://youtu.be/eX5pI9qLCcM.

vived a KKK cross burning in Alliance, Ohio, and even marched with Marcus Garvey. She loved to read and did well in school—until she fell in love with Albert Kirkland, a boarder in her father's house. At fifteen they married and moved to Buffalo. Mamie was still a child when she bore the first of her nine children, six of whom survived. "Losing my children almost killed me," she related. Her husband taught her to cook, and the Great Depression taught her how to manage, feed, and house in their small apartment an extended family escaping the Jim Crow South. Not only did she care for her own children, she didn't mind staying home to watch other women's children when they went out to party to escape the daily drudgeries of life. "She was a pretty woman, and a sharp dresser!" she'd say about a friend, without an ounce of jealousy.

When Mamie lost her husband of thirty-five years, three months, and sixteen days, she became an Avon lady, walking door to door in Buffalo (you could do that in those days), selling beauty products to support herself and her last child and only son, Albert Jr., aka Tarabu, my husband. Avon turned out to be a kind of ministry for her. She was a loving listener and became a counselor to her customers. "I enjoyed it," she recalled. "I didn't need to ask for help from nobody!"

At 108, Mamie still didn't like to ask for help. She did a lot for herself. She washed her own undies, squeezing out the water to keep her hands strong. She gave herself a meticulous daily "gorilla bath," as she called a sponge bath. Mom was so meticulous, she learned not to come into the kitchen when I was cooking because she didn't want to see that I didn't wash my organic cabbage three times, the way she did. I figured I was saving water. She thought I was a barbarian.

There was one requirement that was hard to fulfill. Mom liked her food hot. This was difficult because she was a verrrry slow eater. Mamie chewed her food well, which was one of her secrets of long life. But halfway through the meal, the food would get too cold for her taste (thank god for the hated microwave). I asked her how she managed to keep her own food hot when she had to feed six children in freezing Buffalo. She answered, "Oh, I always fed everyone else first. That's just the way I am."

Mamie pretty much dressed herself except for needing help getting things stored up high in the closet. And dress she did, with her own style: a strong sense of color, plenty of shiny jewelry, and a cool cap to cover her "nine hairs," as she referred to her hair loss. She loved kicking up her feet wearing her red Nikes that her Tarabu bought her. A true fashionista, and a wee bit of a show-

off. A breast cancer survivor with one boob, two lousy hearing aids that she called her "welfare ears," and the same pair of false teeth she'd worn since age fifty, she would laugh and say, "I'm Cinderella." Indeed she was, and Tarabu and I were basically her humble servants six months a year. The other six Tarabu called her daily, from wherever we were in the world.

Another extraordinary thing about Mamie was her memory. She remembered a time when Black people died for the right to vote, so she never missed an election. During Barack Obama's inauguration she leaned toward the TV, pointed her crooked finger, and announced with pride: "That's *our* president!" (After Trump, she'd say, "That's *your* president.") Tarabu tried to get Obama to meet her for her 107th birthday, but she was beaten out by another feisty Black woman who was only 106.

Whereas I generally can't remember what I ate last week, Mamie remembered everything—including who we dined with last year and what we ate. She once heard a story of a friend's daughter who had a car accident after working the late shift at a bar. Two years later when she saw the friend again, she told him: "I've been praying that your daughter gets another kind of job so she won't have to work so late." That's Mamie. Her secret was being fully present. When she was with you, or anyone, she was one hundred percent there.

One thing she remembered clearly was the little house where she was born in Mississippi, and that cold night when her father rushed in and told her mother to pack up the children and catch the morning train to St. Louis. He and a friend were being chased by the Klan and had to leave immediately. Seven-year-old Mamie would never see her home again. Four years later, her father's friend returned to Ellisville and was lynched. She told that story to the family so many times, Tarabu didn't know if it was real or imagined. Then one day, a friend turned Tarabu on to the website of the Equal Justice Initiative. They are documenting the history of lynchings from 1877 to 1950, including the names of 3,959 victims of racial terror. He entered a search for Ellisville, Mississippi, and an article popped up from the *Jackson Mississippi News*: "John Hartfield Will Be Lynched by Ellisville Mob 5pm in the Afternoon." It was June 26, 1919, exactly four years after his mother's family had fled Mississippi. Tarabu picked up his laptop and ran to his mom's bedroom. "Is this your father's friend who was lynched, John . . . or . . . " She responded like lightning, "John Hartfield!"

It was one of the most horrific lynchings in a time called the Red Summer, when hundreds of Blacks were murdered or terrorized, and many more

injured, at the hands of White mobs. With Black people slowly faring better from Reconstruction, after soldiering in World War I and being treated as human beings in Europe, they returned with higher expectations. Whites used violence to maintain dominance. Hartfield was accused of assaulting a White woman. But Mamie's story was that the two of them had a love relationship. Her father begged him not to go back to Mississippi, but Hartfield returned. The Klan tracked him down, shot him in the shoulder, and kept him alive at a doctor's office for twenty-four hours while they advertised his impending murder in the *Jackson Mississippi News*.

Tarabu knew he had to go to Mississippi, and he wanted to take his mom with him. It was time to tell her story. In a few months, September 3, 2015, she would turn 107. That would make it one hundred years since her family had been forced to flee. *100 Years from Mississippi* would be the title of his documentary film that would share her story. Her response to going was a quick "No!" This was common among many African Americans who fled the South, having endured saying "yes ma'am," "no ma'am," and getting off the sidewalk so Whites could pass unimpeded. Mamie remembered hearing her father talk with his pastor friends about seeing yet another Black body hanging from a tree. Any small event could unleash White violence, a brand of terrorism designed to instill fear in Black people and uphold White supremacy. Mamie's response to her memories: "I don't want to see Mississippi even on a map!"

When Mamie dug her feet in the sand, there was no way to budge her. But at breakfast I would share articles from the *LA Times*. This week—April 19, 2015—it was the police killing of Freddie Gray in Baltimore, and the protests by Black Lives Matter. Mamie sipped her coffee as she drank in the situation. That's when she told me she marched with Marcus Garvey. Young Mamie marched with Marcus Garvey! "They'd put out the call, and I'd be there!" And now the news was making her realize that what happened to her family in Mississippi was still happening to Black people today, not only in the South, but in Oakland, Ferguson, Brooklyn, Baltimore. "Is T going to Mississippi by himself?"

My "yes" made her react like a mama bear: "I don't want him to go alone. I better go with him." So that's how in September, just a few days after we celebrated her 107th birthday, we were on a plane to Jackson, Mississippi, with our cameraman-producer friend and special Mamie devotee, James Seligman. This was more than a sentimental journey. Tarabu's film *100 Years from Mississippi* was a pilgrimage, a quest for truth and healing. Mom loved to travel, but this

time Tarabu was filled with anxiety. Were we pushing her too hard? Could her heart take it? I had to convince him that some things are worth it. It was a gamble, but Mom, who was used to playing the numbers, was willing to take a chance. When we landed, she looked out the window and said, "I can't believe it. This is where I was born." She beamed excitement.

Traveling with Mamie was like being with a celebrity. She was greeted by the mayor of Ellisville, who said he was unfamiliar with that lynching "incident" and welcomed her to stay in Ellisville as long as she liked. Waitresses in local coffee shops, both Black and White, cuddled up to her, wanting to take selfies with this lively centenarian. An African American former Ellisville alderman drove us around town and told her that Mount Aid, the Baptist church where her father was called to his ministry in 1901, was still in existence. He painted a rosy picture of the changes in the local scene, although admitting that their schools didn't desegregate until 1972. When we drove alone, we saw run-down Black areas that didn't look rosy at all, while White areas had sprawling homes, rolling green lawns, and a scattering of Dixie flags.

Two African American lawyers from the Equal Justice Initiative, Jennifer Taylor and Kiara Boone, came to interview Mamie as a rare lynching survivor. The organization was in the process of creating the Legacy Museum in Montgomery, Alabama, a place full of sites that told a story: the river where boats unloaded with the enslaved, who walked up to the square where families were separated from their children and sold; across the street, the bus stop where Rosa Parks climbed onto the infamous bus; a couple of blocks beyond, the Dexter Avenue Church, where Martin Luther King Jr. directed the 1956 bus boycott. The Legacy Museum is in a former slave storehouse, where they now connect slavery and lynching from the Jim Crow past with systemic racist policies that keep more Black men in prisons today than there were slaves in 1850. We would later go to Montgomery for the opening of the museum, where her story is preserved, and see the National Memorial for Peace and Justice, a six-acre sacred site that honors the thousands of men, women, and children who were lynched between 1877 and 1950. To see each of their names listed on what look like majestic hanging tombs, including John Hartfield's, made this horrific legacy too real for me. Kamau once told me that you can't know the American story until you know the Black story. Our country cannot be whole until we are able to reckon with and heal from this brutal past.

Jennifer and Kiara had been to Ellisville before. They had been collecting soil from lynching spots to put in glass jars bearing victims' names to be

displayed at the museum. They knew where John Hartfield's lynching happened. The next day we stood on that very site, just steps away from the train tracks that carried Mamie's frightened family to East St. Louis. The gum tree where they hung Hartfield was gone, but still there, across the plaza, was the Alice Hotel and its balcony where they displayed the wounded Hartfield to a gleeful crowd, including some parents who brought their children to witness the gruesome spectacle.

I was trying to comprehend what kind of hate could grow this little town of twelve hundred into a crowd of ten thousand in twenty-four hours. What kind of hate does it take to hang a human being, shoot two thousand rounds at his body, then set him on fire? What kind of hate does it take to cut off his limbs and sell them along with postcards as souvenirs of the event? And what does this hate do to their offspring? From the Equal Justice Initiative we learned that White people who witnessed lynchings as children have stepped forward, sharing how they were haunted for the rest of their lives. This is an unhealed intergenerational trauma for Black people, as well as a scar on the minds and souls of White people in this country.

As we made a circle on the sacred ground where hate made John Hartfield a human sacrifice, Mom squeezed my hand hard, sending a surge of her energy. Tarabu uttered his poignant words, acknowledging the sacrifice of Hartfield and the many other victims who suffered a similar fate. He then poured water as a libation. I looked down at Mom, sitting in the wheelchair, head bowed. She held her tears. She didn't break. She was fully present, facing into this moment, into the fears that made her family flee their home as refugees, into the lynching memory of John Hartfield that echoed through her family. "That could have been my father," she said.

A reporter from the *New York Times* came to Mississippi to witness the event and interview Mamie, who spoke to him with conviction and grace. On September 15, 2015, her story appeared on the front page of the Sunday *New York Times*. Mamie's story about her trip to Mississippi was right next to a story about the Pope's trip to Cuba!

A few months later, Tarabu and I took another journey with Mamie, who was being honored at the Equal Justice Initiative's Legacy Museum and the National Memorial for Peace and Justice in Montgomery, Alabama. She was asked to say a few words. Now, Mamie is not afraid to speak her mind. She is known for her quick and sassy wit. But this was a crowd of six hundred politi-

cally savvy, Black and White bourgeoisie, many of them lawyers. Bryan Stevenson, EJI's founder and the author of the best-selling book *Just Mercy* (2014), introduced Mamie with eloquence as someone "representing all the mothers who have survived slavery and terrorism." Mom walked onto the platform without a walker, just holding tight to her only son's hand (see photo 27).

There she was, in her blazing-red suit and sparkling hat, the 107-year-old fashionista, standing tall in her four-foot-nine frame, taking in the crowd, taking in the moment, taking on the new role, that at 108, she was still living to perform. She lifted her arm and pointed her crooked finger at the rapt audience. "Young people—everyone's younger than me," she chuckled, "I left Mississippi a frightened little girl, but you know what? I'm not frightened anymore." Then surveying the audience, she added, "We got a lot of work to do." Notice she included herself. Mom was not done yet. Along with the rest of the crowd, I was on my feet, giving this fearless memory keeper, this ordinary yet extraordinary woman, just a little of the love that she gave us by her presence in the world.

Mamie once sang *don't get around much anymore*, but she took me places I would never have gone without her. We don't give enough respect to elders in our society. But I feel blessed to have known Mamie Kirkland and Grace Boggs, neither of whom stopped growing and teaching, each in their own way. No matter how old I get, and I'm getting up there, I will mind Mamie's words: "We've got a lot of work to do."

Bambutsu—*All Things Connected*

In the circle we dance
No beginning no ending
In the circle we dance
I am you, you are the other me
Bambutsu—no tsunagari

IT'S SUNDAY, OCTOBER 7, 2018, the final celebration of our sixth season of FandangObon. I'm standing on a circle of bricks embedded in the plaza of the Japanese Cultural and Community Center in Little Tokyo. It should be fall, but the mercury's in the nineties and the sun bakes into our brick circle like summer. Once our ancestors danced around the fire. Now the fire dances around us. Global warming is here—mega-fires, droughts, hurricanes, floods—and we have a government that will deny the children's tomorrow just for more profits today. As temperatures rise, oil and coal are encouraged. As people of color become the majority, the president tries to ban Muslims, builds walls, threatens immigrants, imprisons children, and takes pleasure in fanning the flames of White fear. These are extraordinary times— incendiary, divisive times. Yes, the fire dances around us.

I'm dressed in my *yukata*, a cotton kimono that my people once wore in Japan's sweltering summers. My midriff is bound with an *obi*. My kicks are made of three pieces of wood called *geta*, which once raised our feet off the summer dust and winter mud. I began wearing *yukata* to join in the dances during Obon season. It used to feel foreign to me, but now it's not a costume. It's what my people wore. They stitched it by hand as wearable origami, wasting nothing. My *obi* binds me to a tradition of no waste in a disposable world. I love its simplicity, the surprise of patterns and colors from the Japanese mind. It is practical, beautiful, timeless and timely. It says we are here, we are not going to disappear.

My song "Bambutsu no tsunagari" is on *120,000 Stories* (Smithsonian Folkways, 2021).

But Little Tokyo has been shrinking. Before 1942, it was a bustling place where thirty thousand Japanese lived in the shadow of LA's City Hall. We sprawled across the First Street bridge into Boyle Heights, living among Mexican neighbors. We went south up Central Avenue, where Japanese farms filled the Central Market with their produce, then west up to Jefferson and Adams, where Japanese homes and nurseries mingled with the Black community. I'm standing under an old grapefruit tree that has witnessed our comings and goings for 150 years. When we were evacuated in 1942, that tree saw eighty thousand African Americans squeeze into Little Tokyo, coming for wartime jobs, running from the Jim Crow South. They transformed it into Bronzeville, with jazz clubs, juke joints, and the aroma of soul food filling the air. As early as 1872, Biddy Mason, the freed slave, nurse, and midwife, became a landowner in downtown LA, establishing the First African Methodist Episcopal Church on Spring Street, a stone's throw from Little Tokyo. She is buried in Boyle Heights in Evergreen Cemetery.

When the Japanese returned after World War II, Blacks receded. Little Tokyo grew smaller but remained our cultural heartbeat, changing through the years. Where else would you hang after midnight over a steamy bowl of *chashu* ramen but at the Atomic Café with Nancy's jukebox rocking a mix of punk and Japanese pop? The Troy Café moved next door and picked up the vibe with Chicano rockers. The Amerasia Bookstore was a place with books floor to ceiling that spoke to who you are. And George Abe, who helped run it, read them all. Those spaces are gone, but now we have the Tuesday Night Café, established by artivist traci kato-kiriyama and now run by Sean Miura and a crew of younger Asians like Quincy Surasmith. They have created a loving community for younger artists' voices. Redevelopment has had its good and bad consequences. The metro and urban density is giving in to greedy developers who build highrises with correspondingly high rents, erasing the old hotels and affordable apartments, filling the streets with homeless people. We want environmental sustainability, but we're also fighting for local economic and cultural sustainability. So we are here like that old grapefruit tree, still rooted and bearing new fruit.

We've got anchors like the Japanese American National Museum, the JACCC, East West Players, and Little Tokyo Service Center. The new Budokan sports and community center will bring in streams of youth. That will be important for my grandkids, who love to come here to experience this nugget of their culture, this place where our people's history is kept alive. But it's not just the buildings; it's our presence, creating layers of culture, the territory of the soul, that makes this place our own.

That's why I'm here in the brick circle created by Isamu Noguchi. He made it for Obon, but it's mostly ignored as people rush across the JACCC plaza. A circle is a powerful symbol. To me, he left us a diagram, a message to complete. This circle is an intersection for Japanese, Mexican, African Americans, on the land of the Tongva, the original people in the heart center of LA. So today we fulfill Noguchi's intention with a twenty-first-century Obon, inviting multiple communities into this circle to celebrate our connections with one another and Mother Earth.

The day before FandangObon, we held our Environmental Encuentro (convening), where we put our hands in the dirt with worms; shared seeds and composting methodologies; ate food and exchanged recipes from our cultures; and made art and poetry. Then Martha and Quetzal led us in a collective songwriting workshop, with almost fifty people on the stage of the JACCC Aratani Theatre, in a circle of chairs under the work lights. Kids, oldsters, professors, environmentalists, gardeners—all threw in their words as Martha wrote them on a chalkboard, then formed phrases of a song about gardening. Sandino, Martha and Quetzal's now thirteen-year-old prodigy son, found chords on a keyboard while Asiyah, my granddaughter, found rhythms on her hand drum. All participated in the magic of the creative process. What are we learning here? It's not just songwriting. Creativity does not only belong to those who call themselves artists. Everyone can be creative. We are demystifying creativity. We are democratizing the arts, integrating them into our daily living as a way of collective processing, problem solving, and celebration. As Quetzal puts it: "It's about how we participate in community through culture—how natural and cultural ecosystems are tied together, and how to strengthen them through this process of coming together."[1] We were ready to celebrate on the plaza.

Maceo Hernandez, the Chicano "demon drummer" from East LA, calls us into the circle with his *taiko*. His rhythms vibrate on the brick and concrete like he's calling all humanity. The procession begins. Three giant tree puppets, representing the old grapefruit trees, float onto the plaza. Honored elders—Jan Blunt, dancer-mother of Le Ballet Dembaya; Florence Nishida, master gardener who helps people of South Central transform their lawns into edible gardens; and Ofelia Esparza, *altarista*—carry food offerings harvested from urban gardens to place on the *ofrenda*, a Mexican altar created by Ofelia's *familia*. The altar is lavished with orange and yellow marigolds, fruits, seeds, and green streamers. Our Ofelia, eighty-nine years old, was just awarded the nation's highest honor in folk and traditional arts, the NEA National Heritage Fellowship.

Drummers and dancers from Le Ballet Dembaya dance onto the plaza, responding to Maceo's call with their *djembe*. I love watching the joy of those young Black men in their colorful dashikis. They grew up in a family that drummed and danced. They know it's a scientific fact that their drums synchronize heartbeats. They know you can't do that with a cell phone. Francis Awe's talking drum joins the conversation. He is a first-generation drummer from Nigeria. He and his dancer wife, Omowale, have been teaching and spreading the culture in LA for decades. We have generations here.

The *fandangueros* and Obon contingents follow, with participants on the plaza joining in. Our regulars are here. New faces appear, ready to dance. Others come from our workshops. Some wandered into the plaza and can't leave. Something feels different this year. FandangObon has taken root. Surrounding the circle, Coopera, a worker-owned fruit and vegetable cooperative, sells their organic Mexican meals. There are tables with community gardeners, a worm collective, the *bokashi* composting club, free harvest food, and more. Huge banners hang from the JACCC balcony: REMEMBRANCE, RESISTANCE, RESILIENCE.

Elaine Fukumoto starts the dancing leading a lively old Obon song, "Sakura Ondo," about a Japanese cherry tree. Everyone joins in. Next we do a harvest dance from West Africa, with everyone trying to follow Jahanna Blunt's beautiful long limbs in their own way. Next, our special guests from Veracruz, Julio Mizzumi and his wife, Belem, lead "Guacamaya," about the parrot that is disappearing from Veracruz. Julio is a fourth-generation Japanese Mexican who drinks in the Japanese faces around him, who remind him of his aunties and uncles in Mexico. Julio and Belem are both *fandangueros* and have created a community garden, Jardín Kojima, named after his great-grandfather who came from Japan. There they teach children *son jarocho*, host fandangos, and raise funds through the community by gathering plastic bottles. They are a living example of what FandangObon is about. And *fandangueros* in Veracruz are seeing all this through livestream today!

In the second half, we sing "I Dream a Garden," the song I wrote for Detroit. Detroit is in the circle! We've only rehearsed it during sound check, but Quetzal's got the *jaranas* cooking, the drummers know what to do, and Atomic Nancy, Carla, Martha, Sandino, and Asiyah sing (see photo 30). In the words of our poet laureate, Rubén Guevara: "We're jammin' a prayer." I catch Asiyah's eye. We know it can't get any better than this.

The next piece is "La Bamba," the most famous *son* of the *jarocho* tradition. Ritchie Valens traded the *jarana* for an electric guitar and made it into

a hit in 1958. Here it is beautifully sung in the traditional way. In the middle of the song, an unfamiliar woman's voice enters the space—so deep and penetrating, it grabs me. Martha and Belen are dancing on the *tarima* and an elder woman sits at its foot holding a microphone. She has taken on the song. *Para bailar La Bamba—para bailar La Bamba—se necesita una poca de gracia—una poca de gracia.* We could all feel her as she gave us her soul, creating new verses as she went along.

Later I learned that her name was Tia Licha Nieves. From Veracruz, she was touring the United States with her husband when he fell ill. She has been trapped here for months while he has been in the hospital. She brought her heartache, sang her troubles into the circle. I didn't know her or her story, but heard it in her voice. Our circle held her, gave her love. That's what fandango is about.

Like Tia Nieves, I too bring my worries into the circle: for my Afro-Asian-Muslim grandchildren, for all young people who still must struggle with racism, let alone global warming. I sing my hopes that they will find their own voices, their own liberation, by contributing to the betterment of our world. I am dancing and realize, this is my seventy-ninth circle around the sun! Sometimes I have to pinch myself to remember. I am grateful I can still dance (if more gently), I can still hear songs that want to be born, and I'm grateful to be part of this circle (see photo 31).

Hai! Hai! (Life!), my son chants. I am happy Kamau can be here from Michigan. He now leads the *hadra* (ritual) of the Sufi Muslim tradition. He is showing us how to spin, a slow-motion version of the whirling dervishes. "We are spinning in the direction of the atoms," he explains. Something quantum is definitely happening here. His daughter Asiyah's beautiful voice and hand drum pierce through. The *djembe* and *taiko* follow her. We join in, singing in Arabic: *Ta la al badaru alaina—Min ta ni ya til wada.* Hundreds of bodies are turning. My husband, Tarabu, is in the circle too, slowly, slowly, we're all melting into oneness. Our energy fills Noguchi's plaza, making the whole world slow down. There is love here, there is unity here, there is oneness beyond words. As we go into the final dance, "Bambutsu—No Tsunagari," we *are* all things connected.[2]

In an age in which most of us spend too much time observing the world through our rectangular devices, to step into the circle of FandangObon is a potent communal act. In this circle we reclaim our power, our creativity. We make music with our own hands, our own voices. We circle the Earth with our feet and remember we belong to it. In this circle everyone

is equal, everyone is seen, everyone has a place. In this circle there are no borders, no us and them. There is plenty of room for more circles. In this circle we weave our many roots, knowing our diversity is our strength. In this circle, we are enacting the world we want to live in. In this circle, in this circle . . .

In the circle we dance
No beginning no ending
In the circle we dance
I am you, you are the other me

BAMBUTSU—NO TSUNAGARI

Caracter ceremonial	Ceremonial character
El fandango rompe el orden	Fandango breaks with order
Celebración especial	A special celebration
En donde las almas borden	Where souls intertwine
Con sus ritmos, melodías	With its rhythms and melodies
Que al día de hoy celebramos	From which we celebrate today
Ancestral sabiduría	Ancestral knowledge
Con la cual nos abrazamos	Which we used to embrace

BAM BAM BAM BUTSU—NO TSUNAGARI

In the circle we dance
Like the moon and the sun
In the circle we dance
Let our hearts be the drum

BAMBUTSU—NO TSUNAGARI, BAMBUTSU

Empecemos a remediar	Let's start healing
Con los ancestros del son	With the ancestors of the son
Que es tiempo de celebrar	It's time to celebrate
La vida y fandango Obon	life with FandangObon!

BAM BAM BAM BUTSU—NO TSUNAGARI

In the circle we dance
To remember the dead
In the circle we dance
Oneness is moving

BAM BUTSU—NO TSUNAGARI, BAM BUTSU—HORE MI!
BAM BUTSU—NO TSUNAGARI, NO TSUNAGARI

Somos la fe y esperanza	We are faith we are hope
Somos nuevo amanecer	We are the dawning
Y la energía que alcanza	And the energy that we reach
Dara vida a un nuevo ser	Will give life to new beings
Que el baile y el canto juntos	Let the dance and the song
together	
Rieguen campos de alegría	Make fields of joy
Y que crezca entre la gente	And let it grow among people
Frutos de sabiduría	The fruit of knowledge

BAM BUTSU—NO TSUNAGARI

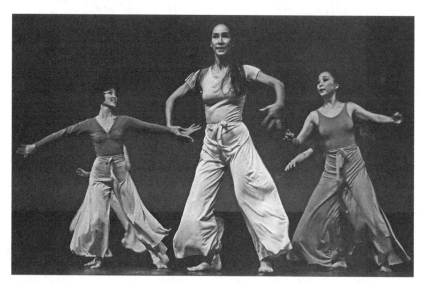

PHOTO 18. Lisa Furutani, Nobuko, and Genie Nakano perform *Women Hold Up Half the Sky* at Schoenberg Hall, UCLA, Los Angeles, 1978. Photo courtesy Great Leap Archives.

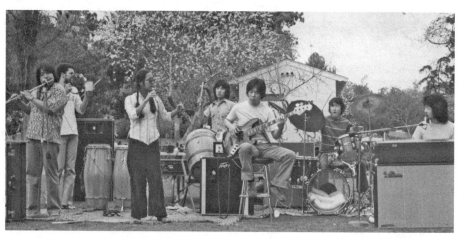

PHOTO 19. The original Warriors of the Rainbow band performing at the Lotus Festival, Echo Park, Los Angeles, 1978. Left to right: Alan Furutani, flute; Bobby Farlice, tambourine; Nobuko, vocals; Kenny Endo, *taiko*; Chris Kawaoka, bass; Danny Yamamoto, drum set; Benny Yee, keyboard. Photo courtesy Great Leap Archives.

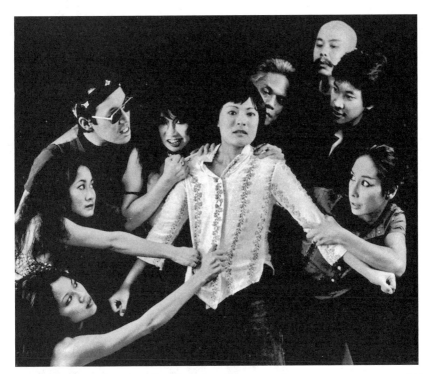

PHOTO 20. *Chop Suey* cast, 1979, with Deborah Nishimura at center and Nobuko at far right. Photo courtesy Great Leap Archives.

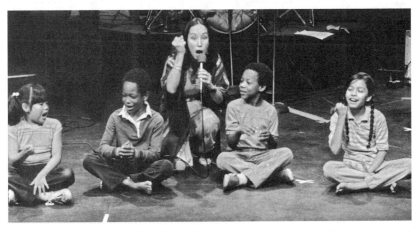

PHOTO 21. Performance of "Jan Ken Po," Gene Dynarski Theater, Hollywood, 1982. Left to right: Erin Inouye, Kamau Ayubbi, Nobuko, Sanza Fittz, and Akemi Kochiyama. Photo courtesy Great Leap Archives.

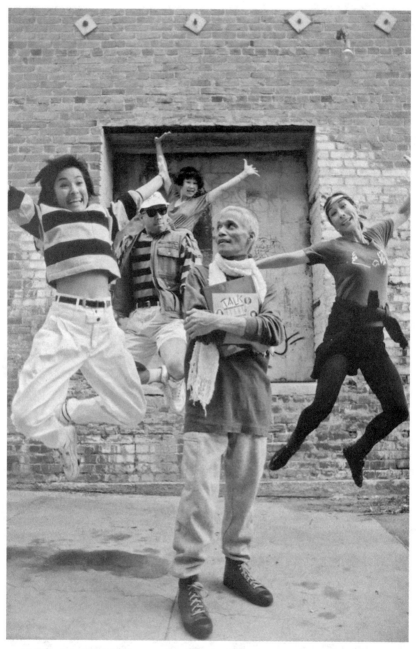

PHOTO 22. *Talk Story* cast, 1987. Left to right: Deborah Nishimura, Michael Paul Chan, Young Ae Park, José De Vega, and Nobuko Miyamoto. Photo courtesy Great Leap Archives.

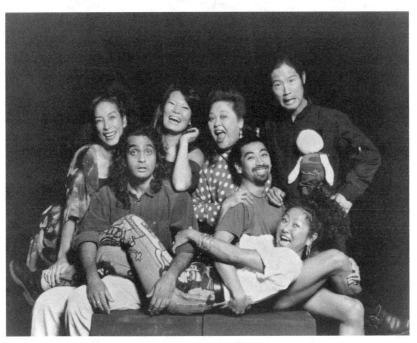

PHOTO 23. *A Slice of Rice* performers, Los Angeles, 1989. Left to right: Nobuko, Shishir Kurup, Jude Narita, Amy Hill, Long Nguyen, Dan Kwong (with baby puppet), and Louise Mita (lying down). Photo courtesy Great Leap Archives.

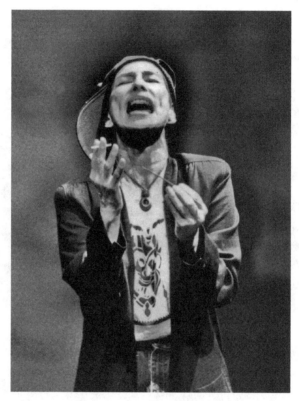

PHOTO 24. Nobuko performs "The Chasm" from her one-person show *A Grain of Sand*, Los Angeles Theatre Center, 1995. Photo courtesy Great Leap Archives.

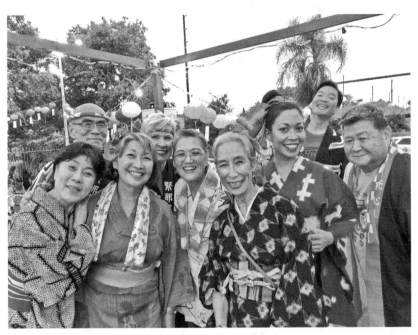

PHOTO 25. FandangObon band, singers, and guest performers at Senshin Buddhist Temple's Obon, Los Angeles, 2015. Left to right: Yoko Fujimoto, George Abe, Atomic Nancy, Kate Meigneux, PJ Hirabayashi, Nobuko, Carla Vega, Franco Imperial, and Johnny Mori. Photo courtesy Great Leap Archives.

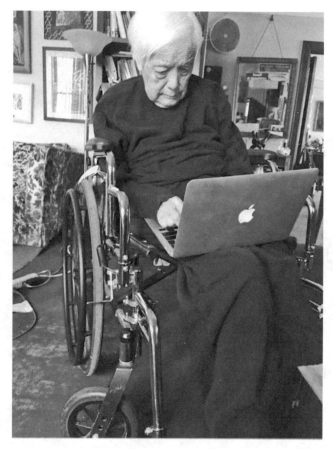

PHOTO 26. "Think Different!" Grace Lee Boggs at home working at her computer, Detroit, 2015. Photo by Nobuko Miyamoto.

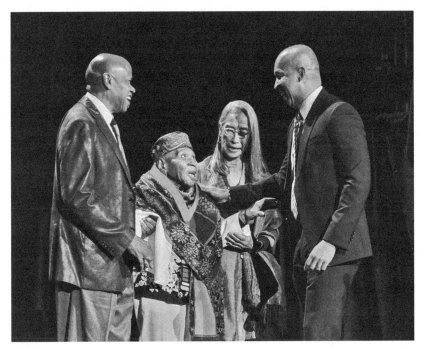

PHOTO 27. Mamie Kirkland at the opening of Equal Justice Initiative's Legacy Museum and the National Memorial for Peace and Justice in Montgomery, Alabama, where she was honored, 2018. Left to right: Tarabu Betserai Kirkland, Mamie Kirkland, Nobuko, and Equal Justice Initiative director Bryan Stevenson. Photo by Kyle Miyamoto.

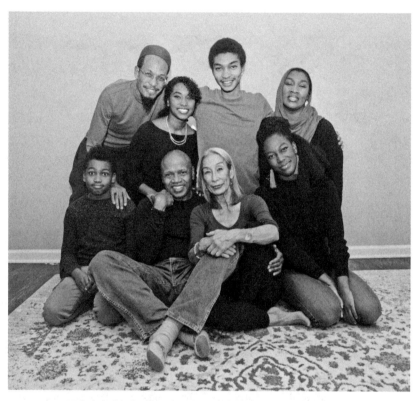

PHOTO 28. Nobuko's family, 2018. Center, seated: Tarabu Betserai Kirkland and Nobuko; surrounding: Kamau and Malika Ayubbi and their children Ahmed, Asiyah, Muhammad, and Noora. Photo by Zohair Hussein, used with permission.

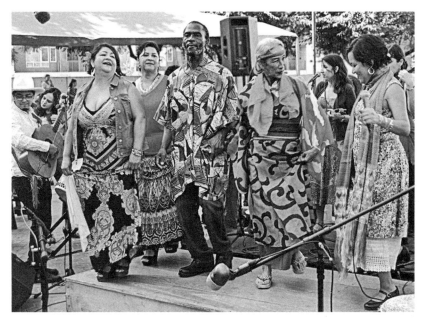

PHOTO 29. Nobuko and Martha González performing with the FandangObon community, Isamu Noguchi Plaza at the Japanese American Cultural and Community Center, Little Tokyo, Los Angeles, 2014. Left to right: César Castro (with guitar), Adriana Delfin, Columba B. Maldonado, E. M. Abdulmumin, Nobuko, and Martha González. Photo by Mike Murase, used with permission.

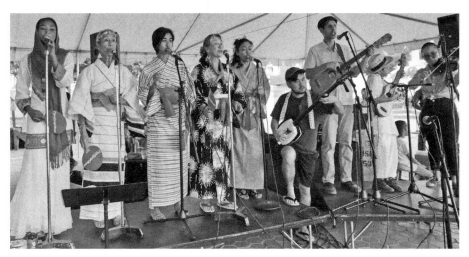

PHOTO 30. FandangObon musicians, Japanese American Cultural and Community Center, Los Angeles, October 25, 2015. Left to right: Asiyah Ayubbi, Nobuko, June Kaewsith, Nancy Sekizawa, Carla Vega, Sean Miura, Quetzal Flores, Sandino Flores, and Tylana Enomoto. Photo by Mike Murase, used with permission.

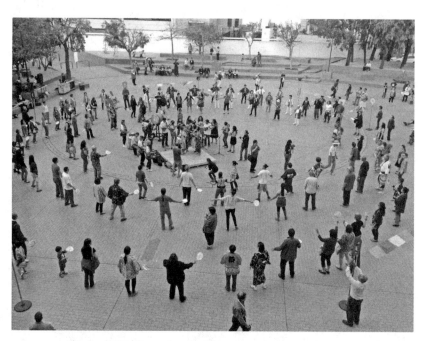

PHOTO 31. FandangObon Festival on the Isamu Noguchi Plaza at the Japanese American Cultural and Community Center, Little Tokyo, Los Angeles, 2014. Nobuko and the singers stand on the *tarima*. Photo by Mike Murase, used with permission.

Epilogue

BEFORE I PUT A FINAL PERIOD on the longest song I ever wrote—this book—I want to mark this moment. We are in the midst of the COVID-19 pandemic, an unprecedented moment that has stopped life as we knew it throughout the planet. On May 25, 2020, during this freeze-frame, we also witnessed a police officer murder a Black man, George Floyd, which was not unprecedented but rather part of an ongoing, untreated virus rooted in America's legacies, reaching from slavery to mass incarceration.

These seemingly disparate viruses intersect when we see that COVID-19 is causing more deaths and illnesses among Blacks and Latinos. Race matters when it comes to health care, housing, jobs, education, when you're locked in a prison, or just walking down the street.

What does this moment teach us? My first thought was: If we can stop the world for COVID-19, why can't we do it for global warming? And look! It's proof, the world *is* interconnected, we *are* all relations! Then when I saw people fill the streets protesting Floyd's death, day after day, week after week, it gave me hope that this was a moment of awakening—with not just Black people, but a mixture of cultures and generations marching; Whites in remote places feeling the need to take a stand; and people across the world speaking out. Is this the moment of reckoning we have needed for so long?

To move forward we must address both viruses. COVID-19 demands us all to protect ourselves and protect others by masking. Simply put, we all benefit by being responsible for each other, just as we will all benefit and heal when we reckon with America's enslavement of Black people and the robbery of this land from Native peoples. And there's another thing simmering beneath all this: fear, fear of people of color becoming the majority. That's a lot for everyone to reckon with.

Change will not happen overnight. Change takes patience, persistence. Change is a process. It's not just about winning, it's a way of living, living our beliefs. It will take creativity to expand our humanity. We need art to grow our souls. We artists are wondering when we will once again sit shoulder to shoulder in a theater. When we will once more dance in a circle on the plaza. Artists will find a way, and the circle we care about is much bigger than a plaza. We will make a way from no way. That's what we do.

So how will we keep the story of two viruses moving? It is said that every generation has its task. You have big ones.

Remember what Mamie said: we've got a lot of work to do.

Nobuko Miyamoto
July 20, 2020

ACKNOWLEDGMENTS

Reverend Mas Kodani of Senshin Temple once said in a talk that the word "me" is a series of relationships. We are each who we are because of the people and events encountered in our life's journey. So let me first thank Reverend Mas for that bit of wisdom and for being a great sensei for a renegade Buddhist like me. He has inspired many songs, and he gave me a home for my work and my life. This book has given me a chance to revisit many of those relationships who are "me," and to share them with you.

I would not have embarked on this venture if not for Grace Lee Boggs. She gave me the assignment: "Write your book." In December 2014 I left her house in Detroit and returned to LA to begin the long journey, the longest song I ever wrote. It was foreign territory for someone who mostly writes three verses, a bridge, and a chorus. It came in fits and starts at first, and then my husband, Tarabu, wisely guided me to a writing class that he had just finished with Jack Grapes. That little chapbook we each made of our writings let me know I might be able to tell my story, not performed on a stage as I was used to, but with words only.

Masumi Izumi of Doshisha University in Kyoto, Japan, first suggested a title—*What Can a Song Do?*—a line from one of my songs, "The Chasm." Although the title eventually changed, each chapter in this book begins with a line from a song with which I had something to do; a few are borrowed. Song was the long spine that drove my story and connected elements of my people's story and their quest for a voice. It did not end up as the final title, but it was a starting point.

My parents gave me their love of music and dance. Even as they struggled to recover from their losses as internees of America's concentration camps, they sacrificed to support my desire and need for training as a dancer. No

child can accomplish that on their own. It not only gave me a head start in a career but taught me perseverance in pursuit of excellence, something that came in handy for the rest of my life.

Another part of "me" is Yuri Kochiyama, who brought me into the Asian American Movement, where I met Chris Iijima. I would not have found my song without Chris. Barbara Dane of Paredon Records recorded our album *A Grain of Sand*, making sure our songs would not be lost to future generations.

Keeping an arts organization like Great Leap afloat since 1978 (forty-two years to date) to support my work and projects that have engaged so many other artists has been a high-wire act with no safety net. I offer my gratitude to my fellow artists and to the community that supports us. It could not have been done without two miracle-working administrators, Donna Ebata and Jenni Kuida, who did their tours of duty and beyond. Dan Kwong, my associate artistic director, has been a creative force and artistic handyman who can figure out most anything. Our small, smart, and mighty board has kept us adeptly afloat and in tune with the times: Meryl Marshall, Ken Hayashi, Eugene Ahn, Clara Chiu, and Quetzal Flores.

I would like to recognize the many contributions to this project: the iconic movement photos of Bob Hsiang; the archives of Visual Communications; the images of UCLA's Marji Lee and Mary Kao; from the Little Tokyo Service Center, Mike Murase's photos; our family documentarian, Harry Hayashida; Mohsen Hussein from my son's Sufi community; and Alan Miyatake, who granted use of his famed grandfather Toyo Miyatake's picture of me. Meibao Nee even gave me a space for a winter writing retreat in Mariposa.

Elaine Fukumoto, the head Obon dance teacher and a choreographer for FandangObon, knew I was writing and put me in touch with her *taiko* buddy, ethnomusicologist Deborah Wong, the perfect person to guide me toward publishing. She got Professor Michelle Habell-Pallán of the University of Washington to read part of the book, and helped me understand the importance of my story for artists and scholars in ethnic and women's studies. Deborah got it to George Lipsitz of the University of California, Santa Barbara, who took the time to drill down into the first complete version of my manuscript, and he provided beautiful comments, even correcting my idiosyncratic personal style of punctuation while showing me where my writing sang. To help me put this elephant of 147,000 words through the eye of a needle, editor Deborah Wong had boundless enthusiasm

and an eagle eye for what was essential for the story, helping me to whittle it down to 114,000 words and ready it for the University of California Press. My longtime friends and colleagues Karen Ishizuka and Masumi Izumi offered engaged feedback as outside readers for UC Press, and I thank them for choosing to reveal themselves.

It was a blessing celebrating my eighth decade on the planet knowing that UC Press would publish this book, and that Smithsonian Folkways Recordings would soon release *120,000 Stories*, a double album of my old and new songs produced by musical gurus Derek Nakamoto and Quetzal Flores. Much of my music is an expression of living, learning, and being in community with dedicated artists, organizers, teachers, environmentalists, and cultural practitioners—especially as part of FandangObon—as we explore the importance of our traditions in this present moment of reckoning and change.

I walk and live this journey with my partner, my love, my husband, Tarabu, who provides immeasurable support with his intelligent reflection, artistry, and steadfast morning practice, which prods me from laziness and keeps my chi flowing. Our family—the Miyamotos, Kirklands, Jeffreyses, and Ayubbis—is a jigsaw of colors and spiritual beliefs that foretell the radical inclusion that is trying to be born. This book holds our stories and our struggles, with the hope that our grandchildren—Asiyah, Muhammad, Noora, and Ahmed—will know their legacy and find their own way to sing change.

NOTES

CHAPTER 1. A TRAVELIN' GIRL

1. Among the guests who came in to teach was the famed artist Isamu Noguchi, who later volunteered to be interned at Poston, in solidarity.

CHAPTER 4. FROM A BROKEN PAST INTO THE FUTURE

1. Boyle Heights in 1948 was multicultural before they invented the word. There were Jews, Russians, Mexicans, and Japanese who returned after the war. It happened in layers. In 1858, when California was part of Mexico, the area was called Paredon Blanco (White Bluffs). The Spanish nudged out the Indians and established ranches there. In 1876 the Southern Pacific Railroad built a train station just west of the Los Angeles River, and the landowner at that time, Andrew Boyle, subdivided the area as a perfect future home for the well-to-do, just across the river from LA's growing downtown. You can see remnants of some of those big houses today. But things didn't work out quite the way Boyle expected. In those days there were restrictive housing covenants attached to deeds that barred Jews, Asians, Latinos, Blacks, and Native Americans from living and buying houses in choice areas of Los Angeles. Eventually Boyle Heights became a magnet for people rejected from the more desirable areas.

CHAPTER 5. TWICE AS GOOD

1. Daniel Berrigan, "Coda," in Judith Ault, *Come Alive!: The Spirited Art of Sister Corita* (London: Four Corners Books, 2007).

CHAPTER 6. SHALL WE DANCE!

1. That scene from *Les Girls* can be viewed at http://www.youtube.com /watch?v=ROXbYtzu2yo.

CHAPTER 8. CHOP SUEY

1. See the *Flower Drum Song* cast on *The Ed Sullivan Show* at https://www .youtube.com/watch?v=jkYQaNHl2K8.

CHAPTER 12. A SINGLE STONE, MANY RIPPLES

1. These notebooks are now part of the hundreds of boxes in the Yuri Kochiyama collection in the UCLA archives.

CHAPTER 15. A SONG FOR OURSELVES

1. These songs and "Jonathan Jackson" are on the album *A Grain of Sand: Music for the Struggle by Asians in America* (Paredon, 1973; rereleased by Smithsonian Folkways, 1997). "We Are the Children," "Free the Land," and "Yellow Pearl" are also on my album *120,000 Stories* (Smithsonian Folkways, 2021).

2. At that time, New York had no Mexican restaurants. In all of New York City, you couldn't scare up a package of tortillas, so tortillas became the gold we returned with from California—gifts for our comrades. A dollar a package and easy to slide into a suitcase!

3. Reverend Mas Kodani and activists George Abe and Johnny Mori started Kinnara Taiko in 1969, inspired by seeing the Japanese actor Toshiro Mifune playing one in the movie *Rickshaw Man* (1958). *Taiko* is a Japanese festival drum used in Buddhist temples once a year for Obon. Abe and Mori multiplied it into a core of drummers, making it more powerful, more collective, more democratic, and more inclusive of women and the rhythms of Black music that naturally flowed through our ears. Kinnara and San Jose Taiko were thoroughly infected with the spirit of the Asian American movement. *Taiko* was a thundering virus that was spreading. It would become our Japanese American music form. While internment caused many Japanese Americans to sever their roots, *taiko* was a way to reweave the broken links to our homeland. *Taiko* inspired deeper interest in studying in Japan. Kenny Endo, a young *taiko* and jazz drummer, was among the first to dive deeply into Japanese music. The primary difference between Japanese *taiko* (Ondekoza) and American *taiko* (Kinnara) is that American *taiko* has the subtle presence of African-influenced rhythms.

4. This led to the establishment of Teatro Campesino, based in the small town of San Juan Bautista, California. Valdez would go on to produce *Zoot Suit*, the groundbreaking play (published in 1978) and movie (released in 1981). His idea of creating theater in the midst of struggle, with and for the people, was revolutionary.

5. I am thinking of Tomie Arai, well known for her murals and public works; Arlen Huang, painter and glass artist; Fay Chiang, a poet who ran organizations that served youth in New York's Chinatown; Takashi Robert Yanagida, a lawyer-activist; Larry Hama, a comic book writer who created the *GI Joe* series; Bob Lee, executive director and curator at the Asian American Arts Centre, New York; Danny Yung, an international artist now based in Hong Kong, and more.

CHAPTER 16. *SOMOS ASIÁTICOS*

1. "Somos Asiáticos" is on the album *A Grain of Sand: Music for the Struggle by Asians in America* (Paredon, 1973; rereleased by Smithsonian Folkways, 1997). A new version is on my album *120,000 Stories* (Smithsonian Folkways, 2021).

2. Venceremos Brigade assembled a songbook, *Venceremos Cantando*, published in 1975 and again in 1976. I'm very proud that two of our songs were in it, "We Are the Children" and "Somos Asiáticos."

CHAPTER 18. A GRAIN OF SAND

1. Our song "War of the Flea" is on the album *A Grain of Sand: Music for the Struggle by Asians in America* (Paredon, 1973; rereleased by Smithsonian Folkways, 1997).

2. Charlie and Chris did another album, *Back to Back* (East/West World, 1982), produced by Warren Furutani, with Charlie's songs on one side and Chris's on the other.

CHAPTER 19. FREE THE LAND

1. See Dan Berger, "'Free the Land!': Fifty Years of the Republic of New Afrika," *Black Perspectives*, April 10, 2018, https://www.aaihs.org/free-the-land-fifty-years-of-the-republic-of-new-afrika.

2. For more information see Vicente "Panama" Alba and Molly Porzig, "Lincoln Detox Center: The People's Drug Program," *The Abolitionist*, March 15, 2013, https://abolitionistpaper.wordpress.com/2013/03/15/lincoln-detox-center-the-peoples-drug-program/.

CHAPTER 21. SOME THINGS LIVE A MOMENT

1. The Mosque of Islamic Brotherhood still exists at 130 West 113th Street in Harlem.

CHAPTER 22. HOW TO MEND WHAT'S BROKEN

1. Playwright Velina Houston infuses her plays with her experience as an Afro-Asian woman.

CHAPTER 24. OUR OWN CHOP SUEY

1. Some previously unreleased songs by Warriors of the Rainbow are on my album *120,000 Stories* (Smithsonian Folkways, 2021). A 1981 performance on Hawaii public TV can be seen at https://youtu.be/RMroLqFrgD8.

2. "American Made" is on my albums *Best of Both Worlds* (Great Leap, 1983) and *120,000 Stories* (Smithsonian Folkways, 2021).

CHAPTER 25. WHAT IS THE COLOR OF LOVE?

1. "Jan Ken Po" is on my album *Best of Both Worlds* (Great Leap, 1983).

CHAPTER 26. TALK STORY

1. The first movement of *Journey in Three Movements* is on my album *Best of Both Worlds* (Great Leap, 1983).

2. "Pilipino Tango" is on my album *120,000 Stories* (Smithsonian Folkways, 2021).

CHAPTER 27. *YUIYO,* JUST DANCE

1. "Yuiyo" is featured in the book/CD *A Gathering of Joy: Obon Music and Dance Traditions in the U.S.*, ed. Chris Iwanaga Aihara (Los Angeles: Japanese American Cultural and Community Center, 1993). It is also on my album *120,000 Stories* (Smithsonian Folkways, 2021).

CHAPTER 30. TO ALL RELATIONS

1. Quoted in Steve Newcomb, "Five Hundred Years of Injustice: The Legacy of Fifteenth Century Religious Prejudice," *Shaman's Drum*, Fall 1992, 18–20, available at http://ili.nativeweb.org/sdrm_art.html.

2. "To All Relations—Mitakuye Oyasin" is on my album *Nobuko: To All Relations* (Bindu Records, 1997), and a new version featuring me with my granddaughter Asiyah Ayubbi is on *120,000 Stories* (Smithsonian Folkways, 2021).

CHAPTER 31. *BISMILLAH IR RAHMAN IR RAHIM*

1. Kwanzaa was invented in 1966 by Black Nationalist Maulana Karenga, once the archenemy of the Black Panthers. An alternative to Christmas, Kwanzaa's seven-day candle-lighting ceremony instills each day with African values.

CHAPTER 32. THE SEED OF THE DANDELION

1. My song "Tampopo" is on my album *120,000 Stories* (Smithsonian Folkways, 2021).

CHAPTER 33. I DREAM A GARDEN

1. Bill Moyers, *Bill Moyers Journal: The Conversation Continues* (New York: New Press, 2013), 225–26.

2. This is from an unpublished reflection that was written for a grant evaluation form.

CHAPTER 34. *MOTTAINAI*—WASTE NOTHING

1. Watch "B.Y.O. Chopstix" at https://youtu.be/n65SuQKverM.

2. "Mottanai" is on my album *120,000 Stories* (Smithsonian Folkways, 2021), and the music video is at https://youtu.be/TrMLqbxLoEo.

3. "Cycles of Change" is on my album *120,000 Stories* (Smithsonian Folkways, 2021), and the music video is at https://youtu.be/3EtzCKLCk7E.

4. "Bambutsu—No Tsunagari" is on my album *120,000 Stories* (Smithsonian Folkways, 2021), and a dance tutorial video is at https://youtu.be/24FEYJYTknQ.

5. "Living Kagai Culture," *Kyoto Journal*, no. 89 (Spring 2017): 23.

6. From the Eastside Café website and mission statement, https://www
.eastsidecafe.org/.

CHAPTER 36. *BAMBUTSU*—ALL THINGS CONNECTED

1. See a video synopsis of the Environmental Encuentro at https://youtu.be
/bi71xAwg3Gw.
2. "Bambutsu—No Tsunagari" is on the album *120,000 Stories* (Smithsonian
Folkways, 2021). Music by Nobuko Miyamoto and Quetzal Flores; lyrics by Nobuko
Miyamoto, César Castro, and Martha González.

INDEX

Hovhaness, Alan, 85
"How High the Moon," 34
Huang, Arlen, 161, 313ch15n5
Huerta, Dolores, 138

I Hate the Capitalist System, 160
"I Dream a Garden," 268, 290
"I Dreamt I Was Helen Keller Last Night!,"
 217
"I Heard It through the Grapevine," 182
I Wor Kuen, 119
Iba, Larry, 181
Iijima, Chris, 118–21, 126–41, 143–44,
 146–56, 193 (photo 11), 194 (photo 14),
 195 (photo 16), 308
Iijima, Kazu and Tak, 118, 120–21
"Imagine," 156
Imam Yassir, 248–250
Indigenous peoples, 73, 110, 131, 147, 241–
 44, 269, 276, 288, 305; American Indian
 Movement (AIM), 242; Many Winters
 Gathering of Elders, 241; Native Ameri-
 can Friendship Dance, 223, 268;
 Tongva, 288
Imperial, Franco, 299 (photo 25)
inipi (sweat lodge), 241–44
International Hotel (I-Hotel), 139–40,
 230
interracial relationships, 51, 53–57, 81–82,
 85, 228–30
Islam, 167, 172–73, 181, 186, 214,
 246–53, 257, 269, 271, 287, 291.
 See also Sufi
Issei, 8, 11, 16, 34, 35–36, 112, 127, 209
Itliong, Larry, 138
Ito, Leslie, 277
Ito, Michio, 47
Izumi, Masumi, 307, 309

Jackson Street Gallery, 139
Jackson, C. Bernard, 208
jan ken po, 213, 295 (photo 21)
Japan America Theatre, *see* Aratani Japan
 America Theatre
Japantown, 83, 123
Japanese (language), 112, 120, 123–24, 221
Japanese American Citizens League
 (JACL), 120, 122, 127–28

Japanese American Cultural and Commu-
 nity Center (JACCC), 215, 217, 223–24,
 252, 277, 278, 288–90
Japanese American National Museum
 (JANM), 288
Japanese Community Youth Center
 (JCYC), 245, 246
Japanese Exclusion Act, 6
Jara, Victor, 148
Jayo, Norman, 139, 228, 230–31
jazz, 11, 34, 79–85, 99, 114, 136, 229
Jeffrey, Howard, 40, 72, 76
Jeffreys, Grandma and Grandpa, 189–90
Jeffreys, Mfalme, 164–81, 178. *See also*
 Attallah Ayubbi, Peter X, and Peter
 Jeffreys
Jeffreys, Peter, 166–67. *See also* Attallah
 Ayubbi, Mfalme Jeffreys, and Peter X
Jeffreys, Lyla ("Mrs. Jeffreys"), 174–75,
 188–90
Jerome War Relocation Center, 6, 112
Jewish Americans, 51, 54–57, 62, 170, 213
Jimenez, Maria, 40, 72–73
JoAnne (and Joanne), 21, 35, 89 (photo 5), 91
 (photo 7); "JoAnne Miya," 78; Jo Miya,
 84; changing to Nobuko, 173–74
"Jonathan Jackson," 133
Jones, Ted (Teddy), 53–54, 55, 79
Journey in Three Movements, 216–17,
 314ch26n1
Journey of the Dandelions, 256–57
Juke Box (musical), 228, 230–31

Kabuki, 35, 66–67; Grand Kabuki, 215–16
Kamau, *see* Ayubbi, Kamau Shigeki Bin
 Attallah
Kan, Mike, 207
"Kanashiki Kuchibue," 34
Karate Kid II, 224–27
kato-kiriyama, traci, 288
Kaur, Krishna, 247–48, 250, 255
Kaye, Suzie, 73, 77
Kearney Street Workshop, 139
Kelly, Gene, 46, 48–50, 60, 64
Kendall, Kay, 49
kenjinkai, 35–36
Kennedy, John F., 82, 147
Kenney, Ed, 62, 64

womanism, 105
Wong, Anna Mae, 61
Wood, Natalie, 74–75
World of Suzie Wong, The, 68
World Stage (Leimert Park), 81
Wounded Knee, 242–43

yagura, 223–24, 276
Yamamoto, Danny, 203, 277
Yamashita, Qris, 136, 277
Yee, Benny, 135, 203–208
Yellow Brotherhood, 123, 180
"Yellow Pearl," 133, 152–56

Yellow Pearl (publication), 140–41, 161
Yellow Seed, 128, 130
yellowface, 62–63
Yippies (Youth International -56, 270Party), 144, 152–56
yoga, 246–47, 251, 255; Black Yoga Teachers Association, 255
Yokohama (band), 136
yonsei, 112
Young Lords Party, 110–11, 114, 124, 143, 148
"Yuiyo," 221–27, 314ch27n1
yukata, 221, 223, 224, 243, 261, 287
Yuriko, 63–64, 66–68

Founded in 1893,
UNIVERSITY OF CALIFORNIA PRESS
publishes bold, progressive books and journals
on topics in the arts, humanities, social sciences,
and natural sciences—with a focus on social
justice issues—that inspire thought and action
among readers worldwide.

The UC PRESS FOUNDATION
raises funds to uphold the press's vital role
as an independent, nonprofit publisher, and
receives philanthropic support from a wide
range of individuals and institutions—and from
committed readers like you. To learn more, visit
ucpress.edu/supportus.